LOCAL/GLOBAL

WE DEDICATE THIS BOOK TO THE LIFE AND WORK OF JOAN KERR,
ART AND ARCHITECTURAL HISTORIAN,
1938–2004

Local/Global:
Women Artists in the Nineteenth Century

Edited by Deborah Cherry and Janice Helland

ASHGATE

Published by
Ashgate Publishing Limited
Gower House
Croft Road
Aldershot
Hants GU11 3HR

Ashgate Publishing Company
Suite 420
101 Cherry Street
Burlington, VT 05401-4405
USA

Ashgate website: http://www.ashgate.com

British Library Cataloguing in Publication Data
Local/global : women artists in the nineteenth century
 1. Women artists - History - 19th century 2. Women artists -
Biography 3. Art, Modern - 19th century
 I. Cherry, Deborah II. Helland, Janice
704'.042'09034

Library of Congress Cataloging-in-Publication Data
Local/global : women artists in the nineteenth century / edited by Deborah Cherry and
 Janice Helland.
 p. cm.
 Includes bibliographic references and index.
 ISBN 0-7546-3197-4 (alk. paper)
 1. Women artists -- Biography -- History and criticism. 2. Women artists -- History --
19th century. 3. Feminist art criticism. I. Cherry, Deborah. II. Helland, Janice.

N8354.L63 2005
704'.042'09034--dc22

 2005048177

ISBN 0 7546 3197 4

Typeset by Bournemouth Colour Press, Parkstone, Poole.

Printed and bound in Great Britain by Biddles Ltd, King's Lynn.

Contents

Joan Kerr is widely known as a leading and distinguished historian of Australian art and architecture. She produced more than a dozen major publications, including the *Oxford Companion to Aboriginal Art*, and edited two major biographical projects: the *Dictionary of Australian Artists: Painters, Sketchers, Photographers and Engravers to 1870* (Melbourne, 1992) and *Heritage: The National Women's Art Book, 500 Works by 500 Australian Women Artists from Colonial Times to 1955* (Sydney, 1995). An edition of her writings on art and architecture will be published by the Power Institute, Sydney (eds Dinah Dysart, Jo Holder and Candice Bruce). Kerr pioneered scholarly inquiry on Australian women artists, bringing together detailed empirical investigation and finely honed analysis. She authored more than a hundred articles – on Australian colonial art, Aboriginal art, architectural conservation, monuments and memorials, contemporary art, art politics and museology. In 2003 she was awarded an Honorary Life Membership of the Royal Australian Historical Society for services to Australian history. The second woman to be so honoured, she received many such awards in her long career.

Joan's writing is a joy to read. Serious, deeply researched and erudite, her prose sparkles on the page, imbued with a mischievous wit and a dry, ironic humour. Her writing is characterized as much by her impeccable scholarship, passionate engagement, exhilarating elan and the clarity of her expression, as by her attention, as she put it, to 'despised genres and unorthodox mediums'. Valued in her lifetime by so many, she leaves, here and elsewhere, an inspirational legacy.

List of Figures

illustration from Edith Œ. Somerville and Martin Ross, 'The Boat's Share', *Strand Magazine*, **39**, January–June 1905, 72, reproduced with acknowledgement to the Board of Trinity College, Dublin

7.5 Edith Œ. Somerville, 'Katie Keohane: Let the Divil Clear Me Out of the Sthrand, For There's No One Else Will Pull Me Out', illustration from Edith Œ. Somerville and Martin Ross, 'The Boat's Share', *Strand Magazine*, **39**, January–June 1905, 80, reproduced with acknowledgement to the Board of Trinity College, Dublin

7.6 Rose Barton, *Going to the Levée at Dublin Castle*, 35.6 x 26.6 cm, watercolour on paper, 1897, Dublin: National Gallery of Ireland

Nuns, ladies and the 'Queen of the Hurons': souvenir art and the negotiation of North American identities

8.1 Work basket, probably Quebec convent work, 27 x 19 x 10 cm, birchbark, moosehair, thread and ribbon, *c.* 1800, Toronto: Royal Ontario Museum, Bedford Collection. 992.274.37.1–2

8.2 Set of playing card boxes, probably collected before 1786 by George or John Cartwright, explorers of Newfoundland, or by another member of the family, Lieutenant-Colonel Henry Watson Powell, 53rd Regiment of Foot, during the American Revolution, 8.5 x 6.5 cm, South Africa: private collection

8.3 Work box, presented to Mrs Benedict Arnold on her departure from Halifax, Nova Scotia, in 1791, 44 x 35 x 15 cm, bird's-eye maple, with fittings of birchbark, fabric, silk, silk embroidery floss and moosehair, on loan from Mrs Arnold's descendants to the American Museum of Bath

8.4 Tea caddy, 23 x 13 x 12.5 cm, late eighteenth century, probably English

work following the fashion of 'Indian' curios, Cotehele House, Cornwall, by kind permission of the National Trust. Photograph: Dennis G. Madge

8.5 Pocketbook, attributed to Sarah Rachel Uniacke, a non-Native woman, with 'Ich dien' (the motto of the Prince of Wales) embroidered on the front fastener, presented to the Prince of Wales in 1860, 12 x 8 x 1 cm, The Royal Collection, © 1997, Her Majesty Queen Elizabeth II, Osborne House, Isle of Wight: Swiss Cottage Museum

8.6 Cigar or cigarette box, Huron-Wendat, bought at Niagara Falls by Mr Döllner in 1847, 14 x 8.5 cm, moosehair embroidered, Copenhagen: The National Museum of Denmark, Department of Ethnography. EHc152

8.7 Box, Euro-Canadian work, 11.8 x 8.8 x 3.8 cm, moosehair-embroidered birchbark, late eighteenth century, Ottawa: Canadian Museum of Civilization, III-H-400

Placing Frances Anne Hopkins: a British-born artist in colonial Canada

9.1 Frances Anne Hopkins, *The Red River Expedition at Kakabeka Falls*, 91.4 x 152.4 cm, oil on canvas, 1877, Ottawa: Library and Archives Canada

9.2 Frances Anne Hopkins, *Canoe Manned by Voyageurs Passing a Waterfall*, 73.7 x 152.4 cm, oil on canvas, 1869, Ottawa: Library and Archives Canada

9.3 Frances Anne Hopkins, *Canoe Manned by Voyageurs Passing a Waterfall* (detail), 73.7 x 152.4 cm, oil on canvas, 1869, Ottawa: Library and Archives Canada

9.4 Daniel Wilson, *West Cliff at Nipigon, Canada West*, 16.2 x 25.1 cm, watercolour, 1866, Ottawa: Library and Archives Canada

9.5 Frances Anne Hopkins, *Timber Raft on the St Lawrence River*, 39.4 x 49.5 cm, watercolour and gouache, n.d., Toronto: Royal Ontario Museum

9.6 Frances Anne Hopkins, *Minnehaha Feeding the Birds*, 61 x 106.7 cm, oil on canvas, 1874, St Paul: Minnesota

Chronicles in cloth: quilt-making and female artistry in nineteenth-century America

10.1 Sarah Furman Warner Williams, *Phebe Warner Coverlet*, 262.25 x 229.87 cm, linen with linen and cotton appliqué and silk embroidery, c. 1803, New York: Metropolitan Museum of Art

10.2 Hannah Stockton Stiles, *Trade and Commerce Counterpane*, 266.7 x 226.06 cm, appliquéd and embroidered cottons, c. 1830, Cooperstown, New York: Philadelphia Fenimore Art Museum

10.3 Elizabeth Roseberry Mitchell, *Family Graveyard Quilt*, 215.9 x 205.74 cm, pieced, appliquéd and embroidered cottons, c. 1843, Frankfort, Kentucky: Kentucky Historical Society

10.4 Lucinda Ward Honstain, *Pictorial Album Quilt*, 243.84 x 218.44 cm, pieced, appliquéd and embroidered cottons, 1867, Brooklyn, New York: International Quilt Study Center, University of Nebraska-Lincoln

10.5 Harriet Powers, *Bible Quilt*, 172.72 x 266.7 cm, pieced and appliquéd cottons, c. 1895, Athens, Georgia: Museum of Fine Arts, Boston, Bequest of Maxim Karolik

Edmonia Lewis's *Death of Cleopatra*: white marble, black skin and the regulation of race in American neoclassical sculpture

11.1 Edmonia Lewis, *Death of Cleopatra*, 160 x 79.4 x 116.84 cm, marble, 1875, Washington DC: Smithsonian National

Museum of American Art, Gift of the Historical Society of Forest Park, Illinois

11.2 William Wetmore Story, *Cleopatra*, height 138.4 cm, marble, 1869, New York: Metropolitan Museum of Art, Gift of John Taylor Johnston

11.3 Edward Augustus Brackett, *Shipwrecked Mother and Child*, 87 x 188.6 cm, marble, 1851, Worcester, Mass.: Worcester Art Museum, Gift of Edward Augustus Brackett

11.4 Edmonia Lewis, *Old Arrow Maker*, 54.61 x 34.59 x 34 cm, marble, 1872, Washington DC: Smithsonian National Museum of American Art, Gift of Mr and Mrs Norman Robbins

11.5 Edmonia Lewis, *Hagar*, 133.65 x 38.74 x 43.5 cm marble, 1875, Washington DC: Smithsonian National Museum of American Art, Gift of Delta Sigma Theta Sorority Inc.

Modernity and tradition: strategies of representation in Mexico

12.1 Josefa San Román, *Portrait of Juliana San Román*, 103 x 81 cm, oil on canvas, 1851, copy after Pelegrin Clavé, Mexico City: Fundación Cultural Antonio Haghenbeck y de la Lama IAP

12.2 Guadelupe Carpio, *Self-Portrait with Family*, 157 x 82.5 cm, oil on canvas, n.d., Mexico City: Jose Mayora Souza Collection

12.3 Eulalio Lucio, *Objects for Embroidery*, 31 x 41 cm, oil on canvas, 1884, Mexico City: Fomento Cultural Banamex

12.4 Eulalio Lucio, *Objects of the Hunt*, 84.5 x 105 cm, oil on canvas, 1888, Mexico City: Fomento Cultural Banamex

12.5 Julia Escalante (1854–1900), *The Milkcarrier*, exhibited 1881 and 1888, oil on canvas, 169 x 75 cm, Dr. Manuel Escalante Legorreta, Mexico City

Notes on Contributors

JANET CATHERINE BERLO is Professor of Art History and Visual and Cultural Studies at the University of Rochester, New York, USA, where she teaches courses on indigenous arts of the Americas, quilt history, and issues of museum representation. Her recent books include *Wild By Design: Two Hundred Years of Innovation and Artistry in American Quilts* (with Patricia Crews, 2003), *Spirit Beings and Sun Dancers: Black Hawk's Vision of the Lakota World* (2000) and *Quilting Lessons*, a memoir (2001).

SÍGHLE BHREATHNACH-LYNCH, PhD, is Curator of Irish Art at the National Gallery of Ireland. She has co-authored with Marie Bourke *Discover Irish Art* (1999) and has published a number of articles and catalogue essays.

DEBORAH CHERRY is Professor of the History of Art at the University of the Arts, London and the editor of *Art History*. She has written extensively on nineteenth- and twentieth-century art, and her publications include *Between Luxury and the Everyday: Decorative Arts in Eighteenth-Century France* (co-edited, 2005), *Art:History:Visual:Culture* (2005), *Speak English* (2002), *Beyond the Frame: Feminism and Visual Culture* (2000), *Painting Women: Victorian Women Artists* (1993).

JANICE HELLAND is Professor of Art History and Women's Studies, and Queen's National Scholar, Queen's University, Kingston, Canada. She is the author of *The Studios of Frances and Margaret Macdonald* (1996), *Professional Women Painters in Nineteenth-Century Scotland: Commitment, Friendship, Pleasure* (2000), and *Women Artists and the Decorative Arts 1880–1935: The Gender of Ornament* (co-edited, 2002).

KRISTINA HUNEAULT is Associate Professor and Research Chair in Art History, Concordia University, Montréal, Canada. She is the author of *Difficult Subjects: Working Women and Visual Culture, Britain 1880–1914* (2002). Her current research explores gendered subjectivity in the work of historical Canadian women artists, and she has recently published on this subject in *Art History* (2004).

JOAN KERR taught and published on Australian art history for over thirty years. Her major work on Australian women artists was the National Women's Art Project, which began with the 1995 National Women's Art Exhibition: 147 exhibitions throughout Australia initiated and co-ordinated with Jo Holder to celebrate the twentieth anniversary of International Women's Year. Her publications included the *Dictionary of Australian Artists: Painters, Sketchers, Photographers and Engravers to 1870* (1992), *Heritage, The National Women's Art Book: 500 Australian women artists from colonial times to 1955* (1995), and *Past Present: The National Women's Art Anthology* (co-edited, 1999). In 1994, she moved from the Power Institute of Fine Arts in Sydney, where she had been based for twenty-five years, to the University of New South Wales, taking up a research professorship in Art History and Theory at the College of Fine Arts. Three years later she became the Inaugural Professor and Convener of the Programme in Australian Art at the Centre for Cross-Cultural Research at the Australian National University, Canberra, returning to the College of Fine Arts in 2003.

CHARMAINE NELSON is Assistant Professor of Art History in the Department of Art History and Communication Studies at McGill University, Montreal. She curated *Through An-Other's Eyes: White Canadian Artists – Black Female Subjects* (Oshawa: Robert McLaughlin Gallery, 1998), authored 'White Marble, Black Bodies and the Fear of the Invisible Negro: Signifying Blackness in Mid-Nineteenth-Century Neoclassical Sculpture', *Revue d'art canadienne/Canadian Art Review*, 27, 1-2, 2000, and co-edited and contributed to *Racism Eh?: A Critical Inter-Disciplinary Anthology of Race and Racism in Canada* (2004).

GRISELDA POLLOCK is Professor of Social and Critical Histories of Art and Director of AHRC Centre for Cultural Analysis, Theory and History at the University of Leeds. Her major research projects concern sexual difference and creativity and her forthcoming books include a study of German-Jewish artist Charlotte Salomon's sole surviving art work, *Life? or Theatre?*, a book on cities and countries in modernism, and further work on trauma and cultural memory in the wake of the Shoah and other political catastrophes.

MARY ROBERTS is the John Schaeffer Lecturer in British Art at the University of Sydney; she writes on colonial art, gender, the culture of travel and cross-cultural exchange. Her publications include *Refracting Vision: Essays on the Writings of*

Michael Fried (co-edited, 2000) and *Orientalism's Interlocutors* (co-edited, 2000). *Intimate Outsiders: Gender, Representation and British Orientalism* is forthcoming.

GAYATRI SINHA is an independendent curator and art critic, based in New Delhi. Her publications include *Expressions and Evocations, Contemporary Women Artists of India* (edited, 1997), *Woman/Goddess* (1998, in a Ford Foundation aided project), *Krishen Khanna: A Critical Biography* (Vadehra Art Gallery, 2001) and *Indian Art: An Overview* (edited, 2003).

JULIE ANNE STEVENS lectures on English literature in St Patrick's College, Drumcondra, in Dublin. With a Government of Ireland postdoctoral fellowship, she set up the exhibition on the manuscripts and illustrations of Edith Somerville and Martin Ross in 2002 in Trinity College Library, Dublin. She has published on nineteenth- and twentieth-century Irish writing and is editing a collection of essays, *Northern Landscapes*, which deals with the representation of late nineteenth-century north European landscapes in art and fiction.

KA BO TSANG is a curator of Chinese painting and textiles at the Royal Ontario Museum in Toronto. She has co-authored, with Hugh Moss and Victor Graham, five volumes of a projected eight-volume series entitled *A Treasury of Chinese Snuff Bottles: The Mary & George Bloch Collection* (1995–2002). She also produced a well-received exhibition catalogue, *More than Keeping Cool: Chinese Fans and Fan Paintings* (Toronto: Royal Ontario Musuem, 2002).

LYNNE WALKER is a Senior Research Fellow at the Institute of Historical Research, University of London, where she also teaches approaches to visual sources to postgraduate students. She has published widely on gender, space and architecture and curated two RIBA exhibitions, most recently, *Drawing on Diversity: Women, Architecture and Practice* (1997). Some of her most current work is in diverse media and includes co-authorship of the European Commission-funded website, *Discovering Contemporary Architecture in Paris, London and Athens* (www.culture2000.tee.gr) and the architecture and film section of *Art & Design: A BFI Sourcebook* (2004).

STACIE G. WIDDIFIELD is Professor of Art History at the University of Arizona. She is the author of *The Embodiment of the National in Late Nineteenth-Century Mexican Art* (1996) and co-editor, with Esther Acevedo, of the forthcoming, four-volume series, *Hacia Otra Historia de Arte Mexicano* (Conaculta/Curare). She has also written a number of articles on nineteenth-century Mexican art that focus on national identity and culture, gender, modernity and historiography.

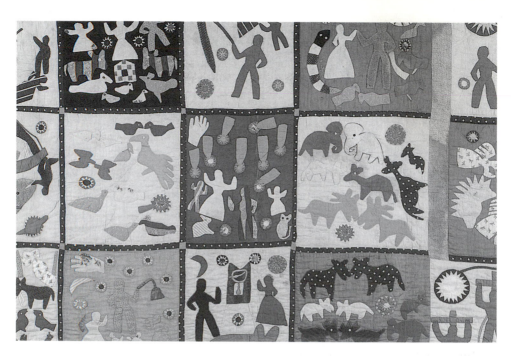

Frontispiece Harriet Powers, *Bible Quilt* (detail), 172.7 x 266.7 cm, pieced and
appliquéed cottons, *c.* 1895, Boston: Museum of Fine Arts, see also
Figure 10.5. At the centre of the quilt Powers portrays the Leonid
meteor storm of 13 November 1833. Against a blue background a
shower of bright yellow stars falls on figures and animals.

Local places/global spaces: new narratives of women's art in the nineteenth century

Deborah Cherry and Janice Helland

In 1893 Noguchi Shonin exhibited her art at the World's Fair in Chicago, winning a prize for her landscape painting. She contributed to the Japanese section, which showcased the art of forty-four women artists selected to represent their nation on the Western stage at one of the largest of the vast, spectacular exhibitions of the *fin de siècle*. Noguchi Shonin and her equally well-regarded colleague, Okuhara Seiko, were part of a large, well-established cultural group in Tokyo that boasted political connections as well as literary and artistic achievements, and like many of their Western counterparts, they taught aspiring young artists in their community.[1] 'Funded by the Empress and run by her daughter, Princess Yasu Mori' (Weimann, 1981, 274), the Japanese section had the sanction of an imperial dynasty concerned to disseminate Japanese culture in a period in which Japanese art was widely known, to secure beneficial economic and trading links, and promote Japan as a modern nation.[2] One of many cultural exchanges that took place in the nineteenth century, this exhibition of art by Japanese women in the American northeast speaks of the many-faceted global encounters brought to light in this book: between old and new nations, contrasting visual systems and contending definitions of the relations between art, nation, empire, and modernity, the key themes of our collection.

Local / Global: Women's Art in the Nineteenth Century is the first book to discuss the lives and works of women artists in disparate parts of the world in the nineteenth century, and to consider women's practice from the perspectives of several cultures. The compass is wide, from Australia, to East Asia, South Asia, West Asia, Europe, North America and Mexico. Subsistence artists are considered alongside elite practitioners, women working in the decorative arts, architecture and photography, as well as sculptors and

painters. With their contrapuntal narratives and alternative epistemologies, these essays emphasise the richness and diversity of the arts produced by women. *Local / Global* sets out to explore how this creative work and cultural achievement was produced and viewed, bought and sold by feminine subjects who were shaped by assymetrical relations of power, freighted by the tensions of race and ethnicity, class and social hierarchy, imperialism and the uneven pace of social change in a world charged by connections between the local and the global. It features women who crossed continents and cultures, artists relocated and displaced by the pressures of global and local change.

Each chapter focuses on a distinct region or place. This frame may be a sub-continent, a city, a country or an immediate location. The locations considered here are not conceived as monolithic or unified areas; rather they are perceived as 'contingent sites of significant cultural activity' ; as much as they are material realities and geographical formations, they are also ideas, 'powerful tropes of nationhood and selfhood' (Castle, 2001, xx). Contributors attend to the local and global sites of production, exhibition and sale of art by women, to the local and globally sourced and traded materials which artists used. Running through the volume is an understanding that space and time are shaped by local and global pressures, that local time is shot through with global temporalities, that local times and spaces coexist, placing subjects contradictorily. Equally significant is an emphasis on the 'overlapping territories, intertwined histories' of this century of empire (Said, *Culture and Imperialism*, 1993).

Central to this collection are the interconnections between working lives, social relations and space. Drawing on an increasing recognition of the importance of the artists' networks and an understanding of artistic sociability, the essays gathered here elucidate the manifold ways in which space shaped what a woman artist could do, how and where she worked: at the corner of a table in an interior, in a studio, in a family residence, in the appointed quarters of the imperial palace in China, in the *haremlik* or the secluded apartments of the *zenana*, on the native reservation. In the West the studio, as an actual place and as a sign, was increasingly defined as the privileged site for artistic production and invited viewing. 'A room of one's own' (Woolf, 1929) came to signify not only the necessary condition for women to make art, but a powerful imaginary space in the fashioning of creative subjectivity. In India, by contrast, the studio was the domain for artistic work commissioned by and connected to a royal house, in contrast to the workshops and ateliers of family production. For many the boundaries between living and working were blurred, and some had no dedicated workspace at all.

Women's artistic practice and training often took place in the family

dwelling. Although its significance has long been recognized, the family was by no means consistent across nineteenth-century societies – in lived experience, in relation to the household, as a unit, or as a social ideal. Families varied enormously, in structure, number and relationships, as well as in their occupation of a 'family' residence; and characteristic of this century was familial scattering and dispersal. Families also varied considerably in their attitudes to the practice of art by women. The distinctively closed form of the bourgeois family undoubtedly created tensions and pressures in which women often negotiated the practice of art in relation to family duties, pleasures and expectations. Artistic families made demands that affected an artist's choice of genre or her access to workspace and materials. The family could prove simultaneously beneficial and detrimental. Stacie Widdifield signals the contradictory pressures of marriage and motherhood in Mexico. And Joan Kerr, noting the irony and inversion with which home, household and homestead were visually portrayed by white women in Australia, cogently remarks that if '[c]hildren curtailed many a woman's career ... they could also be a significant factor in the matriarch's artistic survival.'

Accounts of gender and space have tended to emphasize both the distinctive culture of Western women, and the nineteenth-century concept of the separate spheres, in which a domestic, familial, dependent and domestic femininity is juxtaposed to a masculinity active in the world of work and the public spaces of the city.[3] While deconstruction is shifting the sands beneath binary oppositions such as public/private, masculine/feminine, work/home, the recognition that a good many nineteenth-century artists practised in domestic settings calls into question the vision of home as a private haven secluded from the world of work. Spatial mappings of public and private are also reshaped by attention to artists outside family spaces and structures. The three central chapters in this collection, by Griselda Pollock, Lynne Walker and Síghle Bhreathnach-Lynch and Julie Ann Stevens, focus on the radical lives of independent women in Europe, and the spaces they created and transformed for art, socializing, exhibitions and campaigning. For Janet Berlo, it is the textile arts of American quilts that argue for a re-examination of the separate spheres. These quintessentially homely objects are threaded through with references to historical events and public life, and stitched with an engagement with 'the role of women in American culture, their participation not only in a domestic economy but a global one'. As she points out, 'the more we learn about nineteenth century America, the less do quilts seem to be cloistered solely within a female realm.' If the public/private binary is under debate in the West, studies of art beyond the West are also dislodging these powerful narratives. Ka Bo Tsang explains the spatial, social and bodily protocols for court painters working in the workshops collectively called the *Ruyi guan* or 'Wish-fulfilling Studio', at the

imperial court of the Empress Dowager Cixi in China. And Mary Roberts delineates the regulation of space and social relations in the harems of Constantinople in a period in which they were undergoing profound social change, resulting from selective western influence, 'introducing the harem as a context in which Ottoman women's identity and sociality was renegotiated through image-making'.

What a woman artist made, and what she aspired or desired to make, were, then, closely connected to the spaces she might inhabit and to the webs of social and spatial relations in which she was placed: subjectivity, sociability and spatiality were intimately entwined. A growing awareness of the 'social production of space' and of the 'emplacement' of social beings has emphasized that space, identity and social life are mutually defining (Soja, 1989, 2). Neither a neutral container nor an empty receptacle, space was active in the formation of subjectivities, in the making of social and artistic life. But space was not only material or actual, a site to be accessed or negotiated; space was also imaginary, to be imagined and visually represented.

The 'social production of space' took place in everyday life and social relations, in the making and viewing of art, as well as in the spaces imagined and pictured in paintings and art works. 'Skeins of relations' linked the actual site of an artwork's production, the imaginary territories it portrayed, and the locations of its viewing.[4] And the connective matrix of the work could far exceed the work itself. Textiles travelled extraordinary distances before being pieced and stitched. Artists' materials, and their ingredients, were traded far and wide. And whether they were paints and watercolours, or bark and porcupine quills, these materials were transported by artists on the move: wealthy travellers in search of new subjects; migrants moving from country to city or from metropole to colony; indigenous women forcibly displaced by colonial settlement; art students in search of an education.

Global connections were transformed in the nineteenth century; new forms of mechanized transportation diminished distances and travel times. But travel took many forms, from tourism's pleasures to forced migration or deportation. With it came belonging and dislocation, cross-cultural encounters that provoked confrontations, misunderstandings and betrayals. Mary Roberts investigates how a European artist's fascination with and painterly vision of the 'Orient' was challenged by her visits to an Ottoman harem and her meeting with Princess Nazli Hanım who sat to her. Mary Roberts emphasizes the importance of Ottoman patronage and priorities and the violation of Islamic cultural mores when portraits produced in the harem were publicly exhibited in London. Ka Bo Tsang recounts that when Katherine A. Carl arrived at the imperial court of China, she was subjected to a rigorous scrutiny by the Empress Dowager Cixi, who appraised her

person, her artistic practice and her suitability for imperial commission. Women artists in Australia or Canada faced the challenges of coming to terms with new locations and changing landscapes, renegotiating an artistic practice in and about a new environment. Joan Kerr points out that this was as much the case for Aboriginal women who reworked traditional bark paintings and Western-style illustration, as for white artists. Kristina Huneault traces the excursions to the Canadian wilderness of Frances Ann Hopkins, a woman uneasily placed between Britain and North America, examining how these landscapes were imaginatively recreated time and again on canvas. The voyages of Edmonia Lewis, a mixed-race sculptor of black and Native ancestry who journeyed from North America to Europe and back again, are considered by Charmaine Nelson. She concludes that whereas 'whites were often tourists, blacks, outside of slavery, were more often travellers. While for many bourgeois whites, travel was a means to reinforce or elevate social and cultural status, for blacks, enslaved or free, it often symbolized a search for racial equality and demarcated dramatic shifts in identification.'

And where or what was 'home'? The essays collected here indicate that there were no easy or shared answers. Concepts of home, so central to Western imperial expansion and their territorial presumptions, were intimately tied to concepts of femininity, domesticity and settlement. Invested with nostalgia and desire, this imaginary and actual place attained a strengthening force over the century. Yet, as the epistemic violence of colonization unravelled social relations and destroyed communities, home and homeland came to have a counterforce in shaping a sense of belonging.

Not surprisingly perhaps, nation and empire figure large in this volume, notably in the essays on pre-revolutionary Mexico, post-civil war America, nineteenth-century India, Australia and Canada. Art's investment in empire is variously traced: in the analysis of the colonial territories and Orientalist fantasies embedded in the Western metropolis; in the elucidation of the witty irony of Somerville and Ross in delineating British/Irish relations; in the accounts of settler women deeply implicated in the visual cultures of colonialism. Recent studies have shifted the ground considerably, giving attention to indigenous art, and exploring empires beyond the familiar Western focus. In these pages Ka Bo Tsang examines the imperial ambitions of the Chinese Empress Dowager Cixi, and her calculated deployment of the arts to bolster her unchallenged status in the political arena. Research highlighting the roles of white women artists in the expanding empires of the West is parallelled here by investigations of the transcultural arts produced by indigenous women in the 'contact zones' of colonial interaction (Pratt, 1992, 4) and the processes of image-making in settler societies. Ruth Phillips examines the moosehair embroidery by three distinct groups of women: its

appropriation by French-Canadian nuns and white settlers, and re-appropriation by Native women in the making of souvenir art.

Local/Global demonstrates the uneven pace of historical change across the nineteenth-century world, the co-existence of discrepant modernities, the tensions between different, even opposed, visual systems – as, for example, in nineteenth-century North America, India or Australia. Several essays explore concepts of art that were not premised on notions of modernity, the cultural values accorded to traditional forms, the collisions between tradition and modernity, between established art forms and materials and more recent introductions. Our collection draws attention to artistic interactions, cultural negotiations and hybridizations, as well as appropriations and reappropriations of the imported arts and aesthetics of the West, as much as of indigenous art. Paris as the pre-eminent locus of Western modernity comes under scrunity, but the volume's commitment to diverse cultures and regions seeks to counter the prestige usually accorded to European art and to Europe as a centre of cultural value and meaning.

Nineteenth-century artists are increasingly understood as socially embedded in local and global webs of social and economic relations, extending from dealers to domestic workers. If the myth of the lonely traveller has been convincingly unravelled (Pratt, 1992), so too has the myth of solitary and singular creativity. There is a growing awareness of women's collective practice of art (Helland, 2000), of networks of friendships and creative lives lived outside the spatial and social organization of the family. Lynne Walker draws attention to the spatial arrangements and building projects that fostered novel forms of feminine independence in Britain, delineating the new social and educational spaces for independent women created by women's architectural and design commissions. Foregrounding the friendship between the artist Louise Abbéma and the actor Sarah Bernhardt, Griselda Pollock attends to the social and artistic life of the studio in Paris, tracing the enmeshings of subjectivity, intimacy, and sociability. Síghle Bhreathnach-Lynch and Julie Anne Stevens dwell on the shared lives and complementary creative practices of Edith Œnone Somerville, a painter and illustrator, and co-author, and her second cousin, Violet Martin, who adopted the pseudonym Martin Ross. The atelier practice of Edmonia Lewis who employed teams of technicians in the making of large marble pieces for exhibition, the quilting communities in North America, and the art made by women in India in the studios and workshops of their fathers or brothers all speak of collective endeavour. That the works of art put into the world as by the Empress Dowager Cixi were ghostpainted, or made for her by at least three women, illuminates concepts of authorship at variance to those more common in Europe or North America, forms of artistic subjectivity, as well as kinds of artistic activity, that did not depend on singular agents or individual subjectivity.

Local / Global reveals that across the century and around the world, artistic identity was unpredictable, varying in different cultures and societies, and shaped by race, religion and ethnicity as well as by sexual difference and social status. Discussions of Native women in Australia and North America, Hindu and Muslim women in India, the Egyptian Princess Nazli Hanim, and Edmonia Lewis redress the over-attention to white women in existing studies of women artists, while an exploration of 'white' as a racialized identity is undertaken by several contributors.

The women artists featured here worked in many forms of art: painting, monumental sculpture, calligraphy, textiles, embroidery, illustration and photography, as well as design and architecture, so much so that their creative activity far exceeds any distinctions between high and low, art and craft, professional and amateur, architect and decorator. Broad definitions of 'art' and 'artist' encompass a wide range of practitioners and their work, indicating, too, that women were active, often simultaneously, as makers, viewers, purchasers, critics and patrons. Gayatri Sinha draws attention to women who commissioned buildings and indeed were responsible for the development of whole cities, while Lynne Walker considers women's design and their supervision of building projects. Different cultures held varied expectations about what art by women was acceptable; women negotiated these expectations imaginatively, re-creating and re-inventing forms of art, intervening in established hierarchies, rethinking their practice in new ways and contexts. What is distinctive across this collection is a rich, abundant and complex diversity of inventiveness and imagination. Exploring the ways in which women artists in Mexico represented themselves and their practice, Stacie Widdifield contends that art can offer, a 'stunning allegory of the relationship between women and painting'. For Griselda Pollock, modern painting in Paris created 'outward and visible signs of an inward and invisible subjectivity in the space of the studio'. She explores the contradictions between the decidedly Orientalist interior designed and furnished by Sarah Bernhardt, and 'an all-encompassing aesthetic shaped by the commercial and colonial relays between Europe and its others across which an artist – herself othered by her femininity and her Jewish heritage – staged her own life and made her art'. Mary Roberts also offers a radical revision of European Orientalism, investigating the harem fantasies of Elizabeth Jericho-Baumann alongside the subversion of, and challenges to, the visual codes of Orientalism in the self-images created by Princess Nazli Hanım.

The four essays on North America unpick the United States and Canada as sites of difference, exposing visual representation's entanglement in racial conflict. Kristina Huneault proposes that Frances Ann Hopkins's poetic image of *Minnehaha Feeding the Birds*, a painting based on Longfellow's

popular *Song of Hiawatha*, 'offers more than it would seem to: not a self-portrait, but a parallel – the cipher of a fellow-traveller', and she elaborates the possibility 'that through Minnehaha, Hopkins inscribes her wish to be a woman at home in her native land'. Ruth Phillips discusses the polyvalency of representations of 'Indian' figures, contrasting settler depictions, idealized by comparison to the experiential reality of First Nations peoples, to aboriginal images which shifted the semiotic codes and revised the iconography. Arguing for a form of agency that was, in this period, uniquely possible through the production of visual arts, she concludes that these visual texts 'produced ethnicity not simply by reflecting imposed stereotypes, but by actively negotiating and contesting them.' Janet Berlo demonstrates that the quilts by white and by African-American women were 'chronicles in cloth' tracing autobiographical, social, religious and political narratives and making reference to political campaigning, slavery and abolition. Charmaine Nelson interrogates the making and display of Edmonia Lewis's *Death of Cleopatra* in the years of crisis following the American Civil War. Navigating 'the primacy of white marble and the regulation of race', the sculpture demonstrates the artist's 'continuing use of abolitionist visual culture as a counter-hegemonic source of alternative representations of blackness'. What emerges across this collection is, as bell hooks puts it, that 'representation is a crucial location of struggle.' (hooks, 1995, 3)

Viewing and making, buying and selling, were often closely related: the space of production was often the site in which the work was commissioned and first viewed, in which its meanings were initially proposed and debated. In this century of travel, art works were dispatched across land and sea to local, national and international exhibitions and markets. Viewing by intimate circles of friends, family and acquaintances, and the responses of the community of viewers, owners and users for whom the work may have been initially created, gave way to audiences of distant strangers. In this transit art works were caught into, and interpreted within, systems for assigning cultural value and worth, systems which all too often differentiated men's art from women's craft, Western art from Native artefact. As images and objects travelled, their meanings changed. Creating a spatial dialogue between the exhibitionary locations of Australia and Britain, Joan Kerr is one of a number of contributors to demonstrate how concepts of art and cultural value were shaped by, and resisted in, a colonial setting, by viewers as well as artists.

Linda Nochlin's well-known essay, 'Why have there been no great women artists?', first published in 1971, inaugurated three decades of writing about women artists and feminist studies in art history. A welter of publications, from surveys, overviews and monographs to catalogues and essays, has

brought to light lost lives and works. While the focus on Europe and North America has continued,[5] the geographical compass has broadened to include studies of East Asia, Africa, Central America, South Asia and Australasia.[6] Analyses of social formations, institutional structures and assymetrical relations of power within which women variously lived and worked has produced a substantial literature for both scholarly and general readers, and the study of women artists is now well embedded in the teaching curriculum, particularly in nineteenth-century studies.

Nochlin's writings were by no means the first to document or discuss women artists and the conditions in which they lived and worked. Women artists were newly visible in Western Europe in the 1850s, not just as exceptional or outstanding performers, but as a collectivity to be reckoned with. A new literature rapidly developed to deal with this novel phenomenon, its writers including the many women art historians and critics of the period (Clarke, 2005). As these women knew, and subsequent generations have discovered, the question of numbers has never been the issue: there have been, and still are, numerous women artists, even if aspiring researchers can find it hard to track down information and data. More contentious perhaps have been the approaches brought to bear in the study of women artists and art by women.

Writings on women artists and feminist studies in art history have developed strongly over the past three decades and more, sometimes together, sometimes at variance, and both have had links to the women's movement. Feminism has never been united or homogenous, nor has it had a single cause or constituency. The substantial critiques of mainstream and white feminism, the proposition of 'dissonant feminisms',[7] the discussions of 'post-feminism' and 'third-wave feminism' have all provoked heated debates about priorities, procedures and the field of study itself. If, for some, attention centres on the workings of sexual difference in the domain of the visual and thus on art by men as well as by women, for others the difference that matters is precisely the focus on the creative lives and work of women. Although there is considerable dissent, so much so that Kristen Frederickson and Sarah E. Webb characterize feminist art history in a 'theoretical climate of post-structuralist scepticism' as a 'fraught territory' (Frederickson and Webb, 2003, 1), what has emerged is an entangled and contradictory field that questions the nature of art and agency, investigates subjectivity and sexuality, and illuminates the politics of vision, visual representation and contested regimes of visuality.

Local/Global has been compiled at the interface of feminist studies and post-colonial studies: questions of race, ethnicity, colonialism and difference are among those considered in the essays and in our selection. But no one approach or methodology dominates the collection. Indeed, the diversity of

perspectives is symptomatic of our project's scope, and there are tensions and contradictions between contrasting priorities. In concentrating on one century, this volume focuses neither on one country or region. In the rapidly developing literatures of nineteenth-century studies and feminist studies, a focus on global perspectives, cross-cultural exchange and transcultural arts helps to counteract tendencies to insularity. The essays do not cover the lives and works of women artists in every geographical area. While some focus in detail on a case study, others provide a broader picture; whereas one highlights a singular figure, another traces the art practices and patronage of a continent or a region. All our contributors are concerned with scholarship's role in 'writing' women artists, and they offer rigorous analysis of working lives and visual imagery. Feminist studies are at the forefront of analysis of visual representation as participant in, and productive of, relations of power, whether unfolding the historical and contemporary meanings provoked by a single work of art, or considering the making of, and resistance to, visual regimes. Recognizing that viewers and readers are implicated in the making of meaning, and that interpretation is 'an interactive and implicated process' (Pearce, 1997, 15; Pollock, 1999), feminist analysis has attended to the reception of the work of art, to audiences and spectatorship, to the pleasures and desires of viewers, now and then.

For some contributors, priority is given to recovering the lives and works of those 'hidden from history', to collecting and collating new information and new data, to empirical research undertaken in archives. Yet empirical research is qualified here by a shared understanding that archives are invariably partial, contradictory and fragmented, shaped by those who have compiled them. For several contributors feminist strategies of 'reading against the grain' allow contradictions to prevailing patterns of interpretation, or that bring to light the lacunae in the archive as well as its discursive formations (Pearce, 1991, 5–28).[8] Moreover, although written texts and printed records undoubtedly remain significant, women's history often lies outside the written. Women's creative work speaks of oral and aural cultures, of stories told and recorded in memory, of tales recounted of generations long past, of images and objects that communicate the visual and material cultures in which they were made, handled, viewed, cherished or forgotten. Seeking to establish the presence of women in the artisanal workshops of India despite the absence of written records, Gayatri Sinha not only draws on oral traditions and recollections but historical imagination, a resource that others similarly deploy.

Writings on women artists have tended to focus on individuals. The stories of singular women characterized as exceptional, distinctive and larger than life fill monographs, biographies, surveys of periods or movements. Faced with marginalization or exclusion in conventional histories of art and

the unrelenting popularity of monographs and biographies, there has been a tactical importance in researching and reinventing women as individual creative agents. At the same time feminist, critical and post-colonial debates have called into question a Western preoccupation with the individual subject as agent of history and interrogated the sovereign subject of imperialism. Gayatri Chakravorty Spivak has warned that a mesmerizing fascination with Western individualism and particularly the white feminist heroine can have damaging effects in feminist analysis (Spivak, 1985, 244–6). The inscription of the subject is, therefore, a matter to be handled with care; attention to one or two singular protagonists may risk privileging a few named elite women to the detriment of others, while an over-investment in life stories may fail to take account of the historical or political conditions in which the writing of biography may be inappropriate or impossible. Essays here that focus on the individuated figure of the artist find different solutions, conceptualizing the subject in process, attending to forms of self-fashioning, invoking feminist re-readings of psychoanalytic theory, and engaging with the intricate significance of race and ethnicity. Contributions which undertake a substantial engagement with contemporary theory, advancing theoretical understandings of subjectivity, representation and the disparities of reception, are included alongside essays rooted in empirical research and those which enjoin both.

Local / Global assembles a suite of commissioned essays on women artists. But there is no shared, common or homogenous view of 'woman' or women. Studies of women artists have all too often been charged with refuting heterogeneity; with viewing women and their art through a singular lens of femininity and screening out the wider contexts in which they lived and worked; with creating a supplement to the main story (which usually excludes women artists). We depend on a 'strategic use of essentialism', as Gayatri Chakravorty Spivak puts it, that focuses attention on women without the loss of a critical attention to difference (Spivak, 1993, 3–6). Rather than deploying difference as the unifying position of alterity to which all women are assigned, our selection accentuates the differences between women.

Recent feminist thinking has moved from an emphasis on sexual difference formed in and by language and psychic structures to an analysis of the conflicting and competing workings of difference across race, ethnicities, religion, sexuality, dis/ability, social heirarchy and/or age. Taking these highly variable and often unstable forces into account demands a rethinking of difference which can benefit from Jacques Derrida's propositions of the manifold and restless interplay of *différance*. For Derrida, *différance* teases out both 'distinction, inequality, or discernability', that which marks difference, and the restless movement in which meanings are deferred, unfixed as soon as they are put in place (Derrida, 1973, 129). So *différance*

holds both the radical and difficult nature of difference, which far exceeds 'diversity', and the subversive unravelling and slippages of meanings which allow for challenge, unexpected returns, and counter-movements. It is this *différance* that makes possible to acknowledge, and to come to terms with, the complexities and contradictions of femininities and feminisms.

To characterize the heterogeneity of art by women in the nineteenth century is to identify its extraordinary variety, and to acknowledge the vast differences and distances between its producers. As our contributors propose, writing new narratives of women artists necessitates the expansion of art-historical horizons beyond established boundaries, an address to the connections between the local and the global. Our concern for geography prompts us to organize this book as a journey from continent to continent beginning in the southern hemisphere. The book is dedicated to the memory of Joan Kerr who did so much to establish scholarly investigation on women artists, and Australia is our starting point. From there we move to China, across to India, to the Middle East, to Europe, and to the so-called 'new world' – Canada, the United States and Mexico – with its real and imaginary ties to Europe. Our conclusions are that there is no one approach, no one story, but many dialogues, encounters and journeys that we hope will be continued.

References

Castle, G., *Post-Colonial Discourses*, Oxford: Blackwell, 2001.

Chadwick, W., *Women, Art and Society*, London and New York: Thames and Hudson Ltd, 1990.

Cherry, D., *Painting Women: Victorian Women Artists*, London and New York: Routledge, 1993.

———, *Beyond the Frame: Feminism and Visual Culture, Britain, 1850–1900*, London and New York: Routledge, 2000.

Clarke M., *Critical Voices: Women and Art Criticism in Britain 1880–1905*, Aldershot: Ashgate, 2005.

Cott, N., *The Bonds of Womanhood: 'Woman's Sphere' in New England, 1780–1835*, New Haven: Yale University Press, 1977.

Davidoff, L. and C. Hall, *Family Fortunes: Men and Women of the English Middle Class, 1780–1850*, Chicago: Chicago University Press, 1987.

Derrida, J., *Speech and Phenomena, and Other Essays on Husserl's Theory of Signs*, Evanston: Northwestern University Press, 1973.

Fister, P., *Japanese Women Artists, 1600–1900*, Spenser Museum of Art, University of Kansas, 1988.

Frederickson, K. and S. E. Webb (eds), *Singular Women: Writing the Artist*, Berkeley: University of California Press, 2003.

Gaze, D., (ed.), *Dictionary of Women Artists*, London: Fitzroy Dearborn, 1997.

Helland, J., *Professional Women Painters in Nineteenth-Century Scotland: Commitment, Friendship, Pleasure*, Aldershot: Ashgate, 2000.

hooks, b., *Art on my Mind: Visual Politics*, New York: New Press, 1995.

McClintock, A., A. Mufti and E. Shohat, *Dangerous Liaisons: Gender, Nation and Post-Colonial Pespectives*, Minneapolis: University of Minnesota Press, 1997.

Meskimmon, M., *Women Making Art*, London and New York: Routledge, 2003.

Nochlin, L., 'Why have there been no great women artists?' in *Women, Art and Power*, London and New York: Thames and Hudson Ltd, 1989 (first published 1971).

Pearce, L., *Woman/Image/Text*, Toronto: University of Toronto Press, 1991.

——, *Feminism and the Politics of Reading*, London: Edward Arnold, 1997.

Pratt, M.L., *Imperial Eyes: Travel Writing and Transculturation*, London and New York: Routledge, 1992.

Pollock, G., *Differencing the Canon: Feminist Desires and the Writing of Art's Histories*, London and New York: Routledge, 1999.

Rubinstein, C.S., *American Women Artists: from Early Indian Times to the Present*, New York: Avon, 1982.

Said, E., *Culture and Imperialism*, London: Vintage, 1993.

Smith-Rosenberg, C., *Disorderly Conduct: Visions of Gender in Victorian America*, New York: Oxford University Press, 1985.

Soja, E., *Post-Modern Geographies: The Reassertation of Space in Critical Social Theory*, London: Verso, 1989.

Spivak, G.C., *Outside in the Teaching Machine*, London and New York: Routledge, 1993.

——, 'Three women's texts and a critique of imperialism', *Critical Inquiry*, Autumn 1985, 243–61.

Weidner, M.S., *Views from Jade Terrace: Chinese Women Artists, 1300–1912*, Indianapolis: Indianapolis Museum of Art, 1988.

Weimann, J.M., *The Fair Women: The Story of the Women's Building, World's Columbian Exposition, Chicago 1893*, Chicago: Academy Chicago Publishers, 1981.

Woolf, V., *A Room of One's Own*, London: Hogarth Press, 1929.

Notes

The editors would like to extend their warmest thanks to all our contributors, our team at Ashgate, particularly our commissioning editor Lucinda Lax, and our meticulous copy editor Sarah Sears. And we owe a special debt of gratitude to Steve Wharton, Jerzy Kierkuc-Bielinski, Candice Bruce and Michelle Veitch.

1 Noguchi Shonin (1847–1917); Okuhara Seiko (1837–1913).

2 The Empress, who commanded the resources of a Parisian milliner, made European attire fashionable, decreeing that women must appear at the imperial court in European dress (*Lady's World*, 1887, 39).

3 See, for example, Cott, *The Bonds of Womanhood*, 1977; Smith-Rosenberg, *Disorderly Conduct*, 1985; Davidoff and Hall, *Family Fortunes*, 1987.

4 Alfred Gell's proposition of 'the visible knot that ties together an invisible skein of relations, fanning out into social space and social time' is advanced in his *Art and Agency: An Anthropological Theory*, Oxford: Oxford University Press, 1998, 62; for an elegant application of Gell's theories, see M. O'Malley, 'Altarpieces And Agency: The Altarpiece of the Society of the Purification and its Invisible Skein of Relations', *Art History*, **28** (4), 2005, 417–41.

5 As in Rubinstein, *American Women Artists*, 1982, Chadwick, *Women, Art and Society*, 1990 and Gaze, *Dictionary of Women Artists*, 1997.

6 These include Fister, *Japanese Women Artists*, 1988 and Weidner, *Views from Jade Terrace*, 1988.

7 *Parallax*, 3, 1996; *Feminist Review*, special issue on Nationalisms and National Identities, 44, Summer 1993.

8 Walter Benjamin first used the phrase 'against the grain' to suggest interpretations at odds with those of the historical 'victors'. 'Theses on the philosophy of history', *Illuminations*, ed. Hannah Arendt, trans. Harry Zohn, London: Fontana/Collins, 1973, 258–9.

'Same but different': women artists in colonial Australia

Joan Kerr

The notorious definition of Australia as *terra nullius* – an empty land – not only justified white occupation but also helps to explain why historians have been so exceedingly fond of uncovering white Australian firsts, documenting each step in the appropriation of the land as a 'pioneer' triumph. Nor have Australian art historians been immune to 'the first white man' or 'Captain Cook' syndrome. The flags nailed to the mast of the colonial art history barge include: the first professional artist to come to Australia (the Scottish 'limner' Thomas Watling, transported for forgery in 1791); the first professional artist to circumnavigate the world and include Australia (the English painter Augustus Earle, who missed the boat at Tristan da Cunha in 1824 and after eight months took the next ship out regardless of its destination, which happened to be Van Diemen's Land); the first successful artist to come to Australia voluntarily (John Glover, rich enough from painting sales to become the landed gentleman in Van Diemen's Land he could never hope to be in England); and even the first professional artist to climb Australia's highest mainland mountain (Eugene von Guérard, who spent his fifty-first birthday, 17 November 1862, on Mount Kosciusko).

The idea of valuing artists for their geographic primacy seemed no less peculiar once the colonial chronicle (1788–1901) was belatedly expanded to include pioneer white women. The first woman known to have made a drawing on paper in Australia, for example, was the 'dying, afflicted' wife of Lieutenant George Bridges Bellasis, an East India Company military officer transported in 1802 for killing a man in a duel. During the couple's comfortable two-year residence in Sydney, this undoubted gentlewoman made a small watercolour of a native hibiscus flower annotated: 'The Carrajan by Mrs Bellasis Sydney. The Shrub from the bark of which the Natives make their fishing lines' (Kerr 1992, 62).[1] Later pasted into an album,

now in the Mitchell Library at the State Library of New South Wales (ML), it survived the centuries and is her only known art work.

Although quite undistinguished, this single pink flower pinpoints the moment when the 'accomplished' amateur woman artist appeared in the convict settlement and it foreshadows thousands of flower paintings to come. Most of its successors were of no particular aesthetic or scientific merit either, but family and friends on the other side of the world kept them as proof that the cultural values of 'home' were being inscribed onto the new country. Mrs Bellasis's comments about the Aboriginal use of the plant, on the other hand, were rapidly replaced by 'correct' Latin names, preferably provided by a professional male botanist. In the late nineteenth century many species were named by the Victorian Government Botanist Ferdinand von Mueller, who had a vast network of gentlewomen collecting and illustrating native plants for him. Anna Frances Walker (1830–1913) painted most of the New South Wales and Tasmanian specimens from about 1870 to 1910 and assembling the watercolours in eight volumes (ML). Some also carry Annie's own ignorant, occasionally bizarre descriptions, which better suit the pretty but quite unscientific images that this amateur gentlewoman proudly exhibited, but never sold. Miss Walker won a gold medal for her *Flora of New South Wales* at the London International Exhibition of 1873 and many lesser awards in Australia. A naïve conceit in the superiority of her art was matched by pride in her pure British ancestry (no 'convict stain') and in 1887 she sent Queen Victoria a collection of her flower paintings, accompanied by a family tree.

Earlier amateur lady artists were also encouraged to copy nature exactly as they saw it: to draw specimens and bouquets entirely naturalistically and take no interest in scientific sections or stages of growth. With far less access to professional authorities, they still wanted to add the Latin labels that not only had international currency but also helped them in their aim to be absolutely, impersonally accurate. Most of the flowers painted in Western Australia between 1833 and 1861 by Georgiana Leake, née Kingsford (d.1869), for example, are doubly annotated: once in pencil, evidently from a rudimentary hand-written list she owned entitled 'Names from Kew 1854', then in ink after she returned to London. While resident at the Port Stephens (NSW), headquarters of the Australian Agricultural Company in the 1830s, the commissioner's wife Isabella Parry, née Stanley (c.1801–1839), made watercolour and pencil views of the house, the landscape and the company's coal works at Newcastle. She also collected, dried and painted native plants for her family in Alderley, Cheshire, but complained that few were listed in the only botanical text she had with her and, as the mother of colonial-born twins, she had mixed feelings about her only reliable local informant, the district doctor, 'who knows more of flowers I am sorry to say than *Medicine*' (Kerr, 1992, 606).

Most nineteenth-century women's paintings, sketchbooks and albums are found in libraries and archives, kept primarily for their value as visual information about early, or 'important', places and people (mainly men). Lady Parry's drawings, letters and diaries are among the Parry Papers in the Scott Polar Research Institute in Cambridge, England, Sir Edward also being a noted Arctic explorer. (Jane Franklin's massive personal archive is also there, for the same reason.) Yet these mostly young, affluent and educated women who drew were no mere passive receptacles for their husbands' tastes and values. They actively contributed to the dissemination of British culture, imagery, tastes and values throughout the Australian colonies. The social networks that they established were as intricate, widespread and influential as those of any gentleman botanist from Kew and they could be just as competitive. 'Mrs A. has it not' is triumphantly annotated under two watercolour plants in the Hunter River (NSW) album of specimens compiled in 1833–34 by Dorothy English Paty, née Burnard (1805–1836), now in the National Library of Australia.[2] The range and social significance of colonial ladies' albums and sketchbooks has still only begun to be appreciated (Kerr, 1980, 1984, 1988; Berzins, 1996, 164–8).

Such women rarely considered themselves as professional artists even if they sold and exhibited their art. Distinctions between being an 'amateur', due to birth or lack of opportunity, and 'professional' – from choice, training or financial necessity – seem to have been far more blurred in colonial Australia than at 'home'. At school in Staffordshire Mary Morton Allport, née Chapman (1806–1895) had drawing lessons from Henry Curzon Allport, the headmistress's eldest son, her brother-in-law-to-be and a former student of John Glover, who had also taught at the school. (Annie Walker took lessons from Henry Allport after he migrated to Australia.) Mrs Allport came to Van Diemen's Land with her solicitor husband and their first son in 1831 to seek their fortune farming. Inevitably, they failed. Before her husband successfully resumed his legal practice in Hobart Town, Mary Allport was advertising her willingness to accept commissions for portrait miniatures. In so doing, she became the first known woman in any of the Australian colonies to attempt to make a living from her art. This may not seem a particularly impressive achievement when the first male professional artist had set up business almost thirty years earlier – except that the convict John William Lancashire was paid to paint street numbers on Sydney houses at sixpence per house, not miniatures on ivory.

Only one of Mrs Allport's extant portrait commissions is known, a posthumous miniature on ivory of Mrs Parramore for the recently bereaved widower (Hobart: private collection). Her unusually extensive personal collection, however, survives. It includes dozens of watercolour flowers and views, competent miniatures on ivory of native flowers and local people –

including a clever portrait miniature of the elderly John Glover painting a Tasmanian scene – a few engravings and lithographs, many sketchbooks and albums, scrapbooks she made with her children and her 'Book of Treasures', containing the children's first drawings, personal portraits of family and friends and a tiny, flattering miniature self-portrait as Ophelia. Although none was ever for sale, they were not entirely personal and private either. She showed her paintings (as well as her jam) in several major Tasmanian exhibitions, while her major work – a chess table with sixty-four painted panels depicting 'native flowers of Tasmania' – was sent to the 1855 Exposition Universelle in Paris. It has long disappeared, presumably lost in transit. The rest survive because descendants continued to live in the family home until a bachelor great-grandson bequeathed house and contents to the people of Tasmania, along with adequate funds to maintain them. Virtually all Mary Morton's known art is now in the dedicated collection of the Allport Library and Museum of Fine Arts at the State Library of Tasmania, along with the family silver, furniture, china, glass and Persian rugs. That guaranteed its survival. The downside was that until 1981 Mrs Allport's dining-room suite was better known than her art, for it was only then that the Allport Librarian G.T. Stilwell gave her a retrospective exhibition.

Children curtailed many a woman's career, but they could also be a significant factor in the matriarch's artistic survival. A pioneer amateur photographer son and a professional painter and print-maker granddaughter, Curzona Frances Louise (Lily) Allport (1860–1949), helped to keep the Allport name alive. Artist progeny were even more important for Emma Minnie Boyd, née à Beckett (1858–1936), the first painter-mother in the most famous artistic dynasty in Australia (Dobrez and Herbst, 1990; Niall, 2002). Minnie Boyd's paintings of family scenes, such as the watercolour *Interior with Figures: The Grange 27 March 1875* (Joseph Brown collection) are by no means as well known as her grandson Arthur Boyd's work, but they are now enthusiastically collected after generations of neglect by all except the family. The drawback to this sort of genealogical survival is that although Mrs Boyd painted a great variety of subjects, *only* paintings with family connections are highly valued. And even her splendid paintings of family women at home, like *Afternoon Tea* (1888, Victoria: Bendigo Art Gallery), too closely resemble scenes of cultured, wealthy, English country life – which they were – to have great popular appeal in a country where bush huts, gumtrees, stockmen and shearers have long been art's preferred subjects.

Harriet Jane Neville-Rolfe, later Mrs Holcombe Ingleby (1850–1928), certainly painted lively bush subjects, though solely as informal watercolour sketches for her family in England. They were, however, of unusually high quality. Before leaving Paris in 1883 to visit family members at Alpha, a remote cattle station in central west Queensland, this doyenne of colonial

ladies with sketchbooks had completed eight years' art training in London and Paris, an early student when the Slade School opened in 1871 and a winner of medals in student competitions at the École nationale de dessin des jeunes filles from 1874 to 1877.

Harriet Jane painted throughout her life but the vast majority of her work was done during the two years she spent in the Australian outback, overwhelmed by the novel landscape, lifestyle and inhabitants.[3] She drew most aspects of life on Alpha, its outstations and other places she visited: the station Aborigines, the Chinese cook drawing water from the creek, the mounted postman, stockmen breaking in horses and rounding up cattle, her own domestic and leisure activities. *Breakfast, Alpha* (1884, South Brisbane: Queensland Art Gallery) is set on the enclosed verandah of the crude wooden homestead building and shows the artist's sister, pregnant sister-in-law (in crisp white morning gown), two brothers, brother-in-law and station manager dining off damask and silver while through the bush window – sensibly but unexpectedly opening from the hinges for maximum breeze – can be seen the glaringly bright, parched landscape of a place suffering a long drought (Figure 1.1). The contrast between the setting and the traditional accoutrements of upper-class English country life, including household pets and hunting trophies, is a witty comment on the uneasy Anglo-Australian alliance as well as a modest complement to heroic white male icons of bush life like Tom Roberts's *A Break Away!* (1891, Adelaide: Art Gallery of South Australia). Nor was Neville-Rolfe's appreciation of the unconventional beauty of the land any less vivid because a wry awareness of antipodean inversion permeates every image. In this upside-down world nature controls the inhabitants, and masters and servants are indistinguishable in dress and duties, while maintaining any sort of civilized English lifestyle is full of irony. It was all very different to home life at Heacham Hall, in Norfolk.

Pioneer women who expanded the national artistic repertory more conventionally have also been elevated to the status of 'real' artists in recent decades and their work was been acquired for major public galleries. They include the English-born Theresa Susannah Eunice Snell Walker, née Chauncy, later Mrs Poole (1807–1876), the first resident Australian to exhibit at the Royal Academy of Arts in London, that cynosure of colonial artistic ambition. A pair of wax medallions of a South Australian Aboriginal couple sent from Adelaide was shown there in 1841. Theresa Walker sold her small wax portrait medallions prompted by a financial need that extended over a lifetime, despite two husbands and a fond (but equally impecunious) brother.[4] Because she led a highly peripatetic existence, most of her surviving art works are sale pieces: small oval wax images of settlers and colonial notables in South Australia, Tasmania and New South Wales. Despite the inclusion of colonial bishops and governors (and their wives), her images of

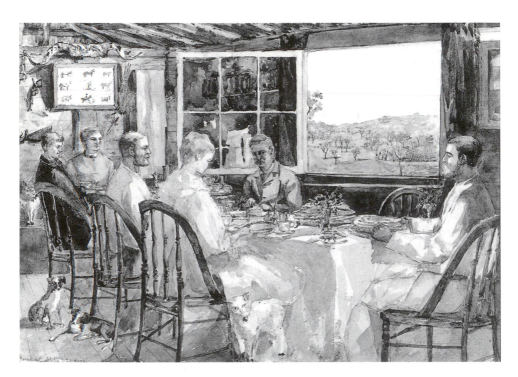

1.1 Harriet Jane Neville-Rolfe, *Breakfast, Alpha*, 25.3 × 35.4 cm, watercolour over pencil on wove paper, 1884

white settlers were not especially popular with anyone but the sitters; the portraits of Kertamaroo and Mocatta shown at the Academy were her bestsellers, and several pairs are known. She also made seaweed photographs when living at Launceston, Tasmania, but they do not seem to have sold and are now lost, including a coloured one that briefly fooled the eminent British botanist W.H. Harvey into believing it was real when he visited this 'very odd person' in 1855 (Ducker, 1988, 199).

Theresa's younger sister Martha Maria Snell Berkeley, née Chauncy (1813–1876) received more lasting support from her (one) spouse yet was still forced to work as a matron in a Melbourne school for four years after she was widowed. Martha came to South Australia in 1836 with her husband and Theresa, and she immediately began painting small oil portraits on commission. Like Mrs Allport, she could never have made much money from it. The year before she migrated she had shown a portrait miniature at the Royal Academy, but she only exhibited locally after her arrival. Since the sisters were highly competitive rivals, Theresa's 'Australian First' at the Royal Academy may well have resulted from her desire to even up the score.

Unlike Theresa, Martha had children – three daughters – to value and keep her work. She became more than a footnote in Australian art history when a descendant offered a number of her exquisite oil and watercolour portraits to the Art Gallery of South Australia in 1994, and curator Jane Hylton organized an exhibition and published a book on both sisters.

Until then, Martha had – typically – been known only for a few watercolour views of the early settlement in the gallery's rarely seen historic South Australiana collection. The most notable, *The First Dinner Given to the Aborigines ... 1838*, shows the distribution of biscuits, meat, tea and blankets to the men and women of the three Adelaide Aboriginal tribes invited to join Governor and Mrs Gawler and the rest of the province's white inhabitants at an open-air gathering held two years after the first settlers had landed in the province. In 1847 Martha Berkeley added a descriptive text to the painting highlighting her awareness of its historic significance.

Naturally, most of the works acquired in 1994 were family portraits, including brilliantly fresh small oil on metal portraits of the artist, her husband, their three eldest daughters, sister Theresa and Theresa's first husband, John Walker, all of a standard indistinguishable from talented British work. Which then is the more 'typically colonial', the exotic colonial scene or the miniature portraits of exiled English gentry? The answer, of course, is both. Indeed, the sisters' art exemplifies the basic colonial dilemma: the desire to be just like 'home' and at the same time produce work to be admired at home as uniquely expressive of the new place. The solution (favoured by most artists outside the metropolis, in Britain and the rest of the empire as well as in Australia) was to choose archetypal local subjects – sunshine and open spaces, the rural and urban prosperity of early settlements, local flora and fauna, and the Aboriginal people, in the case of Australia – and then to depict them in meticulously European styles, mediums and techniques. Stylistic conformity was crucial. To look purely British may not appeal to nationalist desires for a 'distinctively Australian' art that arose in the 1880s and still continues, but it was then the highest form of commendation.

Class could also affect a colonial woman's artistic career, occasionally in topsy-turvy ways. Georgiana Huntly McCrae (1804–1890), the illegitimate but acknowledged daughter of the Duke of Gordon, could have been the leading miniature painter in colonial Victoria had she been allowed to practise her art. Not only had she exhibited landscape, genre and portrait miniature paintings at the Royal Academy every year from 1816 to 1821, and again in 1825, and won a silver palette from the Royal Society for Promoting Arts, Manufacturers and Commerce, but she had also successfully established herself with ducal blessing as a professional portraitist in Scotland. After coming to Victoria in 1841, however, she was forced to give

up any idea of selling her art because her middle-class husband and other members of the McCrae family resident in the colony so strongly disapproved: 'I could now make a few pounds by painting a few miniatures as I have been invited to do,' she wrote in 1845: 'But I dare not do violence to the notions of the family – by "painting for money" though they never objected to my having done so *before* I was married' (MS Journal, 8 February 1845, quoted Niall, 1994, 173).

Georgiana showed old and new work at the inaugural exhibition of the Victorian Society of Fine Arts in 1857 to rave reviews: 'We have seen no miniatures in the colony comparable with those which have been contributed to this exhibition by Mrs. McCrae: while the pencil and watercolour drawings which accompany them are full of talent', stated the *Age* (11 December 1857). Yet despite recurrent financial crises, she was not permitted to exhibit her work again, let alone sell it. Her creativity was largely diverted into keeping a detailed and entertainingly frank journal, published (in censored form) by her grandson Hugh McCrae in 1966. Not only is it a major source of information on early settlement Victoria, but it has also become an Australian literary classic.

Otherwise, Georgiana's oeuvre in Victoria consists of pencil and watercolour sketches of her homes and their environs, family and friends. The latter surprisingly includes sympathetic oval watercolour portraits of Eliza and her husband Ben Benjie, and members of the local Bunnerong people, whom the McCraes befriended when living at Arthur's Seat on the Mornington Peninsula (*c.*1846, McCrae Homestead, National Trust Victoria). Early residents rarely depicted their Aboriginal neighbours and if they did, they normally made them less than human – not good friends! Another of Georgiana's small watercolours on paper (*c.*1860, Melbourne: National Gallery of Victoria) is a portrait of the expatriate English painter, illustrator and writer Louisa Anne Meredith, née Twamley (1812–1895), who had an equally improvident but less puritanical husband, George Meredith (ironically, he became Colonial Treasurer of Tasmania). She also had a more determined – even insensitive – nature that would easily have overridden any attempt to forbid her to work professionally. Since the only way that art in the farthest outpost of Empire – rural Van Diemen's Land – could provide a regular income was through its export, Louisa chiefly wrote and illustrated books for publication in London. They included lively colonial reminiscences as well as a number of sumptuous natural history gift books for good children (see Bonyhady, 2000, chapter 5).

Australia's most popular botanical artist Marion Ellis Rowan, née Ryan (1848–1922), told a great-niece that she took up flower painting because she was bored with marriage (Hazzard, 1984, 73). Like so many well-bred women, Ellis painted watercolours of native flowers in specimens and

bunches – over 3,000 of them in her lifetime. Unlike most of her sisters, she made an extraordinarily successful career from this genteel accomplishment, not only because she was competent and prolific but also because she indefatigably promoted herself and her art. The image she created was of a perfectionist so dedicated to capturing her plants *in situ* that she willingly travelled to the most hazardous, remote locations – including crocodile-infested North Queensland and the New Guinea Highlands (where she made two trips when in her sixties) – always clad in her signature hand-made white lace dresses, which enhanced a tiny, slim figure and an eternally youthful face (thanks to a very early face-lift in the United States of America).

After years of opposition from professional art societies, the Commonwealth Government posthumously purchased Rowan's personal collection of 952 botanical paintings in 1923 for a future national gallery. When it came into existence in 1982 it declined the lot. The collection remains in the National Library of Australia. Ellis never joined any of the art societies that sprang up in late nineteenth-century Australia (monopolized by those disapproving male professionals). Nor did she send work to the Royal Academy. Instead, she was the most successful Australian painter ever to show work in the great international and intercolonial exhibitions of art and industry so popular in the period, where art by men and women, amateurs and professionals hung side by side. Between 1873 and 1893 she won ten gold, fifteen silver and four bronze medals at major shows, culminating in a gold medal at the Chicago World Fair of 1893, where two rooms in the modest NSW Pavilion were hung with her large botanical watercolours. These gigantic overseas trade exhibitions allowed a colonial fine artist to enhance her reputation at home by sending work abroad at little cost. Most colonial governments subsidised transport and displays, and if paintings, weavings, taxidermy, embroidery, decorated furniture and other arts and crafts in which Australian women excelled were swamped by mountains of gold, coal, wool and wheat, this was better than not being seen at all. The first London exhibition exclusively devoted to Australian fine art did not come about until 1898, and then reviews ranged from tepid to hostile and few works sold.

When Adelaide Ironside (1831–1867) left Sydney to study art in Italy in 1855, she became the first Australian-born artist to go overseas for professional training. (The Tasmanian-born Robert Dowling left for London two years later – a smarter choice.) As the only meaningful space a colonial artist had to conquer was the 16,000 miles between Australia and Britain, it was a more noteworthy achievement than taking sketchbooks up mountains. For Ironside, it was an essential means to a nationalistic end. Painting religious and allegorical pictures in Italy and England and gaining overseas acknowledgement for them was the first step in her stated aim: to study

abroad for the length of the siege of Troy and then to return to fresco the walls of Sydney University's Great Hall, the grandest interior in any of the Australian colonies. Sadly, death from tuberculosis at the age of thirty-five intervened and she never achieved the second part of her goal. Even had she lived, it was unlikely to have happened. As she commented, crude colonials found it inconceivable that anyone would pay real money for one of her small paintings.

Ironside's greatest Sydney supporter, the Presbyterian minister Dr J.D. Lang, discovered this bitter truth in 1860 when he tried to get the New South Wales Parliament to grant his protégé a pension. After she died, local admirers set up a fund to purchase a major painting for the Sydney Town Hall in her memory and to publish her *Drawings of native wild flowers, &c.*, which had been awarded an Honourable Mention at the 1855 Paris Exposition Universelle. It failed from want of subscribers. The proposed purchase, her oil painting of Christ's miraculous transformation of water into wine, *The Marriage at Cana in Galilee* (1861, Sydney: Art Gallery of New South Wales), was inspired by her study of Perugino's frescoes, except that Ironside, a fervent republican, modelled both Christ and the bridegroom on the Italian revolutionary Garibaldi. If it can now be read as a visual manifesto of the republican views held by a group of Sydney radicals in the 1850s, that was not its intention. It was, rather, proof that she had established her artistic credentials. Yet, even in 1862 when *The Marriage at Cana* was included in the NSW Court at the London International Exhibition, it was extremely old-fashioned in genre and style – the purest Nazarene-style oil painting by an Australian in existence. (The elderly German Nazarene Friedrich Overbeck was one of Ironside's admirers in Italy.) By 1880, when it was hung at the official opening of the National Art Gallery of New South Wales along with her two other major paintings, it was embarrassingly out of date.[5] It was only saved from destruction by St Paul's Anglican College at the University of Sydney offering to hang it in the dining room. Only since 1995 has it hung in its current location, initially lent for a national exhibition of women's art, then given on permanent loan.

Until the 1890s few would-be professional fine artists, male or female, had the necessary contacts, money and determination to overcome Australia's 'tyranny of distance'. European study was especially difficult for women, of course, and yet two managed to get there in the 1860s and become amazingly successful – far more so than any male contemporary. If they were later forgotten, that was less because of their gender or outmoded artistic style than because neither returned to Australia after their initial overseas success. And both were sculptors, always the least popular of the fine arts in Australia!

There was certainly little demand for cameo cutting in colonial Australia,

yet both Elizabeth A. Kelly (birth and death dates unknown) and Margaret Thomas (*c*.1843–1929) exhibited highly praised portrait cameos at the 1866 Melbourne Intercolonial Exhibition. Kelly showed an unspecified number of shell cameos, including a pair of Queen Victoria and Prince Albert which were awarded a medal. The medal was designed by Charles Summers, the most eminent sculptor in gold-rush Australia and the man who seems to have been chiefly responsible for the antipodean blossoming of this esoteric art. Thomas was Summers's star student and far more versatile than Kelly. She had already shown a varied collection of works at the 1864 Victorian Exhibition of the Fine Arts held in her teacher's studio, including *The Quadroon Girl*, a plaster figure inspired by Longfellow. In 1866 the exhibition jurors commended this 'most industrious student of art, who has exhibited many well-executed copies in oil, as well as models in plaster, and an original portrait cameo, excellently carved'. Not all the paintings were copies; they included an oil version of *The Quadroon Girl* and a life-size original portrait of her teacher.

When Summers, his wife and son returned to Europe in 1867, the two young women followed.[6] Both settled in London, where Kelly won instant fame for her cameos. The *Art Journal* reported that Queen Victoria had purchased two of the Australian works, obviously the prize-winning royal portraits; Mr Gladstone commissioned portrait cameos of himself and his family and gave Kelly access to his collection of china and woodcarvings to copy; and the Duchess of Argyll was another patron. As yet, however, her only identified cameo is a profile portrait of Bishop Charles Perry, Anglican Bishop of Melbourne in 1848–74, which is inscribed verso 'E.A. Kelly Sculptor Melbourne' (Dixson Library, State Library NSW). This exquisitely detailed, highly naturalistic work alone, which was probably also shown at the Melbourne exhibition in 1866, justifies the *Art Journal*'s conclusion: 'It is not too much to say that nothing so good, in this class of art, has been heretofore produced in England.'

The fulsome review, reprinted in the *Sydney Mail*, included a far less credible tale of Kelly's 'early education in art in the "bush" of Australia', i.e., the densely populated suburb of Carlton in Melbourne, where without knowledge or mentor, 'guided by what is erroneously called chance', she was drawn to 'first carving heads on pieces of Australian lava, and thence proceeding to the shell, sometimes copying from such engravings or models as came in her way, far from any "school", and occasionally designing as well as carving' (8 January 1870). From this bucolic existence in the *terra nullius* of civilization, Kelly proceeded direct to London, fame and fortune. She was not the first colonial-born artist to exploit the myth of natural genius blossoming despite – or because of – never having seen another artist or an original work of art. Robert Dowling preceded her. Nor was she the last. The legend

continues, now most commonly applied to Aboriginal painters who seem to find pulling British legs as irresistible as Irish-Australians like the Kellys did.

Margaret Thomas's success was less meteoric but more lasting. After a couple of false starts, she entered the Royal Academy Sculpture School in 1871 and ended up being awarded its silver medal for modelling, the first woman ever to achieve this distinction. (Summers, incidentally, had only won a bronze medal in 1850.) She went on to have a most successful career as a portrait painter, also carving the occasional life-size marble bust, and by 1888 she was wealthy enough to abandon portrait commissions in favour of writing and illustrating travel books. Born in Surrey, she had come to Melbourne with her family when aged about nine. She never pretended to be a wild colonial girl; on the contrary, she recognized no distinction between colony and country and no flaws in her Melbourne training. Indeed, she thought Summers the greatest sculptor and teacher in either hemisphere. Her best-known works are all of her mentor: the life-size painted portrait she exhibited at Melbourne in 1866 and then apparently reworked after Summers died in 1878 (State Library of Victoria), a posthumous marble bust (Shire Hall, Taunton, Devon) and a hagiography published in 1879 aptly titled *A Hero of the Workshop*.

In Australia Kelly was forgotten until 1995, while Thomas was chiefly remembered for her painting of Summers, which includes a maquette of his large Burke and Wills sculpture erected in Melbourne and is therefore of local interest. Even so, expatriate artists were of far more interest to posterity than resident Australian artists who turned their backs on the wide brown land. Florence Elizabeth Williams, née Thomas (1833–1915), whose engineer husband's career took her back and forth from London to Sydney and Hobart, exhibited and sold excellent oil paintings in all three cities for decades and yet made no lasting mark in any of them. In England her career has been subsumed under her husband's and confined to the flower and fruit paintings she showed at the Royal Academy, the British Institution and the Society of British Artists between 1852 and 1864 (Wood, 1995, 574). She painted a far broader range of subjects over a much longer period, however, including Australian paintings shown in London in 1868. Most of all, she showed numerous English-looking genre and still-life subjects in Australian fine art exhibitions between 1873 and 1885, regularly exhibiting with the NSW Academy of Art until 1880 (silver medal 1873) and then with the breakaway Art Society of NSW – confined to professional artists – of which she was a founding member. While living in Hobart she also sold her paintings through Hood's commercial art gallery: Mrs Allport's son Morton, 'an acknowledged connoisseur', purchased a pair of her English flower paintings there.

Florence Williams's 'most attractive and original design', *Ophelia*, was

shown at the Art Society of NSW's inaugural exhibition in 1880, for sale at a substantial price of £75. Extravagantly praised as one of the few figure paintings and the most expensive work in the exhibition, it is now lost. We know this heroine did not emulate the drowning figure posed by Elizabeth Siddal in the earlier English painting of the same name by John Everett Millais, but instead was seen 'standing upon the "envious silver", the breaking of which is so soon to precipitate her into the cold dark water beneath' (*Bulletin*, 1 January 1881). Nevertheless, the choice of subject was no accident. Florence was the daughter of Millais's first patron, the barrister Ralph 'Serjeant' Thomas (demonized in J.G. Millais's biography of his father and defended by Florence in a pamphlet privately printed by her brother in 1901).[7] Florence saw *Ophelia* and *A Huguenot* in Millais's studio in 1852 before they were sent to the Royal Academy.

The artist also exhibited, 'charming groups of flowers and one fruit picture' typical of the compositions she painted throughout her life. In the 1880s James Green ('De Libra') called her fruit paintings 'perfect of their kind' and not unworthy of the popular English still-life painter William Henry Hunt, while a pair of paintings of peaches could have been taken 'for real but for the frames' (*Sydney Morning Herald*, 16 July 1884). All resembled early Pre-Raphaelite work in their minute attention to detail and in bright acid colours. Despite some unexpectedly strong competition,[8] Williams's oils probably adhered more closely to the original principles of the Pre-Raphaelite Brotherhood than any other art works done in the antipodes. Both features are evident in two extant mid-1870s figure paintings featuring her elder daughter at home in Sydney: *The Story Teller* (Edith, known as Edie, reading a story to her doll) and *The Doll's House* (Edie playing with a large, splendidly fitted-out doll's house), which was awarded a Certificate of Merit at the 1875 Academy of Art exhibition (Figure 1.2). Although Millais's 1872 etching, *The Baby-House*, may have inspired the latter subject, the composition and style were quite unlike his. Doll's house, child and setting were obviously painted from life, even though they appear somewhat frozen because every detail is rendered with such microscopic intensity.

Florence had not learnt to paint like this as a child but by following Johnny's career and developing her own in London. After she settled permanently in Australia in 1865, however, her art did not change. Her work is as competent as anything by a rather old-fashioned British artist because that was what she always was. She failed to realize that the Australian colonies were not, after all, remote English counties and she lived as if there was no difference. Hers was a common colonial belief, even an ideal to aspire to – as two lines from the anthem sung at the opening of the 1879 Sydney International Exhibition composed by the Anglo-Australian poet Henry Kendall assert: 'Mighty Nations, let them see / How like Britain we can be.'

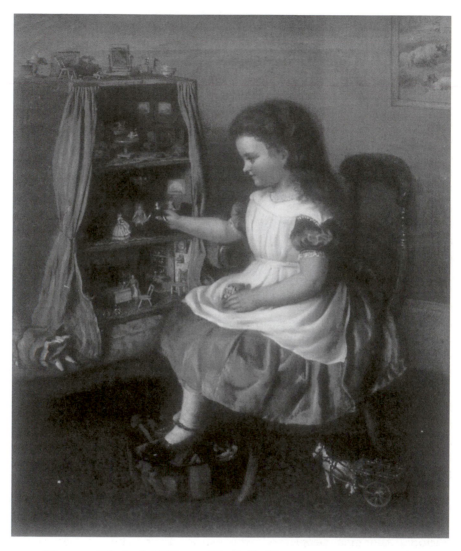

1.2 Florence Elizabeth Williams, *The Doll's House*, 59.5 × 49.25 cm, oil on canvas, *c.* 1875

The alternative – to depict Australia's natural glories as enviable and/or exotic – was equally powerful as well as more popular with posterity. This helps to explain the dominance of landscape painting and 'strong masculine labour' in the Australian fine art scene. But that was never the whole story either. The gentler 'British' arts favoured by so many talented women are worth incorporating into Australia's popular 'bush' legend, not only because

of their quality, subjects and makers but also because they contribute to an inclusive art history that focuses on taste as well as place.

Arts and crafts made in the nineteenth century by Australia's indigenous inhabitants – that crucial yet long-neglected half of the colonial equation – are still barely visible across the years. Indigenous works were confined to anthropological museums and not considered 'art' at all. Nor did the handful of white colonial women artists who took an informed interest in Aboriginal culture by visually recording the people and collecting their artefacts consider such things relevant to their own artistic practice. Growing up with the Richmond River Aboriginal people led Mary Bundock, later Mrs Murray-Prior (1845–1924), to make important collections of weapons and women's artefacts from the district, including dilly-bags shown at the 1879 Sydney International Exhibition, which she gave to museums in Australia, Britain and Europe. Her collecting activities, however, replaced rather than encouraged her own youthful sketching efforts (McBryde, 1978, 135–210).

Early cross-cultural products made by women so far identified confirm that the influences between the dominant and subject cultures were overwhelmingly one way: a patchwork quilt made by a Sunday School class of Aboriginal children in Western Australia before 1848 (National Library of Australia), or baskets, mats and other weavings made on government and mission reserves such as Coranderrk in Victoria from the 1850s. Shell-covered baskets, boxes and boomerangs were made and sold to Sydney tourists visiting the La Perouse Aboriginal reserve at least from the 1890s (tiny shoes later became another speciality). By the early 1900s 'Queen' Emma Timbery's shellwork was said to be admired in England as well as throughout Australia. No early examples survive, but we know what they looked like because an unbroken line of La Perouse 'shellers' continued to make them to the present day.[9]

The only white woman whose art seems briefly to have interacted with this sort of Aboriginal souvenir art was Ellis Rowan's aunt, Caroline Le Souëf, née Cotton (1834–1915), who grew up with the Goulburn River (Victoria) Aboriginal people and who married their (white) government-appointed 'Protector of Aborigines' in 1853. In the late 1860s she engraved and inked little scenes of Aborigines dancing, hunting and living traditional lives in the bush on several long wooden boxes – a technique that looks just like pokerwork or pyrography (where the black results not from ink but from burning in the drawing with a hot wire) – another popular craft that Aboriginal artists took over from the white settlers and made their own. Caroline's boxes containing sets of miniature Aboriginal weapons carved by her husband Albert were shown at major exhibitions in Melbourne and Europe, then acquired by museums (Figure 1.3).[10] Stylistically, her decorations seem less related to contemporary European-Australian

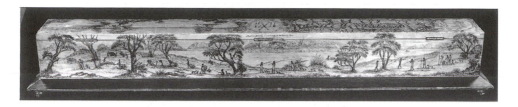

1.3 Caroline Le Souëf, *Miniature Weapons Used By The Australian Blacks*, 15.1 × 102 cm, etching and ink on wood, 1867

women's work than to some of the Aboriginal drawings being made at the time, particularly by the Murray River Aboriginal trader and sketcher Tommy McRae, known to Theresa Walker as Yakaduna. Between 1861 and 1864 Mrs Walker acquired at least three of the lively ink sketches of Aboriginal life and ceremony that McRae sold to Europeans. She was one of the first people to collect his work (Sayers, 1994, 41).

Although lots of Aboriginal men who subsequently drew on paper have been identified, only one nineteenth-century Aboriginal woman sketcher is known: Yertabrida Solomon, a young Ngarrindjeri mother who lived at Raukkan (Point McLeay, South Australia) and made many drawings for the missionary Rev. George Taplin between 1867 and 1876. Apart from a watercolour group of Aboriginal men tentatively attributed to her because it was once in Taplin's possession (South Australian Museum), Yertabrida's work is known only from reworked illustrations in two anthropological texts. Six redrawn originals appeared as engravings in Taplin's *Folklore and Customs of the South Australian Aborigines* (Adelaide, 1879), while a hunting scene from Taplin's collection was photolithographed (so is presumably more accurate) for Thomas Worsnop's *The Prehistoric Arts, Manufactures, Works, Weapons, etc., of the Aborigines of Australia* (Adelaide, 1897; Figure 1.4). In it, all the episodes in a story of a couple out hunting kangaroos are simultaneously depicted, a technique common enough in Aboriginal bark paintings (and medieval art) yet quite unlike the simple Western-style images attributed to her by the admiring Taplin. Indeed, although Caroline Le Souëf's long panoramic scenes, which include a comparable *Stealing of Game*, are sequential, they look more like the Yertabrida illustration in Worsnop than Taplin's reproductions do, even though we have little notion of what her drawings actually looked like.

Indigenous as well as non-indigenous art historians are now looking for originals by Yertabrida (and other Aboriginal women), so some seem likely to turn up eventually. Unknown, important white women's art works reappeared once nineteenth-century European-Australian art began to be

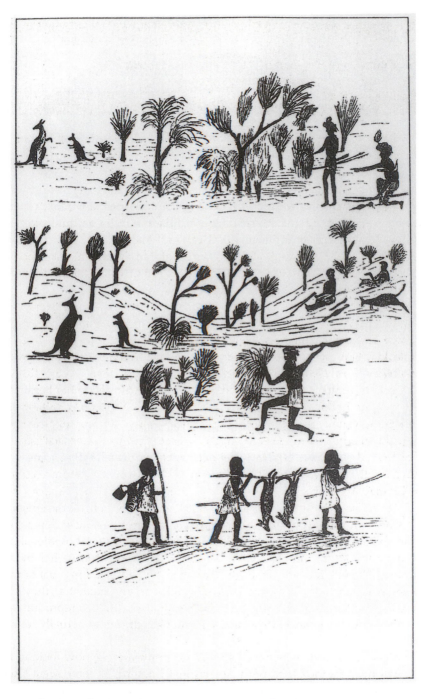

1.4 After Yertabrida Solomon, *Hunting Party after Game*, 1876

redefined as overlapping visual narratives, not as a single patriarchal 'pioneer' story. Artistic life in Australia's six British colonies meant an uncompromising art of exile for some, an exotic new location to be recorded for 'home' or posterity for others, and a place where historic firsts were possible for a few. Although it rarely included interaction with the indigenous peoples, who were considered incapable of making art in that anglocentric world, they were nevertheless doing so.

It seems a mere truism to state that Australian colonial art was created by black and white, amateur and professional, rural and urban, male and female Australian artists – residents, migrants and visitors – and was neither fully autonomous nor an unmodified extension of British art. Nevertheless, were such a comprehensive definition wholeheartedly adopted, it would not only expand the space allocated to women artists but would fundamentally change the nature of conventional Australian art history.

References

Berzins, Baiba Beata, *North Coast Women: A History to 1939*, Sydney: Royal Australian Historical Society, 1996.

Bonyhady, Tim, *The Colonial Earth*, Melbourne: Melbourne University Press, 2000.

Dobrez, Patricia and Peter Herbst, *The Art of the Boyds: Generations of Artistic Achievement*, Sydney: Bay Books, 1990.

Ducker, Sophie C. (ed.), *The Contented Botanist: Letters of W.H. Harvey about Australia and the Pacific*, Melbourne: Melbourne University Press, 1998.

Hazzard, Margaret, *Australia's Brilliant Daughter, Ellis Rowan: Artist, Naturalist, Explorer, 1848–1922*, Melbourne: Greenhouse Publications, 1984.

Kerr, J., 'Colonial ladies' sketchbooks', *Art and Australia*, **17** (4), 1980, 356–62.

———, 'Mary Morton Allport and the status of the colonial "lady painter"', *Tasmanian Historical Research Association Papers and Proceedings*, **32** (2), 1984, 3–17.

———, 'Putting the colonial lady painter in her place', in Toy, A., (ed.), *Hearth and Home: Women's Decorative Arts and Crafts 1800–1930*, Sydney: Historic Houses Trust, 1988, 9–14.

———, (ed.), *Dictionary of Australian artists: painters, sketchers, photographers and engravers to 1870*, Melbourne: Oxford University Press, 1992.

———, (ed.), *Heritage: The National Women's Art Book*, Sydney: Art and Australia, 1995.

McBryde Isabel (ed.), *Records of Times Past: Ethnohistorical Essays on the Culture and Ecology of the New England Tribes*, Canberra: Australian Institute of Aboriginal Studies, 1978.

Niall, Brenda, *Georgiana: A Biography of Georgiana McCrae, Painter, Diarist, Pioneer*; with a catalogue of the plates by Caroline Clemente, Melbourne: Melbourne University Press, 1994.

———, *The Boyds: a Family Biography*, Melbourne: Melbourne University Press, 2002.

Sayers, Andrew, *Aboriginal Artists of the Nineteenth Century*, Melbourne: Oxford University Press in association with the National Gallery of Australia, 1994.

Wood, Christopher, *Dictionary of British Art, Volume IV: Victorian Painters*, Woodbridge: Antique Collectors' Club, 2 vols, 1995.

Notes

1 Biographies and examples of the work of all the women artists mentioned in this chapter appear in one – sometimes both – of the two large Australian Artists' dictionaries that I edited, with entries by hundreds of contributors (Kerr, 1992 and Kerr, 1995). Entries in both books are organized alphabetically so I have avoided peppering the text with references to these basic sources.

2 Once gentlewomen's discoveries were recorded in their albums, however, they were disseminated as freely as if they had been published by a Royal Society. 'Mrs A' was a Maitland friend, Mrs Auley, who allowed Mrs Paty to copy several of her sketchbook flowers in September 1834, when the favour was doubtless reciprocated (Kerr, 1992, 609).

3 Clement Ingleby gave eighty-four of his mother's Australian watercolours to the Queensland Art Gallery, which regularly displays a few of these 'pioneer' works. Many others remain with the family.

4 Philip Chauncy's sentimental reminiscences of his sister at least kept alive Theresa Walker's memory until posterity got around to re-evaluating her art. Although he ignored her wax portraits, at least he shared her interest in Aboriginal people and their art.

5 The three major oil paintings by Adelaide Ironside hung together at the opening of the National Art Gallery of NSW in 1880 were: *The Marriage at Cana in Galilee*, *Fame crowning Genius* (an 'ideal' portrait of Adelaide and her mother, believed destroyed) and *The Manifestation of Christ to the Gentiles* (private collection, Sydney). None was acquired. Until 1995 the gallery owned only Ironside's first oil painting, the tiny *St Catherine of Alexandria as Patroness of Philosophy* of 1859, and a minor drawing.

6 Another sculptor protégé of Summers, the equally talented William Stanford, was left behind, being more closely confined to the colony than any woman with most of a sentence of twenty-two years for highway robbery and horse stealing yet to serve in Melbourne Gaol.

7 Ralph Thomas, *Serjeant Thomas and Sir J.E. Millais Bart, P.R.A.*, London: the author, 1901.

8 Three PRB associates came out to the Victorian goldfields in 1852: Thomas Woolner, Edward La Trobe Bateman and Bernhard Smith (see Kerr, 1992). All worked as artists in Australia, although only Bateman worked in oil. Smith did small fantasy drawings and Woolner made relief portraits in plaster or bronze.

9 Although no extant shellwork by 'Queen' Emma Timbery is known, early twentieth-century shelled slippers and a boomerang by her granddaughters, the Sims sisters, are illustrated and discussed by Ann Stephen in *Heritage* (Kerr, 1995, 129–30 and 449–50).

10 Le Souëf boxes in Australia are held in the Museum of Victoria and the National Museum of Australia.

In Her Majesty's service: women painters in China at the court of the Empress Dowager Cixi

Ka Bo Tsang

The Empress Dowager Cixi (1835–1908) was the most powerful and controversial woman on the political scene during the last few decades of the Qing dynasty (1644–1911) in China. Née Yehenala, she was born into the family of Huizheng (1805–1853), a Manchu minor civil official.[1] Her humble beginning would have promised a mundane life had there not been a government regulation that required all baby girls of Manchu descent to be registered at birth so that when they came of age they could be summoned as candidates to the selection of imperial consorts. Under this system, when Yehenala reached the age of seventeen in 1861,[2] she was chosen to enter the palace, to be a low-ranking concubine of the reigning Xianfeng Emperor (r. 1851–1861). From then on, through beauty, wit, charm and, most important of all, the good fortune of bearing a son, Yehenala was able to advance steadily. Within seven years, she rose from her initial lowly title of *guiren* (Concubine of the fifth rank) to the much more dignified title of *guifei* (Concubine of the second rank). A few years later, when the Xianfeng Emperor died unexpectedly and Yehenala's son, the sole heir, succeeded the throne as the Tongzhi Emperor (r. 1862–1874), she was conferred with the honourable title of the Empress Dowager, with the honorific name Cixi (Motherly and Auspicious). She, together with the Empress Dowager Ci'an (the empress of the Xianfeng Emperor, 1837–1881, her honorific name meaning Motherly and Peaceful), acted as co-regents for the infant emperor, then only six years old. However, as Ci'an was neither ambitious nor interested in politics, it was largely Cixi who made decisions in state affairs.

Cixi's control of the empire, whether directly or indirectly, was to last until the very end of her life. During almost half a century she engineered the enthronement of three emperors,[3] consolidated her power by surrounding herself with people eager to obey her orders and eliminating those who either

dared to oppose her or who did not carry out her wishes satisfactorily. She proved herself resourceful and tactful too, surviving major crises that would have led to her downfall. For instance, she thwarted a plot by the eight co-regents to gain supreme control of the government immediately after the death of the Xianfeng Emperor in 1861,[4] frustrated the Guangxu Emperor's plan in 1898 for national reform and her confinement, and managed to regain her power and international reputation after her return to Beijing from her flight to Xi'an, a traumatic experience precipitated by the Boxer Rebellion of 1900.

Although Cixi devoted considerable energy to keeping a tight rein on affairs of the state, she still found time for entertainment and leisurely pursuits. She took pleasure in music, theatrical performances, literature, painting, calligraphy, keeping pedigree dogs, and cultivating flowers and gourds. With such a strong interest in art and patronage, Cixi managed to achieve both her artistic and political goals.

MALE PAINTERS AT THE COURT

The imperial court relied on a large number of artisans with different skills to produce objects or art works for the documentation of important events, for daily use, and for interior decoration. They worked in various workshops located in the Qixiang gong (Palace of Brightness and Auspiciousness). These workshops were collectively called the Ruyi guan (Wish-fulfilling Studio). Painters who had been recruited to serve the court also worked there.

The exact number of painters who served during the period in which the Empress Dowager Cixi was in power is uncertain. A memoir published by Isaac Taylor Headland in 1909, *Court Life in China*, asserts that there were eighteen (Headland, 1909, 89). This figure would have represented only the number working during the last two decades of the Qing dynasty, when Headland lived in Beijing. He professed to be intimately acquainted with most of these painters. Headland, however, does not mention any of their names save a Mr Kuan (Guan). Only fifteen names can be identified from various other sources. These include: Gai Zhuqiao,[5] Gao Tongxuan (1835–1906), Guan Nianci (d. 1909), Li Peiyu (Qu, 1993, 23), Liang Shisi (Qu, 23), Ma Wenlin (Qu, 23), Qu Zhaolin (1866–1937),[6] Shen Quan,[7] Shen Zhenlin,[8] Wang Chulin (Su Hua, 1953, 83–4), Wang Jiming,[9] Wu Jiayou (d. 1893),[10] Yu Zhenpei (d. 1926; Wu, 1960, 19a), Zhang Kai[11] and Zhang Qiming.[12]

Headland was also able to find out how the eighteen painters worked. According to him, they were divided into three groups. Each group, made up of six people, was required to be on duty on a ten-day rota system. If a painter excused himself from reporting to the Ruyi guan for whatever reason, he would be required to produce a minimum of sixty paintings in that year,

which were to be submitted around the time of the important feasts. These unsigned works, together with his regular output while on duty, and those produced by his colleagues, would be stamped with the Empress Dowager's seals and inscribed with poems by members of the Hanlin yuan (Imperial Academy) or by high officials. Cixi would then bestow the paintings on people she esteemed.[13]

Aside from this main task, the court painters were also expected to produce works for Cixi's own enjoyment, such as paintings that portrayed her in her favourite guise of Avalokitesvara, the Goddess of Mercy (Figure 2.1) or engaged in leisurely pastimes.[14] In addition, they were responsible for painting scenes of nature and botanical subjects in both large and small formats. These might be mounted as hanging scrolls for wall decoration. They might also be mounted on folding screens or openwork wooden partition panels, placed strategically to enhance the ambiance of the various palaces (Qu, 23). These painters performed the role of designers as well. Their services were called upon in matters as wide-ranging as the production of stage backdrops,[15] the creation of patterns to be woven into or embroidered on various articles of clothing for the high-ranking members of the royal family,[16] and the conception and implementation of pageantry to be staged during major festivities.[17]

The Empress Dowager Cixi took an avid interest in all the works assigned to the court painters. She always inspected their preliminary drawings, censured them or made suggestions for improvement according to her likes and dislikes, and gave approval for the drafts to be further developed (Carl, 1907, 58; Yu, 1957, 73). Her wishes were law as regards choice of subject matter and style of execution and her decisions final. Working in this restrictive atmosphere, no painter would dare to deviate from the approved norm. Wang Chulin, for example, is recorded as having remarked more than once, years after the Qing dynasty had come to its demise and he was no longer associated with the imperial court, 'Since I became a court artist I have had no time to paint the things I like. I have seen many famous pictures, but what help is that with my own painting? I'm afraid it has only prevented me from doing bold and original work' (Su Hua, 83–4). Wang's lament of insufficient time for personal artistic development is certainly a valid one, yet the Empress Dowager Cixi's iron will probably also played an important part in thwarting the painter's desire for artistic growth. Nor was court painter Wang Chulin alone in expressing his frustration: Wu Jiayou and Gao Tongxuan, too, must have shared similar feelings. These two were summoned to work at the court because of their widespread fame. However, they found the new environment stifling and, realizing that their artistic potentials would never be fulfilled, they soon left the court to pursue their own interests in their much freer home environment (Zheng, 1982, 39; Wang, 1963, 14).

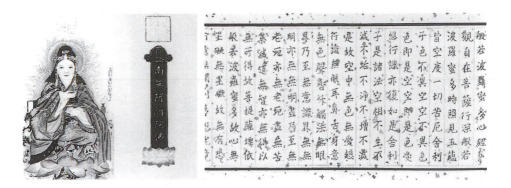

2.1 Section of a handscroll with the text of the *Heart Sutra* written by the Empress Dowager Cixi (right), with a portrait of her painted by a court painter mounted at the beginning (left)

Court painters not only worked in the studio. Occasionally they would be summoned and would have to present themselves to make sketches of Cixi's pet dogs or fresh blooms in the imperial garden. While carrying out these open-air assignments they would still need to conform to palace regulations, such as kneeling on the ground to show due respect for their exalted patron.[18] Cixi, however, was generous towards those painters, who won her admiration either through their artistic skills or because of their likable personalities. She rewarded them with large sums of money, promotion, honorary titles, and all sorts of personal favours. Gao Tongxuan, for example, was granted an opportunity to tour the most scenic spots within the imperial precincts in order to select the ideal elements with which to compose the setting for a portrait of Cixi. On completing this work, which depicted the august figure assuming the guise of a fisherman recluse idling on a boat in a dreamlike landscape, Gao Tongxuan received from a very satisfied Cixi 500 taels of silver (Wang, 14).[19]

Qu Zhaolin joined the Ruyi guan at the young age of eighteen. Over the years, he gradually rose from the lowest rank to be the head of this organization because the Empress Dowager was particularly appreciative of his paintings of pines, cranes and the *lingzhi* (fungus of immortality), subjects that he often ghostpainted for her. She was quite impressed as well by his ability to imitate works by Giuseppe Castiglione (1688–1766), a highly regarded Jesuit painter active in China during the reigns of the Kangxi (1662–1722), Yongzheng (1723–1735), and Qianlong (1736–1795) Emperors. For many years either Her Majesty or the Guangxu Emperor (r. 1875–1908) would order him to produce similar works for decoration in the palaces (Qu, 23).

Another court painter, Shen Zhenlin, was an all-round practitioner. Capable of painting a wide range of subject matter, including portrait, landscape, figural themes, animals, birds and flowers, and producing wonderful results, he was showered with sumptuous rewards by the Empress Dowager, among them the honoured title of *fengchenyuan qing* (Director of the Imperial Parks and Hunting Grounds) and a large wall tablet inscribed by Her Majesty with the laudatory remark, *chuanshen miaoshou* (an expert in transmitting the inner spirit [of his subjects]). He was eventually promoted to be the head of the Ruyi guan, with its commensurate second rank and salary (Sheng, n.d., *juan 29*, 9b).

The magnitude of Cixi's largesse towards her favourite court painters, however, is best manifested in Guan Nianci, also popularly known under his style name, Qu'an. According to an unofficial record, Guan was, before he joined the Ruyi guan, a handsome dandy gifted in painting and music (Xiaohengxiangshi zhuren, 1981, 98). He was disowned by his father because he lived off his parent's small income, led an aimless way of life, and would not give up his penchant for indulging in sensual pleasures. Forced to make his own living, he travelled to Beijing to look for opportunities. It so happened that the Ruyi guan was recruiting painters. Guan sat the qualifying test and came out top of the list of applicants, so gaining admission to the painting section of the imperial workshop.

However, unlike most of his colleagues, who worked hard in order to gain imperial attention and favour, Guan Nianci knew how to ingratiate himself, first with the eunuchs, and then with the Empress Dowager. It was through the good office of the head eunuch Li Lianying that Guan Nianci gained an opportunity to demonstrate his artistic ability in front of the Empress Dowager who, upon seeing his work, took an immediate liking to it. Guan Nianci was not only instantly promoted to be the head of the Ruyi guan, but also permitted to enter the living quarters of the imperial household. This unprecedented privilege created many opportunities for the artist to impress Cixi further with his other talents. He entertained her with snippets of news from outside the palace and sang and played the popular tunes of the Jiangnan region. These melodies, soft and filled with melancholic emotions, were new to Her Imperial Majesty's ears; they were so different from the solemn ceremonial music of the north that they immediately appealed to her sensibilities. Cixi grew so fond of Guan Nianci that she would often jokingly call him her son and shower him with valuable gifts and vast sums of money. She also saw to it that he took a wife and that they lived in a comfortable residence just outside the palace. In fact, a decade or so after he joined the Ruyi guan, Guan Nianci had become so well off that he could start his own business in the capital. Among the court painters who had the good fortune to serve the Empress Dowager Guan Nianci's experience was indeed exceptional.

WOMEN PAINTERS AT THE COURT

Although the Empress Dowager Cixi had a corps of court painters to serve her needs, other considerations prompted her to take a serious interest in producing art work herself. Traditionally, the Chinese regarded calligraphy and painting as the two highest forms of art. Those who were able to master these skills would be admired for having cultivated an air of artistic refinement. For the Empress Dowager Cixi, such an ability not only meant that she could indulge herself in a worthy pursuit in her leisure moments, but also, culturally speaking, it would set her above all the womenfolk of the imperial clan. Moreover, there was a court tradition for the ruler of the empire to brush large characters with auspicious significance and bestow them on favourite imperial relatives and high officials on festive occasions (Mao, 1996, 240–3). Cixi, after she had come into power, wanted to perpetuate this tradition and thus desired to become proficient in the two art forms.

Cixi knew that she needed to seek proper guidance in these matters. Yet, because of her exalted position and the rules of propriety, she could not take lessons from the court painters. In 1888 she solved the dilemma by sending out orders to conduct a nationwide search for women painters with excellent skills to give her instruction (Ke, 1992, 171, n.1).[20] From the official record we know of at least four women who were deemed to be qualified and who served her in this capacity for various lengths of time (Zhao et al., 1977, *juan* 508, 14054–5). They were: Gua'erjia Hualiang, Miao Jiahui (1841–1918), Ruan Yufen, and Wang Shao.

Among these four painters Miao Jiahui was the best known; the other three scarcely appear in the record. Gua'erjia Hualiang was even unknown to scholars who have written about the women painters in Cixi's employ.[21] Based on the brief information given in *Qingshi gao* (Draft of Qing History), we know only that she was the wife of Renxing, a Manchu officer stationed at Hangzhou (Zhao et al., 14055). From the fact that she had published a painting manual entitled *Zhaofanshi huafan* (A Painting Guide from the Studio of a Superior Model), however, it appears that she was reasonably well educated and, judging from the name she chose for her studio, quite proud of her artistic achievement.

Ruan Yufen was a native of Yizheng in Jiangsu province.[22] Before joining the court, she was known under her style name, Pingxiang. The name Yufen (Jade Fragrance), which she assumed later in life, was bestowed upon her by the Empress Dowager as a mark of appreciation of her art. She was a descendant of Ruan Yuan (1764–1849), a distinguished scholar and high official who, during the Daoguang period (1821–1850), was elevated to the status of *taifu* (Grand Tutor).[23] As for Ruan Yufen herself, we only know that she was married into a Ma family. In her art she excelled in painting bird-

and-flower subjects. Her works are said to have been imbued with sensitive refinement, a quality that won Cixi's admiration. How long she was in Cixi's service is uncertain. It is known that she eventually tendered her resignation on account of advanced age and retired to West Lake, a scenic area in Hangzhou, Zhejiang province. That Ruan Yufen chose to retire to Hangzhou instead of her hometown Yizheng is worth noting. Her decision may well have been made on the advice of her colleagues, Gua'erjia Hualiang and Wang Shao, who both hailed from Hangzhou. If proved to be the case, this information may serve as evidence of an amicable relationship among the women painters.

Wang Shao's style name was Yuyun.[24] She was also known under her style name, Dongqing nüshi. The daughter of Wang Di, who served as the Sub-Prefect of Hangzhou, she was married to Fu Lehe, a Manchu officer garrisoned at Hangzhou. In painting she ably depicted landscape, orchid, and bamboo, but she excelled in floral subjects.[25] In calligraphy she emulated the elegant style of Yun Shouping (1633–1690), an early Qing painter who had enjoyed an almost unrivalled reputation in bird-and-flower painting during and after his lifetime. Wang Shao's oeuvre is said to have been characterized by an exquisite delicacy and was highly regarded by the Empress Dowager. Yet, her career at the court was cut short by her premature death. She left behind a collection of poems, published under the title of *Dongqingguan shi* (Poems from the Evergreen Studio).

If Gua'erjia Hualiang, Ruan Yufen and Wang Shao won the Empress Dowager's respect as painters in the palace, it was their co-worker, Miao Jiahui, who won her heart.[26] Miao was a native of Kunming in the southwest province of Yunnan. Her style name was Suyun. At an early age she already showed talents in painting, calligraphy and playing the *qin*. When she married she moved with her husband, Chen Rui, to his official post in Sichuan province but unfortunately Chen passed away when their son was still young. Without financial support, Miao and the boy returned to Kunming. She began to eke out a living by offering musical entertainment and selling paintings.

Miao's luck took a better turn when the Empress Dowager issued the edict to find proficient women painters. On the recommendation of the Governor of Sichuan, she was sent at once to the capital. The work she produced at the test in the palace pleased Cixi enormously. Thus she was admitted to the court and began a new life. Cixi, in fact, continued to take delight in Miao's attractive creations of floral subjects throughout her tenure (Figure 2.2). In due course Her Majesty became so attached to Miao that she kept the painter constantly in her company, even when she fled to Xi'an in 1900 (Ke, 1992, 171, n.1; Zhao, 1987, 18). Cixi also honoured Miao with many unprecedented privileges, such as granting her the title of Painter-in-Attendance of the third

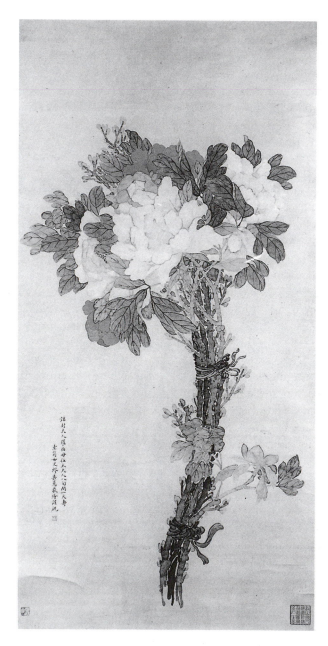

2.2 Miao Jiahui, *Bouquet of Peonies*, n.d.

rank and providing her with its corresponding costume; awarding her a monthly stipend of two hundred taels of silver; exempting her from observing the kneeling protocol; instructing everyone to address her politely as the 'lady painting master' or 'Master Miao', and presenting her with ancient paintings from the palace collection.[27]

Because she was Cixi's favourite woman painter, Miao Jiahui's artistic talent became quite well known in Beijing high society. People sought her works eagerly. Princess Chun, for example, who was the youngest sister of the Empress Yehenala, befriended her and owned a number of her paintings. Once, when she learned that Headland was desperate for an example from Miao's brush, she used her influence to obtain one for him (Headland, 87).[28] Although Headland asserts that he could not find any work by Miao on the market (Headland, 85), some historians believe that Miao did produce works for sale in the famous Liulichang market street in Beijing and that she became so well off that she was able both to acquire a piece of property near Prince Chun's residence and to purchase for her son the position of Secretary of the Grand Secretariat (Li, 1999, 99).[29] Miao Jiahui's respectable position not only benefited her son, it probably also enhanced her elder brother's career opportunities as well. This elder brother, named Miao Jiayu, was also more than competent in calligraphy and painting. He successfully took the provincial civil service examination during the Guangxu period and became a *juren* (second-degree graduate). In 1889 he was recommended to be an instructor of Chinese classics to Prince Chun's two sons, Zaifeng and Zaixun. He also joined the Empress Dowager's retinue to Xi'an in 1900, acting at first as the Assistant Director of the Commissary and then as a Prefect. Later he was posted in Jiangsu province where he died from illness (Pu, 1987, 27). Miao Jiahui continued to work for Cixi until the latter's death in 1908. She would have liked to stay on but the new Empress Dowager Longyu (formerly the Empress Yehenala) had no interest in art. So she left the court not long after the demise of her long-time patron. It appears that she remained in the capital for some years, devoting herself to painting and tutoring students of both sexes. Counted among them were Prince Chun's two sons, Zaifeng and Zaixun (Pu, 27), as well as a certain Ling Shuhua (1904–1990), whom Miao Jiahui considered to have been the best among her girl students (Su Hua, 86 and 253).[30] Eventually, she returned to her home town Kunming and may well have died there.[31]

CIXI AS AN ART STUDENT, A PAINTER AND A CALLIGRAPHER

Whether the Empress Dowager Cixi had tried her hand at painting prior to appointing women painters is uncertain. If she had no practical experience before these painters were brought into her service in 1888, then she would

already have been about fifty-four years old when she took up the brush seriously. Miao Jiahui once recalled, during a chat with Mrs Headland, that the Empress Dowager was very enthusiastic when she began to paint under her tutelage. They would spend a large part of the day either practising with the brush, with the teacher assisting the student to copy type forms from painting manuals, or they would study together original works by renowned masters in the palace collection (Headland, 88). A handscroll by Cixi mounted with a series of painting exercises of flowers and insects bears witness to yet another method of learning (Weidner et al., 1988, 162–3). The student would copy the teacher's own creations, designed as exemplars to help the student to develop a good grasp of the diverse nuances of ink tonality, a fluency in the manipulation of the brush, and a proficiency in representing images correctly. The teacher would then correct the student's exercises, noting with red circles, crosses and comments beside details either omitted or executed successfully or poorly, so that the student would get both sound advice and encouragement.

After Cixi had gained enough confidence through repeated exercises she wanted to progress, to produce her own art work. It is likely that when she did so, she may have first discussed an idea with her teacher, formed some kind of compositional concept, made a rough work on a separate sheet of paper, and then attacked the subject on proper paper or silk. Or, she may have communicated to the teacher the subject she wished to represent, let the teacher sketch in lightly the outlines of the compositional elements, and then followed the general outlines to finish off the painting.[32]

Anecdotal evidence gives some indication about Cixi's behaviour in her painting or calligraphy sessions. One source tells that as soon as she had put the first stroke down on the material she would lament that the stroke had been poorly done and the whole work would be ruined by it (Ma, 1962, *juan* 1, 17). At such times, her favourite eunuchs would chime in to reassure her that the stroke was perfectly all right, and it was only upon hearing such words that she would continue her endeavour; otherwise she would immediately tear up the material and begin anew. Another source mentions that once, when Cixi was painting a crane and muttered to herself that she could never do the legs well, Miao Jiahui quickly came to her aid by drawing some on a piece of paper for her to imitate (Xu, 1994, 452–3). In calligraphy Cixi may have learned from Miao Jiahui and other women painters. Yet, judging from the bold appearance of most of the large characters with auspicious meanings that have been attributed to be from her hand, it would seem more likely that she learned by imitating the calligraphy of some of her court painters or officials in the Imperial Academy, ink-rubbing specimens taken from stone steles, or similar large characters executed by former emperors.[33]

Although there are accounts of her writing individual large characters in front of her court retinue (Carl, 1907, 135–6; Derling, 1992, 159), these may not have been created entirely on her own. Two methods could well have been employed to assist her in the achievement of acceptable results. White powder might be scattered along the punctured contours of a character pre-written by a skilled calligrapher to transfer its outlined image onto the paper on which Cixi would be writing. With this method all she would have to do would be just to write within the white contours and the result would appear to have been done 'freehand'.[34] The other method was to have the double outlines of a character sketched in beforehand in pale ink so that Cixi could follow these guiding lines. Her bold strokes would not only fill up the spaces within these lines, but also cover up such lines.[35]

With the aid of these preliminary preparations, no wonder Cixi could produce passable calligraphic specimens in front of spectators. Interestingly, sometimes when she wrote large characters in the hanging scroll format she would need to stand on a footstool to enable her to wield the brush with greater ease. Nonetheless, Rongling observed in her memoir that when Cixi was engaged in this endeavour she always looked like she was making great exertions. Yet, when she was in a good mood, she could write as many as seven or eight square sheets a day, each with a single large character (Yu, 1957, 73).[36]

It has been estimated that about seven hundred paintings attributed to Cixi still exist in private and public collections (Li, 1999, 92).[37] They date from 1870 to 1908;[38] most, however, were produced between 1888 and 1908. Except for the handful painted by Cixi on her own,[39] the majority were either done by Cixi working closely with her painting instructors or created entirely by male court painters or women painters commanded to do so on Her Majesty's behalf. Also, save a few paintings executed solely for her own enjoyment,[40] most were intended to be given away as tokens of imperial favour.

In her works Cixi followed one general format: the compositional elements would be disposed to the lower two-thirds of the painting proper; a large square seal with the legend *Cixi huangtaihou zhi bao* (a treasure of the Empress Dowager Cixi) would be impressed at the centre just below the upper border; a short dated inscription claiming the work to have been from the imperial brush, followed by one or two of Cixi's supplementary seals, would be located to either the left- or right-hand side in the upper third of the painting proper; and a laudatory poem or two composed by one or more high officials with both literary and calligraphic skills would be written in spaces specifically reserved for this purpose in the lower half.

In subject matter these paintings mainly depicted motifs imbued with felicitous connotations derived either from legendary beliefs or the intrinsic

characteristics of the objects they represented. Some, through word play, suggested homophones to convey the desired blessings. Examples included were the peony which represented wealth; the peach, pine, prunus, *lingzhi*, rock and crane, which all symbolized longevity; as well as the bat (*fu*) and flowing clouds (*yun*), both of which stood for good fortune. In composition floral subjects would be centrally located and drawn from close up against a neutral background. Scenes in which twigs of pine, bamboo or prunus are represented may be enhanced by flowing mists, clouds, or a full moon for atmospheric effect. Generally speaking, the guiding principle was to avoid the incorporation of redundant details so that the subject would stand out and immediately communicate its symbolic significance to the viewer.

Three types of colour schemes were evident. The most conspicuous would use vibrant colours, such as red, orange, blue and purple, to depict flowers (peonies) or fruit (peaches). These colours, however, would appear in subdued shades, achieved by increasing the water content of the washes or using them in conjunction with white pigment. The aim was to instil into the idealized image(s) a cheerful note and a sense of exuberance. Another colour scheme would depict, in subtle washes of green, brown and bluish grey, pine, prunus, or bamboo twigs veiled partially by drifting mists and occasionally accompanied by cranes, bats, or the moon. Such renditions were intended to impart a feeling of tranquillity, refinement and harmony. The third type would use only ink to delineate the subject; prunus branches laden with blossoms being the favourite theme. Paintings achieved in this manner followed a scholarly tradition and naturally were intended to convey a sense of cultivated simplicity. As a whole, because the works were from different hands, the quality of the brushwork would vary. Some might be technically polished while others might be just proficient.

Cixi's own works were usually wrought with marks of inadequacy and awkwardness. A painting featuring two stems of peonies (Toronto: Royal Ontario Museum), for example, testifies to her limitations in creating an effective design and in the usage of colour washes in its execution.[41] Represented in the *mogu* (boneless) manner, her handling of the colour washes is weak. The foliage, in particular, depicted in small groups of light and dark dapples of colour to indicate the upper- and undersides, simply lacks visual coherence. While this work shows Cixi attacking the subject with timorous caution, another painting of blossoming prunus, once owned by Isaac Taylor Headland, demonstrates another extreme one can expect from the royal hand (Figure 2.3). This time, the subject is treated in a bold manner. The tree branches are dashed off by means of a series of overpowering strokes. They make abrupt ninety-degree turns and intertwine to form a diamond pattern. So contrived and whimsical is the layout of the compositional elements in this painting that it is no wonder that, when one

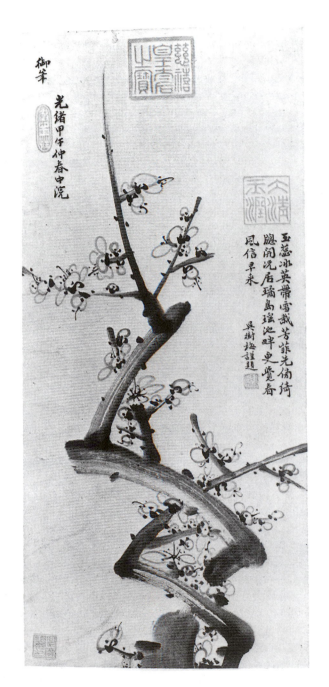

2.3 Empress Dowager Cixi, *Sprigs of Prunus Blossoms*, 1894

of Cixi's court painters was shown this particular piece by Headland, he remarked '…it is proof positive that it is her work.' (Headland, 90)

For Cixi's authentic handwriting, we need only to turn to two published documents written by her. The first is an imperial edict issued on behalf of the infant Emperor Tongzhi denouncing Prince Gong for his misdeeds and stripping him of all titles and power.[42] The text is composed of askew columns of naively rendered characters. The spacing both between each character and between the strokes within each character is generally very unbalanced. As a result, some strokes are squashed together and some characters are closely connected. The overall impression is that the writer sorely lacks skill in handling brush and ink. Any concept of space in terms of text layout, too, is minimal. The other piece of evidence is a handscroll mounted with the text of the *Heart Sutra* written out by Cixi (Figure 2.1). As Cixi was a devout worshipper of the Goddess of Mercy and copying sutra texts was one way of gaining spiritual merit, this text could not have been done by anyone but Her Majesty.[43] Executed in a careful manner to show her piety, the spacing, the form of each stroke, and the construction of each character is even and calculated. The text appears to be neatly done, yet, because the calligraphy lacks variation and a natural flow, the quality of the handwriting still leaves much to be desired.

A FOREIGN WOMAN PAINTER AT THE COURT

In 1903 Sarah Pike Conger, wife of Edwin H. Conger, the American Minister to China from 1898 to 1905, conceived the idea of engaging the service of a woman painter to paint a portrait of the Empress Dowager. It was also her idea that the portrait be sent to the St Louis Louisiana Purchase Exposition (April–December 1904). She hoped that Americans, given a chance to see the charming side of this much-maligned Chinese ruler, would change their bad impression of her. With this noble aim in mind, she presented the proposal to Cixi who, although initially hesitant, gave her consent.

The woman painter recommended by Mrs Conger was Katharine A. Carl (Figure 2.4), an American portraitist who had received her art training in France and who lived in Europe and America.[44] She had a brother named Francis, who worked in the Customs Service in Yantai in Shandong province. Carl came to China sometime in 1902, probably to visit her brother.[45] At the time when Mrs Conger hit upon this idea the artist was visiting Shanghai. Carl was willing to do the portrait, but as a first-time visitor to China, aged about forty, she had no knowledge of the Chinese language. She had to her advantage, however, pleasing manners, artistic skill, and the acquaintance of the two daughters of Yu Geng (d. 1905), Derling and Rongling, who were the Empress Dowager's favourite companions between 1903 and 1905.

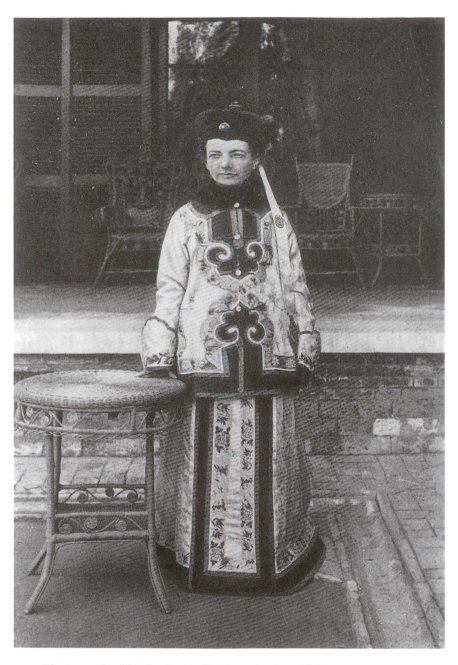

2.4 Photograph of Katharine A. Carl posing in a Chinese court costume bestowed by the Empress Dowager Cixi

Carl's experiences at the Chinese court were both enjoyable and frustrating. During her sojourn there of less than a year she was encouraged to join Cixi's retinue in daily promenades, occasional theatrical performances, and all the celebratory events. Although at first she was grateful for these opportunities to learn more about Chinese court life, after a while she preferred to forego such privileges in order to concentrate on her work. Cixi mostly ignored her desires, however: not only was Carl required to work at odd hours, she was also instructed to stop painting the moment Cixi felt tired of posing (Deling, 116–17). She had to adjust to makeshift studios set up in different parts of the palace precincts, notably the Summer Palace during the summer months and the Forbidden City in the winter.

As a portraitist, Carl would have liked to get to know her subject and establish a rapport with her to discern her subject's best side and make the most of it. Yet, little by little, she was to find out that she would have to comply with Cixi's wishes and conform to Chinese artistic conventions.[46] These included, for example, the decision on the dimensions of the portrait to be sent to the St Louis Exposition: 6 x 10 ft, according to Cixi's specification, rather than 5 x 8 ft, as Carl had wished (Carl, 217); strict adherence to a symmetrical composition (Carl, 238); and no say in the choice of any detail in the portrait. Thus, a red lacquer throne Carl thought would go well with the lines of the composition was categorically ruled out (Carl, 161 and 216), and her request to Cixi to pose her hands differently was flatly refused, with the royal sitter expressing her displeasure by saying, 'But I like them like that.' (Carl, 217) Furthermore, Cixi would allow not a fold in either gown or sleeves, no shadows on her face, no variegated colours for the pearls she wore, and very little perspective (Figure 2.5). She also constantly inspected Carl's work and demanded that changes be made to the jewellery already painted (Carl, 237 and 287–8). In the end Carl gave up fighting for her own ideals. She admitted losing interest in the project, saying, 'I was no longer filled with the ardent enthusiasm for the work with which I had begun with it, and I had many a heartache and much inward rebellion before settling down to the inevitable' (Carl, 161) and 'I had now resigned myself to convention and tradition, and I copied mechanically what was placed before me, and made no more efforts at artistic arrangements, nor tried any experiments in execution. I worked like a good artisan, finishing so many inches a day' (Carl, 238).

In all Carl painted four portraits of Cixi. Having accomplished more than she had anticipated, she felt that she 'could not go on forever painting portraits, according to Chinese traditions, of the Empress Dowager' (Carl, 306), and with mixed feelings she left, with this diplomatic statement: 'Though I longed to be where I might paint in a freer way, I looked forward with real regret to leaving the Palace, and especially to leaving the Empress

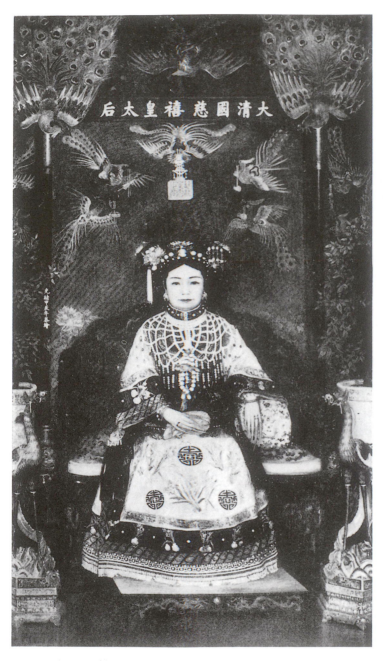

大清國慈禧皇太后

2.5 Katharine A. Carl, *Portrait of the Empress Dowager Cixi*, painted for the St Louis Exposition, completed 1904

Dowager and the young Empress, for I had come to really love them.' (Carl, 306)

The Empress Dowager Cixi was the first female de facto ruler who kept both male and female painters in her service. The male painters were recruited by the Ruyi guan; once admitted, they became official court painters. Their duties were to produce designs and drawings of articles for daily use or for special events, as well as paintings for Cixi's personal enjoyment and for her to give away as tokens of imperial favour. They were paid a monthly stipend that ranged from fifteen to sixty taels of silver, depending on their grades and proficiency (Qu, 1993, 23).[47] Those who were popular and whose works were in demand outside the palace would paint privately at home for friends and acquaintances either to forge goodwill or to sell their work to augment their income.[48] A few, who were fortunate enough to count themselves in Cixi's good graces, would receive honourable titles, substantial monetary rewards, and even special personal favours.

For women painters the selection process was somewhat different. Upon the recommendation of local officials, they travelled from their home towns to the capital to be tested by Cixi herself. It is not known how many candidates were sent forth, nor how many city or provincial officials were able to offer potential candidates. The four successful finalists were from three southern provinces – Jiangsu and Zhejiang in the east, and Yunnan in the west.

The women painters lodged outside the palace. They worked in the Fuchang dian (Hall of Happiness and Prosperity). Their duties were to teach the Empress Dowager both the basics and the finer points of painting and calligraphy as well as to ghostpaint for her. As they were Cixi's intellectual companions, she treated them kindly. Among the artists Miao Jiahui distinguished herself as Cixi's favourite. She received a monthly stipend far exceeding that earned by most court painters and her third-rank title was also above that held by most court painters. Similar to some of the court painters, however, she also freelanced to satisfy requests from friends and acquaintances as well as to enhance her financial security. In retirement two of the four women painters continued to contribute their knowledge to the artistic community: Miao Jiahui offered art tuition to young people; Gua'erjia Hualiang produced a painting manual.

Katharine A. Carl also entered the palace by recommendation, but hers was from the wife of a foreign diplomat, instead of from a city or provincial official. Her sole duty was to paint portraits of Cixi, using the Western medium of oil colours. She worked in improvised studios set up in the Forbidden City and the Summer Palace. She was treated with ostentatious warmth mixed with suspicion (Deling, 103–104, 114; Yu, 38). When the

artist's mission was accomplished, Cixi, though not exactly satisfied with the results, showed her largesse by conferring on Carl a medal (the Double Dragon, Third Class of Second Division), bestowing on her silks and jewellery, and paying her a handsome fee amounting to twelve thousand taels of silver.[49] After Carl had returned to the United States she published a memoir entitled *With the Empress Dowager of China*, in which she gave a detailed account of her unique experiences in the Chinese court. As a result, the artist became a celebrity of sorts.

Working in the palace brought prestige and, for the lucky few, wealth as well. Behind the glory, however, all artists – male or female, native or foreign – had to come to terms with their imperial patron's likes and dislikes. Often they were forced to suppress their creative spirit and forsake individual expression in order to ensure the Empress Dowager's approval. The Chinese women painters provided Cixi with a basic knowledge of art, its theories, and the methods of artistic practice. They ghostpainted for her to enable the Empress Dowager to assume a cultured profile. Unfortunately, in artistic matters Cixi lacked perceptive power, creative talent and technical skill, and her ignorance and arrogance kept her from developing a sound connoisseurship. It is not surprising therefore, that no great works of art were generated under her uninspired direction.

Nevertheless, although Cixi failed to promote a high standard for court art, she did set some precedents. Her employment of Chinese women painters as her art instructors and ghostpainters was unprecedented in the history of Chinese art. Her invitation of a foreign woman painter to be her portraitist was unheard of, too. After Carl's large portrait of the Empress Dowager had been exhibited in St Louis, it was presented to the President of the United States. No doubt engendering some curiosity in America, the painting promoted Cixi's image as a symbol of grace, and as a state gift it reflected her spirit of goodwill. Though all these decisions were made for her own benefit, Cixi did open up opportunities for a few gifted women to reach out beyond their familiar home environment, to lead more interesting lives, and to bring fame and material gain for themselves and their families. In the last decades of the Qing dynasty they became the envy of many people. In the first few decades of the Chinese Republic (beginning 1912), when new ideas of the rights of women and independence spread, they could well have been cited as exemplars for modern women to emulate.

References

Bland, J.O. and E. Backhouse, *China Under the Empress Dowager*, London: William Heinemann, 1910.

Brown, Claudia and Ju-hsi Chou, *Transcending Turmoil: Painting at the Close of China's Empire 1796–1911*, Phoenix: Phoenix Art Museum, 1992.

Carl, Katharine A., *With the Empress Dowager of China*, New York: The Century Co., 1907.

Chou, Ju-hsi, *Scent of Ink: The Roy and Marilyn Papp Collection of Chinese Painting*, Phoenix: Phoenix Art Museum, 1994.

Christie's, Hong Kong, *The Imperial Sale – Yuanmingyuan*, 30 April 2000.

Collier, V.W.F., *Dogs of China and Japan in Nature and Art*, New York: Frederick A. Stokes Company, 1921.

Conger, Sarah Pike, *Letters from China*, Chicago: A.C. McClurg & Co., 1910.

Deling, *Qinggong shenghuo huiyilu*, Hunan sheng: Sanhuan chubanshe, 1992.

——, *Qinggong mishi*, Taipei: Dazong duwu, 1992.

Fairbank, John King et al. (eds), *The I.G. in Peking: Letters of Robert Hart, Chinese Maritime Customs 1868–1907*, Cambridge and London: The Belknap Press of Harvard University Press, 1975.

Gugong bowuyan, *Qingdai gongting huihua*, Beijing: Wenwu chubansche, 1992.

Guoli gugong bowuyuan, *Gugong minghua xuancui*, Supplement, Taipei: Guoli gugong bowuyuan, 1973.

Headland, Isaac Taylor, *Court Life in China*, New York: Fleming H. Revell Company, 1909.

Hummel, Arthur W. (ed.), *Eminent Chinese of the Ch'ing Period (1644–1912)*, Washington: United States Government Printing Office, 1944.

Ke, Xing, *Sai Jinhua zhuan*, Hong Kong: Tiandi tushu, 1992.

Li, Chu-tsing, *A Thousand Peaks and Myriad Ravines*, Ascona: Artibus Asiae, 1974.

Li, Shi, 'Cixikuan huihua ji gongyi nühuajia', *Gugong wenwu yuekan*, **191** (2), 1999, 92–9.

——, 'Cixi de shuhua ji daibiren', *Shoucangjia*, **42** (4), 2000, 60–4.

Ma, Zonghuo, *Shulin jishi*, in Yang, Jialuo (ed.), *Yishu congbian*, series 1, vol. 6, Taipei: Shijie shuju, 1962.

Mao, Xianmin, 'Huangdi yuci "fu shou" zi', in Cui, Zhi (ed.), *Zhongguo gongting shenghuo*, Shanghai: Shanghai wenhua chubanshe, 1996.

Penghao, 'Cixi liuxun qingdian dianjing', *Zijincheng*, **19** (3), 1983, 31–3.

Pu, Ren, 'Jiaocang tiaofu shigao', *Zijincheng*, **42** (5), 1987, 27.

Qu, Zuming, 'Wan Qing Ruyiguan huajia Qu Zhaolin', *Zijincheng*, **76** (3), 1993, 23.

Sheng, Xun, *Qingdai huashi zengbian*, Shanghai: Youzheng shuju, n.d.

Sotheby's, Taipei, *Fine Chinese Paintings from the Dingyuanzhai Collection*, 10 April 1994.

[Ling], Su Hua, *Ancient Melodies*, London: The Hogarth Press, 1953.

Suzuki, Kei, *Comprehensive Illustrated Catalog of Chinese Paintings*, vol. 4 *Japanese Collections: Temples and Individuals*, Tokyo: University of Tokyo Press, 1983.

Tsang, Ka Bo, 'Receiving Imperial Favour: Paintings by Cixi, the Empress Dowager', *Oriental Art*, **35** (4), 1989/90, 207–217.

——, *More than Keeping Cool: Chinese Fans and Fan Paintings*, Toronto: Royal Ontario Museum, 2002.

Wang, Shucun, *Gao Tongxuan*, Shanghai: Shanghai renmin meishu chubanshe, 1963.

Weidner, Marsha et al., *Views from Jade Terrace: Chinese Women Artists 1300–1912*, Indianapolis: Indianapolis Museum of Art, 1988.

Wu, Xingu, *Lidai huashi huizhuan bubian*, Taipei: Qiwen chubanshe, 1960.

Xiaohengxiangshi zhuren, *Qinggong yiwen*, in *Qingchao yeshi daguan*, vol. 1, reprint, Shanghai: Shanghai shudian, 1981.

Xu, Che, *Cixi dazhuan*, Shenyang: Liaoshen shushe, 1994.

Xu, Yuting, 'Wan Qing gongting yanxi diandi', *Zijincheng*, **34** (3), 1986, 38–9.

Xue, Tianpei, *Yizhou shuhualu*, reprint, Taipei: Hanhua wenhua shiye gufen youxian gongsi, 1971.

Yang, Yi, *Haishang molin*, reprint, Taipei: Wenshizhe chubanshe, 1975.

Yu, Bingkun, 'Cixi jiashi kao', *Gugong bowuyuan yuankan*, **3**, 1985, 127–33; **4**, 1985, 9–17.

Yu, Jianhua, *Zhongguo meishujia renming cidian*, Shanghai: Shanghai renmin meishu chubanshe, 1981.

Yu, Rongling, *Qinggong suoji*, Beijing: Beijing chubanshe, 1957.

Zhao, Ersun et al., *Qingshi gao*, Beijing: Zhonghua shuju, 1977.

Zhao, Huirong, 'Qinggong nühuashi Miao Suyun', *Zijincheng*, **39** (2), 1987, 17–18.

Zheng, Yimei, *Qingyu manbi*, Shanghai: Shanghai shudian, 1982.

——, et al., *Qinggong jiemi*, Hong Kong: Nanyue chubanshe, 1987.

Notes

1 For a detailed study of Cixi's genealogy, see Yu, 'Cixi jiashi kao', 1985; also Hummel, *Eminent Chinese of the Ching Period*, 1944, 295–300.

2 The Chinese take into account the gestation period necessary for the development of a foetus. They consider a new born child to be one year old.

3 These were the Tongzhi Emperor, the Guangxu Emperor, and the Xuantong Emperor. When enthroned, the Tongzhi Emperor was six years old. His two successors were both only three years old.

4 The Xianfeng Emperor on his deathbed appointed the eight co-regents as guardians of his infant heir. They were the two princes Zaihuan and Duanhua, and six high officials, namely Jing Shou, Su Shun, Mu Yin, Kang Yuan, Du Han, and Jiao Youying.

5 Gai Zhuqiao is mentioned in Qu, 'Wan Qing Ruyiguan huajia Qu Zhaolin', 1993, 23. Gao's given name was Yinzhang. His association with the Ruyi guan is different from most of his colleagues. He had already established a reputation and was summoned to serve the court by the Empress Dowager. See Wang, *Gao Tongxuan*, 1963, 14. For information about Guan Nianci, see Wu, *Lidai huashi huizhuan bubian*, 1960, juan 3, 27b. For illustration of a fan painting by him, see Suzuki, *Chinese Painting*, 1983, JP36-002.

6 For information about Qu Zhaolin, see Qu, 'Wan Qing Ruyiguan huajia Qu Zhaolin', 23. For illustration and discussion of a painting of an eagle on a cypress tree executed by him, see Chou, *Scent of Ink*, 1994, 152–3. Another painting depicting bats hovering over rocks and choppy sea waves is included in Gugong bowuyuan, *Qingdai gongting huihua*, 1992, 248.

7 For his biographical sketch, see Yu, *Zhongguo meishujia renming cidian*, 1981, 420. For illustration of a fan painting by him, see Tsang, *More than Keeping Cool*, 2002, 150.

8 Shen Zhenlin has been misidentified as a woman painter in Brown and Chou, *Transcending Turmoil*, 1992, 20. For his biographical sketch, see Sheng, *Qingdai huashi zengbian*, n.d., juan 29, 9b. For some of his works, see Collier, *Dogs of China and Japan*, 1921, frontispiece, 160 (facing page); Guoli gugong bowuyuan, *Gugong minghua xuancui*, 1973, fig. 49; Gugong bowuyuan, *Qingdai gongting huihua*, 247; and Tsang, *More than Keeping Cool*, 46–9.

9 A collaborative work done by four court painters, including Wang Jiming, is illustrated in Gugong bowuyuan, *Qingdai gongting huihua*, 242–5. He is, however, unrecorded.

10 For information about him, see Yang, *Haishang molin*, 1975, juan 3, 25 and Zheng, *Qingyu manbi*, 1982, 38–9.

11 Qu, 'Wan Qing Ruyiguan huajia Qu Zhaolin', 23. For a work by him depicting a group of musicians playing music, see Gugong bowuyuan, *Qingdai gongting huihua*, 246. Another painting, which he did in collaboration with Wang Jiming, Zhang Qiming, and Qu Zhaolin, is also illustrated in the same publication, 242–5.

12 Zhang Qiming is not recorded. For a painting signed with his name and those of three other court painters, see Gugong bowuyan, *Qingdai gongting nuihua*, 242–5.

13 These included members of the royal clan, such as Prince Qing (1836–1918), see Tsang, 'Receiving Imperial Favour', 1989/90, 209; high officials, such as Li Wentian (1834–1895), see Christie's, Hong Kong, *The Imperial Sale*, 30 April 2000, lot 616; foreign diplomats, such as Baron Goto Shimpei (d. 1928), the Japanese Ambassador to Beijing, see Li, *A Thousand Peaks and Myriad Ravines*, 1974, vol. 1, 273–6, vol. 2, fig. 64; and wives of some of the diplomats, such as Mrs Sarah Pike Conger, wife of the American Minister in China, see Conger, *Letters from China*, 1910, 226, 274.

14 For illustrations of portraits of Cixi assuming the guise of the Goddess of Mercy, see Headland, *Court Life in China*, 1909, frontispiece, and Li, 'Cixi de shuhua ji daibiren', 2000, 61 and 64. For a painting depicting Cixi playing a board game in a garden setting, see Li, 63.

15 For illustration of a stage backdrop, see Xu, 'Wan Qing gongting yanxi diandi', 1986, 38; for that of a painted bamboo grove background for Cixi posing for the camera as the Goddess of Mercy together with a eunuch and two court ladies, see Headland, *Court Life in China*, facing 90.

16 These articles included clothing, handkerchiefs, napkins, shoes, and bed curtains. See Qu, 'Wan Qing Ruyiguan huajia Qu Zhaolin', 23 and Deling, *Qinggong shenghuo huiyilu*, 1992, 376.

17 Katharine A. Carl, for example, mentions that the court painters were responsible for decorating thousands of lanterns used in the palace ceremonies and processions. See Carl, *With the Empress Dowager of China*, 1907, 173. For illustrations of designs prepared for the celebration of Cixi's sixtieth birthday, see Penghao, 'Cixi liuxun qingdian dianjing', 1983, 31–3.

18 In her memoir Rongling mentions her experience of seeing several court painters kneeling on the ground in the presence of the Empress Dowager while sketching chrysanthemums. See Yu, *Qinggong suoji*, 1957, 74.

19 This was a huge amount. According to Qu Zuming, grandson of Qu Zhaolin, the monthly salaries of the court painters, depending on their ranks, varied from 15 to 60 taels of silver. See Qu, 'Wan Qing Ruyiguan huajia Qu Zhaolin', 23.

20 This is the only source that gives a definite date for Cixi's call for women painters. This date has yet to be verified. Most sources say it happened during the middle of the Guangxu period (1875–1908).

21 For example, her name is not mentioned in Li, *A Thousand Peaks and Myriad Ravines*, 273–6; Weidner et al., *Views from Jade Terrace*, 1988, 159; Li, 'Cixi huihua ji gongyi nahuajia', 1999, 96–7.

22 For her biographical sketch, see Sheng, *Qingdai huashi zengbian*, *juan* 27, 6a.

23 For his official biography, see Zhao et al., *Qingshi gao*, 1977, *juan* 364, 11421–4.

24 For her short biography, see Sheng, *Qingdai huashi zengbian*, *juan* 18, 4a.

25 A work (subject unspecified) by Wang Shao was included in a set of six fan paintings by various painters in an auction. See Sotheby's, Taipei, *Fine Chinese Paintings from the Dingyuanzhai Collection*, 10 April 1994, lot 98.

26 For her biography, see Xiaohengxiangshi zhuren, *Qinggong yiwen*, 1981, 99.

27 For example, Cixi once gave Miao Jiahui an ink painting depicting prunus blossoms. Entitled *A Breath of Spring*, it was done in 1360 by the renowned Yuan painter, Zou Fulei. See Li, *A Thousand Peaks and Myriad Ravines*, vol. 1, 276.

28 This painting of a cock watching a beetle is illustrated on the facing page.

29 A fan painting depicting lotus and insects, dated 1902 and bearing Miao's signature and an inscription without a dedication, supports this assumption. See Weidner et al., *Views from Jade Terrace*, 163. The painting of a bouquet of peonies, illustrated in fig. 2.3, is another work which Miao did for a patron to be used as a birthday gift.

30 Note that Su Hua does not use a standard romanization system. She is also inconsistent in her own romanization. She refers to Miao Jiahui by Miao's style name, Suyun, in one case as Mua Su Yun (86) and in another as Mua Su Chung.

31 For the information about her return to Kunming, see Su Hua, *Ancient Melodies*, 1953, 253.

Another source, however, asserts that she died in Beijing. See Zhao, 'Qinggong nühuashi Miao Suyun', 1987, 18.

32 For illustration of a painting by Cixi showing this feature, see Tsang, 'Receiving Imperial Favour', 1989/90, 211, fig. 7.

33 Cixi's interest in calligraphy can also be corroborated by a special meeting she granted Yan Yinliang, a celebrated calligrapher, in which she exchanged views with him on the art of writing and showed him specimens of ink rubbings taken from famous stone steles from ancient times. See Xue, *Yizhou shuhualu*, 1971, 118.

34 Although this method is described to have been used by Puyi, the last emperor of the Qing dynasty, when he had to write large characters, it may well have served Cixi for the same purpose. See Zhao, 'Qinggong nühuashi Miao Suyun', 1987, 17.

35 For a discussion of this tracing technique used by Cixi in writing large characters and illustrations of examples, see Tsang, 'Receiving Imperial Favour', 214–15. Also see Zhao, 1987, 'Qinggong nühuashi Miao Suyun', 17.

36 Rongling, together with her mother and elder sister, Deling, stayed in the palace for two years as Cixi's companions.

37 The bulk of these are in the Palace Museum in Beijing; the Royal Ontario Museum in Toronto owns four.

38 For illustration of the earliest dated work, which depicts three dogs in a garden setting, see Collier, *Dogs of China and Japan*, facing 142.

39 For illustrations of these examples, see Tsang, 'Receiving Imperial Favour', 208–210.

40 For illustration of a landscape, see Bland and Blackhouse, *China under the Empress Dowager*, 1910, facing 284.

41 For illustration, see Tsang, 'Receiving Imperial Favour', 208.

42 Zheng et al., *Qinggong jiemi*, 1987, [10] of first set of illustrations.

43 For confirmation of this habit of Cixi, see Headland, *Court Life in China*, 90.

44 Based on her dedication to Robert Hart, written in New York for her book, she may have lived in New York. See Carl, *With the Empress Dowager of China*, [v].

45 In the postscript of Robert Hart's letter to James Duncan Campbell dated 7 December 1902 Hart mentions that Carl's mother died at Chefoo [Qufu] on 28 November while Carl was absent on a visit to Hart. It is not certain whether Carl travelled with her mother to China to visit Francis or whether she came to China alone to visit her mother who might be living with Francis. See Fairbank et al., *The I.G. in Peking*, 1975, 1335.

46 In portraiture the Chinese disliked seeing shadows on a face cast by the facial features lit by an oblique light source. They felt that such shadows were ugly and would also reduce the verisimilitude between the image and the subject it represented. As a result, a portraitist would always paint as though the face of a sitter were lit by a direct light source. The use of highlights to mark areas that reflected light would also be avoided, the use of gentle tonal gradations and shading to bring out the physiognomy being preferred. These concepts were also applied to the representation of the sitter's clothing.

47 The grades ranged from second to seventh.

48 Guan Nianci, for example, took sick leave to paint privately in order to increase his regular income. See Headland, *Court Life in China*, 89–90. Qu Zhaolin, too, produced paintings for patrons. For a painting depicting an eagle on a cypress tree, which he did for a General Huchen in 1874, see Chou, *Scent of Ink*, 153.

49 This would be equivalent to some 1,500 guineas. See Fairbank et al., *The I.G. in Peking*, 1414; also Yu, *Qinggong suoji*, 37; Deling, *Qinggong shenghuo huiyilu*, 1992, 170.

3

Women artists in India: practice and patronage

Gayatri Sinha

The history of women's art in nineteenth-century India is embedded as much in the volatile history of the subcontinent and its residual patterns of patronage, as in its new engagements with emergent concepts of nationhood and modernity. This century marked the beginnings of debate around vigorous social reforms that particularly addressed the status of women, some of which were subsumed in the nationalist movement as it gathered momentum in the last two decades. Women's practice was diverse. Here, as in other parts of the world, women gained some opportunities from their male relatives and they frequently worked in ateliers without the benefit of individual recognition. In artisan practice, they were deeply affected by the influence that an imperial economy and industry wrought on traditional ways of life and their integration of art with cultural practices. By the end of the nineteenth century women were working in *zenana* (women's) photography studios. Art and architecture benefited from commissions from women acting as patrons in the royal courts.

Women's cultural history in India has traditionally been linked to caste and social affiliations. This directly affected their education and their engagement with ideas of humanism and modernity. Undoubtedly, women of privileged classes who enjoyed the benefits of a tradition of patronage or the fruits of a perceived modernity were at the apex of visibility. At the beginning of the nineteenth century there were no known institutions for women's education, and an entrenched ancient culture of defined gender roles acted as a powerful deterrent. Although the first women's colleges were introduced in the mid-1850s, many women of the upper castes continued to be educated at home and even by 1911, the number of literate women was just over 1 per cent as against 11 per cent in the case of men. The British administration

introduced four art institutions: in Bombay (1856), Calcutta (1854), Madras (1850) and Lahore (1879). By the latter part of the century women were participating in journalism and literature. Members of the Brahmo Samaj, a reformist sect initiated in Bengal, started a spate of journals to promote education and culture among women. These included the *Bamobodhini*, launched in 1863 and edited by Umesh Chandra Datta; *Mahila*, edited by Girish Chandra Sen; and *Bharati*, initiated by Dwijendranath Tagore and edited by his sister-in-law Swarnakumari Ghosal and her two daughters. The *Suprabhat* was run by two sisters, Kumudini and Basanti Mitra. These journals carried illustrations which offered women secluded in their homes their first introduction to a new experience in visuality.

Heated debates took place about the emancipation and education of women. The position of woman was contested by Hindu nationalists on the one hand, who spoke of a continued tradition of Hindu women from the Vedic era, and the British administration on the other, who urged reform and promoted women's rights in marriage, inheritance and in social discourse. The Brahmo Samaj took a strong position against purdah and the harsh distinctions of caste segregation. But women were not made partners in these debates; they were not allowed to decide whether women's health and inheritance rights were more compelling concerns than, say, widow remarriage. Women's education moreover remained broadly static.

THE STUDIO

Studio art practice in nineteenth-century India was an adjunct to the triad of the impulses in art for nationalist themes, strong interests in portraiture and the influence of Western academic art. The notion of woman as artist, however, was not new. There are references to queens as painters in *Abhignan Sakuntalam*, a play by Kalidasa, the leading Sanskrit poet of the fourth century. In addition, woman as artist was part of convention in *ragamala* miniature painting which flourished in the seventeenth and eighteenth centuries.[1] For example, a woman painting the image of her lover appears in *Ragini Dhanasri*, 'Taking a lovely drawing board she draws his picture in many forms, – Dhanasri – the great beauty with the loveliness of the blue lotus.' (Ebeling, 1973, 116) It has been suggested that in *Ragini Dhanasri*, the fact that the woman draws on a board, which allows for repeated erasure, suggests a preoccupation with art as serious study, rather than just casual engagement (Lyons, 1997, 113). Such painting flourished in north India through much of the eighteenth and early nineteenth centuries. The woman as artist who sits drawing, possibly with a group from the harem, is also the subject of a Mughal miniature now in the Benaras Hindu University collection (*c.* 1640), which suggests the presence of women artists at the

Mughal court. In the collection of the National Museum there is a painting of
a woman painter, identified as Bhakkan Jindi, who is depicted as one of a line
of painters from eighteenth-century Mewar. These may be isolated examples,
but they are not the only instances of women artists who worked in secluded
or familial spaces, possibly drawing on patronage routed through their male
relatives, or through women in power.

The first opportunities for more public participation opened up during
this century. Writing of the Calcutta Art Society exhibition of 1879, Partha
Mitter has noted 'The most remarkable feature of the show was the presence
of twenty-five women artists, most of them Bengali and married' (Mitter,
1994, 75). Women who had hitherto been bound by the strict laws of caste and
gender seclusion joined the political struggle through their male relatives.
Women artists usually followed in the footsteps of male relatives and while
the facility of the studio and a supportive family structure may have enabled
their participation and allowed their skills to flower, their artistic reputations
also came to be subsumed in the reputations of the more famous male artist,
often leaving little detail of their creative contribution to the atelier. In India,
distinctions between the studio and the atelier were subject to the pressures
of modernity. The studio implies ownership, and the usage of space by a
single person or at least those bound by social or familial bonds. Atelier has
a looser definition, simply because it may not imply individual ownership of
space, or more specifically a fixed space for the making of art works, or be the
site where an individual executed an autonomous work. In the Indian atelier,
some activities, such as the grinding of colours from vegetable or mineral
sources, may have been carried out by women, while men undertook the
drawing and painting: different parts of a painting would be completed by
different grades of artists, with specialist skills in painting animals, landscape
or borders, determined by their level within the hierarchy, while the main
figures in the image would be executed by the master artist. In the atelier
artists might have come and gone, particularly if the atelier belonged to a
community, a royal personage, or a religious organization.

Probably the first recorded woman artist of the nineteenth century who
worked within an atelier or a studio was Mangalabai Tampuratti (1866–1953),
sister of the most fêted Indian painter of the period, Raja Ravi Varma
(1848–1906). Rabindranath Tagore spoke of Ravi Varma's success in 'restoring
to us our inheritance', presenting to India images that constructed bridges
between an idealized Hindu past and the nation's present (Tagore, 12 May
1893, in Mitter, 1994, 218). Ravi Varma's success lay in his revitalization of
mythology, releasing Hindu icons from the constraints of convention-bound
sculpture, and lending them a fleshly sensuousness that was acceptable to
elite and poor alike. Mangalabai Tampuratti, by contrast, seems to have
tended towards portraiture. Despite her marital status and her

responsibilities in an aristocratic ruling family, she learned the art of oil painting and shared her brother's professional pursuits. Two pictures by Mangalabai Tampuratti – one on the subject of giving alms, the other, her well-known portrait of her illustrious brother Ravi Varma (Figure 3.1) which reveals her considerable skill, hang in the state museum at Trivandrum Kerala, while other works are in family collections.

Mangalabai is now a shadowy figure, known for assisting her brother in his highly publicized and successful career. There is no record of the status that she enjoyed in her brother's atelier, although she is occasionally mentioned in the diary of Raja Raja Varma, Ravi Varma's brother and his chief assistant. *The Diary of C. Raja Raja Varma with Historic Photographs* dates from 1895 to 1904 and covers the extensive travels and commissions undertaken by India's first professional oil painter. Raja Raja left a dogged, detailed account of their engagements with patrons, primarily the royal houses of Baroda and Travancore. According to the editors of the journal, Mangalabai Tampuratti also received training in painting from her uncle Raja Raja Varma. A rare photograph shows her in her old age still practising her art (Neumayer and Schelberger, 2003, 154). The extent of Mangalabai's contribution to Ravi Varma's substantial body of work can only be guessed. From the late 1880s to the early 1900s Ravi Varma was India's leading artist and he fulfilled numerous private commissions. It is perhaps safe to assume that he trusted his sister's painting skills because he involved her in two prestigious and challenging projects. In 1888 the Gaekwad of Baroda, Sayaji Rao, commissioned Ravi Varma to make fourteen mythological works from India's ancient epics, the *Ramayana* and the *Mahabharata*, as well as from the *Puranas*,[2] for the *durbar*, or court hall, in the new Laxmi Vilas Palace. 'Ravi Varma worked on the 14 Pauranic paintings of the Baroda commission in Kilimanoor and Mavelikara where his studio was at the second floor of Ulsava Madham Palace [sic]. His helpers were C. Raja Raja Varma as well as his sister Mangalabai Tampuratti and another assistant Kilimanoor Kunjan Varrier' (Neumayer and Schelberger, 174).

The selection of subjects for the Baroda commission is of considerable interest. It includes *Nala Damayanti, Shantanu and Ganga, Arjuna and Subhadra*, which are epic/Puranic narratives of love and separation, founded on Hindu ideals of heroism. Other paintings in this collection – *Keechak and Sairandhari, The Disrobing of Draupadi, Bharata and the Lion Cub* and *Sita Swayamvaram* – engage with the narratives of three epic heroines: Shakuntala, Draupadi and Sita. Leaders like Mahatma Gandhi, Rabindranath Tagore and Swami Vivekanand actively invoked these heroines of ancient India, models of rectitude and motherly devotion, during the nationalist struggle. For Tagore, 'The secret of their appeal is in reminding us how precious our own culture

RAJA RAVI VARMA (1848–1906)

3.1 Mangalabai Tampuratti, *Portrait of Raja Ravi Varma*, 136 × 63 cm, oil on canvas, 1907

is to us, in restoring to us our inheritance.' (Mitter, 1994, 218) Ravi Varma submitted ten paintings to the World's Fair in Chicago in 1893, several of which were painted at his maternal home at Kilimanoor, where he lived for twelve months to perform the *diksha* ceremonies, the customary period of mourning following the death of his mother's uncle. During this time he produced two large history paintings, both with groupings of more than ten figures – *The Brave Kurumavati* and *Draupadi at the Court of Virat* – as well as his well-known pictures, *Damayanti and the Swan* and *Shakuntala Assailed by a Wasp Calls the King to Help Her*. Mangalabai may well have assisted with the lucrative commission from the ruler of Mysore. From April to September 1905, Ravi Varma painted nine works for the Mysore commission at Kilimanoor. Significantly, these were done after his brother's death and when his own health was poor. The editors of the *Diary* note: 'Ravi Varma by that time suffered from an unsteady hand and his son and his sister were of great help during the work on the paintings' (Neumayer and Schelberger, 135).

Mangalabai's position in the structure of the feudal house of Kilimanoor was significant with regard to her practice as an artist. Her presence in her maternal home and her access to her brother's studio and the visual evidence from the paintings makes her participation in the Mysore commission highly likely. In the matrilineal line of Kerala, a daughter had assured access to her mother's home – even privileges that exceeded those of her brothers. Ravi Varma maintained an atelier in his mother's home at Kilimanoor and it is possible that Mangalabai assisted her brothers here. That Mangalabai painted commissioned portraits, particularly after Ravi Varma's death, points to a commitment to art beyond the immediate influence of her brother; indeed, she was much sought after as a portrait artist after Ravi Varma's death (Schelberger and Neumayer, 166). She was also instrumental in recording Ravi Varma's life, probably giving substantial amounts of information to his first biographer, N. Balakrishna Nair.[3]

The life and work of Mangalabai's successor in the line of women artists, Sunayani Devi (1875–1962) is much more thoroughly documented. Like Mangalabai, Sunayani Devi came to art through her illustrious brothers Abanindranath Tagore (1871–1951), the founder of the Bengal school, and Gaganendranath (1867–1938), maverick satirist and self-styled cubist who absorbed Western and Asian principles in his art practice. As a daughter of the powerful and artistically distinguished Tagore family, Sunayani Devi grew up in the family home of Jorasanko, which was a key centre in the Bengali Renaissance of the late nineteenth and early twentieth centuries. The Tagores actively participated in theatre, art, music and dance. According to Partha Mitter, during this period 'the traditional folkloric rhymes and idioms received a new lease of life and a modern form' (Mitter, 1994). Sunayani

Devi's contribution to visual art might be considered in a somewhat similar vein (Figure 3.2).

The Tagores were a family of social reformers, with a gift for creativity. Rabindranath Tagore acknowledged: 'Most of the members of my family had some gift – some were artists, some were poets, some musicians and the whole atmosphere of our house was permeated with the spirit of creation.' (Rabindranath Tagore, in Mitter, 1994, 272) The outer part of the family mansion in which Europeans were entertained for business contained oil portraits of the family, commissioned from visiting European artists and foreign *objets d'art* such as lacquer boxes and ivory pagodas. Indian pictures in 'Indian' materials, however, were to be found in the women's quarters: 'Women as upholders of traditional virtues performed the daily rituals of Hinduism which explains the sacred pictures in their quarters' (Mitter, 1994, 273). One of Abanindranath's aunts collected Calcutta Art Studio prints of the gods, traditional *patas*, or scroll paintings, and Krishnanagar clay sacred images that were reverentially kept in the *andarmahal*, or inner court (Mitter, 1994, 273). Abanindranath may have had access to these images, but his sister Sunayani Devi would have grown up among them. She is also likely to have been exposed to art from other sources, but those largely determined by the vision of the Tagore family. It is entirely possible that she was familiar with the Western-style oil portraits that hung in the *baithak khana*, or Indian-style drawing room, built by Dwarkanath Tagore. Her father dabbled in art and had trained at an art school. She was well aware of the different artistic directions taken by her brothers. Inspired by E.B. Havell, the English principal of the Government College of Art, Abanindranath had established what has come to be recognized as a *swadeshi*, or nationalist art, one that derived from Indian subjects and Mughal painting techniques. His belief in an indigenous art articulated with characteristic Tagore refinement dynamically influenced at least two generations of art practitioners from different parts of India who trained directly under him at the Indian Society of Oriental Art.

However, Sunayani Devi stands out not because of her degree of conformity to her male peers but because of her distinct pursuit of a personal vision. Although Abanindranath Tagore and the Bengal school would have been influential, her concerns were more mythic than historicist. In addition, she was inspired by the folk *pata* painting style, familiar to the women in the Tagore household. Her subjects include women at their toilet, dolls, players, actors and themes from the mythic *Radha-Krishna* cycle. A precursor of folk art in the fine art tradition, she anticipated the more full-blown realization of Jamini Roy (1887–1972). She also introduced a more *margi*, or heterodox element in an art practice that was seeking an exclusive identity.

Married at the age of eleven to the grandson of the social reform leader

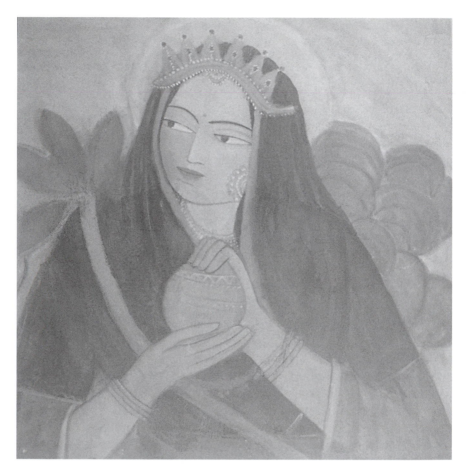

3.2 Sunayani Devi, *Milkmaids*, 34.2 x 33.5 cm, wash and tempera on paper, *c.* 1910

Raja Ram Mohun Roy, Sunayani Devi was self-taught. In an interview with Dwarikanath Chatterjee, when Devi was eighty-one years old, she recalled that,

I had seen my brothers paint and I wanted to paint like them, to soak the paper. I told my husband about my desire to paint. He was very happy. The next day he returned from the office in the evening with a small packet for me. My first colours, paper and brush had arrived. … As soon as my husband and children left the house I would take pencil and paper and start drawing. I was very shy so I made it a practice to hide these drawings before my husband returned.

She also spoke of her art as a sensuous evocation that grew partially out of her childhood experiences:

When I was a child I was greatly influenced by my aunt Kumudini Devi. She was an elegant lady. Every evening I would go to her room and watch her arranging her long lustrous hair. She was fond of birds and there were many in her room, from the walls hung paintings on mythological subjects. I particularly admired the paintings by Ravi Varma. (*Sunayani Devi: A Pioneer amongst Indian Women Painters*)

Her daughter-in-law, Manimala, whom she taught to paint, recounted how this family matriarch would paint surrounded by the women of the household, as they chopped vegetables and attended to the family cooking. Sunayani's paintings were widely known, and published in vernacular Bengali journals. Her significance lies in welding myth to folk art and sidestepping the high moral ground of the Bengal school.

Sunayani Devi's art is rooted in a broader cultural context. Sumanta Banerjee has noted that the Bengali *bhadralok*, or Western-educated elite of Bengal, wanted to discourage their women's contact with Vaishnava singers and performers. However, the revival of Vaishnavism in the second half of the nineteenth century was profoundly influential. Very often for women in the *andar mahal*, the conduit for contact with the outer world were lower caste women, particularly those of the barber caste who attended to the nails or painted the feet, and maids and singers and the sellers of fish and vegetables. These women were like unlettered artists who kept alive a vivid oral tradition of narrative and song, predominantly around the cycle of festivals and rituals. The followers of Vaishnavism opened 'their arms to those who are rejected by all others – the outcasts, the crippled, the diseased and the unfortunate.' (The Census of India, Bengal 1872 quoted in Banerjee, 1993, 134). Vaishnavism permeated the culture of the village, the city street and the *andar mahal* of the *bhadralok*, or upper-class women. In the Tagore household, Swarnakumari Devi, the elder sister of Rabindranath Tagore, described how all the children were taught to read and write by an elderly Vaishnava woman in a tradition that was current at that time, even though the singers were eventually banned from the family home because of the erotic content of their songs (Banerjee, 1989, 151–4). Sunayani Devi's strong preference for Vaishnava themes – the milkmaids of Vrindavan, Radha and her companions – belongs within this learned and valued tradition, one that had been absorbed in childhood even in a Brahmo household.

WOMEN IN ARTISANAL PRACTICE

Perhaps the most difficult history to map is the presence of women in the artisanal sector. In *Company Paintings: Indian Paintings of the British Period*, Mildred Archer explains artisanal traditions: 'artist families in places such as Tanjore, Trichinopoly, Delhi, Murshidabad, Patna, Calcutta, Benaras and Lucknow all produced paintings of subjects of local styles and hawked them

around the British stations or sold them to travellers at well known halting places on the rivers' (Archer, 1992, 17). She reproduces images of women of the artisanal class which show them as equal participants in their family trade.

Company painting, as the name implies, was usually executed by Indian artists for British patrons who were serving with the East India Company. A distinct body of works within the India Office Library Collection concerns India's craftsmen and women, and artisans. Traditional artists in India belonged to the artisanal class (like masons or basket weavers or carpenters) who were often educated in traditional religious texts, which they would inscribe on illustrated manuscripts. In the context of Pahari painting (from *pahar*, literally hill), or painting executed in the Punjab hills in northwest India, the role of women is suggested by the marital connections between families of painters. The fact that a school of painting was controlled and determined by hereditary lines must have had a profound influence on the desire to maintain distinct identities. There is a strong possibility that women, as carriers of knowledge and closely guarded secrets, had a powerful impact on artisanal painting. 'It can be assumed that inter-marriage took place among the painter families from various places in the hills. A position like this could have resulted in changing the style of painting to some extent' (Ohri and Craven, 1998, 13). Goswamy and Fischer, who have studied family records to reconstruct these genealogies, write

Occasionally one comes upon references to a painter's grandmother coming from another artist family or a daughter visiting a centre of pilgrimage and bringing for immersion the ashes of her father and father-in-law, both painters. Oral tradition among painters living today generally insists on 'family secrets' of painting not being passed on to the daughters, for fear that these would then be available to the painter's families into which they married. But it is difficult to imagine the daughters being left out of the process of painting completely as they helped greatly in the grinding of colours, some of these 'family secrets' must have been known to them.' (Goswamy and Fischer, 1992)

Some of the evidence suggests that women did rather more than just grind colours. The miniature of a woman painting a group in the open air (Mughal, Bharat Kala Bhavan) or the identification of Bhaktian Jindan as a woman painter in Mewar (National Museum collection) are important pointers to lines of continuity among women. Tryna Lyons describes the tradition among women painters of artist families in the temple town of Nathdwara in Rajasthan. These women paint 'sceneries' or imaginary landscapes, a tradition that is documented back to women artists in Nathdwara in the early decades of the twentieth century, and may well have extended still further back. Clearly these women shared in the same work as their male relatives (Lyons, 1997, 102–23).

The presence of women in the household of the Pahari artist or the

Nathdwara painter is no longer a matter of conjecture. Yet the economic deprivation brought about by the break-up of village societies in the nineteenth century directly affected the artisanal structures of India. The importation of chemical inks and dyes, mechanical presses and photographic processes directly affected Indian artisans engaged in traditional forms of production in weaving, printing and painting. As Indian/indigenous trade could not compete with escalating British imports, well-established patterns of patronage, particularly for music, dance and the arts declined. Traditionally, women told stories of village life and cyclical myths through embroidery, or even wall-painting. Some of these arts were lost; others have been revived in the twentieth century.[4] The histories of women artists in artisanal practice remain frustratingly elusive, however. To what extent did traditionally defined social roles allow women self-expression, even within artisan's families? Did the home-based studio occlude women's practice? With the passage of time, the absence of records and oral testimonies makes this information more and more tantalizingly distant.

WOMEN IN THE *ZENANA* STUDIOS

An important change in the representation of women coincided with the arrival of photography in the subcontinent in the 1840s. Photography served the Indian middle class well as it provided a means of self-representation beyond the more elite genre of oil portraiture. Photography historian Sabeena Gadihok explains the conditions that women photographers initially experienced:

Professional photography especially in early years required patronage or a considerable economic investment. It also demanded certain physical mobility in terms of travel or access to professional societies. In early years most women including those who qualified as 'professional' would have photographed in spaces less visible than those occupied by male photographers. (Gadihok, 2003, 37)

As photography gained in popularity, it entered the domain of the *zenana*, or women's quarters. Hindu and Muslim women in *purdah*, or seclusion, could not be photographed by men. Lala Deen Dayal (1844–1905), a pre-eminent nineteenth-century Indian photographer, opened the first *zenana* studio (for women only) in 1892 in Hyderabad because male photographers like himself had to be veiled to enter the women's quarters (Worswick, 1990, 9). When Lieutenant James Waterhouse photographed the Begums Sikander Jehan and her daughter Shah Jehan in Bhopal in the early 1860s he elaborately covered his face before viewing his subjects through the lens (Gadihok, 38). Lala Deen Dayal's *zenana* studio, with its high walls and ensured privacy, employed

foreign and Indian women photographers and technicians for its women clients.

By the end of the century, Bengali women began to take photographs. A *Mahila*, or women's art studio, run by Sarojini Ghosh was mentioned in the journal *Amrita Bazaar Patrika* in 1899 (Gadihok, 38). Raja Ravi Varma was the first Indian painter to work with photographs to produce portraits of elite Indians. In his diary, his brother Raja Raja Varma refers to an Italian photographer who ran her own studio: 'This evening we visited the photo studio of Miss Sabina a pleasant looking young Italian lady who has opened her studio at Chudder Ghat.' (7 February 1902) The Siddharth Ghosh collection records the contribution of Indian women photographers like Annapurna Dutta (1894–1976), who became a professional photographer at the age of twenty-five. She worked from within her Calcutta home, doing her own printing and working on commissions from families where the women were secluded, especially the Muslim elite, such as members of the family of Hasan Suhrawardy, poet Jasimuddin and singer Abbas Uddin.

WOMEN AS PATRONS OF ARCHITECTURE

A history of women as patrons of architecture in India has yet to be written. However, from the Gupta period (fourth to sixth century CE) onwards women's patronage is well documented in different parts of the subcontinent. In the tenth century Sembiyan Mahadevi, aunt of the Chola ruler Rajaraja Chola (r.985–1018 CE) devoted a lifetime to temple building, even exceeding the great Chola rulers with the extent of her patronage.[5] Sembiyan Mahadevi's patronage was multidimensional; she commissioned new stone temples, renovated old brick temples in stone, initiated a high level of bronze casting of icons for worship, and made generous gifts of lands, livestock and jewellery to temples (Venkatraman, 1976). In the Chola era the temple was a self-sufficient social unit, often like a small town enclosed within walls, and Sembiyan Mahadevi's contribution in this vision was significant.

During the Mughal era (sixteenth to nineteenth centuries) the practice of commissioning monuments received a fillip through the efforts of Emperor Humayun's queen Haji Begum. She constructed Humayun's tomb in Delhi, a structure in red sandstone and white marble that anticipates the Taj Mahal. Completed in 1565, it owes its exquisite design to the Begum's choice of a Persian architect, Mirak Mirza Ghiys. The double-storeyed Khair ul Manzil (1561–2), a *madarsa*, one of the early seminaries of the Mughal era, which still stands opposite the Old Fort was built by Humayun's heir, Akbar's wet nurse. The famed empress Nur Jahan, whose power exceeded even that of her husband the Emperor Jehangir, built at Agra the tomb of her father

Itmad-ud-daulah in 1626. Made entirely of white marble, it is probably the first Mughal building to make such extensive use of *pietra dura* and it is embellished with delicate fretwork. Nawab Qudsia Begum, a dancing girl in the royal harem, whose son Ahmad Shah (1748–54) was Mughal emperor, built a large garden on the banks of the River Yamuna that flows through Delhi, and commissioned the Sonehri Masjid, or Golden Mosque (Figures 3.3 and 3.4) in 1751. Standing in the garden of the palace, this distinctive mosque gains its name from its three domes, which were gilded with copper.[6] Significantly, some one hundred years later the mosque was deemed worthy of restoration by the last Mughal emperor Bahadur Shah, and was repaired in 1852.

This tradition of commissioning monuments of remembrance or piety continued well into the nineteenth century. Here, however, women's contribution should be seen in the context of the domination of the East India Company, as well as in the rising tide of nationalism. One conspicuous figure in the early nineteenth century was Begum Samru, who maintained a standing army, governed a small township at Sardana in north India, and ran her estates with an iron hand. Originally a dancing girl, she had first married a Frenchman known as Le Sombre (hence Samru) and then later the German adventurer Walter Reinhardt. Having converted to Catholicism, she commissioned the building of an imposing cathedral in 1822. She built a palace in Delhi's Chandni Chowk area – now the State Bank of India but used for storing gunpowder during the uprising of 1857. She also built a presbytery and a Catholic church for the British soldiers in Meerut in 1834.

Several women rulers followed in the footsteps of their male relatives. In the northern Shia Muslim kingdom of Avadh, or Lucknow, the commissioning of Imambaras was a favoured activity. (Imambara literally means the seat of the Imam: the building of such a structure was seen as an act of piety.) Shia architecture and design owes much to Iranian inspiration and is distinct from the more dominant Mughal style of the north. The Imambara of Mughal Saheb, a structure that employs beautiful stucco work, was built by Fakhrunnissa Begum. More unusually, Bahu Begum, the wife of one of the last rulers of Avadh, Shujaddaullah, left a sum for the construction of her own tomb. Built at Faizabad in 1816, the monument is currently in a state of neglect but it is an extraordinary mausoleum in marble, with a marble sepulchre 140 ft high.

But perhaps the Begums of Bhopal are the most extraordinary as regards the history of women's role in Indian architecture. They virtually ruled this central Indian state in a matrilineal line for much of the nineteenth century. Led by Qudsia Begum (1801–1881), who took control of Bhopal three days after her husband's death in 1819, the Begums modernized Bhopal, and built

3.3 Sonehri Masjid (Golden Mosque), commissioned by Nawab Begum Qudsia in 1751

edifices that exceeded in size and splendour anything anywhere in the subcontinent.

A devout Muslim, Qudsia Begum built the Jamai Masjid in Bhopal (1857) which, with its distinctive gold spikes atop minarets, resembles the grand mosque in Delhi, the crowning monument of the emperor Shah Jahan's sacred buildings. She paid for lodgings for poor pilgrims travelling from Bhopal to the holy cities of Mecca and Medina to enable them to make the *hajj* in relative safety and comfort. Qudsia Begum was also responsible for building public *sarais*, or hostelries and administrative buildings in her state. Qudsia's daughter, the formidable Sikander Begum (r.1847–1868) restructured Bhopal's administration, revitalized the state's depleted finances and built the Moti Masjid, or Pearl Mosque, in 1860. Shah Jahan Begum (1868–1901) exceeded her mother and her devout grandmother by building the Taj-ul Masjid, or the Crown of Mosques, in the late nineteenth century. The largest mosque in India, it surpasses the great mosque at Fatehpur Sikri, built by the Emperor Akbar. Its pink stone structure, two white-domed minarets and three distinctive domes dominate the Bhopal skyline. Assuming power in her mother's lifetime, she also built a palace

3.4 Sonehri Masjid (Golden Mosque), commissioned by Nawab Begum
Qudsia in 1751

called the Taj Mahal, and modernized Bhopal's railways, waterworks and
postal system. This spurt of late nineteenth-century building continued when
most states in India had ceded to British control, and marks the hard-fought
victory of the Begums of Bhopal to administer their own property.

This brief account of building commissioned by nineteenth-century Indian
women is by no means complete. In some cases it points to the division of
patronage between rulers and their consorts according to secular or religious
favour. This was a pattern that had existed in Hindu kingdoms from the
Gupta period onwards. In other cases what is notable is the evidence of a
distinct design sensibility at work, the shift to architecture on a smaller and
more intimate scale perhaps, but with distinctive elements of design.
Through such large-scale commissions the Begums of Bhopal demonstrated
financial might and piety. By engaging in both sacred and secular
architecture, they interjected the power of woman as sovereign into a
traditionally patriarchal sphere. Through their large-scale commissions the
Begums challenged the image of woman's patronage of architectural
structures as delicate, personal or familial.

Women artists and patrons in nineteenth-century India exemplify many of the conflicts and vicissitudes of a nation in flux. The introduction of new media, chemical inks and mechanical reproduction by the 1840s altered the nature of art practice in India forever. In the words of Partha Mitter, 'it signalled the death of traditional art and the coming of age, of a new West-inspired one. And with the new art came a new class of artists – the artist as gentleman' (Mitter, 1992, 278). As courtly culture declined, traditional artists, and by extension their families, were compelled to shift to urban centres, to bazaar and company painting, or were obliged to make a complete break with their cultural heritage. The Great Exhibition of 1851 and the foundation of four art schools by the British in different cities of the subcontinent transformed art education into a formal, urban and an increasingly upper-class phenomenon. As women's presence in artisanal practice declined, so educated elite women had opportunities to enrol in art classes, display work in salons or experiment with new media. Women's art underwent profound changes, both in the decorative or domestic arts – of embroidery for wedding or ritual garments or painting and decoration of prayer objects – and in their use of paper, canvas and chemical paints and processes. By the end of the century the visual field was preparing for the accommodation of women in positions of prominence in the arts, new media and the cinema of modernity.[7]

References

Sunayani Devi: A Pioneer amongst Indian Women Painters, National Art Academy of India.

Archer, M., *Company Paintings: Indian Paintings of the British Period*, Ahmedabad: Mapin (in association with the Victoria and Albert Museum), 1992.

Banerjee, S., 'Women's Popular Culture in Nineteenth Century Bengal', in Sangari, K. and S. Vaid (eds), *Recasting Women: Essays in Indian Colonial History*, New Delhi, 1993.

——, 'Marginalization of Women's Popular Culture in Nineteenth-Century Bengal' in Sangari, K. and S. Vaid (eds), *Recasting Women: Essays in Indian Colonial History*, New Delhi, 1989.

Chola, D. E., *Early Cola Architecture and Sculpture 866–1014 A.D.*, London: Faber, 1974.

Chatterjee, K., *Sunayani Devi: A Pioneer amongst Indian Women Painters*, Rashtriya Lalit Kala Kendra exh. cat., University Women's Association, 1977.

Ebeling, K., *Ragamala Painting*, Basel: Ravi Kumar, 1973.

Embree, A. and C. Worswick, *The Last Empire: Photography in British India, 1855–1911*, Millerton, N.Y.: Aperture Books, 1976.

Gadihok, S., 'Looking Back at Women Looking: Early Photographic Practices of Women in India', *Visual Arts Gallery Journal*, **3**, 2003.

Ghosh, S., *Chhobi Tola: Bangalir Photographic Charcha* (Talking Pictures), Calcutta, Ananda Publishers, 1988.

Goswamy, B. N. and Eberhard Fischer, *Pahari Masters: Court Painters of Northern India*, Zurich: Artibus Asiae Publishers Supplementum, **38**, 1992.

Khan, S. M., *The Begums of Bhopal: A Dynasty of Women Rulers in Raj India*, London: 2000.

Lyons, T., 'Women Artists of the Nathdwara School', in V. Dehejia (ed.), *Representing the Body: Gender Issues in Indian Art*, New Delhi: 1997.

Mitter, P., *Art and Nationalism in Colonial India 1850–1922: Occidental Orientations*, Cambridge: Cambridge University Press, 1994.

——, 'The Status and Patronage of Artists c. 1850–1900', in B.S. Miller (ed.), *The Power of Art: Patronage in Indian Culture*, Delhi: Oxford University Press, 1992.

Neumayer, E. and C. Schelberger, (eds), *The Diary of C. Raja Raja Varma with Historic Photographs*, Vienna, n.d.

——, *Popular Indian Art: Raja Ravi Varma and the Printed Gods of India*, New Delhi: Oxford University Press, 2003.

Ohri, V.C. and R.C. Craven, Jnr, *Painters of the Pahari Schools*, Delhi: Marg Books, 1998.

Rajadhyaksha, A and P. Willeman, *Encyclopaedia of Indian Cinema*, Delhi: Oxford University Press, 1999.

Venkatraman, B., *Temple Art Under the Chola Queens*, New Delhi: 1976.

Notes

1 Ragamala painting is a tradition of miniature manuscript illustrations that flourished in the seventeenth and eighteenth centuries. Here, ragas and raginis, (male and female) musical compositions, are depicted pictorially.

2 There are eighteen major Puranas and eighteen minor Puranas believed to have been written between the fifth and the twelfth centuries. These contain genealogies of kings and mythic narratives.

3 The biography was written in Malayalam, the principal language of the South Indian state of Kerala.

4 Between 1814 and 1835 British textile exports to India rose from one million yards to thirty-one million yards. Women's role in the artisanal sector shrank; their presence in the 'modern' sector of industry, the new crops of jute, tea and indigo, was negligible. The transmission of knowledge of medicines, plants and songs among women who had worked among traditional crops, from the seed to the harvesting stage, declined.

5 Douglas Barrett in *Early Cola Architecture and Sculpture*, 1974, lists the temples that she commissioned and patronized over a sixty-year period.

6 They were later repaired by the last Mughal emperor Bahadur Shah Zafar in 1852.

7 Amrita Sher-Gil is widely acknowledged as the first 'modern' Indian artist to be trained at the Ecole des Beaux-Arts (1929–34). Subsequently she returned to India to make a significant body of work. Fatma Begum, India's first woman film producer, started her production company in 1925, and made her debut film directional venture, *Bubul-e Parastan* in 1926. In the next few years, other women followed as directors and producers of films (Rajadhyaksha and Willemen, *Encyclopedia of Indian Cinema*, 1999, 19).

Harem portraiture: Elisabeth Jerichau-Baumann and the Egyptian Princess Nazli Hanım*

Mary Roberts

I had promised to show Nazili Hanum [my] pictures … It was an exhibition of a particular kind. Two and two the often pretty female slaves held each of the rolled out paintings; the small paintings were in frames. I think that this way of exhibiting would even have created a sensation in Paris which is overfilled with paintings, there they would have possibly found the live easels more interesting than the pictures themselves, and they would especially not have noticed the pictures for the beautiful princesses of the harem who admired them. Here however it was the other way around. Here it was the first time that man's artistic imitation of the human face and of all the phenomenal appeared to these beautiful harem eyes. It was such a naïve, quite primitive, uncritical admiration that was given to my work. One of the ladies … tried to touch a piece of painted golden jewellery, another touched the silk dress of the portrait of the Princess of Wales, that was of special interest to those who had met her during her stay in Constantinople. Thereafter it was pictures of my three blonde daughters that pleased them. These … and a little girl from the Island of Amager … [were] passed from hand to hand and from mouth to mouth and … kissed, and this latter painting became the favourite of the harem, just as another painting representing an Italian mother breastfeeding her child. (Jerichau-Baumann, 1881, 23)

When Elisabeth Jerichau-Baumann entered Mustafa Fazil Paşa's harem in November 1869 her ambitions were more unusual than the myriad other European lady travellers who visited harems in Istanbul during the same period. The artist's intention was to persuade the senior harem princesses to grant her permission to paint the young princess Nazli Hanım, and she proceeded with characteristic determination, undeterred by the unusual nature of her request (Jerichau-Baumann, 20). It was this motivation that lay behind the artist's unprecedented step of bringing with her into the harem a range of her portraits and subject paintings to display for Nazli and the senior women of the harem hierarchy. The painter approached this improvised harem exhibition with a mixture of fascination and anxious

* Throughout this chapter the modern Turkish spelling of Hanım is used, except in nineteenth-century quotations.

anticipation. Much hinged on the response of the harem princesses whose imprimatur she was seeking. Inside the harem, these senior women had the authority to grant or to deny what the artist most desired, the harem portrait sitting. Yet, at this moment of intimate encounter, inside Mustafa Fazil Paşa's harem, the authority of the Western orientalist was provisional, her achievements were as yet uncertain.

Jerichau-Baumann recorded this encounter in her travelogue, published a little over a decade after the portraits had been painted. It was retrospectively cast in such a way as to suggest the entanglements of the Western orientalist's gaze and the alternative priorities of the harem princesses. Humorously recounting the unusual conditions of display of her art inside the harem, Jerichau-Baumann positioned herself as a proxy for her Parisian audience, anticipating their fascination with the harem princesses whose beauty was so dazzling that it even eclipsed a fascination for the slave girls, who acted as 'human easels'. Jerichau-Baumann's authorial priority is established by this invocation of her imagined Parisian audience: the artist is intermediary, fascinated and enchanted, turning the harem women into an exotic spectacle for her readers' delight. Her text also registers another set of priorities, those of the harem women, and with it the Ottoman cultural context for the reception of European art that has to date been absent in the study of nineteenth-century women's orientalism (Lewis, 1995 and 1996). Through a study of Jerichau-Baumann's harem portraits and the range of other harem images they inspired, this essay will address both the Ottoman and European contexts for their reception and their shifting meanings as these paintings crossed cultural boundaries from Istanbul to London. The introduction of Elisabeth Jerichau-Baumann's harem portraits into the study of harem paintings extends the parameters of the genre by prompting a consideration of the role of cross-cultural exchange in the production of these paintings and brings into view the sitter's priorities in choreographing her representation.

'THE STAR OF MY ORIENTAL DREAMS'[1]

Jerichau-Baumann had both aesthetic and financial motivations for visiting Istanbul and Cairo in 1869. Travel to the Ottoman Empire presented the prospect of both exotic subjects for her art and lucrative portrait commissions.[2] Before embarking on her trip, the East must have seemed particularly promising because, as a woman, Jerichau-Baumann had unique access to the secluded harems. As it did for so many other Europeans, however, the experience of travel in the Ottoman Empire not only fuelled her fantasy, it also provided distinct challenges to it. While excited at the prospect of visiting harems, what Jerichau-Baumann encountered inside them presented a profound challenge to the exotic stereotype of these forbidden

realms. She witnessed harems in a process of profound social change resulting from selective Western influence and many of the women she met made demands upon her that were contrary to her expectations. In this respect her encounter with Princess Nazli was exceptional because it sustained the artist's fantasy of the harem, while in the process significantly reconfiguring its characteristics.

Danish royal connections facilitated Jerichau-Baumann's painting in Istanbul and Cairo. When the artist first visited the two cities in 1869 she took with her letters of introduction from the Danish Princess Alexandra (the Princess of Wales). Jerichau-Baumann had come to know Princess Alexandra through her role as portraitist to the Danish royal family. Princess Alexandra had visited the Ottoman Empire with the Prince of Wales on their grand tour in early 1869. In Egypt they met Khedive Ismail and visited the Suez Canal with Ferdinand de Lesseps. In Istanbul they met the Sultan Abdülaziz and senior dignitaries of state. Princess Alexandra visited the Valide Sultan (the Sultan's mother) and his wife at the Dolmabahçe Palace harem and was entertained by Mustafa Fazil Paşa's daughters at his yalı on the Asian shore of Istanbul (Grey, 1869; Russell, 1869). Princess Alexandra's letters of introduction facilitated Jerichau-Baumann's entry into these highest levels of elite Ottoman society, where she met Mustafa Fazil Paşa's daughter Princess Nazli.

Of all the harem women Elizabeth Jerichau-Baumann encountered during her travels it was Princess Nazli who held a special significance. In her letter to her husband and children on 19 November 1869 she wrote: 'Yesterday I … fell in love with a beautiful Turkish princess Mustafa Fazil Pasha's daughter, niece of the viceking of Egypt.'³ Nazli became the cynosure for her fantasy of Oriental beauty. Describing her first encounter in her travelogue, she wrote:

[when the door to the reception room opened] there – appeared the star of my Oriental dreams. It was Nazili Hanum, the Khedive's niece, who quietly and with dignity stood up from the richly decorated Turkish ottoman … The precious carpet was thick, soft and elastic like the moss of the forest; on a low, richly inlaid table there was one of the most precious French Sèvres vases I had ever seen, again a mix of Oriental and Parisian luxury; the same was also the case for the way the Princess was dressed. Nazili Hanum was then 15 years old, but quite grown up. She was a strange mix of Oriental and European influence. Thus her movements were rounded, soft, elastic, slow and yet as sneaky and powerful as a panther's movements. Her elongated almond-shaped black fringed eyes were light blue, languishing and wild with very big black pupils and this same eye could burn and throw sparks while she listened to what I told her … In Nazili's dress the influence of Parisian fashion was clearly traced; with a black dress in silk grenadine, embroidered with coloured silk flowers that only just hid the wide harem pants that apparently had modified the Paris-cut of her dress. Her tasteful, light turban, decorated with three yellow feathers, and her long dark silk veil … embroidered

with gold and coloured silk and fringes in gold … surrounded her fine face, that was enclosed in waves of her well-kept hazelnut – blonde hair which loosely fell down her shoulders and surrounded her velvety cheeks without any makeup to disfigure them. The mouth was exceptionally small … During this my first visit I received a very positive impression of this interesting young creature, [of her] loving grace, female dignity and Oriental 'prestige' … This, combined with a thorough European upbringing, was however not completely able to eradicate the Turk in her and gave her a divine, enchanting appearance, and this creature, so clean and yet so glowing, had been raised in a harem (Jerichau-Baumann, 22).

This remarkably sensual description of Nazli is evidence of Jerichau-Baumann's investment in a harem fantasy and an example of the citational nature of orientalism; what Jerichau-Baumann sees and experiences upon meeting Nazli is recognized through pre-existing ideals of the odalisque of Western fantasy. And yet there is also a transformation of the fantasy. For Jerichau-Baumann, Nazli's appeal resides in a combination of seemingly contradictory attributes: she is both languishing, wild, panther-like, enchanting in appearance and yet dignified, graceful and genteel in her manners. For Jerichau-Baumann, Nazli is an ideal synthesis of European and Oriental influence in both dress and upbringing.[4]

In Jerichau-Baumann's text a discourse of desire is enmeshed within a discourse of social progress. The artist's perception of Nazli as her harem ideal is premised on a set of distinctions between this Egyptian Princess and the other women of Mustafa Fazil Paşa's harem and ultimately a condemnation of the harem system for stifling the young princess. Jerichau-Baumann's derisive account of Nazli's mother, Bukana Hanım, operates as a foil highlighting Nazli as the exemplary modern harem woman. The artist's account of Bukana Hanım's rudeness during their first meeting forms a striking contrast to Jerichau-Baumann's first impressions of Nazli's gentility. She wrote: '[Bukana Hanım] felt our clothing, smoked cigarettes and for the occasion made comments in Turkish which offended those who understood them.' (Jerichau-Baumann, 22) Nazli's fluency in several European languages and her fascination for European culture is contrasted with her mother's illiteracy in her own language; her misguided efforts to speak a few words of English; and her adherence to so-called traditional 'superstitions'. These differences in education and attitude towards European culture can be understood in terms of generational differences in Ottoman harems in a period of momentous social change (Davis, 1986; Mardin, 1974; Şeni, 1995; Leyla (Saz) Hanımefendi, 1995). However, for Jerichau-Baumann, such distinctions are apprehended through the prejudicial filter of her orientalist values in which Ottoman traditions are equated with superstition and prejudice, and this strategy of contrasts serves to highlight Nazli as an ideal.

Jerichau-Baumann's feminine fantasy is premised on a notion of the pure

beauty of Nazli and again this is established by negative reference to the lewdness of her mother and the immorality of the harem system. The opinionated artist was left speechless when Bukana Hanım drew her attention to the 'eunuch-qualifications' of her cat whom she called her 'favourite'. She was similarly offended by what she construed as an indelicate song about a Persian painter that was sung in her honour, which was,

not at all suited for polite, sensitive ears ... it is easy to see that the habits of the harem are not suitable for blushing maidens; yet Nazili Hanum has escaped so pure and untouched by these surroundings, so that one must consider her as someone who, if placed in a proper position of progress, could regenerate the unhappy position of the Oriental woman. (Jerichau-Baumann, 25)

In Jerichau-Baumann's travelogue Nazli emerges as a victim of circumstance, constrained by the weight of tradition within the harem system. Nazli's European education which, according to Jerichau-Baumann, raised her expectations for liberty, assumes a tragic cast because of her continuing entrapment within the harem. Despite her faith in Nazli as a model of social progress, Jerichau-Baumann stops short of endorsing other advocates for social reform that she met inside the harems of Istanbul. Neither is Jerichau-Baumann's view consistent with feminist orientalism of the same period where the Eastern seraglio is often invoked as a pretext for critiquing domestic relations at home (Zonana, 1993; Cherry, 2000). Reflecting an attitude that is consistent with her distaste for feminism in Europe, Jerichau-Baumann dismisses aspirations for reform as entirely misguided. Rather than reconciling her praise for Nazli with any call for general social reform, instead Jerichau-Baumann's individualism, which colours her attitude to harem life, is channelled towards her artistic aspirations. Reinterpreting a familiar orientalist theme of cloistration, Nazli emerges as the perfect hybrid of European education and Oriental beauty, a pure beauty heightened by tragic circumstance because of her entrapment in her gilt cage – an ideal subject for Jerichau-Baumann's art.

From her first meeting Jerichau-Baumann was enchanted by the fifteen-year-old princess and was determined to be able to paint her portrait. In order to achieve what she desired the artist sought permission from Nazli's parents and after several visits it was granted. Portrait painting was rare in Islamic cultures because of the traditional prohibition of figural representation. There were, of course, notable exceptions, including the traditions of portraiture in the Ottoman and Persian courts, and portraiture was to become increasingly popular amongst the Ottoman elites in the nineteenth century (Gîray, 1995, 185). Female portraiture was more unusual, given the law of the veil which prohibited the public visibility of Islamic

harem women. So why was permission granted in this instance? In answering this question it is crucial to consider the social and family milieu in which Nazli was raised.

Princess Nazli was part of the Muhammad Ali dynasty, her father Mustafa Fazil Paşa was the disaffected brother of Khedive Ismail.[5] During his 'exile' in Istanbul, Mustafa Fazil Paşa was one of the most prominent members of the social elite, colloquially known as the 'Egyptians', who were renowned for their openness to Western culture. Like a number of the men of the ruling Egyptian family, he had studied in France as a young man and was a vocal proponent of modernization. In the restructuring of the Ottoman state, in the Tanzimat period Nazli's father was a prominent advocate of Western-style political reform as a solution to the Ottoman Empire's beleaguered situation. His commitment to reform was most famously evident in his *Letter addressed to Sultan Abdülaziz* (published in 1867 while he was resident in Paris), in which he advocated Constitutional government for the Empire (Mustafa Fazil Paşa, 1867; Russell, 1869; Kuntay, 1944; Tugay, 1963; Özel, 1985; Davison, 1986; Süreyya, 1996). Mustafa Fazil Paşa's liberal political views were matched by social liberalism: he opened the first gentleman's club in Istanbul in November 1870 which, contrary to strict Islamic values, permitted gambling. Mustafa Fazil's house on the Asian shore in Kandilli became well known for its political and literary meetings as well as its garden parties and masked balls, to which the aristocratic elite, foreign dignitaries and their wives were invited (*Dünden Bugüne İstanbul Ansiklopedisi*, 1995, vol. 2, 464 and vol. 3, 172). Mustafa Fazil Paşa entertained the Prince and Princess of Wales during their visit in 1869 and was friends with Napoleon III. His liberal views extended to his family life, including the way that his daughters were raised. Two of his daughters, Nazli and Azize, had European governesses; they spoke French and English fluently and were given an unusual degree of liberty for Muslim women of their era (Tugay, 111). Considering the relatively liberal views of Mustafa Fazil Paşa, it is not surprising that he should consent to his daughter's portrait being painted.

However, permission to paint was not granted immediately: several visits and a careful process of negotiation had taken place, through which trust was established between the artist and the senior women of the harem. In Ottoman harems, especially those of the elite, considerable power was vested in senior female members of the household and matriarchal elders had authority over both young men and women in the family.[6] In Jerichau-Baumann's travelogue the exercise of matriarchal authority is registered as a barrier to the artist's desire to paint the young princess, and Nazli is portrayed as her co-conspirator in a shared mission to achieve the sittings. Jerichau-Baumann characterized the successful conclusion to her

negotiations with Nazli's mother Bukana Hanım by stating, 'the plan worked, the fortress was surrendered.' (Jerichau-Baumann, 24)

As the sittings proceeded Nazli was fascinated with the process of painting, often sitting next to the painter and watching her at work, whereas her mother remained wary of these portraits of her daughter. Jerichau-Baumann wrote that Bukana Hanım was quite frightened by the result of her work and reported to the other Turkish women that, 'The stranger has stolen the eyes and soul of my daughter' (Jerichau-Baumann, 24). This contrast between Nazli's fascination with easel painting and her mother's grave reservations is indicative of the differing beliefs in the power of the figurative image within Ottoman culture in this period. This interchange suggests that liberal views were not uniformly held in the households of the Islamic elites open to Western influence. However the Western orientalist painter curtly dismisses Bukana Hanım's reservations as resulting from ignorance and superstition.

Three portraits of Nazli were produced from these sittings. The first portrait of Nazli, as Jerichau-Baumann first encountered her, in her hybrid mix of French and Ottoman clothing, was given to the Princess of Wales (Jerichau-Baumann's patron and Nazli's friend). The second portrait of the Egyptian princess depicting her, as Jerichau-Baumann characterized it, in her 'true harem costume', the artist was permitted to keep. This gift seems fitting, given Jerichau-Baumann's preference for reiterating exotic dress in her later harem fantasy paintings produced once she had returned to Europe. The third portrait, 'with her hair let down, her eyes turned up just like an angel', was presented to Nazli (Jerichau-Baumann, 24). Another painting exchanged hands in this harem: a miniature of the Princess of Wales was presented as a gift to Nazli. At this stage, or perhaps during her second visit in 1874–5, Jerichau-Baumann was given a *carte de visite* by Nazli, which remains in the collection of the artist's family in Denmark (Figure 4.1). This is a striking photograph of an elegant, worldly young woman. Like other Ottoman women of her elite social standing in Istanbul, Nazli wears the latest Parisian fashion.

The two portrait paintings of Princess Nazli that Jerichau-Baumann took with her from the harem were exhibited at the New Bond Street Gallery in 1871. They were hung alongside her Norse mythological paintings, sentimental depictions of children and her canvases from recent travels to Greece, Turkey and Egypt (including a portrait of the Queen of Greece). This was an eclectic exhibition of the painter's work that was characterized as ranging from the 'epic' to the 'ethnological' (*Art Journal*, 1871, 165). How were the portraits of Nazli interpreted in this new context? Given that they conformed to the codes of honorific portraiture that emphasized the individual character of the sitter, it is possible that they challenged the

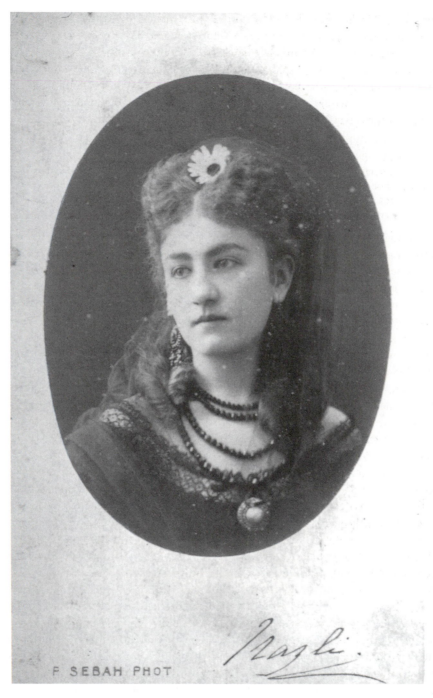

F SEBAH PHOT

4.1 Princess Nazli Hanım, *carte de visite*, n.d.

London gallery's viewers. The notion of the timeless, exotic odalisque was also potentially dispelled by one of the portraits, in which Nazli was represented in her hybrid mix of French and Ottoman costume. The response of the *Art Journal* critic registers a challenge to prevailing fantasies of the odalisque, affirming the veracity of the artist's unique eye-witness view of harem life; however, the paintings are interpreted as anonymous ethnographic types rather than honorific portraits.

'The Favourite of the Hareem,' an oil-picture, declares itself at once a veritable study from Oriental life. All attempts at improvisation of Hareem beauty by painters and poets have been very wide of the truth, as we learn from this and other genuine representations of so-called eastern beauty. There are several pictures of eastern women: what is most valuable in them is their indisputable nationality, which is brought forward without conventional prettiness of feature.[7] (*Art Journal*, 1871, 165)

In this instance the portraits' shift in context entails a loss of connection to the individual subject, a wrenching of signifiers from honorific portraiture (with its implications about the sitter's subjectivity) to an anonymous racial type.

The display of these portraits in the London gallery also raises an ethical issue. Given the strictures around the visibility of Ottoman women and their representations, it is likely that their exhibition to the London audience was a betrayal of Nazli's trust. The portraits were presented as private gifts to Nazli's two friends, the artist and the Princess of Wales; they were not intended as objects for public presentation. Although no record is known of Nazli's response to their exhibition (or indeed whether she was cognizant of it), evidence from other accounts suggests that the visibility of her portraits at the New Bond Street Gallery would have been a profound violation of Islamic cultural mores. Even in those more liberal harems open to experimentation with Western modes of visual representation, extreme measures were taken to ensure that these representations of Islamic women were not publicly visible. For instance, Mary Walker noted in 1886 that her harem portrait of Zeïneb Hanım was covered with a curtain to ensure that it was not even seen by the household servants (Walker, 1886, 17; Roberts, 2002). Ellen Chennells, an English governess in the Cairo harem of Nazli's relative Khedive Ismail, sheds more light on the cultural sensitivities involved. Chennells maintained that in order to ensure secrecy, portrait photographs were taken inside the Khedive's harem garden. An Ottoman photographer was engaged rather than a European because it was feared that they 'might sell her likeness, or send it to Europe for sale [which] would violate all ideas of oriental propriety' (Chennells, 1893, 114). Bukana Hanım's initial caution about Jerichau-Baumann's portrait of her daughter turns out to be fully justified. And Jerichau-Baumann's declaration that the harem 'fortress' had been 'surrendered' takes on the more troubling implications of orientalist conquest when we become aware of the epistemic violence of the

portraits' public display in London. Inside their harem in Istanbul, the granting of permission to paint was the result of a collaboration with Nazli; in the British capital Nazli is reduced to an object of fascination for a Western audience.

Jerichau-Baumann's visit to Nazli Hanım not only resulted in these harem portraits but also inspired a number of other fantasy paintings which are extremely unusual for a woman artist of her era, one among them *The Princess Nazili Hanum* of 1875 (Figure 4.2). Languidly reclining in traditional harem costume with her black servant crouched mysteriously among the curtains in the background, this white odalisque strokes the head of her pet monkey, offering herself to the viewer and actively inviting engagement in a game of erotic seduction.[8] This painting stages a familiar Western fantasy of the harem in which the odalisque is an alluring object of desire at the same time that her own desire is directed towards captivating the Western viewer. The surprising aspect of this work lies in the fact that a Western female artist should orchestrate this circuit of desire.

Jerichau-Baumann's odalisque paintings were clearly aimed to satisfy the expectations of her European audience. She was undeniably an ambitious painter with a strategic eye on the various requirements of the differing art markets in which she aimed to sell her work. However, it seems that her investment in these fantasy paintings was not solely market driven: there is abundant evidence in her letters to her husband and children and in her published travelogue of her own pleasures in a harem fantasy. In contrast to the veiled eroticism of other women harem painters and travel writers, Jerichau-Baumann's desire to unveil the harem, and her captivation with Nazli in particular, is undisguised. Nazli became the focus for the artist's harem fantasy and surprisingly this did not preclude a continuing friendship between the two women. And yet the artist's respect for the Egyptian princess did not eclipse her sense of her own cultural superiority or her apparent obliviousness to her transgression of Islamic cultural decorum.

Jerichau-Baumann's orientalism redefines and reaffirms orientalist categories. A complex range of attitudes towards the harem, and Nazli in particular, emerges in her travelogue, paintings, portraits and letters. The exhibition of her harem portraits and fantasy paintings configures Nazli respectively as an ethnographic curiosity and as the languid, exotic odalisque for a Western audience. The complexity of social change in harems that is registered in Jerichau-Baumann's diary is absent from the harem fantasy paintings that she produced back in Europe. Whereas Jerichau-Baumann's portraits potentially challenged the Western sexualized harem stereotype and her diary incorporates a complex mix of social and sexual discourse, her fantasy paintings reaffirm the trope of the sensual harem beauty. Elisabeth Jerichau-Baumann's fantasy of the Orient fundamentally challenges Western

4.2 Elisabeth Jerichau-Baumann, *The Princess Nazili Hanum*, 132 × 158 cm,
oil on canvas, 1875

gender categories because the artist is positioned as a desiring subject and yet
Jerichau-Baumann achieves this through works which are surprisingly
similar to the familiar trope of the languid odalisque. This is an instance
where women's orientalism is, to quote Yeğenoğlu, 'inevitably implicated
and caught within the masculinist and imperialist act of subject constitution'
(Yeğenoğlu, 1998, 82).

 And yet it is too limiting to see the exchange between Jerichau-Baumann
and Princess Nazli solely in terms of enabling this European painter to claim
her place in orientalist discourse, for this is to ignore the context of Ottoman
patronage. Instead I would argue that Jerichau-Baumann's portraits are
entangled objects, whose meanings shift and are displaced in the differing
cultural contexts they inhabit. Nicholas Thomas's characterization of cross-
cultural exchange as a 'movement and displacement of competing
conceptions of things' that enables indigenous cultures to reinvent and
reinterpret objects is particularly pertinent here (Thomas, 1991, 108). To date,
the notion of cultural exchange has seemed foreign to the analysis of harem

paintings because the Western fantasy of the seraglio has been seen as the archetype for Western appropriation of the Orient (Richon, 1984; Kabbani, 1986). A consideration of the dual contexts for reception of Jerichau-Baumann's harem portraits necessitates a radical revision of this understanding of the harem genre, emphasizing cross-cultural exchange and the processes by which these harem paintings were created in response to local Ottoman priorities. This becomes apparent when considering the cultural milieu for Jerichau-Baumann's third portrait that remained inside Mustafa Fazil Paşa's harem and in particular Nazli's subsequent career. So far the itinerary of the two portraits in Europe has been traced. However, when the focus is shifted back to Istanbul it becomes apparent that there were other consequences of Jerichau-Baumann's visit, arising from the fifteen-year-old Princess Nazli's fascination for the practice of easel painting.

'HERE HOWEVER IT WAS THE OTHER WAY AROUND'[9]

Evidence suggests that Nazli's portrait-sitting to Jerichau-Baumann was not for her an isolated encounter with easel painting. She grew up in an Islamic family milieu that was engaged with Western cultural practices, including painting, music and sculpture. Nazli's uncle, Prince Halim, commissioned and collected Western art. His collection, housed in his mansion on the shores of the Bosporus at Baltalimanı, included a portrait of his father Muhammad Ali Paşa by Horace Vernet, portraits by Jerichau-Baumann and views of Istanbul by her son Harald which were purchased in 1875 (Jerichau-Baumann, 101 and 126–8). Nazli spent much time in the company of her uncle's family and in all likelihood was very familiar with this art collection. Her husband, Halil Serif Paşa, was also an important patron and collector. They married in 1872 after Halil Paşa returned to Istanbul from a diplomatic post in Vienna. He was a statesman and advocate for political reform and one of the most prominent Ottoman diplomats in Europe in the 1860s and 1870s (serving in Athens, St Petersburg, Vienna and Paris). Halil Paşa was renowned in Second Empire Paris for his flamboyant lifestyle and is remembered in art-historical literature for his collection of nearly one hundred modern and old masters, including J.-A.-D. Ingres's Le Bain turc (1862), and Gustave Courbet's L'origin du Monde and Les Dormeuses (1867), which he acquired while living in the French capital from 1865 to 1868 (Haskell, 1987, 175–85; Davison, 1981, 203–221; Davison, 1986, 47–65; İnankur, 1996, 72–80; Haddad, 2001).[10] Although most of Halil Paşa's art collection was auctioned in January 1868 before he left Paris (and there are no records of what he continued to collect once he moved back to Istanbul from Vienna in 1872), there is every likelihood that he remained interested in art

during his seven-year marriage to Princess Nazli and that this, in turn, had an influence on her own artistic concerns.[11]

In 1880, the year after her husband's death, Nazli's own art came to public prominence. She exhibited four still-life paintings at the inaugural exhibition of the ABC club (Artists of the Bosphorus and Constantinople). The Salon held at the Greek Girls' School on the shores of the Bosporus in Tarabya was one of a very significant series of exhibitions for the development of easel painting in the Ottoman capital. These exhibitions, in which both European and Ottoman painters participated, laid the foundations for the development of modern Turkish art (Öner, 1991 and 1992). Nazli's participation is a very early example of an Ottoman woman painter working within the Western easel-painting tradition, but she was certainly not the first female Ottoman artist. There were a number of Ottoman women renowned for their skills in the art of illumination, poetry and other traditional arts such as music and dance (Çağman, 1993, 242–55).[12]

The reviews of the Salon of 1880 published in Denmark and Istanbul provide important insights into the differing cultural contexts for reception of Ottoman and European orientalist painting. In 1880 the Danish writer for *Dagbladet* completely disregarded the work of the thirty European and Ottoman painters who exhibited at the Istanbul Salon, focusing instead on what he presumed to be more fascinating to his European audience – the fact that an Ottoman harem woman, Princess Nazli Hanım, had exhibited there. In his review the Danish critic reveals a distinct preference for biography over art. The reviewer stresses that Nazli was the wife of Halil Bey, who 'as the envoy of the High Port in Paris, squandered an enormous fortune during the wildest of escapades.' Reiterating a familiar cliché of the despotic Turk, this writer was preoccupied with a rumour that 'at the side of this unworthy husband the unhappy princess spent sad days: although she according to her education and upbringing was entirely European, she had to put up with being treated just like a Turkish wife by her husband, who was far from being able to judge her according to her merits' (*Dagbladet*, 11 November 1880).

A very different perspective on the Istanbul exhibition emerges in a contemporary Ottoman source. The review in the Ottoman newspaper *Osmanlı* challenges an approach to orientalist visual culture as exclusively an expression of the politics of Western domination. In contrast to the Danish reviewer's emphasis on Nazli's biography as an exotic curiosity, the Ottoman writer pronounced the entire exhibition a source of Ottoman cultural pride. This cultural insider claimed the event as an Ottoman exhibition (despite the large number of European painters) because 'the natural beauty of our country and ethics have been appreciated by the artists.' The same writer also praised the English exhibitor Mary Walker, for 'rendering a great service to

our country' by training Ottoman women painters, and wrote that the
international recognition of Osman Hamdy Bey's art was a 'source of pride
for our country'.[13] From an Ottoman perspective, this engagement with
Western easel painting is a source of national pride, and cultural exchange is
characterized as a productive collaboration between European and Ottoman
painters. The difference between these two reviews indicates the disparities
between Western and Ottoman perceptions of Ottoman culture. While the
persistence of Western stereotypes of the exotic Orient cannot be ignored,
what is required is a radical revision of the paradigm of Orientalism that
acknowledges productive cross-cultural collaborations and the priorities of
Ottoman audiences (Çelik, 1996 and 2002; Benjamin, 1997).

As far as I am aware Nazli did not pursue a public career as a painter, but
nor did she disappear without trace. She moved to Cairo after the death of
Halil Paşa and was actively engaged in the cultural life of that city. She
conducted a distinguished salon in the late nineteenth and early twentieth
century where Arab nationalists, advocates for women's rights, British
colonialists, such as Lord Kitchener and Sir Evelyn Baring, Lord Cromer and
other members of the social elite, were welcomed.[14] Nazli is mentioned in
several accounts from the period, including an article in the Arabic journal *al-
Muqtataf* of 1897 which praised her recently published book (1897, no. 21;
Humbold, 1902, 331–2). Through these sources Nazli's shifting political
allegiances are evident. She supported the nationalist leader Ahmad Urabi,
but shifted her support to the British upon his defeat. Nazli's allegiances
appear to have been pragmatic and were most likely coloured by internecine
Khedival family politics; no doubt a primary motivation was her contempt
for her cousin Tevfik (Lutfti al-Sayyid, 1968, 95).[15] Nazli was reputedly a great
friend of Kitchener but rather than being a compliant member of the
Ottoman-Egyptian elite complicit with British imperial ambitions, there is
evidence to suggest that she was vociferous and staunchly independent,
often critical of Kitchener's ignorance of Egyptian culture.[16]

In this period, probably in the 1880s, Princess Nazli produced her most
exceptional self-portrait, one which, I would argue, satirizes the Western
stereotype of the harem. On a page in an anonymous album in the Sutherland
archive, two portraits of Princess Nazli sit next to one another, like an
uncanny stereoscopic plate (Figure 4.3). The Egyptian Princess has playfully
choreographed her representation against the same studio backdrop of
pyramid and palm trees. In the photograph on the left Princess Nazli is
elegant and composed in Western dress. This is not an unusual
representation for an Ottoman Princess of her era, but like her earlier *carte de
visite* and portrait paintings, it is contrary to European expectations of the
exotic odalisque. Next to it on the right is a more whimsical photograph of
Nazli dressed as an Ottoman man while her companion masquerades as an

4.3 Unknown photographer, *Princess Nazli Hanum*, photograph, n.d.

Egyptian pottery seller, posed as if she is part of Nazli's imaginary harem. While the context for the production of these photographs remains obscure, they do invite speculation. Perhaps Nazli visited the photographer's studio to have the photograph on the left taken and decided to play with the props that she found there. Cross-dressing is familiar among Westerner travellers, particularly with the fashion for *turqueries* that arose from the late eighteenth century onwards. Here, though, is an Ottoman woman.[17] Nazli may be imagined cross-dressing, playfully posing with mock solemnity while the photographer registered this image and in doing so upending the stereotypic codes of the odalisque of Western fantasy.

One way of interpreting this photograph is to consider its subversive relationship to existing Orientalist photographic codes. Most likely, this photograph was taken in one of the many studios in Cairo that produced honorific portrait photography for local residents while simultaneously mass-producing orientalist clichés for the tourist market. I imagine Nazli in the photographer's studio cognizant of the degraded stereotypes of the harem that were on sale in the same establishment, parodying such representations. Nazli's harem is a comic reference to Western notions of the exotic East and a seemingly limitless fascination with the idea of the seraglio. The humour in this photograph is premised on its homology with these other tourist photographs.[18] It references the many orientalist photographic clichés of the harem whose appeal resided in the fantasy of possession that they offered the Western viewer. Nazli's photograph travesties such codes. This time the harem woman plays her role as harem master against the painted backdrop while the theatricality of these two figures burlesques the staginess of the orientalist photograph.

There is another level at which I wish to read the erotic subtext of this photograph and that is specifically in relation to Jerichau-Baumann's fantasy paintings. There is a striking coincidence between Nazli's pottery seller and Jerichau-Baumann's *An Egyptian Pottery Seller Near Gizeh*, 1876–78 (Figure 4.4). It is uncertain whether Nazli saw this or the painter's other eroticized representations of Egyptian pottery sellers. However, both have a shared derivation in orientalist stereotypes of the sexually available peasant woman: one reaffirms this cliché while the other mocks it. In Jerichau-Baumann's paintings there is a collapsing of any social distinctions between her pottery sellers and her odalisques as both become alluringly available to the viewer. In Nazli's photograph the social distinction between elite Ottoman woman and poor pottery seller is reinscribed. The wealthy harem women who have commissioned this photograph can playfully enact various roles in the photographer's studio – distinct and distanced from the illiterate pottery seller whose role they play.[19] In contrast to the physical availability of the pottery seller and odalisque in Jerichau-Baumann's art, in Nazli's

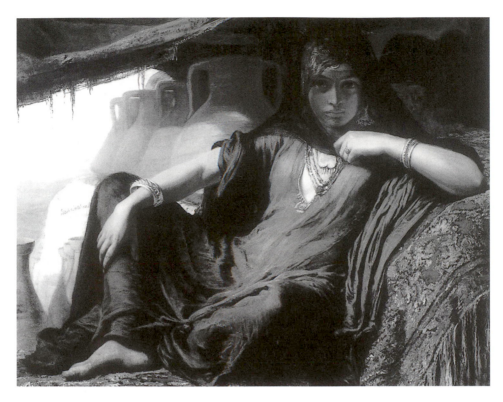

4.4 Elisabeth Jerichau-Baumann, *An Egyptian Pottery Seller Near Gizeh*, 92 x 114 cm, oil on canvas, 1876–78

photograph her body is covered and this Egyptian pottery seller is mischievously posed as Nazli's possession rather than offering herself to the viewer.

More than any of the other portraits of Princess Nazli that I have considered throughout this essay, this photograph 'substitutes performance for any attempt at presence' (Solomon-Godeau, 1986, 77).[20] Nazli's impassive look promises no insights into the psychological interiority of this sitter; instead attention is shifted to the theatrical staging of a performance. Indigenous agency does not imply substituting some notion of essence or presence for the silenced other; instead there is an irreverent performativity. Awareness of this photograph makes it is possible to think of the range of her *cartes de visites* and portrait paintings as a playful, changing characterization of self orchestrated by Nazli.

This study of Nazli's harem portraits introduces the entanglements of cross-cultural exchange to an understanding of the harem genre. The

encounters between Jerichau-Baumann and Princess Nazli in Istanbul in 1869–70 and 1874–75 were productive for the European artist and her audience but also for Nazli. But this is not just a story of productive exchange – exchange here is about betrayal as much as collaboration. It is also about lacunae in communication and the overriding desire within Europe for a reaffirmation of the timeless, erotic Orient of Western fantasy. As Zeynep Çelik argues, the problem of 'speaking back' might be as much about failures to listen and to hear (Çelik, 2000, 96). Nonetheless this narrative also touches on the currency of visual representations in late Ottoman culture and profoundly shifts understanding of women's orientalist art by introducing the harem as a context in which Ottoman women's identity and sociality was renegotiated through image-making.

References

'A Fine Arts Exhibition in Tarabya', *Osmanlı*, 11 Şevval 1297, no. 14, 1880.

Alloula, M., *The Colonial Harem*, trans. M. Godzich and W. Godzich, Manchester: Manchester University Press, 1986.

al-Muqtataf, XXI, 1897.

Art Journal, 1871, 165.

Benjamin, R., 'Post-colonial taste: non-western markets for Orientalist art', *Orientalism. Delacroix to Klee*, Sydney: Art Gallery of New South Wales, 1997, 32–40.

Çağman, F., 'Women and the Arts', *Woman in Anatolia. 9000 years of the Anatolian woman*, exh. cat., Exhibition held at the Topkapı Sarayı Museum, 29 November 1993 – 28 February 1994, 242–55.

Çelik, Z., 'Colonialism, Orientalism and the Canon', *Art Bulletin*, **78** (2), 1996, 202–205.

——, 'Speaking back to Orientalist discourse at the World's Columbian Exposition', in H. Edwards (ed.), *Noble Dreams and Wicked Pleasures. Orientalism in America, 1870–1930*, Princeton: Princeton University Press, 2000, 77–95.

——, 'Speaking back to Orientalist discourse', in J. Beaulieu and M. Roberts (eds), *Orientalism's Interlocutors. Painting, Architecture, Photography*, Durham: Duke University Press, 2002, 19–41.

Cezar, M., *Sanatta Batti'ya Açılış ve Osman Hamdi*, 2 vols, Istanbul: Erol Kerim Aksoy Kültür, 1995.

Chennells, E., *Recollections of an Egyptian Princess by Her English Governess. Being a Record of Five Years Residence at the Court of Ismael Pasha, Khédive*, 2 vols, Edinburgh and London: William Blackwood and Sons, 1893.

Cherry, D., *Beyond the Frame. Feminism and Visual Culture, Britain 1850–1930*, London and New York: Routledge, 2000.

Dagbladet, 11 November 1880.

Davis, F., *The Ottoman Lady. A Social History from 1718 to 1918*, New York: Greenwood Press, 1986.

Davison, R.H., 'Halil Şerif Paşa, Ottoman Diplomat and Statesman', *Osmanlı Araştırmaları (Journal of Ottoman Studies)*, **2**, Istanbul, 1981, 203–221.

——, 'Halil Şerif Paşa: the influence of Paris and the West on an Ottoman diplomat', *Osmanlı Araştırmaları (Journal of Ottoman Studies)*, **6**, Istanbul, 1986, 47–65.

Diba, L.S. and M. Ektiar, (eds), *Royal Persian Paintings. The Qajar Epoch, 1785–1925*, New York and London: Brooklyn Museum of Art and I.B. Tauris, 1998.

Dünden Bugüne İstanbul Ansiklopedisi, Kültür Bakanliği ve Tarih Vakfi'nin Ortak Yayinidir, İstanbul, 1995, vol. 2, 464 and vol. 3, 172.

von Folsach, B., *By the Light of the Crescent Moon. Images of the Near East in Danish Art and Literature, 1800–1875*, Copenhagen: The David Collection, 1996.

Getin, A., 'Hidiv Ailesi', *Dünden Bugüne İstanbul Ansiklopedisi*, 4, İstanbul: Kültür Bakanliği ve Tarih Vakfi Ortak Yayini, 1994, 59–61.

Gîray, K., 'Introduction to the History of Turkish Painting', *The Sabanci Collection*, Istanbul: Akbank, Culture and Art Department, 1995, 182–210.

Grey, T., *Journal of a Visit to Egypt, Constantinople, The Crimea, Greece &c. In the suite of the Prince and Princess of Wales*, London: Smith, Elder and Co, 1869.

Haddad, M., *Halil Şerif Paşa, Bir İnsan, Bir Koleksiyon*, Istanbul: P. Kitapliği, 2001.

Haskell, F., 'A Turk and his Pictures in Nineteenth-century Paris', *Past and Present in Art and Taste. Selected Essays*, New Haven and London: Yale University Press, 1987, 175–85.

Humbold, H., *Recollections of a Diplomatist*, vol. 2, London: Edward Arnold, 1902.

İnankur, Z., 'Halil Şerif Paşa', *P*, 2, Summer, 1996, 72–80.

Jerichau-Baumann, E., *Brogede Reisebilleder (Motley Images of Travel)*, Copenhagen, 1881.

Kabbani, R., *Europe's Myths of Orient*, London: Pandora, 1986.

Kuntay, M.C., *Namık Kemal, Devrinin İnsanları ve Olayları Arasında*, İstanbul: Maarif Mataasi, 1944, vol. 1, 311–39.

Larsen, P.N., 'Fra nationalromantisk bondeliv til Orientens haremsmystik. Elisabeth Jerichau Baumann i dansk og europæisk 1800-tals kunst', *Elisabeth Jerichau Baumann*, på Øregaard Museum and på Fyns Kunstmuseum, 1997.

Lewis, R., *Gendering Orientalism. Race, Femininity and Representation*, London and New York: Routledge, 1996.

——, 'Women Orientalist Artists: Diversity, Ethnography, Interpretation', *Women. A Cultural Review*, 6 (1), 1995, 91–106.

Leyla Hanımefendi, *The Imperial Harem of the Sultans. Daily Life at the Çirağan Palace during the 19th century. Memoirs of Leyla (Saz) Hanımefendi*, trans. Landon Thomas, Istanbul: Peva Publications, 1995.

Low, G.C.-L. 'White Skins/Black Masks: the Pleasure and Politics of Imperialism', *New Formations*, 9, Winter 1989, 83–103.

Lutfi al-Sayyid, A., 'Rumblings of Opposition', in *Egypt and Cromer. A Study in Anglo-Egyptian Relations*, London: John Murray, 1968.

Mardin, Ş., 'Super westernization in Urban Life in the Ottoman Empire in the last quarter of the nineteenth century', in P. Benedict, E. Tümertekin and F. Mansur (eds), *Turkey. Geographic and Social Perspectives*, Leiden: E.J. Brill, 1974.

Mustafa Fazil Paşa, *Lettre adressée à Sa Majesté le Sultan par S.A. le Prince Mustapha-Fazil-Pacha*, Paris, 1867.

Öner, S., 'Tanzimat Sonrası Osmanlı Saray Çevresinde Resim Etkinligi', unpublished PhD thesis, Mimar Sinan University, İstanbul, 1991.

——, 'The Role of the Ottoman Palace in the development of Turkish painting following the reforms of 1839', *National Palaces*, Istanbul, 1992, no. 4, 58–77.

Özel, İ., 'Tanzimatin Getirdiği "Aydin"', *Tanzimat'tan Cumhuriyet'e Türkiye Ansiklopedisi*, İletisim Yayınları, İstanbul, 1985, vol. 1, 65.

Özendes, E., *From Sébah and Joaillier to Foto Sabah. Orientalism in Photography*, Istanbul: Yapı Kredi Yayınları, 1999.

Öztuncay, B., *Vassilaki Kargopoulo. Photographer to his Majesty the Sultan*, Istanbul: Birleşik Oksijen Sanayi A. Ş, 2000.

Peirce, L.P., *The Imperial Harem. Women and Sovereignty in the Ottoman Empire*, Oxford and New York: Oxford University Press, 1993.

Perez, N.N., *Focus East. Early Photography in the Near East (1839–1885)*, New York: Harry N. Abrams, 1988.

Richon, O., 'Representation, the despot and the harem: Some questions around an academic orientalist painting by Lecomte-du-Nouy', in F. Barker et al. (eds), *Europe and its others. Proceedings of the Essex Conference on the Sociology of literature*, vol. 1, Colchester: University of Essex, 1984, 1–13.

Roberts, M., 'Contested Terrains: Women Orientalists and the colonial harem' in J. Beaulieu and M. Roberts (eds), *Orientalism's Interlocutors. Painting, Architecture, Photography*, Durham: Duke University Press, 2002.

Russell, W.H., *A Diary in the East during the tour of the Prince and Princess of Wales*, London: George Routledge and Sons, 1869.

Şeni, N., 'Fashion and Women's clothing in the Satirical Press of Istanbul at the End of the 19th century' in Sirin Tekeli (ed.), *Women in Modern Turkish Society. A Reader*, London and New Jersey: Zed Books, 1995, 25–45.

Shaw, S.J. and E.K. Shaw, *History of the Ottoman Empire and Modern Turkey, vol. 2, Reform, Revolution and Republic. The Rise of Modern Turkey 1808–1975*, Cambridge and New York: Cambridge University Press, 1995.

Solomon-Godeau, A., 'The Legs of the Countess', *October*, **39** Winter 1986, 65–108.

Storrs, R., *The Memoirs of Sir Ronald Storrs*, New York: Arno Press, 1972.

The Sultan's Portrait. Picturing the House of Osman, exh. cat., Istanbul: Topkapı Palace Museum, 6 June – 6 September 2000, Istanbul: Türkiye İş Bankası, 2000.

Süreyya, M., *Sicill-i Osmanî*, Istanbul: Kültür Bakanliği ile, 1996, vol. 2, 511.

Thomas, N., *Entangled Objects. Exchange, Material Culture and Colonialism in the Pacific*, Cambridge Mass., and London: Harvard University Press, 1991.

Tugay, E.F., *Three Centuries. Family Chronicles of Turkey and Egypt*, Oxford and London: Oxford University Press, 1963.

de Villemessant, H., *Mémoires d'un journaliste. 6éme série, mes voyages et mes prisons*, Paris: E. Dentu, Libraire-Éditeur, 1876.

Walker, M., *Eastern Life and Scenery with Excursions in Asia Minor, Mytilene, Crete and Roumania*, London: Chapman and Hall, 1886, vol. 1.

Yeğenoğlu, M., *Colonial Fantasies. Towards a Feminist Reading of Orientalism*, Cambridge and New York: Cambridge University Press, 1998.

Zonana, J., 'The Sultan and the Slave: Feminist Orientalism and the Structure of *Jane Eyre*', *Signs*: Journal of women in Culture and Society, **18** (3), 1993, 592–617.

Notes

My sincere thanks to the editors of this volume Deborah Cherry and Janice Helland. I am also grateful to Jocelyn Hackforth-Jones and Anita Callaway for inviting me to present this research at conferences in London and Canberra. I have benefited from their feedback as well as dialogue with the following scholars: Jill Beaulieu, Roger Benjamin, Zeynep Çelik, Fred Bohrer, Aykut Gürçağlar and Reina Lewis. I would also like to thank the following research/translators: Anne-Mette Willumsen for Danish translations; Pınar Öztamur, Berfu Aytaç and Marcus Barry for Turkish translations; Laurent Mignon for Ottoman translations and Kate Daniels for Arabic translations. The research for this project was funded through the University of Sydney Sesqui Research and Development Scheme and the Australian Research Councils Discovery Grant Scheme.

1 Jerichau-Baumann, *Brogede Reisebilleder*, 1881, 22.

2 Writing from Cairo to her children about her portrait commissions for the viceking's (Khedive Ismail's) children, Jerichau-Baumann stated: 'I have made so incredibly much money.' (3 March 1870, Elisabeth Jerichau-Baumann papers, Royal Library Copenhagen)

3 Letter from Constantinople 19 November 1869 to her husband Adolf and children (Elisabeth Jerichau-Baumann papers, Royal Library, Copenhagen).

4 In other circumstances Jerichau-Baumann had written of the hybrid fashions that were popular among Ottoman women in Istanbul as an unlucky reunion and a misalliance (Jerichau-Baumann, *Brogede Reisebilleder*, 123).

5 Mustafa Fazil Paşa lived in luxurious exile in Istanbul after his failed attempt, in collaboration with his uncle Prince Halim Paşa, to depose Khedive Ismail – after the Egyptian ruler displaced their right to succession. In 1866 Ismail persuaded Sultan Abdülaziz to change the law of succession enshrining primogeniture thereby ensuring that his son Tevfik Paşa was the heir presumptive rather than Prince Halim. See S. J. Shaw and E. K. Shaw, *History of the Ottoman Empire and Modern Turkey*, 1995; and Getin, 'Hidiv Ailesi', 1994, 59–61.

6 Bukana Hanım's stature in the harem is indicated by the fact that she had 175 slaves at her command (Jerichau-Baumann, *Brogede Reisebilleder*, 22). Leslie Peirce notes that, 'the segregation of the sexes [in Islamic society] permitted the articulation of a hierarchy of status and authority among women, parallel to that which existed among men' (Peirce, *The Imperial Harem*, 1993, ix).

7 In Jerichau-Baumann's papers there is another review transcribed by the artist that corroborates this ethnographic reading: 'Mme Jerichau's gallery at 142 New Bond Street where the artist brings before the public several of her eastern studies very remarkable as to the different Egyptian types displayed … Mme Jerichau has also been able, thanks to HRH the Princess of Wales, and HM the King of Greece introductions, to enter the private Harems of highest rank. She has been favoured with portrait orders of H. Highness the Kehedives sons and daughters and her two eastern pictures of *immense* value, as being the first ever seen and ever painted, are portraits of Ladies of highest rank inhabitants of the Harem. Mme Jerichau was allowed to life the edge of its veil.' (Untitled and undated letter, Jerichau-Baumann papers, Royal Library, Copenhagen).

8 For analysis of this painting see Larsen, *Elisabeth Jerichau Baumann*, 1997, and Folsach, *By the Light of the Crescent Moon*, 1996, 86.

9 Jerichau-Baumann, *Brogrede Reisebilleder*, 23.

10 In France he was referred to as Khalil Bey (he was promoted in rank from Bey to Paşa in 1871).

11 When Villemessant visited Halil Paşa at his Vienna residence between 1870 and 1872, he observed that the Ottoman diplomat had a fine collection of French painting and sculpture as well as family portraits. It is likely that these paintings returned with him when he journeyed from Vienna to Istanbul in 1872, the year when he married Princess Nazli (Villemessant, *Mémoires d'un journaliste*, 1876, 106).

12 At the 1880 Salon Osman Hamdi Bey exhibited *Two Musicians*, a painting representing skilled young Ottoman women playing traditional Turkish instruments. This painting is reproduced in Cezar, *Sanatta Batti'ya Açiliş ve Osman Hamdi*, 1995, vol. 2, 668.

13 'A Fine Arts Exhibition in Tarabya', *Osmanlı*, 11 Şevval 1297, no. 14, 1880.

14 Afaf Lutfi al-Sayyid notes that Princess Nazli's salon was one of the three famous salons in late nineteenth-century Cairo in which there were signs of political activity ('Rumblings of Opposition', 1968, 95).

15 Again her animosity seems to have been prompted by the fact that Tevik's father Khedive Ismail had usurped her father's and uncle's right of succession to the Khedivate.

16 Lord Kitchener's secretary Ronald Storrs recorded the following feisty interchange between Princess Nazli and Kitchener: 'Against the combined volume and velocity of her conversation in English, French, Arabic and Turkish, the protests of the Field-Marshal rang surprisingly mild. "You think, I suppose, that the Egyptians are afraid of you, Lord Kitchener, sitting in Kasr al-Dubara? They laugh. And how should they not laugh when you allow to be made Minister a dirty, filthy kind of a man like …" "Really, Princess Nazli! I don't think …" "You don't, and if you had …", and the next victim would come up for dissection' (Storrs, *The Memoirs*, 1972, 124–5). Emine Tugay reports a similar heated interchange (*Three Centuries*, 1963, 112).

17 On the practice of cultural cross-dressing see Low, 'White Skins/Black Masks', 1989, 83–103.

18 For an analysis of harem postcards produced for the Western tourist market see Alloula, *The Colonial Harem*, 1986.

19 On the photographic studios in Istanbul and Cairo see Perez, *Focus East*, 1988, Özendes, *From Sébah and Joaillier to Foto Sabah*, 1999, and Öztuncay, *Vassilaki Kargopoulo*, 2000.

20 I am struck by the parallels between the theatricality of Nazli's photographs and the Countess de Castiglione's photographic self-portraits. See Abigail Solomon-Godeau's essay 'The Legs of the Countess', which addresses the complex issues of masquerade and self-representation in the Countess's oeuvre (77).

Louise Abbéma's *Lunch* and Alfred Stevens's *Studio*: theatricality, feminine subjectivity and space around Sarah Bernhardt, Paris, 1877–1888

Griselda Pollock

This essay proposes a sinuous argument about reading nineteenth-century paintings of studios and sociality. The question faced by feminist interventions in art's histories is how to frame images that have become illegible because of what has been authorized as an appropriate method for the study of art history. At the same time, there is a desire to contribute substantively to the changing history of art history as a practice challenged by both the complexity of art and the difficulty of history as well as differenced by the question of gender, race, class and sexual desire.

Three alternative methods present themselves. One involves the close reading of two late nineteenth-century paintings of studio interiors that appear to have no connection but whose affinities can be revealed through the discovery of the shared figure of the actor and artist Sarah Bernhardt (1844–1923). Increasing interest in this remarkable nineteenth-century woman has led to a range of studies of her relations to celebrity, to Jewish identity and anti-Semitism, to emerging technologies of representation in photography, cinema and voice recording. Younger scholars are attending to her work as an artist.[1] The second involves a move from an art-historical and textual attentiveness to images to a cultural reading of symbolic scenarios that, in quite different ways, staged concepts of Western feminine subjectivity on the cusp of the radical shift from a public, medicalized and specular view of hysteria to a psychoanalytical retheorizing of subjectivity with its redefinition of psychological interiority. The third concerns the building into cultural history of a complementary archive on women and their struggle for cultural inscriptions of subjectivity, in which the freedom of the actress to offer a theatrical enunciation of passion challenged the pacifying, hystericizing specularization of woman as image, as surface without psychic or intellectual depth. In their strategic, rather than disciplinary, interplay in

this moment of reading, the ever-perplexing archive called history, and in the desire for feminist understanding of that contested territory, the subtle and differencing inscriptions of feminine subjectivity through the space of painting emerge into critical visibility. This strategy builds on and reconfigures existing feminist considerations of modernity and the spaces of femininity to stress the continuing vitality and necessity for theoretical and historical work.

PUZZLING OVER A PAINTING

A large horizontal canvas (194 x 308 cm) hangs in the Musée des beaux-arts in Pau, France for which municipality it was bought in 1888 from an exhibition at the Salon des amis des arts de Pau (Figure 5.1). This painting is titled *Le Déjeuner dans la Serre (Luncheon in the Conservatory)*, and is dated 1877. Exhibited at the Salon in Paris that year, it received serious, if mixed, press attention. This rich, dark and intriguing painting is the best-known and largest work in a public collection by the French nineteenth-century painter Louise Abbéma (1858–1927).

One of the many hundreds of women artists who were received with sustained critical recognition during their careers, the afterlife of Louise Abbéma lies at best at the forgotten edges of art history, and at worst in a half-life in the auction rooms and, latterly, in feminist dictionaries of women artists.[2] Awarded the Légion d'honneur in 1906, Abbéma was commissioned to produce major decorative schemes for several town halls and for theatres in Paris, while winning medals and mentions at the Salon for a series of contemporary portraits of leading artists, intellectuals, architects and political figures, including Charles Garnier and Edmond de Lesseps. At the age of eighteen, as a pupil of Jean-Jacques Henner (1829–1905), Charles-Auguste Carolus-Duran (1837–1917) and briefly Charles Chaplin (1825–1891), Louise Abbéma made considerable impact at the Salon of 1876 with a portrait of Sarah Bernhardt (Figure 5.2) with whom she became passionately involved at this time. The affair yielded to a lifelong companionship and a final portrait of Bernhardt in her studio was exhibited in the Salon in 1922, a year before she died. Having encountered the actor at the Salon in 1871, Louise Abbéma, as a thirteen-year-old aspiring painter, immediately made a watercolour sketch on which she worked for several years until she obtained permission for a formal sitting. She then completed the oil painting on the basis of her sketch, and at the Salon of 1876 the painting was received with serious critical and public attention.

The identification of the figures in Abbéma's *Le Déjeuner dans la Serre* is provided in the documentation from the museum at Pau, and is repeated by

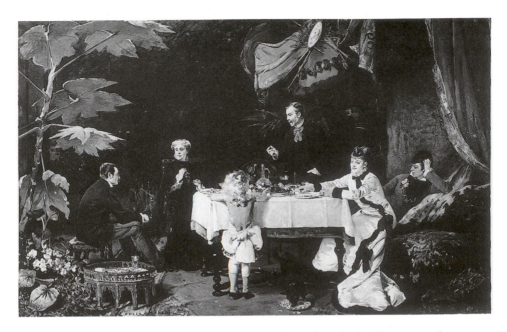

5.1 Louise Abbéma, *Le Déjeuner dans la Serre (Luncheon in the Conservatory)*, 194 x 308 cm, oil on canvas, 1877

most scholars. Not only am I not confident that these identifications are correct, but the whole meaning of the painting is changed if the internal evidence of the work itself is carefully re-examined. Firstly, there is an older couple understood to be the parents of the artist, the father standing and the mother seated. Then there is the playwright Emile de Najac, seated on the left. We are also told that the two women on the right in the painting are the sisters Jeanne and Sarah Bernhardt. There is no mention of the child or the dog.

Abbéma's painting may be compared on the grounds of its subject matter – informal sociality – to Edouard Manet's puzzling painting *Le Déjeuner dans l'Atelier (Luncheon in the Studio)*, exhibited at the Salon in 1869. Abbéma's picture does not represent such a studio interior; it is located in a conservatory or winter garden. Thus it is less likely to be a statement about either artist or contemporary art, as that by Manet promises to be in its oblique self-referencing across the several figures, props and space. Yet such intertextuality should be allowed to leave open this possibility. Two years after Abbéma's widely noted Salon painting, Manet also painted an encounter in a lushly green winter garden. *Dans la Serre (In the Conservatory*, 1879, Berlin: Staatliche Museen) portrays a couple whose identity is known

5.2 Louise Abbéma, *Portrait of Sarah Bernhardt*, 1876

to art historians but which would not have been publicized, leaving the nature of the undefined relations between an elegant bourgeois couple – both noticeably displaying wedding rings – part of the enigma of the painting's modernist refusal of mere novelistic insight typical of the genre of such scenes amongst his Salonnier contemporaries.[3] In his choice of the aftermath of an informal meal or the intimate yet quizzical encounter in the paradoxical space of an interior bursting with the vegetation from exotic exteriors, Manet marks these new spaces and domestic rituals with modernist appeal while refusing point-blank any hint of narrative to sustain and explain the *dramatis personae*, the subject, or the situation. Manet thereby affirms the new painting's attention to the spaces of private life and intimacy, but suspends their psychological promise in order to hold the viewer, in what becomes the modernist turn, at the surface of materialization rather than in the narrative space of representation, at an equivocation between surface and subject matter. While being equally fascinated and self-conscious about their medium and its process, certain artists retained, or rather developed, a novel psychological interest that, without being prosaically anecdotal, allowed the representation of modern spaces to suggest aspects of modern subjectivity through the non-allegorical invocation of psychological interiority. In this transaction, as with the development of the modern novel, the feminine subject and feminine sociality held a significant iconic and symbolic place that was indexed through the visual representation of a spatial interior as visual counterpoint to an invisible inner psychological space. Painted, as Gérard Schurr argues (Schurr, 1975, 103), with something of both the crispness of Bazille – the young impressionist painter who created scenes of bourgeois family gatherings with new and heightened colour, but who was killed in 1870 – and the compositional authority, astringency of colour and tone, and daring brushwork typical of Manet, Louise Abbéma's scene defied its initial readers and leaves belated viewers and feminist students of art's histories today to ask how it was conceived, and what it was produced to do/say/affirm/remember/suggest/hide?

For a start, where is it taking place? Is it a conservatory? Or is it, in fact, a studio? Whose? What is happening in the picture: the aftermath of a social ritual or the representation of a relationship? What is the significance of the groups, generations and genders represented? Why are there two centres of clearly depicted social and personal interaction while a single figure, lounging in a singular and significantly informal manner on a leopard skin on a divan under an array of oriental objects and African weapons, appears a detached observer of others' interactions? Who is this figure?

The room contains six figures and a black dog. Two well-dressed bourgeois men, one standing and one seated, one older and one younger, seem to be in 'conversation' as a respectably dressed, older woman, in

matronly black with silver-grey hair attends to the younger man while nibbling a bunch of grapes which she holds in her elegant hands. It is possible that luncheon has been served and that the company is now relaxing with a small array of fruit and wine: it is not, therefore, a luncheon in the conservatory, but a moment of sociality following what cannot have never been a formal occasion – the table is too small; nor is it laid for such a gathering. Three dark figures form a group stretched out across space but connected by directional looks and gestures while they are dramatically, and with a visual difficulty overcome by Manet-like sharp contrasts of tone, set off against the deep darkness of the interior recess from which only the faint green of a giant fern glimmers behind the head of the standing man. An expanse of white-clothed table luminously marks a separation of this plane from the middle- and foreground, suggesting a light source above to illuminate this otherwise dim environment.

Shifted to the right, another trio is represented, composed of the standing blond-haired child in a grey dress with a huge pink bow that ties the centre of the painting together. The sex of this child is hard to determine for at such an age both boys and girls might well sport a dress and have flowing locks. The pink bow and its size, coupled with the length of the curling hair, predispose me to read it as a young girl while certain biographical possibilities tip us towards a boy-child. The child's *profile perdu* does not prevent its figure from being highly expressive as s/he seems to engage with the woman seated in a dramatic winter daydress of white satin lined with brown fur that sweeps down from a froth of lace at the neck. This ruffle frames a face topped with a pile of red-brown hair, styled with an even fringe that covers the forehead. Both the slim-fitting dress, with a ruff at the neck and trimmed with fur in winter, are known as features of the style of dress devised for and favoured by Sarah Bernhardt during the 1870s, as seen in another portrait by a member of her circle of friends, Georges Clairin, where the lace trim is white. Of further significance is the use of a particular setting for the portrait (1876, Paris: Musée du Petit Palais): a couch covered with rich red cloths, rugs and oriental cushions. At her feet in Clairin's painting a wolfhound sleeps on a large animal skin. In the half-light behind the actress, a mirror reflects a collection of objects and a large castor oil plant.

In Abbéma's picture, the woman in white is seated, leaning on the table and encouraging the child to take some fruit. Her coloration and attire suggests an indoor costume; she is, I propose, the hostess. Yet there is a softness to this exchange and at least one commentator has suggested that the child might be identified as Maurice, the son of Sarah Bernhardt, born in 1864.[4] But this would make him twelve by 1876 when the painting was being prepared and it is unlikely, though not impossible, that the beloved child was kept in traditionally childish clothing until his early teens. Clarifying this

family history introduces a maternal dimension to the scene, shifting the characterization of the woman in white away from the simmering fatal beauty projected by Georges Clairin to another imaging of Sarah as a mother in affectionate conversation with a child.

The woman in white is, however, seated on the same divan and in close bodily proximity to the reclining woman who wears a formal jacket with starched shirt collar and a tied bow at her neck. A pink corsage and the loops of a watch chain complete the outfit. Is this a riding dress? The costume of the *Amazonne*? Or is the favoured dress of a woman defining herself through a refusal of both the respectable garb of the bourgeois matron and the fashionably feminine glamour of the seated hostess? This costuming might be linked to the politics of feminist dress reform with its adaptation of the simplicity of men's suits either to a statement of general progressiveness or to a personal choice that bespoke a sexual disposition: a lesbian desire declared through a self-fashioned style. The choice of a distinctive and uncluttered tailored dress itself marks another identification with a famous lesbian and artist of the nineteenth-century art world: Rosa Bonheur, about whom Louise Abbéma wrote:

While still a little girl, I heard Rosa Bonheur much spoken of, and it was her talent and her fame that decided me to become an artist. I began drawing with ardour, yearning for the time when I too should be a celebrated woman painter, a prospect that seemed to me, and indeed still seems, one of the finest attainable (Stanton, 1910, 140).

There is furthermore a striking comparison between the specifics of the grey dress and collar of the reclining woman here and the self-portrait of Louise Abbéma (Figure 5.3) which, although inscribed with a date 1923, clearly belongs to the 1870s. This leads me to confirm Miranda Mason's identification of the reclining woman as Louise Abbéma.[5]

The two women, Sarah Bernhardt and Louise Abbéma, are seated in an easy intimacy on an imported piece of North African furniture: the divan or sofa which had significant orientalist, and hence erotic, associations in colonial France (Farwell, 1990, 45–54).[6] A smaller canvas, *Sarah Bernhardt's Winter Garden* of 1876 (location unknown, sale Hôtel Drouot, 18 March 1874), is probably a study for the scene in the larger painting, complete with the dais, the sofa, the hanging shields, spears, weapons and the giant castor oil plant. Along the top of the canvas, standing for the back wall of the room, a clerestory window is shown, resolving the mystery of the light source but making clear this is not a conservatory, but rather a studio, with its high, north lights. In the dismal black-and-white photograph of an untraced painting (55 x 80 cm), the intense luminous centre of the painting is the dazzling white tablecloth set amidst the sombre tones of rich carpets, velvet

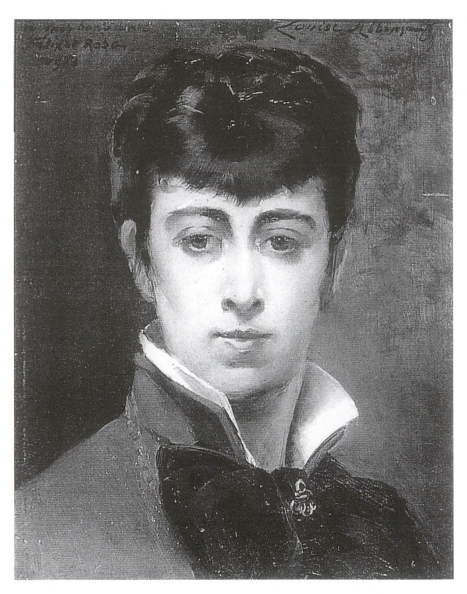

5.3 Louise Abbéma, *Self-portrait*, 35 × 26 cm, oil on panel, *c.* 1877

hangings and some luxuriant vegetation. Another light source is just visible, possibly a doorway, in the far distance to the right.

That *Le Déjeuner dans la Serre* is set inside the newly built and exotically furnished house of Sarah Bernhardt is suggested by a detailed watercolour, *Sarah Bernhardt in her Salon*, by Marie-Desiré Bourgoin (1879, London: private

collection), which shows Bernhardt sculpting in an interior of the mansion that the actress built for herself in 1876 on the rue Fortuny and avenue de Villiers, in Paris, at the cost of half a million francs. Designed and furnished by her, its distinctive eclecticism combined medieval and Oriental features, collections of Asian objects and antiques, animal rugs and Persian and North African woven carpets with strategically placed pots of large indoor plants. This space, with its high windows on the left and opening onto a distant garden, is a place of work. It is also in itself a work, allowing a reflex between its maker and its occupant defined by an all-encompassing aesthetic shaped by the commercial and colonial relays between Europe and its others across which an artist – herself othered by her femininity and her Jewish heritage – staged her own life and made her art.

The strong influence of Bernhardt's interior design as a means of defining a singular artistic space is apparent in the studio space that Louise Abbéma composed and portrayed in her painting of 1885 depicting a late afternoon 'at home' in her studio (Figure 5.4). Here is an informal gathering of friends and family amongst rich cushions, a draped arras with divan, Japanese lacquer and ceramics, as well as indoor plants and a large tiger skin on the floor.[7]

Louise Abbéma's *Le Déjeuner dans la Serre* (Figure 5.1) is, I propose, a representation of a studio space in Sarah Bernhardt's specially fashioned and personalized home in which the actress–artist is the luminous and hospitable centre of an informal sociality traversing the generations. Yet what *differences* Abbéma's painting is the lack of an over-dramatization of an exoticizing representation of the sinuous, dark-haired beauty. Spreading the scene across a large horizontal canvas places the viewer in the room as the carpet covering the sofa and the sweep of dress spill towards the lower edge of the picture. This proximity allows the viewer to read the painting for personality rather than type, for expression rather than pose, and, grasping the singular character of each person represented, thus to see, by means of its calculated compositional strategy, the relay of social contact and exchange: intimacy and sociality as it is created in this the world of Sarah Bernhardt.

Thus Abbéma's painting does not offer yet another image of the iconic Sarah Bernhardt. Instead it sets a person into the frame of an intimate, social gathering, taking place in the interior of her specially created home, shown as comfortably informal, richly but not excessively furnished with selected items from India, Africa, Asia. Unlike Manet's addition of discarded attributes of the *pompier* studio, these elements are active components of a created world; they serve to set off its causing subject – Sarah Bernhardt – while also integrating her into a milieu of individuated members of her own and friends' families. To underline the semiotic freight of the colonial, orientalist environment in signifying both difference and self-definition on the part of the complex persona of Sarah Bernhardt as perceived by those in

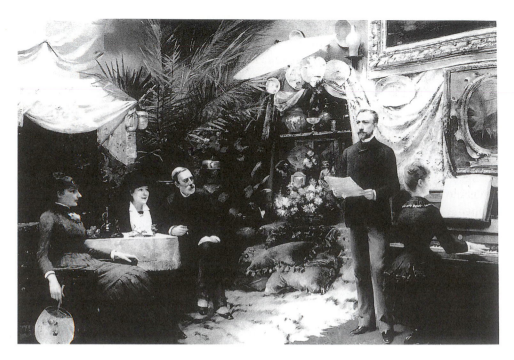

5.4 Louise Abbéma, *Le Chanson de l'après-midi (Singing in the Afternoon)*, 150 X 220 cm, oil on canvas, 1885

her intimate circle, a painting by another of her intimates, the Belgian painter Alfred Stevens, can help. In this grand painting of the salon in his own specially decorated apartment on the rue des Martyrs, *Le Salon du Peintre* (1880, private collection), the artist's collection of paintings, Chinese screens and Oriental carpets are, none the less, set within the gilded mirrors and formally upholstered chairs and settees of seventeenth- and eighteenth-century French furniture that determine the body postures and social interactions of formally dressed women.

In Abbéma's painting, reclining and a little aloof, in a pose between reverie and observation, the artist takes her place within the created scene, identifying herself with the issue of vision that is central to her role as the painter, the creator of images. Self-fashioning in her own distinctive costume and features, she places herself both as a member of the gathering and in a more intimate proximity to her lover in a gesture so obvious and yet so subtle that it has passed unsaid or unacknowledged both by contemporary critics and recent art historians. The physical proximity of these two women's bodies means they form the de-centred couple in a painting where space between every other figure marks the visualization of social intercourse. It

could be argued that this reclining figure, extending out to the extreme right of the painting ties in the extreme left of the canvas through the a horizontal eye-line match that traverses the canvas to connect with the seated figure of Emile de Narjac. His gaze rises, however, to meet that of the standing man we think is Monsieur Abbéma before being returned and endorsed by the seated Madame Abbéma. Turned away and hidden, the child at the table reaching on tiptoes for the fruit, gazes into the face of the seated hostess, interrupting this sequence. To this child is permitted the sight of the face of the picture's central and defining figure, introducing against that exchange of masculine conversation the poignancy of connection and affection both invisible and yet rendered in a way as innocuous as it is intense. Louise Abbéma met Sarah Bernhardt when she was only thirteen, and clearly remained caught up with the artist; it was Bernhardt that she portrayed in her major statement of coming of age as an artist following the exhibition of a portrait of her mother in her Salon début in 1875. This figure of luminous dignity in Abbéma's painting forms a diagonal axis with the seated Bernhardt, sharing the angle of her head and a quality of attention to an other.

While clearly appearing to its immediate publics as a painting of a social scene whose recognizable participants remained tacitly unnamed, this painting uses the pictorial creation of a viable and identifiable architectural space to project an image whose meanings extend from the reverie of the reclining woman whom I identify as a representation of the artist: she who sees, she who thinks, she who feels and desires, and she who combines these elements of subjectivity into a form of visual representation in which the painting of an interior space – a studio space – becomes the means of signifying both a psychological interiority and a desire for a woman, Sarah Bernhardt, who, in being imaged and imagined, is never reduced to mere icon. Creating this painted space places the artist off-centre. Yet in being there, shown looking, she becomes the site of an encompassing gaze in which several elements of her history, her biography, her present – family and love, art and thought – combine in an image whose configurations have, however, not only remained unread but been displaced by the suggestion of a Bernhardt sister, rather than a lover.

This was, I suggest, noticed at the Salon of 1877, if only registered negatively or by silence, turning away from what is now becoming clearer as a radical statement of female artistic ambition and lesbian desire. Edmond Duranty called the work an 'incomprehensible interior' and both he and critic Paul Mantz lectured the artist in their reviews on the lack of enveloping harmonies, which would subdue the harsh colour and the intense brilliance that set off the individuals rather than creating a single unified whole, i.e., that would render the specific plottings of two scenarios within the work inivisible. Mantz noticed

that there was a purpose in the play of illumination from an unseen high point, but not what it set up as the visual plot of the painting (Lecocq, 1879, 14–15). Irritated by her daring engagement with an acrid colouring and untempered whites associated with early impressionism and with the work of Manet from the 1860s, the critics refused to engage with the subject of a painting that might otherwise appear unexceptional. Through its calculated structure, colouring and mobilization of skills in portraiture, however, Abbéma's painting creates too many interruptions to the normalizing representation of the bourgeois family interior relaxing after a friendly meal, for each individuated woman is present in a way that escapes stereotyping as matron, mother, fashionable woman and so forth. But equally, there is clearly a purpose in these combinations, not created, as are Manet's, precisely to baulk the novelistic expectations of meaning. The painting works between the conventions of the portrait, biographical reference and a modern contemporary genre scene to seek a way to allow the space of the bourgeois interior not to be the mirror of the decorative surface expected of 'Woman at Home'. Here women listen, think, talk and relate across space in ways that a painting practice informed by progressive radicalism, but resistant to its modernist loss of psychological and signifying potential, carefully plotted out and pictorially realized.

Following Mieke Bal (2000), I am reading *Le Déjeuner dans la Serre* as a proposition made through those elements of painting that allow the thought and the felt to achieve visualization by means of a reworking of the visual rhetoric of the image. The proposition involves presenting women as sentient, thinking, feeling and desiring subjects situated within their own self-fashioning and self-affirming environments where colonial collecting is used by European women to declare their own world-making. If the critical question of modernity and sexual difference would subsequently ask what a woman actually wants, this painting offered a large statement sixty years before Freud finally formulated the question.

Louise Abbéma's passionate desire for the greatest actress of her time, and her identification with its most renowned woman painters, is the historical condition that opens up the space between image and act, between performance and performativity, between spectacle and self-fashioning that feminist thought and historical cultural reflection allows to re-emerge, making it possible to reconstrue images that the viewer often does not know how to read. It is time now to turn to other interiors. But first a visit to two doctors is necessary.

SPACE, INTERIORITY AND FEMININE SUBJECTIVITY

To begin: a simple contrast between the public medical space in which Jean Martin Charcot lectured on hysteria, the epidemic affliction of pre-feminist

nineteenth-century femininity, and the interior of Sigmund Freud's final home at 20 Maresfield Gardens, where he reconstructed his consulting room from 19 Berggasse, Vienna, and hung a print, after André Brouillhet's painting, of *Charcot's Tuesday Lectures at Salpetrière* over the analysand's couch (Figure 5.5). In the print a woman's unconscious body is the sign of an experimental demonstration of the medical expert whom the image both portrays (it shows a recognizable historical individual, Jean-Martin Charcot) and allegorizes as the man of science. The image of the hysteric borrows its bodily rhetorics from a scientifically inspired creation of a photographic iconography directed by the art historically astute Charcot, in which the 'passionate attitudes' identified with progressive phases of an hysterical attack – plotted along an epileptoid trajectory – were represented in a medical restaging of Le Brun's *têtes d'expression*, also drawing extensively on contemporary theatricality, also circulated through contemporary photography, notably of the leading actor of her moment, Sarah Bernhardt.

The photograph of Freud's last consulting room frames the medical scene of Charcot and his performing patient as an image on its wall amongst a collection of classical and Egyptian statuettes, books and other pictures. At its centre, however, is a couch, covered with rich Persian and North African carpets and cushions, a couch that is not quite – but not distant from – the sofa of the harem or the divan of the orientalist interior. Yet Freud's orientalist use of non-European artefacts, colours, textures and furniture needs to be acknowledged in order to understand the visual semiotics by which the space in which psychoanalysis was made was changed from a medical setting to become the *mise en scène* of psychological interiority, the dream space of psychoanalysis and its journey to the 'other scene': the unconscious. On a couch, which is not for formal social sitting and which is equally not a bed but is for resting or reclining, not a patient, but an analysand will explore, through free-floating *verbal* associations offered to a listening (rather than lecturing) Other, his or her own unconscious as an other, invisible, interior *scene/seen*. Thus, the Freudian interior implicitly reverses the terms installed by the image of Charcot displacing his officialized medical gaze and woman as spectacle for a process premised on informal, associative conversation: a sociality adapted to investigation of human interiority which will begin its revolutionary intervention precisely in 'conversation' with women.

Between these two poles, one a theatrical visual regime attributed to Charcot by his Viennese pupil (Freud called Charcot *un visuel*) with its rhetorical performance by the posed and gesturing body and the acoustic space of a psychoanalytical concept of a fantasizing subjectivity turning inward on the carpet-covered and cushioned divan, investing its remembered body with meaning and desire, it is possible to move onto yet another interior: a studio, which weaves together these tissues of seeing,

5.5 Sigmund Freud's consulting room and study, 20 Maresfield Gardens, London

enacting, subjectivity and creativity around a richly red sofa/couch with its own orientalist performance, offering in a work by a man, nonetheless, a feminist counterpoint. Is it possible, however, to study nineteenth-century images of interiors and women to plot the space of subjectivity that provided a non-hysterical visualization of subjectivity – notably feminine subjectivity – in the European art of the later nineteenth century?

In the Studio, 1888

In the Studio by Alfred Stevens, dated 1888 (Figure 5.6), catches up, in a network of glances that traverse a central absence, three female figures in what Stevens renders as the imagined site of artistic production, that is, another important symbolic interior. The studio, entering slowly into nineteenth-century visual art and photography, would become a critical trope of modernist painters' self-reflexivity in the early twentieth century;

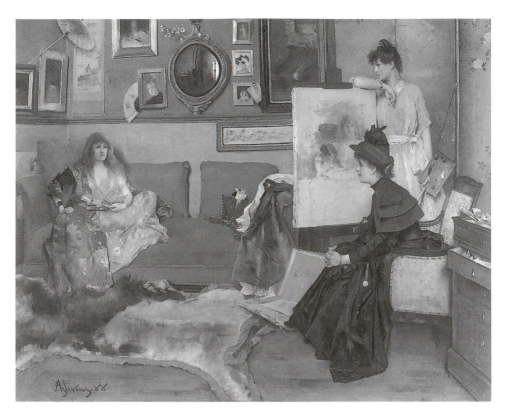

5.6 Alfred Stevens, *In the Studio*, 105 × 134 cm, oil on canvas, 1888

until Matisse, few so consistently painted this space as an exploration of what art means as Stevens. In Stevens's work, the representation of an interior becomes the iconic sign that visualizes a subjective condition: the artist, who can never be signified simply by a portrait of the man or woman with professional attributes. To visualize what an artist is, the scenario must stage both seeing and being seen; it must create the space in which we see the active process of seeing as both a form of work and as a psychological process defining its subject. The external sight – a figure shown seeing – makes visible an invisible operation: art.

In Stevens's canvas this drama is projected across a space triangulated by a trio of women, each signifying by their dress and attributes a facet of a condition that taken collectively performs this dialectic and more. In addition to the representation of three figures seeing or being seen, 'fictive' looks gaze down from the back wall, which is punctuated by gilt-framed paintings. As copies – such as the tiny panel after Velázquez – these already inscribe a

double viewing and representing. These paintings within the painting reverse the gaze, and look back at the spectatorial viewpoint. At the painting's off-centre core a convex mirror, reminiscent of the one in the *Arnolfini Portrait* by Van Eyck (1434, London: National Gallery), reflects a more mundane stereotype of the artist's studio's heating and its light source in a small, partially revealed window. Yet the mirror does not catch in its surface the image of the painter painting, before whom this feminized scenario of painting is staged. It sees nothing, and shows no one, indexing the activity but reflecting back its agency into the visual scene and its three female protagonists.

Beside a small cabinet with one of its drawers partially opened, in a chair in which the artist herself was recently seated before her canvas, sits a fashionably dressed woman in an expanse of smart, daytime black punctured by an ornament, her fob watch, dangling from her waist, her folded hands and her attentive profile reminiscent of the eager posture turned into profile from Edgar Degas's perplexing portrait of fellow artist Mary Cassatt (1880–84, Washington: National Portrait Gallery). This well-dressed visitor to the studio looks across the space to the divan on which is seated a woman with flowing hair, dressed in a deep orange-gold, embroidered garment which is gauzy and semi-transparent at the arms and over the breasts. A heavy, silken Japanese gown with a glittering golden hem hangs over one arm and shoulder while its blue silk lining is visible behind her raised knee. She is seated in an unusual and indeed daring pose, with one leg raised on the divan and both legs spread wide apart with only gauzy cloth to shield the gaze from her sex. On her lap are a golden platter and a jewelled knife; these are the iconographic attributes of the Biblical figure of Salomé, the dancing princess whose sexual appeal to her elderly stepfather encompassed the decapitation of John the Baptist.

A version of this figure reappears in roughly blocked-in areas of colour on the canvas against which the woman in black is silhouetted. The painting shows only the traced outlines of the pose with an elbow bowed out and the smudge of red cushion behind her loosened hair. It signifies the magic of artistic creation as *matière*, process and fabrication through the slowly layered veils of colour effects. The mirroring of model and image links the two sides of the canvas across which are strung two gazes, both fixed on the seated woman in fancy dress whose face appears utterly impassive and unconnected to the two women who so intently gaze at her. She sees nothing but waits to be found again by her portrayer, who has momentarily stepped aside from her seat in front of her angled canvas to allow her visitor to occupy her former line of sight.

In a loose gown tied at the waist with a lilac sash, this painter is shown in sharp profile, elbow leaning possessively on the canvas behind which she

appears to stand, holding the palette on which the red, white, brown and black pigments already used in the *ébauche* on the canvas are visible. Painter, visiting connoisseur and model: three figures of the world of art are caught in the painting's stillness. Two look but not at the painting. They look only at the model rising up out of the spread-eagled animal skin rug in her gorgeous, *fantasiste* Oriental attire, with her deep, dark eyes staring hieratically out of an impassive face. The model's own contemporary clothes, that would make her appear just like the visitor, part of the present, here and now, lie discarded on the other end of the couch. They form, for the art historians, an intertextual reference to a contemporary Salon painting: *Rolla* of 1878 (Bordeaux: Musée des beaux arts) by Stevens's one-time pupil Henri Gervex, based on a poem (1833) by de Musset, in which Rolla, a decadent young man, has spent all he has for one night with a famous courtesan, Marion, who lies naked upon the bed while he himself pauses before leaping from the window to end it all. Stevens's placement of the model's clothes recalls Degas's legendary advice to Gervex to show the discarded corset of the naked courtesan as the sign by which his nude would be scandalously modernized. The racy, red-ribboned corset would signify the sexual commerce of transition from clothedness to nakedness that the permanent and ideal nudity of art should banish from all contemplation of a painting. The folded street clothes on the divan in Stevens's painting, however, do more. They establish the masquerade, and thus the artifice of artistic invention as a made-up studio job, and suggest a passage from one kind of modern femininity to someone else's fantasy: a fantasy for some European men of racial otherness, vice and sexual threat, but also an image for European women of exotic sexuality and female desire, stories of which they might see dramatically performed by great tragediennes upon the stage. By introducing the theme of theatricality and its potential to offer differencing, even identificatory, meanings for women spectators in the nineteenth century, we are reminded that Mary Cassatt's opening modernist gambit in 1878 was a series of paintings of women at the theatre, preoccupied with their own looking, sometimes dressed in smart, matinée black.

Stevens's painting is paradoxical; it gives and takes back in equal degrees, promising to some the unusual delight of contemplating the conjugation, in representation, of woman and creativity, woman and intelligence, while binding both of these to a proto-symbolist fascination with woman as threat and sexual danger, all of whom are encompassed in the gaze of the actual, but absent, painter rendered masculine by his otherness of seeing the seen and from whose exterior position of production we, the proposed viewer of the whole painted *mise en scène*, encounter and experience it. Like Freud's metonymically signified presence in his consulting room, the artist who made this painting is an indexical effect of the iconic signifiers that are not of,

but stand for, his creativity. Thus, in *In the Studio*, the three spaces are apparent: the space being represented, the studio; the space of representation, the actual spatial relations and configuration on canvas which figures three faces of the feminine; and, finally, there is the space, a masculinized one, from which the representation is made – that is, the one that predisposes structurally the viewer's experience and the meanings that the viewer is positioned to receive.

To make sense of this painting is to be placed in the position of the historic, classed and culturally situated masculinity from which it was made: to see it as a feminist historian is, however, to track down that structure and mirror back, Medusa-like, a critical and intrigued, but not deadly, gaze that desires a difference that the painting, none the less, allows into visibility – through political desire for the historic woman of which it indirectly speaks. So I ask, what does it show us, this painting of three women, this image of two women at work, of two women actively seeing, thinking about the question of making images, of imagining, of seeking reflection and difference in the space of art and art-making? What, we might ask, does the model perform for the women who look at her, rather than the painting, with such intense regard?

ACTING, CREATING, THINKING

The third female figure, the model, is clearly posing. But it could also be said that she is acting the role of Salomé – a subject painted by Stevens in 1888. Is it his painting that the painted painter appears to be imagining and creating? I do not think so. This delicately featured red-haired model has not the Egyptian face of Stevens's *Salomé* (1888, Brussels: Royal Museum of Fine Arts). Her pose is rather a compound of Stevens's frontal and seated half-figure and the *Salomé* exhibited at the Salon of 1870 by Henri Regnault (1870, New York: Metropolitan Museum of Art), here relieved of its excessive sensuality in favour of a more psychologically enigmatic reading of the role. The barely brushed-in *ébauche* of this figure with her semi-veiled, hieratic face and staring eyes gazes out at the viewer from the canvas with considerable dignity and self-mastery. She imposes herself between the informally dressed artist in sharp and, I suggest, recognizably famous profile and the pert visitor, whose astonishing hat evokes the famous bat hat created for and worn by Sarah Bernhardt and shown in a photograph by Nadar dated 1883. The artist in profile clearly evokes the tragedienne.

In Stevens's painting, two women – modern in their active involvement in art as maker and connoisseur – gaze intently across the surface of the painting at a contemporary woman, masquerading as a legend, one of Christian literature's most dangerously destructive seductresses and

vicarious murderers, the object of endless interrogation and fictional imagining by French and Irish writers from Flaubert to Mallarmé and Oscar Wilde, who would conceive his outrageous *Salomé* in Paris in 1891 and write it in French especially for Sarah Bernhardt to play. (It was staged by Lugné-Poe in Paris in February 1896 without her, although she rehearsed the role for a forbidden performance in London in 1892).

While I agree with Peter Mitchell, therefore, that the painter in *In the Studio* is Sarah Bernhardt, I think it is a matter of intended but oblique reference rather than portraiture.[8] The famous actress became a pupil and a close associate of Alfred Stevens from the moment she took up the arts when ill health forced her partial retirement from the theatre for a period around 1874.[9] Stevens is known to have painted at least five images of Sarah Bernhardt over the years of their continuing friendship. *Fedora* of 1882 (New York: private collection) pictures the actress in the costume and role of Fedora from the Sardou play of 1881, performed in 1882 in Paris. The face is not a portrait; it represents a moment of the character's reverie. A second painting dates from 1885 (Los Angeles: UCLA Hammer Museum) and is, by contrast, what should be called an intimate portrait. Against shimmering light that makes her red hair glow, Stevens represents the artist/actress's pale skin and intense blue-grey eyes, set off by the matching ribbon at her neck. Against harmonies of golds, browns and blacks, a vivid flash of colour marks her white and pink corsage. This is a rare instance of special intimacy and particularity for Stevens, who almost never painted a portrait.

The final painting of the sequence (*c*.1890, private collection) falls between portrait and genre for it shows Sarah Bernhardt neither in a role nor as a portrait, but as the artist in her studio.[10] The artist's conventional attire, dress and apron, contrasts with some famous photographs of Sarah Bernhardt in the 1870s *à l'artiste* in a specially designed Worth 'pant suit', which she called her boy's clothes. None of these images of Sarah Bernhardt in role, in person, as artist, however, match the dissembled complexity of conception and *mise en scène* of Stevens's *In the Studio* (Figure 5.6). Their existence and variety, however, supports my proposal to read all *three* women in *In the Studio* as facets of Sarah Bernhardt. Not as icon or celebrity, these three conditions are the signifiers of a more complex representation of femininity, creativity, and interiority precisely because Sarah Bernhardt herself worked, professionally and creatively across the spaces and modes of representation between theatrical imag(in)ing and visual representation in painting and as an artist.

None of the three figures is, therefore, intended as a *portrayal* of Sarah Bernhardt. Yet all these facets are part of an interest in the complexity of her otherness as woman, as artist, as creator of dramatic roles. The only one that approximates to the historical Sarah Bernhardt as she authored herself as artist is, in a paradoxical way, the red-haired, staring model dressed up in

exotic costume. As woman assuming a role, she is meant to evoke the dramatic assumption of a character into whose psyche the actor must penetrate in order to reveal it through external bodily gesture and facial expression, a mode of being or even extimacy that is called acting.

Close readings of the spaces and socialities of two non-canonical paintings in the larger context of a feminist re-reading of a third, theatrical and imaginary space show how paintings created outward and visible signs of an inward and invisible feminine subjectivity in the space of studio, sociality and self-fashioning. This may explain why so many interesting artists who were women chose to practise in this art historically exnominated space between past and present, between genre and modernist *matière*, still intrigued by how painting could produce through its particular modes of space the extimacy of subjectivity around the figure of woman as (self-) creator.

References

Bal, M., *Looking In: The Art of Viewing*, London: Routledge, 2000.

Brontë, C., *Villette*, ed. Mark Tilly, Harmondsworth: Penguin Books, 1979 (1853).

Coles, W.A., *Alfred Stevens*, Ann Arbor: University of Michigan Museum of Art, 1977.

Didi-Huberman, G., *L'Invention de l'hysterie: Charcot et l'iconographie photographique de Salpetrière*, Paris: Macula, 1992; *Invention of Hysteria: Charcot and the Photographic Iconography of the Salpetrière*, trans. Alisa Hartz, Cambridge, Mass.: The MIT Press, 2003.

Farwell, B., 'Manet, Morisot and Propriety,' in Teri Edelstein, (ed.), *Perspectives on Morisot*, New York; Hudson Hills Press, 1990.

Guibert, N. (ed.), *Portrait(s) de Sarah Bernhardt*, Paris: Bibliothèque nationale de France, 2000.

Lecocq, G., *Louise Abbéma*, Paris: Librairie des bibliophiles, 1879, 14–15.

Pollock, G., *Differencing the Canon: Feminist Desire and the Writing of Art's Histories*, London: Routledge, 1999.

———, *Mary Cassatt: Painter of Modern Women*, London: Thames and Hudson, 1999.

Schurr, G., *Petits maîtres de la Peinture 1820–1920*, Paris: Editions de l'Amateur, 1975.

Spivak, G.C., *In Other Worlds: Essays in Cultural Politics*, New York: Methuen, 1987.

Stanton, T., *Reminiscenes of Rosa Bonheur*, London: Andres Melrose, 1910.

Notes

1 Carol Ockman, 'When is a Jewish Star Just a Star? Interpreting Images of Sarah Bernhardt', in Linda Nochlin and Tamar Garb, (eds), *The Jew in the Text*, London: Thames and Hudson Ltd., 1995, 121–39; Janis Bergman-Carton, 'Negotiating the Categories: Sarah Bernhardt and the Possibilities of Jewishness', *Art Journal*, Summer 1996, 55–64; *Sarah Bernhardt and Her Times*, New York: Wildenstein, 13 November – 28 December 1984; David B. Winter, *Sarah Bernhardt 1844–1923*, London: Ferrers Gallery, 1973.

2 Louise Abbéma has a substantial entry in Delia Gaze, (ed.), *Dictionary of Women Artists*, London and Chicago: Fitzroy Dearborn, 1997, written by Dominique Lobstein, of the Documentation at the Musée d'Orsay. There are no monographs or articles on the artist and no special studies of any of her major works.

3 Adolphe Tabarant identified the sitters as Jules Guillemet and his American wife, owners of a well-known fashion house at 19 rue du Faubourg St Honoré, although the standing man with cigar also bears a resemblance to Manet himself, who wrote playful letters to Mme Guillemet about her couture – drawing her stockinged and shod feet beneath a pleated skirt in a watercolour in a letter of 1880. Françoise Cachin et al., *Manet 1832–1880*, Paris: Réunion des musées nationaux, 1983, 434 and 458. The catalogue also remarks on the recurrence of the cigar smoker in this painting referring also to *Déjeuner dans l'Atelier*. This painting is situated in a real conservatory that was part of the studio Manet rented at 70 rue d'Amsterdam, 1878–79.

4 The catalogue author in *Le Parisien chez lui au xixième siècle*, Paris: Archives nationales, 1976–77, entry no. 650.

5 The self-portrait is annotated with a dedication and a date – 1923 – but in style and from the age of the sitter, the painting must be contemporary with the *Luncheon in the Conservatory*. Miranda Mason is researching Sarah Bernhardt and Louise Abbéma at the University of Leeds and I am grateful for her decisive help in developing this reading of the painting.

6 Sofa is a Turkish word for the raised dais covered with rugs and cushions that surrounds the common room in a harem, on which the women lounge, visit, drink coffee and smoke, stressing the projection of erotic fantasies in European Orientalism. Farwell discusses Manet's use of the reclining pose for female sitters on divans and sofas thus exposing their respectability to public impugning.

7 Gabriel Weisberg, in his entry for the sale catalogue (Sotheby's, New York, 2 May 1995, lot 282) quotes Louis Ennault, *Paris-Salon*, 1885: 'Buen-Retiro délicieux, avec ses curiosités bien choisies, ses objects d'arte de grand style, et la grâce aimable et hospitalière de celle qui en fait les honneurs a ses amis comme une jeune Muse cortoise et souriante, l'atelier de Mlle. Louise Abbéma est chaque jour, de quatre à six heures, un des petits coins les plus agréables de notre grand Paris… *La chanson de l'après-midi* – c'est le titre du tableau qui reproduit cette jolie scene d'intérieur avec une facilité gracieuse et une fidelité spirituelle.' I am grateful to Dominique Lobstein of the Musée d'Orsay for assistance in finding material on Louise Abbéma.

8 Peter Mitchell, the art dealer who has worked extensively on Stevens, makes this proposed identification.

9 Stevens had many students: Berthe Art, Marie Collart, Georgette Meunier to name but three of the Belgians trained by him. Katlijne van Stighelen and Mirjam Westen, *A chacun sa grace: femmes artistes en Belgique et aux Pays Bas 1500–1950*, Gent: Ludion, 1999.

10 William Coles's scholarship provides the basis for much current work on this artist.

Women patron-builders in Britain: identity, difference and memory in spatial and material culture

Lynne Walker

For many women artists, designers and architects based in Britain in the nineteenth century, the studio was located in the domestic space of the home. Whether in new or refurbished buildings, creative middle-class women devised, altered and/or subverted private space, redefining the home to advance social, political and artistic projects and to promote cultural change. These domestic practices were allied with cultural entrepreneurship and building outside the home in the wider public sphere of women's education, health care and public affairs. Thus, in the space between diverse intersections – of public and private, of the artistic and social, of the personal and political – social and physical spaces were made for the production of new subjectivities, knowledges and opportunities. Women patrons, too, planned projects, commissioned architects, provided financial resources through donation and fund-raising, organized support through writing and lecturing, and, in a more hands-on way, selected building sites, led building committees, negotiated with architects and supervised builders. However, the domestic space of home and studio and the spatialities associated with the organizations, networks and agenda of women's movements were among the diverse sites in which women made interventions in nineteenth-century spatial and material culture, ranging from the abolition of slavery to abstinence from alcohol, from housing the rural poor to the moral and physical regeneration of cities. In addition, while the women's movement was a particularly fertile ground for architectural and cultural production, there was considerable social and political diversity between women patrons, as well as between their tightly meshed connections through organizations and informal circles of friendship and family ties. For example, the sculptor HRH Princess Louise, Queen Victoria's daughter, commissioned architect-designed and architect-decorated studios at Kensington Palace, and the anti-

suffragist Mary Ward, the novelist and philanthropist, built the Passmore Edwards Settlement House in Bloomsbury, in central London.

Bringing together feminist and post-colonial studies, this chapter connects the domestic space of the home and concepts of home in a global sense, as a representation in Britain and its empire of national identity, nation and homeland, and as a matrix for social and cultural reform. By interrogating these representations across themes of identity, difference and memory, a critical reading of architectural projects develops that removes divisions which have separated a consideration of colonial discourse and women's participation in nineteenth-century spatial and material culture in Britain. Grounding investigations in the global space of empire and focusing on the activities of women builders, designers and users of the built environment in Britain, I argue here that the operation of cultural and spatial strategies undertaken by women producers and consumers challenged dominant institutions' powerful control of material provision and spatial definitions. Nevertheless, these new spaces, both physical and social, and the practices of their makers and users, need to be explained as part of and embedded in – as well as resistant to – colonial discourse.

IDENTITY

Combined with the idea of the home, and emphasized in this chapter, is the physical, material house and its interior spaces, its surroundings and occupants. Although Amos Rapaport has warned that considering house and home together can lead to a confusion of terms (Rappaport, 1995), the slippages between house and home, from metaphor to material fact, from the symbolic to the physical, from spatiality to decoration, from the imaginative to the functional, constitute and complicate understanding of the concept of home and its implications for nineteenth- and early twentieth-century culture in colony and metropolis. Central to this understanding is home as house *and* home. How the house and its spaces were employed and occupied; how it was laid out and decorated; how it was fitted and furnished; these were all central to the making of identity and to lived experiences of space. Spatiality participates in the structuring and production of subjectivities and identities; as well as playing a crucial role as the site of the contestation of meanings that in part determines ideas and feelings about social relations between genders, sexualities, age groups and classes. Historians writing since the 1970s have depicted the Victorian home in England as the site where middle-class beliefs about 'proper' social relations and the positionality of men and women in nineteenth-century culture and society were inscribed in the fabric of the building and embodied in its physical and social spaces (Franklin, 1970; Girouard, 1971; Walker, 2001). Sharon Haar and Christopher Reed have

identified the dynamics and impact of this interactive spatiality as the 'embeddedness of identity within normative structures of home' (Haar and Reed, 2000, 272). Spatial definitions and cultural conventions about how space should be segmented according to hierarchies of gender, class and age were in circulation, for example, through design books for architects, but these definitions had to be constantly repeated and performed, and their meanings reproduced through use and perceived through experience. As a result, spatial definitions and divisions, although culturally sanctioned, were not immutable but were amenable to the intervention of living agents. Space, its regimes and cultural knowledges, therefore, were – and are – open to rethinking and reconfiguration, as well as subject to change through use.

Art and politics were powerful grounds for rethinking the domestic space of home; they produced new identitites and new subjectivities for women. After selling Arts and Crafts products from a shop below her home in the Hampstead Road Emmeline Pankhurst (to become a noted suffrage campaigner) moved her family to No. 8 Russell Square in Bloomsbury. There she elided public and private space to political ends, adapting her house for meetings and receiving a stream of diverse political visitors. The Pankhurst home would have been decorated along the lines of the goods that she sold at her new shop off Oxford Street: 'old Persian plates, Chinese teapots, oriental brasses', fabric in the Arts and Crafts style and Turkish carpets (Purvis, 2003, 27). These, and similar 'aesthetic' things, often imported from Asia, were among the components of what Judith Neiswander has called 'the liberal interior' (Neiswander, 1988, 91). In contrast to the darker, more masculine, moral interior of the previous generation or the later, profoundly anglicized, Arts and Crafts, the considered, tasteful mixing of old styles, goods from the East and those newly minted by the Aesthetic Movement were arranged with authority and taste by the woman of the house. Favoured by progressive people in the late nineteenth century, 'the liberal interior' was informed by liberal principles of individuality, elitism, science and cosmopolitanism and was noted for the enlarged role it gave to women in its selection and arrangement.[1] However, while less insistently imperial than the later rhetoric of the Arts and Crafts movement, liberal cosmopolitanism allied to the unencumbered borrowing, selection and mixing of styles and goods from around the world can be read now, from a post-colonial perspective, as incorporating domestic spatialities and material culture within discourses of imperialism and expansion. Catherine Pagini has contextualized the Victorian enthusiasm for Chinese art in relation to the British success in the Opium Wars (1839–1842) and linked it to 'sentiments of cultural and moral superiority', meanings which survived into the later part of the nineteenth century (Pagani, 1998, 28–9). She argues that after 1842,

because China and the Chinese after the end of the wars were depicted unfavourably as 'uncivilized', Chinese art was even more coveted and highly acclaimed than previously. Similar anomalies resided in Liberal, Gladstonian thought: advocates of the strength of empire 'at home' could be combined with an opposition to colonial wars.

Emmeline Pankhurst used her home as a political base for herself and her husband, who was ambitious to become a Liberal Member of Parliament. But what is most significant is how she employed performance and self-representation, creating in her home an identity as a modern, public woman. Within spatial and material cultures, threaded with imperial meanings, she defined, represented and performed a classed femininity and national identity expressed through her artistic sensibilities, fashionable taste and hospitality. For the suffragist Millicent Fawcett the home was 'the most important institution in the country' (Fawcett, n.d.). Within the bounds of 'enlightened' middle-class respectability, Emmeline Pankhurst used that significance and its moral authority, combining it with feminine, artistic taste that carried imperial weight and fantasies. Thus by joining the artistic and the domestic, Emmeline Pankhurst moved beyond them both, taking up an identity as a public woman to intervene in public affairs away from home, so making full use of her position within the powerful matrix of empire and class.

Eliding politics and home was a strategy adopted by an earlier generation of female anti-slavery campaigners, but from the mid-1870s, designers and feminists, Agnes Garrett and her cousin Rhoda Garrett, ran their practice from their house in Gower Street where they had a studio, trained pupils, received clients and, as Elizabeth Crawford has convincingly demonstrated, used the interiors of their residence not only as a showroom for their designs but as the basis for the illustrations in their book *Suggestions for House Decoration in Painting, Woodwork, and Furniture* (Crawford, 2002, 177). However, the use of personal space to produce an identity as a professional, artistic woman active in public affairs was perhaps most fully developed by the artist, feminist and benefactor, Barbara Leigh Smith Bodichon. She had her studio(s) at home, but she also used domestic space to generate and maintain public organizations and social networks associated with the women's movement and to establish and organize many of its activities, including female suffrage, employment, education and property rights. Operating in a global spatiality between Britain and North Africa and between town and country in England – from her town houses in Marylebone and Hastings, to two country cottages in Sussex and Cornwall and a home in Algeria – she recruited new members to the women's movement; brought congenial people together for professional or political ends; and supported and encouraged students at Girton, the Cambridge women's college, which she assisted financially and helped to

found, plan (architecturally) and decorate, and whose first candidates were examined in her London residence (Girton Archive, e.g. 1874 and 1875; Perry and Sparks, 1991, 5).

If professional identity was shaped within the private space of home and in the public world of politics and philanthropy, it equally was defined in relation to the contrasting yet overlapping spatialities and sensibilities of city and country. In the countryside, the domestic space of home became a site of self-fashioning and professional consolidation for Bodichon who designed Scalands Gate, near Robertsbridge (1860, with additions 1878–9), a house in the country, built on the model of a small Sussex manor house (Figure 6.1). Located near her family's country home, which held fond memories of her childhood, Scalands was an escape from urban pressures, but first and foremost it enabled Bodichon to work, to draw from nature, to paint in her studio and outdoors. Here, she invited friends to join collaborative projects in which the line between public and private endeavour was virtually erased. Some of the earliest discussions about Girton College were held at Scalands, and from 1878 Gertrude Jekyll designed its gardens, well before she set up in business as a horticulturist and garden-maker (Jekyll, 1934, 209). At this time, Jekyll and Bodichon were very close, having spent nearly half a year (1873) travelling together, visiting each other in London and Algiers and in Jekyll's home and studio, where Bodichon contributed drawings to an exhibition (Jekyll, 96; Festing, 1991, 88). Thus, it seems reasonable to suggest that Jekyll contributed to the design of the additions and alterations to Scalands, which she drew in plan in 1878 (University of California). By mid-century the idea of an artist or writer designing her own house in the country was not uncommon among progressive women. Harriet Martineau, whom Bodichon knew, had designed The Knoll (1846, University of Birmingham) in Ambleside in the Lake District. Like Jekyll's drawing, her plan shows an entrance porch, sitting room and large 'study' (called 'reading room' by the less earnest later Victorian), and above two bedrooms, a dressing room, servant's bedroom, storage and lavatory (evidence of their shared interest in the reform of domestic sanitation). In the simple vernacular interior of Scalands feminist culture was constituted and reproduced at the symbolic heart of the home, with its powerful associations with women's place. In a bonding ritual, the parlour fireplace and its brick surround were signed by distinguished guests (including George Eliot, Emily Davies and Hertha Ayrton) who rewrote the space of women's domestic labour and its limitations through the lived experience of art, social action and friendship.

In reconfiguring middle-class femininity, Elizabeth Garrett Anderson not only intervened in the visual culture of nineteenth-century Britain; she also transformed its spatial cultures and experience. The spatial relations of Garrett Anderson's medical practice were most fully represented in two

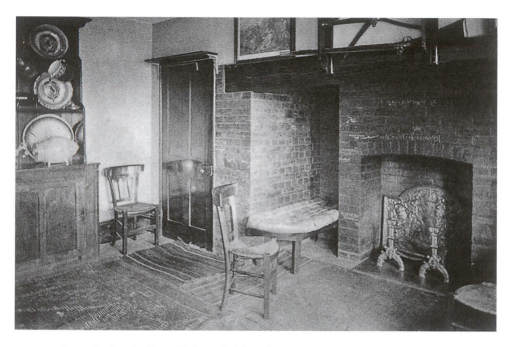

6.1 Scalands Gate, Robertsbridge, Sussex

buildings which she commissioned: the New Hospital for Women and her rebuilding of the London School of Medicine for Women in the 1890s. At the sites of both the hospital and the school, where her identity – as a learned woman, a practitioner of scientific medicine, and a bona fide member of the medical profession – was articulated, Garrett Anderson put into effect her ideas about the practice of medicine by women and for women (Cherry and Walker, 2002).

Within colonial discourse, Garrett Anderson, like Florence Nightingale, argued for a women's hospital and medical school precisely to educate British women doctors for service in India and for the training of Indian women. The colonial wars of the 1880s and the heightened feelings of loyalty to country and empire which they engendered provided the basis for what a contemporary called a wider 'sphere of usefulness' for women doctors to relieve the perceived suffering of 40 million women in India alone (Balfour, 1885). In a space of decorative and artistic display which was both feminist tactic and cultural negotiation, a fund-raising bazaar for the hospital identified the interests of middle-class women in the metropolis with the needs of sick and poor women in the colonies (Figure 6.2). Opened by a veiled Lady Salisbury and attended by 'Indian visitors', the bazaar's 'Indian

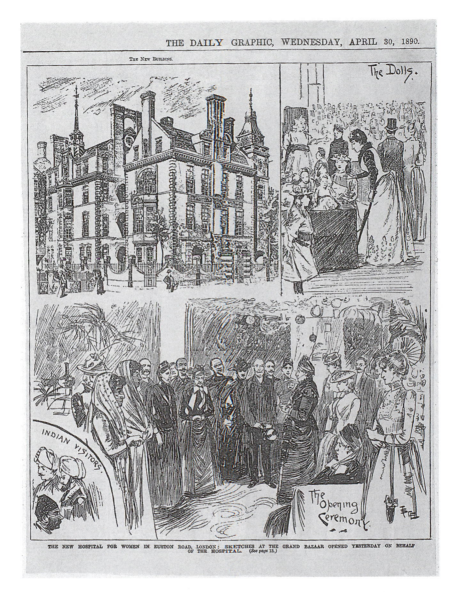

THE DAILY GRAPHIC, WEDNESDAY, APRIL 30, 1890.

THE NEW BUILDING.

The Dolls.

INDIAN VISITORS.

The Opening Ceremony.

THE NEW HOSPITAL FOR WOMEN IN EUSTON ROAD, LONDON : SKETCHES AT THE GRAND BAZAAR OPENED YESTERDAY ON BEHALF OF THE HOSPITAL. *(See page 13.)*

6.2 'The Indian Temple Bazaar', visitors and the New Hospital for Women, *Daily Graphic*, 30 April 1890

Temple' was described by the *Daily Graphic* as 'a room hung with Oriental draperies and filled with delightful fans, Benares brasswork and Indian carpets, and other beautiful Indian things' (*Daily Graphic*, 1890). The illustrator Kate Greenaway, a private patient of Dr Anderson, and Mrs

[Margaret] Oliphant, the prolific author, were among the contributors to this bazaar.

Visualizing desire for the artful, if needy, other, the bazaar and Garrett Anderson set forth a story that situated the debate for women's access to medical training and employment not only locally but in the globalized space within its nationalist narratives of empire, where the provision of women doctors could be seen as part of a philanthropic enterprise applied to colonial 'dependants'. Nevertheless, support was marshalled and developed with the assistance of wealthy Asians in India and Britain, and the school and hospital, which trained Indian women from 1890, were bolstered by aristocratic patrons and royals, including the Empress of India herself. The alliance of Asian and English women is exemplified by the attendance at the Indian-themed hospital bazaar of both Sophia Duleep Singh and Garrett Anderson and the WSPU's Black Friday March in 1910. Rosina Visnam has demonstrated that 'early Indian nationalists and their allies brought the struggle for justice and reform to Britain', influencing Parliament and public opinion and becoming involved in 'British political movements', including the campaigns of the women's movement (Visram, 2002).

Participating in a complex and influential wider network of professional status, patronage and recognition, Garrett Anderson was at the centre of a culture of sociality and space in which friends and relations, who were architects, patrons and clients, provided the initiative, cash and expertise to build a new public architecture associated with the women's movement, projects that included women's colleges, co-operative flats for educated middle-class women, women's clubs in the West End of London and restaurants for working women (Crawford, 2002; Rappaport, 2000; Vickery, 1999, Adams, 1996; Pearson, 1988).

While domestic spatiality advanced the public participation of artistic, professional and public women, individual identities which consciously masked a working life could also be produced. Louise Campbell has shown how the understated, tile-hung studio house which Kate Greenaway commissioned in north London from the architect Norman Shaw (1883–4), was both 'a key element in the creation of Greenaway's professional and artistic identity' (Campbell, 2003, 10), and also, to some extent, a 'masquerade'. Greenaway's house, she writes, 'served to endow with old-fashioned charm and to render individual, feminine and domestic what was in practice a highly disciplined routine in which the entire family was to some degree involved.' (Campbell, 14) To help to resolve the classed and gendered tensions elicited by her remarkable success (her first two books sold around 250,000 copies), Greenaway cloaked her hard work, soaring profits and lower middle-class origins with an unassertive, ladylike image that she configured through a countrified house and a simple, retiring

lifestyle, to rewrite the commercial art of the illustrator as a lady's accomplishment and to shield her from criticism and self-doubt. In spite of its vernacular unworldly air, Greenaway was provided with a studio 40 ft long, facing Hampstead Heath and adjoining a tearoom for the artist and her young models, who posed for her portrayals of a sweet, simple, pre-industrial childhood. Hidden away on the floors below, the well-ordered household, run by her family, supported and organized her work and contractual responsibilities (Campbell, 1–21; Girouard, 1977, 146).

The studio was both site of an artist's identity and a tool of her self-representation. Kate Greenaway's teas and her self-conscious modesty provided an alternative narrative to the late Victorian studio as a space of glamorous entertaining and the lavish display of artwork and accessories,[2] and to 'the collaborative studio project', in which artists shared a space and worked together, countering the mythologies of the individual, solitary artist (Helland, 1996). Margaret Macdonald and her sister Frances were among the many artists and designers in Glasgow to establish a collaborative practice, siting their studio at 128 Hope Street (1894–9). The Macdonald sisters were happy to let their work be jointly credited and, like many collaborators, their work was so intertwined that it is virtually impossible to identify individual contributions. Collaboration provoked some of their most distinctive metalwork, such as 'The Birth and Death of the Winds' (1895). When they married, the sisters closed their joint studio, continuing to collaborate with their marital partners (Charles Rennie Mackintosh and Herbert MacNair) in home-based studios.

DIFFERENCE

Reading the space of home against the wider spatiality of colony and metropole, as Antoinette Burton has suggested, can displace 'the Victorian home' from the metropolitan centre and challenge the 'originary status' of the English house (Burton, 2001). By extension, the space of the Victorian home can be seen as a product of the colonial encounter in terms of its material and symbolic forms, furnishings and decoration; it can be understood as a site of fantasy and desire – a hybrid in space, whose spatialities and material formations were forged intersticially between colony and metropolis. At another level within the social spaces of the home, subjectivities and identities were constituted, which incorporated and individualized cultural difference. In the late nineteenth century the concept of the home and Britain as home were interwoven spatially and materially. Moreover, difference inscribed through spatial and material formations was also reinforced by language: popular speech and critical writing on architecture differentiated the 'English home' from 'Irish cabins' and 'African huts'. Thus, the English

middle-class house and debates about the Englishness of English architecture can be explained in part as defined in opposition to colonial formations and by the languages and experiences of empire. For example, the local styles, vernacular forms and simple materials of English Arts and Crafts architecture can be understood as honed within the high style, rich materials and curvilinear forms of Indian architecture. Britain's colonial enterprise helped to trigger the Ruskinian search for a national style worthy of empire, and the double meaning of home as nation *and* dwelling place, to which Ruskin spoke, drawing attention to the necessity for the revival of domestic architecture and design, in which the Arts and Crafts house participated. This insistently English architecture offered sites of resolution for the anxieties and contradictions generated by the separations and dislocations of colonial life and culture.

The architects Ethel and Bessie Charles were born in India where their doctor father was in the Indian Army; after his retirement into private practice they lived first in France and then for almost twenty years in Rome with summers in Switzerland. The tangential relationship to England of these very 'English' young women can by characterized by their unfamiliarity with the climate which, according to family lore, prompted them to leave Somerville College, Oxford, after a year (1891–2) because they could not endure the cold. Nonetheless, the Charles sisters were apprenticed to the architectural firm of George & Peto. They made a systematic study of English architectural history at the school of architecture at University College, London, and on sketching trips they imbibed Arts and Crafts architecture, finding its visual and spatial language distinctively 'English', and reassuringly representative of home as dwelling place and as nation. Living in co-operative housing, their work was predominantly domestic, but through the profits from their practice, they built a home in Britain and made Britain their home. Most importantly, the need to belong directed them to seek entry into the prime institution of the architectural profession in Britain, the Royal Institute of British Architects, the body which signified and produced a national as well as professional identity for English architects. After almost six and a half decades of single-sex professionalism, RIBA admitted Ethel and Bessie Charles as its first women members (in 1898 and 1900 respectively), an event that marks the beginning of the modern, more inclusive architectural profession in Britain. Its immediate impact, however, was muted by the controversy surrounding Ethel Charles's membership, and the number of women entering the architectural profession fell between 1891 and 1911.

MEMORY

Establishing difference through race, class and ethnicity was one of the chief occupations of architecture in colony and metropolis, whether in the spaces of domesticity or in gardens, which provided changing delight and comforting memories of home in England – not least through sensory memory (King, 1976, 142). Spaces between buildings, including gardens, were important to ruling colonial technologies, while the manipulation of space participated in 'the "domesticating" impulse of European rule', which privileged and installed European authority and culture (Cooper and Stoler, 1997, 17).

Gardens were a common and important feature of houses designed for the English at home and away. In South Africa, like dressing for dinner, they produced a highly visible and privileged form of cultural difference (King, 142). Building his first garden for himself in South Africa at The Grotto, a house adjoining Rhodes's Grote Schuur in the Western Cape, the architect Herbert Baker enlisted the advice of the supremely knowledgeable Gertrude Jekyll, for whom 'matters concerning domestic architecture almost equal [her] interest in plants and trees.' In a series of letters she advised on the garden and offered a detailed and extensive planting scheme which, amongst other suggestions, put into circulation again plants of colonial origin that by the late nineteenth century had become naturalized both literally and figuratively in English gardens: roses of many varieties, for instance, and magnolia and Cyprus macrocarpa, 'a Californian kind very handsome and fast-growing'. She discouraged 'the Cape plants I do not like … the numerous Aloes and their allies', recommending that 'there should not be too much of the prickly Pear sort of plant', as well as abjuring palms (RIBA Mss & Archives, 1893–4). Since the 1770s South Africa had been a rich source of plants for gardens in Britain, a change in direction 'from Britain's traditional dependency on the American colonies for new flowers and trees' (Drayton, 2000, 46). Unlike white settlers, Africans were regarded as not having gardens, nor, indeed, the aesthetic sense to make or enjoy them. These perceptions ignored the gardens designed, planted and maintained by indigenous peoples, which were vegetable gardens, as Olive Schreiner pointed out in *Trooper Peter Halket of Mashonaland* (1897). However, such productivity and expertise in South African gardens did not, she considered, exclude the enjoyment of beauty and the decorative qualities of gardens and their products, such as flowers, which were cut and placed in tin vases outside homes (Schreiner, 60). Although troubling anxieties in England were expressed that colonialization would destroy not only natural beauty and landscapes but the goal of the imperialist project itself, the raw materials which stoked Britain's industries, trade and power in the domestic space of

white colonial gardens, nature and the new country could be tamed, home could be remembered and reproduced, and comfort and pleasure sought in a new land, all activities which contributed to ruling-class identities and racial distinctions.

When the artist and traveller Marianne North established a studio and gallery of her botanic paintings, landscapes and specimens in the Royal Botanic Gardens at Kew (Figure 6.3), its director, Sir Joseph D. Hooker, stressed the relationship of architecture, memory and empire in the preface to the gallery's first catalogue:

very many of the views here brought together represent vividly and truthfully scenes of astonishing interest and singularity, and objects that are amongst the wonders of the vegetable kingdom ... [many] are already disappearing or are doomed shortly to disappear before the axe and the forest fires, the plough and the flock, of the ever advancing settler or colonist. Such scenes can never be renewed by nature, nor once effaced can they be pictured in the mind's eye, except by means of such records as this lady has presented to us, and to posterity. (Hooker, 1892 [1882], 2)

Opened to the public in June 1882, the Marianne North Gallery was initiated and funded by the artist, who chose the site and commissioned and instructed her friend James Fergusson, whose established reputation in architectural circles would, she believed, protect her and her project from criticism. Not a practising architect, Fergusson may have come to mind as a scholar of Indian architecture,[3] as North wanted the building to be 'rather Indian in its outline', even if, in the end, it was built in a plain classical style, though featuring a verandah (Kew Archives, 11 August 1879, letter from Marianne North to Sir Joseph Hooker, 4).

Presenting 862 paintings to the nation (in the final count), North planned the interior design of the gallery in negotiation with the architect; carried out the execution of the decoration; and supervised the mounting, framing and hanging, as well as organizing and paying for the publication of its catalogue (North, 1892, vol. II, 87; and Kew Archives). The gallery was a small but very public monument to North's art, a product of empire and assiduous travel over five decades. The peripatetic North, who lived in a flat in Westminster, recognized the need for work space, which was met in the studio attached to the gallery, built, as she recorded in her journal, 'for myself or any artist to paint flowers in at any time' (North, vol. 2, 86). Parallel to the interest of the women's movement in public conveniences and the provision of women's restaurants and clubs, North's programme for the project also featured 'a rest-house and a place where refreshments could be had – tea, coffee, etc.' (North, vol. 2, 86). In fact, North would have known the similar facilities that Barbara Leigh Smith Bodichon had sponsored at the Ladies' Institute in Langham Place. Marianne North's father was a Member of Parliament from Hastings, and she was an old friend of Bodichon and frequent visitor to

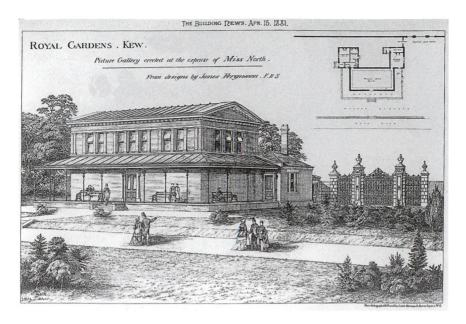

6.3 North Gallery, showing studio and public refreshment facilities,
Building News, 15 April 1881

nearby Scalands Gate. Although the refreshment room was rejected by Kew's
director – who later threatened to erect screens when North planned tea
breaks from her studio on the verandah (Kew Archives, Letter from
Marianne North to Mr Dyer, n.d., 72) – Scalands Gate became something of
a watchtower for the Kew project with North's close friend Mary Ewart
keeping an eye on the building work from there, during North's absence in
Australia and New Zealand. Writing from Scalands Gate, Ewart assertively
defended the building from what she perceived as unauthorized changes,
and she made it her practice to appear on the building site unannounced to
check on progress, complaining directly to the foreman if things were not in
order, and sending missives via the director to the architect (Kew Archives,
Letters from Ewart to Hooker, 23 and 26 May 1880, 40, 42 and 49).

 North's cultural and spatial strategy put her paintings and studio at Kew
Gardens, the most important and respected scientific institution of its kind,
and the centre of the botanic imperial project. The gallery spatialized the
memory of her colonial travels on 'All the continents' (North, vol. 2, 217) and
archived its images. It became the home of North's paintings and, like the
domestic space of home, the gallery acted as 'an archive, a storage space from
which the past can be gleaned', structured and narrated over time through its

spaces, furnishings and decoration (Burton, 2001). In the gallery home of her paintings, the anxieties and sense of doubt about the empire could be minimalized and the gallery became a space which signified colonial greatness and bounty but distanced colonial history's violence (Burton, 2001).[4] In other regimes, architecture could evoke memories that recalled personal productivity and happiness. On her death, Barbara Bodichon left her Cornish cottage and garden at Zennor to Gertrude Jekyll, a material and spatial remembrance of their friendship and mutual interests. This gift in Bodichon's will also serves as a memorial to one of her most significant political achievements, the Married Women's Property Acts, which secured women's rights to own, assign and inherit architecture (Bodichon, 1885).

Women patrons, designers and architects, as well as users of the built environment, adopted diverse strategies for remapping spatialities in Britain in the late nineteenth century, commissioning and designing architecture and decoration which created new social spaces that challenged dominant interests' powerful control over material provision and spatial definitions. However, this is not simply a triumphalist narrative. The spatialities and cultural meanings they produced within architectural discourse around issues of identity, difference and memory were shaped within colonial and imperial discourses, which privileged white middle-class British producers and consumers. In retracing and assessing these sites and spaces, I have argued that in artists' studios, domestic dwellings and the gendered spaces of Victorian public architecture, new subjectivities and identities were defined and signalled. The concept of home was rethought as a public, politicized space and the public space outside the home was claimed, created and utilized.

References

Adams, A., *Architecture in the Family Way: Doctors, Houses and Women 1870–1900*, Montreal and London: McGill-Queen's University Press, 1996.
Balfour, E. to Editor, *The Times*, 18 October 1885, 288.
Barbara Bodichon Papers: Girton College Archives, Cambridge, a copy of her will, 23 January 1885; n.d., B56; 21 January 1872, B57; 5 September 1874; n.d., B110.
Burton, A., 'Archiving the Domestic: the Figure of the Victorian Home in Late-Colonial India', conference paper, *Locating the Victorians*, London, 2001.
Campbell, L., 'Questions of Identity: Women, Architecture and the Aesthetic Movement', in *Women's Places: Architecture and Design 1860–1960*, London: Routledge, 2003, 1–21.
Cherry, D. and L. Walker, 'Elizabeth Garrett Anderson: Image, Identity and Space in the Modernization of Medicine', *Visual Culture in Britain*, **2** (3), 2002, 33–56.
Cooper F. and A.L. Stoler, 'Between Colony and Metropole: Rethinking a Research

Agenda', in F. Cooper and A.L. Stoler, (eds), *Tensions of Empire: Colonial Culture in a Bourgeois World*, University of California Press, 1997, 1–58.

Crawford, E., *Enterprising Women: The Garretts and Their Circle*, London: Francis Boule, 2002.

Daily Graphic, 30 April 1890, 232.

Drayton, R. (2000), *Nature's Government: Science, Imperial Britain, and the 'Improvement' of the World*, London and New Haven: Yale University Press, 2000.

Fawcett, M. (n.d.), 'Home and politics', an address delivered at Toynbee Hall and elsewhere, London Society of Women's Suffrage, n.d.

Festing, S., *Gertude Jekyll*, London and New York: Viking, 1991.

Franklin, J. (1970), *The English Gentleman's Country House*, London: Routledge & Kegan Paul, 1970.

Girouard, M. (1971), *The Victorian Country House*, Oxford: Clarendon Press, 1971.

———— *Sweetness and Light: The 'Queen Anne' Movement 1860–1900*, Clarendon: Oxford, 1977.

Haar, S. and C. Reed, 'Coming Home: a Postscript on Postmodernism', in C. Reed, (ed.), *Not at Home: The Suppression of Domesticity in Modern Art and Architecture*, London: Thames and Hudson, 1996, 253–273.

Harriet Martineau Papers: University of Birmingham Library, 1845/6, HM 1302.

Helland, J., *The Studios of Frances and Margaret Macdonald*, Manchester and New York: Manchester University Press, 1996.

Hooker, J.D., *Royal Gardens, Kew. Official Guide*, 5th edn. London: HMSO, 1892.

Jekyll, F., *Gertrude Jekyll: A Memoir*, London: Jonathan Cape, 1934.

Kew Archives, Royal Botanic Gardens, MN/1/7: Kew North Gallery 1879–1896.

King, A.D., *Colonial Urban Development: Culture, Social Power and Environment*, London and Boston: Routledge & Kegan Paul, 1976.

Neiswander, J.A., 'Liberalism, Nationalism and the Evolution of Middle-Class Values: the Literature of Interior Decoration, 1875–1914', PhD thesis, University of London, 1988.

North, M., *Recollections of a Happy Life Being the Autobiography of Marianne North*, ed. Mrs. J.A. [Catherine] Symonds, vol. 2, London and New York: Macmillan, 1892.

Pagani, C., 'Chinese Material Culture and British Perceptions of China in the Mid-Nineteenth Century', in T. Barringer and T. Flynn, (eds), in *Colonialism and the Object: Empire, Material Culture and the Museum*, London and New York: Routledge, 1998, 28–40.

Pearson, L.F., *The Architectural and Social History of Cooperative Living*, London: Macmillan, 1988.

Perry, K. and P. Sparks (eds), *Barbara Bodichon 1827–1891: Centenary Exhibition*, Cambridge: [no press], 1991.

Purvis, J., *Emmeline Pankhurst: A Biography*, London: Routledge, 2002.

Rapaport, A., 'A Critical Look at the Concept of "Home"', in D. Benjamin, (ed.), *The Home: Interpretations, Meanings and Environments*, Aldershot: Avebury, 1995, 25–53.

Rappaport, E.D., *Shopping for Pleasure: Women in the Making of London's West End*, Princeton: Princeton University Press, 2000.

Royal Institute of British Architects, London, MSS & Archives Collection, British Architectural Library, BAH/5/1, 1893–4.

Schreiner, O., *Trooper Peter Halket of Mashonaland*, London: T. Fisher Unwin, 1897.

Twells, A., 'Homes, Huts and Cabins: Domestic Reform and Nineteenth-Century Missionary Practice', conference paper given at *Locating the Victorians*, London, 2001.

University of California, Berkeley, Environmental Design Archives, Gertrude Jekyll Collection, 1955–1.

Vickery, M.B., *Buildings for Bluestockings: The Architecture and Social History of Women's Colleges in Late Victorian England*, Newark, DE: Delaware University Press, 1999.

Visram, R., *Asians in Britain: 400 Years of History*, London: Pluto Press, 2002.

Walker, L., 'Home and Away: The Feminist Remapping of Public and Private Space in Victorian London', in I. Bordain et al., (eds), *The Unknown City: Contesting Architecture and Social Space*, Cambridge, MA: MIT Press, 2001, 296–311.

Notes

1 Neiswander argues that in the 1870s and early 1880s these interiors were not 'using the environment to promote English identity' (Neiswander, 'Liberalism, natonalism and the evolution of middle-class values', 1988, 102 and 128).

2 I am grateful to Louise Campbell who discussed this point with me.

3 Fergusson's histories and writing were structured by ethnographic and racial distinctions and categories.

4 Burton is concerned with representations of the home in Partition novels, but here I have applied her arguments to paintings housed in the gallery archive.

The Irish artist: crossing the Rubicon

Síghle Bhreathnach-Lynch and Julie Anne Stevens

In 1876 the author of *English Female Artists*, Ellen C. Clayton, warned of the dangers for British women if Nature had been unkind enough to weight them with any extra portion of artistic talent.[1] In particular, she noted the fate of any female aspiring to be more than a fashionable amateur. 'The moment she dares to cross that Rubicon, she forgets ... her social position, and is henceforth barely tolerated.' The use of the term 'English' here is generic. Clayton, in fact, was alluding to the prejudices faced by female artists throughout the British Isles, which in the nineteenth century included Ireland.[2] On the subject of Irish artists, she referred to an Irishwoman of her acquaintance who had informed her that the social constraints on women of the upper classes were not quite as restrictive as in mainland Britain. 'In Ireland a lady may seek notoriety as a rider, a huntress, or a flirt in the ballroom or promenade, without committing any flagrant breach of propriety.' She might even dress as extravagantly as she desired without damaging her reputation in society. The only stipulation was that she be 'duly chaperoned'. Yet despite fewer social restrictions than her British counterpart, the Irish gentlewoman felt greater pressure not to become an artist. While at the top end of the social scale young Irish women were actively encouraged to be 'accomplished' in the arts, professional women artists in Ireland remained atypical until well into the twentieth century (Sheehy, 1987, 7–11).

This essay examines the world of Irish women artists in the context of the career of artist and writer Edith Œnone Somerville (1858–1949). It traces her training as a fine artist and subsequent career as illustrator and co-author with her second cousin Violet Martin (1862–1915), who adopted the pseudonym Martin Ross. Writing as Somerville and Ross, they published a string of successful books, essays and travelogues, whose texts and illustrations provide a detailed and often satirical view of life in Ireland at the

turn of the century and beyond. The problems Somerville faced in convincing her family to permit her to pursue professional training, to take her work seriously despite her sex, plus her determination to succeed, provide productive juxtapositions with other Irish women working in the arts in the same period. Although her career path differed from that of fellow female artists, she shared with them an Anglo-Irish background, upper-class social status and an affiliation to the Protestant faith.

Institutional life for the arts in Ireland started with the founding of the Dublin Society in 1731. In order to foster the fine arts, the society started to award premiums for painting and sculpture. These were open to both men and women although almost from the start a distinction was made between the sexes. When the society set up formal drawing classes in the 1740s, all the pupils were boys. Thus, until well into the middle of the next century women who made any professional mark were almost exclusively from families of artists. Like elsewhere in western Europe, a family involvement in art was the only satisfactory way in which women could get a professional training. Until 1893 only men were allowed to train as artists at the Royal Hibernian Academy. Though there were a number of private academies, it was the state-supported schools of design in Dublin, Belfast, Cork and elsewhere that would provide the principal means by which women could obtain any formal education in the arts. In the case of Dublin, in 1849 the schools of the Royal Dublin Society came under the South Kensington system as one of the Government Schools of Design. The London schools had been set up to provide the necessary training in design for manufacture and women were accepted as pupils. Once under the South Kensington system the Dublin schools were obliged to open their doors to aspirant female artists, albeit reluctantly.[3] As elsewhere, they were excluded from the course of lectures on anatomy.[4] In 1877, while remaining affiliated to South Kensington, this school became the Dublin Metropolitan School of Art (DMSA) and its curricular development, thanks to improved political, cultural and social conditions in Ireland, would prove to be a progressive one until the advent of the 1914–18 war (Turpin, 1995).

Although many young women were to avail themselves of art education in Dublin and elsewhere in Ireland, some trained outside the country.[5] Edith Somerville was one of a number of educated, upper-class Anglo-Irish women who benefited from the opening up of art education to females resident in the British Isles and who began her training in London. Born in Corfu in 1858, the eldest of a family of six boys and two girls, she was to spend much of her life in the family home, Drishane, in Castletownshend, Co. Cork, on the southwest coast of Ireland (Somerville and Ross, 1917, 106). Her earliest passions were drawing and riding which she described as going further back into her consciousness than any other of the facts of life. Like girls of similar

background, her formal education, including instruction in art, was spasmodic. But when she was about seventeen her godmother invited her to stay with her in London and to work for a term at the South Kensington School of Art. In *Irish Memories*, Somerville describes how she went from 'a lawless life of caricaturing my brethren, my governesses, my clergy, my elders and betters generally, copying in pen and ink all the hunting pictures from John Leech to Georgina Bowers, that old and new "Punches" [sic] had to offer … to a rule of iron discipline' (Somerville and Ross, 1917, 107). She found the South Kensington system with its emphasis on 'design for industry' extremely tedious. She describes the painstaking study of decoration and ornament, the outlining of casts of detached portions of the human figure and their stippling as 'heart-breaking and time-wasting'.[6] Not surprisingly, although she succeeded in progressing to the next stage of training, she declined to do so and returned home to Co. Cork.

She fared much better during her second term of apprenticeship in Düsseldorf some years later. Her cousin Egerton Coghill (later married to her sister, Hildegarde) was in the city studying fine art and suggested that she join him in his studio.[7] She went in the spring of 1881 and there made her first drawings from life (Somerville and Ross, 1917, 109). On her second visit the following spring she took singing lessons as well as pursuing her painting classes. When her cousin moved to Paris, she was keen to follow him. Unlike most other young women artists, she was in the unusual position of being able to contribute to her own financial support; as early as her teens, she had sold drawings to a card manufacturer called Page (Lewis, 1985, 84). Despite her relative independence, what happened next is a revealing example of the problems faced by Victorian women deciding to pursue a career. While Somerville's family did not oppose the idea of her becoming an artist and in fact encouraged her initial training, it was an entirely different matter when she announced that she wanted to go to Paris. By the 1870s the city was full of students from places as diverse as Great Britain, Scandinavia, Russia and the United States.[8] One reason for its attraction to women was that the ateliers were open to students of both sexes. Moreover, all students had access to life drawing. Several Irish women artists who would go on to achieve critical acclaim in their careers were in Paris in the last quarter of the century, among them the portrait painter Sarah Purser (1843–1943), portrait and genre painter Helen Mabel Trevor (1831–1900), the watercolourist Rose Barton (1856–1929), and her cousin Edith Somerville.[9]

The Somerville family's negative reaction to their daughter's desire to train in Paris is depicted with irony in *Irish Memories*:

'Paris!'
They all said this at the top of their voices. …
They said that Paris was the Scarlet Woman embodied; they also said,

'The IDEA of letting a GIRL go to PARIS!'
This they said incessantly in capital letters . . . and my mother was frightened.
So a compromise was effected and I went to Paris with a bodyguard consisting of
my mother, my eldest brother, a female cousin, and with us another girl, the friend
with whom I had worked in Düsseldorf. (Somerville and Ross, 1917, 110–11)

However, within weeks the family had returned to Ireland, unused to the discomforts of Parisian *pensions*. With a chaperone to keep her company, Edith began her studies in the studio of Filippo Colarossi. In spring 1886 she was a student in the 'ladylike' studio near the Étoile, but in May she and two friends moved to Colarossi's more professional studio in the rue de la Grande Chaumière. Over the next six years she was to make regular visits to Paris to continue her training. Some of that training was acquired at the Académie Délécluze.

Somerville reveals the social and professional gendering of space in her account of her training in Paris. The first Colarossi studio she attended in the rue Washington (avenue des Champs Elysées) was an offshoot of the main atelier in the Latin quarter. It was established not only to attract British and American clients but also young, *bien élevées* French women whose parents were unhappy about their daughters being seen to attend the studio in Paris's notorious Latin quarter. A sort of professional chaperone was installed who oversaw, among other things, the poses of the models (much to the students' annoyance). The ludicrous extent to which a woman's reputation was to be preserved at all costs is wittily recalled in the account of one French student. In spite of the fact that her home was situated very close to the studio, and although she was 'as old as she would ever, probably, admit to being', a *bonne* was sent to the studio every day to escort her home for lunch. The extreme pressures to conform to societal norms were such that there was no way that she would attempt the journey without the maid, for fear of family wrath. In this rather stifling atmosphere Somerville was relieved to escape the 'refined astral body, *"près L'Étoile"* ' to work in Colarossi's serious professional studio (Somerville and Ross, 1917, 113–14). At last she felt herself a proper art student.

What unites Somerville with her fellow female artists elsewhere is her willingness to embrace hardship, including the fact that she was prepared to put her reputation at risk for the sake of art. Both Somerville's copious correspondence with Martin Ross and her diary entries while she was away on training trips clearly indicate her determination to overcome any obstacle that might prevent her from pursuing her studies.[10] She writes of the engrossing toil of the studio, of continuous study from eight in the morning until five in the evening, with no days off. Concentration on the model was all. She did not work or mix with amateurs. On the contrary, to her and to most of her fellow students, it was extremely important that they should train

to a professional level because they all wanted to remain financially independent throughout their careers. Somerville herself was self-supporting but there was little money to spare, and the most stringent economies became necessary: her living conditions were very sparse, and her diet often inadequate.

Two paintings from this period demonstrate her early promise as a fine artist. *Retrospect*, completed in 1887 (Figure 7.1), is her first serious painting on an ambitious scale. Although rejected by the Salon, it was exhibited at the Winter Exhibition at the Dudley Gallery in London. The reaction of the art critic of the *Daily Telegraph* indicates the gendered reception of women's art work. He calls it 'masterly', comments on the balance of the tones and the vigour and decision shown in the handling of the paint, and sums up by saying that these features are 'rare and remarkable qualities to find in a lady's work'.[11] *The Goose Girl* (Figure 7.2) was painted one year later; like *Retrospect*, it shows a similar absorption of French peasant realism.

Significantly, both works also reveal Somerville's genuine interest and empathy with the villagers of West Cork. Such understanding is not simply the result of French influence in the representation of peasants in art but has to be viewed within a broader social and political context. In a country torn apart by land agitation and with the Catholic nationalists' desire for Home Rule increasing, the predominantly Protestant Anglo-Irish society faced conflicting political alliances. The artist and her family maintained close links with Great Britain; nevertheless, they (Edith Somerville especially) regarded themselves as fervent cultural nationalists dedicated to preserving the Irish world they loved.[12] For the most part, army and professional class connections overrode differences in religion. Both in these early paintings and then in collaboration with Martin Ross, Edith Somerville's perceptiveness of, and sensitivity to, the complex nuances of Irish life can be traced. Their texts and illustrations can be read for period detail on the manners and habits of all classes in Ireland in the period 1880–1920. In a time when romantic nationalism idealized all things Irish, their ironic and self-conscious sensibilities allowed for a darker and more naturalistic representation of the Irish countryside and its people.

Somerville and Ross began their collaborative career in 1887, writing witty and often satirical travelogues, essays, stories and novels; the former illustrated most of their works. The pair were to achieve critical acclaim with *The Real Charlotte* (1894) and popular success with *Some Experiences of an Irish R.M.*, first published in *Badminton Magazine* between 1898 and 1899. During the final decade of their joint career they concentrated on the publication of illustrated short fiction, eventually collecting these story cycles into three volumes known as the Irish R.M. series: *Some Experiences of an Irish R.M.* (1899), *Further Experiences of an Irish R.M.* (1908) and *In Mr Knox's Country*

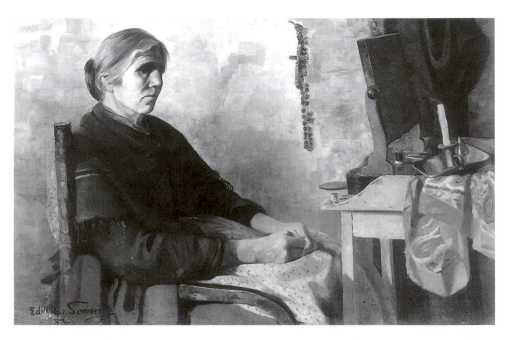

7.1 Edith Œ. Somerville, *Retrospect*, 81 x 122 cm, oil on canvas, 1887

(1915). From the start they enjoyed an easy familiarity with the periodical press in Britain. Through her brother, Robert Martin, Ross knew Mr Watson, editor of *Sporting and Dramatic*, and she became friends with Edmund Yates, editor of the *World* and Charles Graves of the *Spectator* and *Punch*.[13] Because of her background in illustration, Somerville naturally gravitated towards illustrated magazines. In fact, most of the Irish R.M. stories were first published in illustrated newspapers and magazines.

Somerville's illustrative work, Ross's essays and the pair's travelogues and stories appeared in a range of magazines from sporting journals (*Badminton Magazine*) and ladies' magazines (the *Lady's Pictorial*) to illustrated newspapers (*Graphic, Strand Magazine*) and the established political periodicals (*Blackwood's, National Review*). The most prestigious magazines, *Blackwood's, National Review* and *Cornhill*, were the authors' preference. The *Spectator* and *Punch* held less appeal because of their cheaper rates. The immediacy and swift economic returns of magazine publication, the demands made by editors for ready material, the commercial potential for the 'racy' type of story, the necessity of continuing to publish popular material regularly: all provided a crucial site for ongoing concerns of the day. The magazine, increasingly ephemeral and of the moment with the technical improvements of the 1890s, was especially adept at relating popular interests in the different sectors of society.

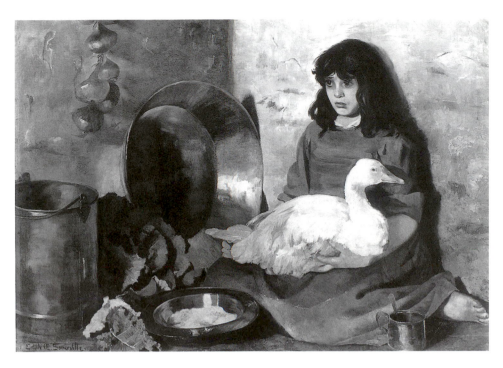

7.2 Edith Œ. Somerville, *The Goose Girl*, 95.5 x 132 cm, oil on canvas, 1888

When publishing for the ladies' magazines, both Somerville and Ross were well aware of a reading public made up of 'young unmarried women who are supposed to know but one side of life'. Literature, as George Moore had already claimed in 1885, '[was being] sacrificed on the altar of Hymen.'[14] In the late nineteenth and early twentieth century, Edith Somerville was not so much concerned with moral censorship as she was impatient with depictions of 'the Eternal Feminine in crinoline and silk'.[15] Nonetheless, Somerville and Ross published in these magazines because of their copious illustrations and appeal to women of the leisured class. Somerville, in particular, would have been attracted to magazines like the *Lady's Pictorial* because of its reputation for being one of the best illustrated papers in England, frequently bought for its drawings alone.[16] To appear in such magazines, however, could mean a compromise of artistic integrity. Somerville's naturalistic and comic illustrations, for instance, suffered alteration in the early years of her career when her sense of humour did not accord with notions of femininity and Irishness as perceived in the popular British press.[17] The original illustrations for the first touring articles she produced with Martin Ross, 'Through Connemara in a Governess Cart',

published by the *Lady's Pictorial* in 1891, were either altered or omitted because they might 'shock delicate ladies' (quoted in Somerville and Ross, 1917, 261). The magazine illustrator, W.W. Russell, copied the originals and altered them significantly. Comparison of Somerville's original sketches from life and the published version show that Martin Ross's pince-nez has been removed and her ungainly gestures have become graceful and feminine postures. A grotesque dwarf does not appear in the English publication. Comic action pictures have also disappeared and 'A Gentle Angler', with his wrinkled face and hooked nose, has become 'A Fisherman at Recess', a perfectly ordinary chap. Comedy and charm are lost in the generic types of the reformed pictures. A rather inflammatory picture by Somerville, 'Donkey with Cropped Ears', has become a boy with a donkey, and the various grotesque female faces of the originals – with huge noses and missing teeth – do not appear at all.[18]

As noted earlier, the nineteenth-century commentator Ellen Clayton observed how Irish women possessed greater social freedom than their English counterparts. Somerville and Ross exploited this notion of Irish women and relied on humour in their writings and in Somerville's illustrations to explore different kinds of femininity. Although aware that being funny might lessen their credibility, they also realized that using comic material gave them the opportunity to display humanity, especially female humanity, in subversive ways. So while Irish women artists/writers like Somerville and Ross may have struggled to be recognized as professionals, they also had access in the relatively freer Irish countryside to material that challenged those limitations. The alterations and censorship of her early work indicate how Somerville's pictures of Irish women subverted popular notions of femininity.

Edith Somerville saw illustration as an essential addition to the written text, not merely a repetition of the same. Although she illustrated the writing she produced with Ross with some typical action scenes, especially of the hunt, she preferred her character illustrations, because they enhanced the narrative. Her correspondence with her literary agent James Pinker, a former editor of popular magazines, shows her constant awareness of the importance of illustration in its own right:

I have the greatest dislike – as I think I have told you before – for little line drawings repeating facts sufficiently expounded in the text. My cousin agrees with me in thinking that character studies of the more important or interesting people in the stories . . . are both more interesting and more suited to my capabilities. I detest, with but few exceptions, my drawings in the Irish R.M., but I fear my cousin and I would both detest any other artist's attempts to realise our people even more![19]

Somerville's approach to illustration is indicated in a story published in *Strand Magazine*. This magazine showed a special interest in the making of

pictures: the question of beauty, the significance of scale, the importance of perspective, and so on. It published 'The Boat's Share' from *Further Experiences of an Irish R.M.* in 1905. The story demonstrates the manner in which the authors negotiate the claims of the picturesque and the feminine. Its publication in *Strand* is apt because it deals with the visual image, with a 'face and its fortunes' – the face of the peasant woman Mrs Honora Brickley, whose appearance, like 'a sacred picture', belies a savage greed that wins her a small fortune (Figures 7.3 and 7.4).

Honora Brickley fulfils our expectations of the picturesque. Her wrinkled skin and hunched figure in its long cloak have a charm that age and hardship have bestowed. Edith Somerville's illustrations emphasize her venerable dignity, what Ruskin would have described as the 'unconscious suffering' of the picturesque. In both sketches she disdains the reader's eye while the careless folds of her cloak and the rough texture of her worn hands and face lend interest and appeal to her depiction. The illustrator's understanding of Honora Brickley's character type, however, becomes apparent in the third illustration, a comic sketch rather than a life drawing, of Mrs Brickley's foe Kate Keohane (Figure 7.5). The third sketch clearly presents a defiant picture of Irish peasant womanhood: fierce, strong and crude.

The written text of 'The Boat's Share' works in a different way to subvert stereotype. Mrs Brickley carries herself with a 'nunlike severity' in her 'stately blue cloth cloak'; she is 'an example of the rarely blended qualities of picturesqueness and respectability' with her 'rippling grey hair', her 'straight-browed and pale face'. Yet it is she, who 'might have been Deborah the prophetess, or the mother of the Gracchi', who tells Major Yeates of women brawling on Hare Island strand, where 'the faymales is as manly as the men! Sure the polis theirselves does be in dhread o' thim women! The day-and-night screeching porpoises!'[20] The text responds not only to the picturesque discourse, reacting to the stereotyped Irish peasant and offering a more truly picturesque version, but also to that of venerable femininity, exploding the surface appearance with a supposedly truer reality. At the same time, text and illustration draw attention to the object's self-conscious pose. Mrs Brickley's posture and appearance are false, deliberately manufactured for the public's benefit. She is as intent on being as picturesque and old-womanish as her English observer or her Irish enemy might make her. It suits her purpose.

It is the willingness and the ability to slip in and out of being 'a sacred picture' which characterizes Somerville's illustrations and becomes apparent in her treatment of Irish character and landscape. Edith Somerville did not hesitate to rely upon stereotype to emphasize the immense suitability of the Irish countryside and its charming peasantry to the making of pictures. As a commercial artist, her awareness of the possibilities of the picturesque

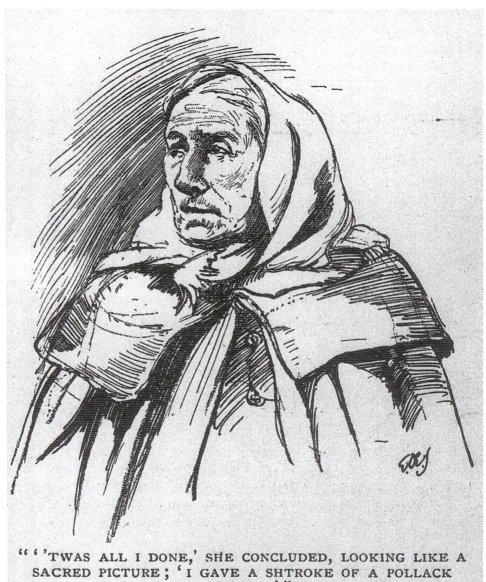

" " 'TWAS ALL I DONE,' SHE CONCLUDED, LOOKING LIKE A
SACRED PICTURE; 'I GAVE A SHTROKE OF A POLLACK
ON THEM.'"

7.3 Edith Œ. Somerville, 'Mrs. Honora Brickley: Looking Like a Sacred
Picture', illustration from Edith Œ. Somerville and Martin Ross, 'The Boat's
Share', *Strand Magazine*, **29**, January–June 1905, 79

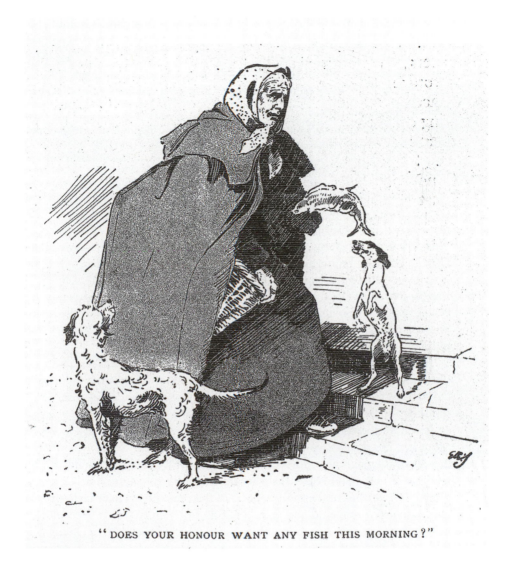

"DOES YOUR HONOUR WANT ANY FISH THIS MORNING?"

7.4 Edith Œ. Somerville, 'Mrs. Honora Brickley: Does Your Honour Want Any Fish This Morning?', illustration from Edith Œ. Somerville and Martin Ross, 'The Boat's Share', *Strand Magazine*, **39**, January–June 1905, 72

becomes clear in an article of 1900: 'West Carbery as Sketching Ground'. She depicts the topography of West Cork as 'sea and sky and distant headlands which make pictures whichever way you turn'. She describes Castletownshend with its 'irregular horde of grey, slated cottages' and the market crowds of Skibbereen as 'the most picturesque peasants in the Three Kingdoms':

Do not believe the common fable of the Irish cocked nose, the illimitable Irish upper lip. You find both, of course – and very amusing to draw they generally are – but oftener … the Spanish type recurs … [or] women with heavy blue-hooded cloaks and kerchiefs of many colours.[21]

At the same time, Edith Somerville ostensibly rejected stereotype and Irish stage-buffoonery. She agreed with her cousin in *Some Irish Yesterdays* in 1906, for instance, that the Irish experience in England suffered because of its typecasting.[22] The captive 'Children of Erin' have sold their songs in the London drawing-rooms and now must listen to the English strumming the Irish harp: 'They must smile, however galvanically, when friends, otherwise irreproachable, regale them with the Irish story in all its stale exuberance of Pat and the Pig.' (Somerville and Ross, 1906, 275) The captive race is doubly bound, first by its subordination and second by its humiliation, the mirroring of its image in the feeble jokes of the 'tormentors'.

This same year, Edith Somerville was writing to James Pinker about her illustrations of Irish types as 'a class of drawing not easily come by as they are all from real Irish country people, & are typical of their class'. From 1904 until 1907 Somerville and Ross published six stories of *Further Experiences of an Irish R.M.* in *Strand Magazine,* and Somerville wrote frequently to Pinker about her illustrations of these stories, arguing that her work was unique, 'not illustrations in the ordinary sense of the word, but supplements [to] the text' (21 April 1906). Like the stories themselves, Somerville's pictures presented 'sketches of the more salient of the peasant & lower class people' although her work would add to the writing, not merely repeat 'facts already recorded in the text' (13 November 1902). Somerville had no interest in drawing pictures 'of struggling gentlemen in evening clothes' (25 September 1904) but saw herself as one who could best depict the Irish: 'our Irish characters require to be done by someone who knows them intimately', Somerville wrote to James Pinker, 8 October 1904.[23] The issue was not so much whether the stage Irishman existed or not but who had the right (and the knowledge) to depict this type.

Somerville's and Ross's handling of the demands of the British popular press was achieved through the careful assessment and adroit management of popular expectations of feminine or Irish behaviour. Throughout their working lives, the artist/writers struggled to gain recognition for their work

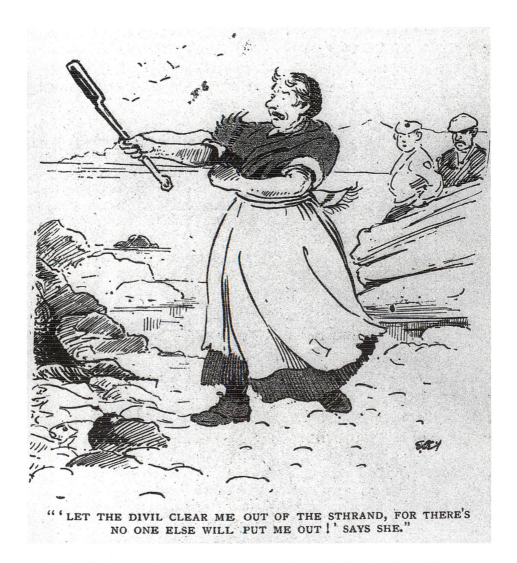

7.5 Edith Œ. Somerville, 'Katie Keohane: Let the Divil Clear Me Out of the Sthrand, For There's No One Else Will Pull Me Out', illustration from Edith Œ. Somerville and Martin Ross, 'The Boat's Share', *Strand Magazine*, **39**, January–June 1905, 80

while also achieving commercial success that would guarantee their continued employment. At times, market interests conflicted with artistic intents. Thus, their determination to represent the Irish people, and especially Irish women, in a naturalistic manner could be confounded by what Somerville described in 1911 as the narrowed interests of ladies' magazines. In a speech addressed to the Munster Women's Franchise League, Somerville's argument for the reform of these periodicals was based on past experience as a magazine writer and illustrator forced to tailor the crude realities of Irish life to the limiting demands of these popular magazines:

The Editors of the Ladies' Papers seem to have agreed that though Lookers-on may see most of the game, they cannot be expected to regard it with any enthusiasm. And so they narrow down their topics to the arbitrary estimate of women's intelligence, & narrow down women's intelligence to the contemptible level of their topics. There are columns in many papers, generally near the end and imbedded in advertisements, headed 'things interesting to Ladies.' We know the class of fact that we shall probably find under that heading.[24]

Despite frustrating obstacles, Somerville and Ross's work stretched the limited space of the ladies' magazines by utilizing the comparative freedom of the Irish scene. The determination of the Irish artist/writer to produce successful and excellent material was indicated early on in their career with Somerville's struggle to discover professional training space in Paris and her own and Martin Ross's ongoing search for the best vehicle to convey their work. Meanwhile, by the end of the nineteenth century, Somerville's artistic compatriots were already enjoying success.[25] By 1891, Sarah Purser was elected an Honorary Academician by the Royal Hibernian Academy in recognition of her success (she later became the first female full member). Watercolourist Rose Barton moved between Dublin and London, exhibited regularly and was elected an Associate member of the Royal Watercolour Society in 1893. Pictures such as *Going to the Levée at Dublin Castle* of 1897 (Figure 7.6) were typical of her representations of contemporary urban life and led to the publication of a number of her watercolours in her books, *Picturesque Dublin: Old and New* (1898) and *Familiar London* (1904). Helen Mabel Trevor exhibited regularly at the Paris Salon from 1889 to 1899, mostly portraits and genre scenes. She also exhibited at the Royal Academy and the Royal Hibernian Academy.

Interestingly, although very successful as a writer and illustrator and justly proud of her achievements, in later life Somerville expressed regret at not having pursued a career as a fine artist. After Martin Ross's death in 1915, she continued to publish fiction under their joint names but also began to spend more time painting in oils, recording the beauty of the West Cork and Kerry landscape. These Irish pictures were shown at her first one-woman show at the Goupil Gallery in London in 1920 and at Walker's Gallery in

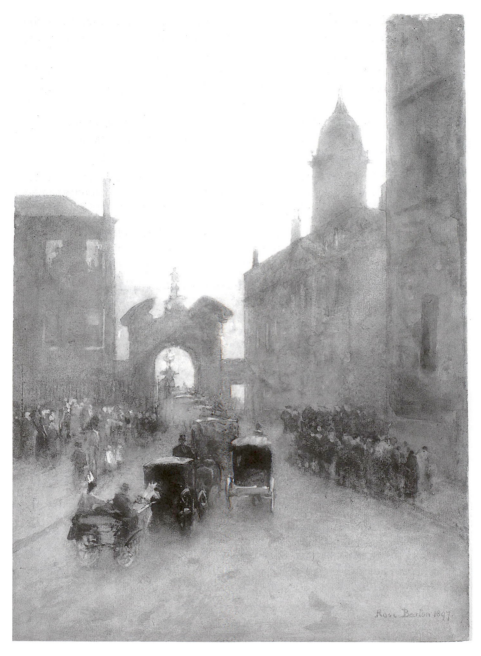

7.6 Rose Barton, *Going to the Levée at Dublin Castle*, 35.6 x 26.6 cm, watercolour on paper, 1897

Bond Street in 1923 and 1927. In 1929 she visited the United States and three exhibitions of her work were held there. She was also represented in the first Irish Exhibition of Living Art in 1943.[26] It is clear that Ellen Clayton's dire warnings about Irish women seeking careers had been successfully challenged in the latter decades of the nineteenth century. Having crossed the Rubicon, Somerville and her female colleagues ensured that the next generation of women would enjoy a less stormy route to success.

References

Bhreathnach-Lynch, S., 'Framing the Irish: Victorian Paintings of the Irish Peasant', *Journal of Victorian Culture*, **2** (2), Autumn, 1997, 245–63.

Campbell, J., *The Irish Impressionists : Irish Artists in France and Belgium, 1850–1914*, exh. cat., Dublin: National Gallery of Ireland, 1984.

Crookshank, A. and the Knight of Glin, *Ireland's Painters, 1600–1940*, London: Yale University Press, 2002.

Lewis, G., *Somerville and Ross: The World of the Irish R.M.*, London: Viking, 1985.

——, (ed.), *The Selected Letters of Somerville and Ross*, London: Faber and Faber, 1989.

Moore, G., *Literature at Nurse or Circulating Morals*, London: Harvester, 1976 (1885).

Powell, V., *The Irish Cousins*, London: Heinemann, 1970.

Rauchbauer, O., *The Edith Œ. Somerville Archive in Drishane*, Dublin: Irish Manuscripts Commission, 1995.

Sheehy, J., 'The training and professional life of Irish women artists before the twentieth century', *Irish Women Artists from the Eighteenth Century to the Present Day*, exh. cat., Dublin: The National Gallery of Ireland and The Douglas Hyde Gallery, 1987.

Somerville, E., 'The Educational Aspect of Women's Suffrage', address to the Munster Women's Franchise League, 15 December 1911, in 'Essays on Irish and Suffragette Affairs by E. Œ. Somerville, 1910–1925', Belfast: Queen's University Library, Somerville and Ross Manuscript Collection, no. 898.

——, letters to James Pinker, The Pinker Correspondence, Dublin: Trinity College Library, no. 3330–1.

——, 'Paris Notes', in *International Art Notes*, March, 1900, 10–13.

——, 'West Carbery as Sketching Ground', in *International Art Notes*, May, 1900, 83–4.

Somerville, E.Œ. and M. Ross, 'The Boat's Share', *Strand Magazine: An Illustrated Monthly*, vol. **39**, 1905, 72–80.

——, *Irish Memories*, London: Longmans, Green and Co., 1917.

——, *Some Irish Yesterdays*, London: T. Nelson and Sons, 1906.

——, *Stray-Aways*, London: Longmans, Green and Co., 1920.

Stevens, J.A., 'Picturing the Past: Reaction to Popular Representation of the Nation in Somerville and Ross's *Irish R.M.* Stories', *Journal of the Cork Historical and Archaeological Society*, **105**, 2000, 175–90.

Strickland, W.G., *A Dictionary of Irish Artists*, 2 vols, Shannon: Irish University Press, 1913, Appendix.

Thorpe, J., *English Illustration: The Nineties*, London: Faber and Faber, 1985.

Turpin, J., *A School of Art in Dublin since the Eighteenth Century: A History of the National College of Art and Design*, Dublin: Gill & Macmillan, 1995.

Notes

We would like to acknowledge the support of Gifford Lewis in the writing of this article.

1 Ellen Clayton, *English Female Artists*, 2 vols, London: Tinsley Brothers, 1876, quoted in Jeanne Sheehy, 'The training and professional life of Irish women artists before the 20th century', 1987, 7–14.

2 The Gaelic Irish had been a subordinate people from Tudor times following crown plantation schemes and more informal settlement schemes in the seventeenth century. The schemes provided advancement for landless younger sons in England and later Scotland, as well as outlets for surplus population. These land-owning families lost most of their power towards the end of the 1870s as agrarian unrest in Ireland sapped their economic foundations. With an increasing shortage of money and the break-up of numerous ancestral homes and estates, Anglo-Irish society gradually declined over the next hundred years. It is into this class that Edith Somerville was born. Her family had first settled in Ireland in the late seventeenth century. See Gifford Lewis, *Somerville and Ross: The World of the Irish R.M.*, 1985, 17.

3 The Royal Dublin Society Distribution of Premiums from 1844 to 1855 makes constant references to a supposed feminine taste detectable both in the work of female students and in the domestic character of the female.

4 They were also excluded from the ceremonial annual prize-giving attended by the Lord Lieutenant for Ireland, on the grounds that it would be inconvenient and disagreeable to them.

5 For instance, Sarah Celia Harrison (1863–1941), a distinguished Irish portrait painter, studied under the French artist Alphonse Legros at the Slade School in London in the mid-1880s. Helen Mabel Trevor (1831–1900) began her art studies at the Royal Academy, London, before going on to Paris.

6 Despite Edith Somerville's amusing dismissal of her early training in South Kensington in *Irish Memories*, as a young woman she wrote to her mother of how she had learned to master the drawing of form in England. Letter to Adelaide Somerville, c. 1881. Otto Rauchbauer (ed.), *The Edith Œnone Somerville Archive in Drishane House*, 1995, 160–1.

7 Egerton Coghill (1853–1921) was born in Castletownshend in Co. Cork. He was a man of private means who studied art abroad; he studied at the Académie Julian in 1881 and had a studio in Paris c.1885–86. He painted landscape at Barbizon. He moved to London c.1887 and became a member of the New English Art Club with whom he exhibited until 1891, returning to Cork c.1890. He succeeded his father as baronet in 1905.

8 Julian Campbell provides an account of how Irish artists fared in their studies on the Continent. See *The Irish Impressionists: Irish Artists in France and Belgium, 1850–1914*, exh. cat., 1984.

9 Purser continued her training in Paris at the Académie Julian 1878–79. Helen Trevor was also a student at the Académie Julian c.1880. Among her teachers was Charles Carolus-Duran. As was the custom among women students at the Académie, she went to Brittany and Normandy where she painted some striking pictures of peasants – now in public collections in Ireland. Rose Barton had drawing and painting lessons in Brussels and then in the early 1880s she studied in France, probably under Gervex.

10 Queen's University, Belfast, Somerville and Ross manuscript collection, GB 0752 SRMC and Trinity College, Dublin, manuscripts department, MIC 140-143, complete set of Somerville and Ross letters from New York Public Library, made for Gifford Lewis.

11 'Winter Exhibition at the Dudley Gallery', *Daily Telegraph*, 15 November 1887. Quoted in Gifford Lewis, *Somerville and Ross: The World of the Irish R.M.*, 89.

12 Otto Rauchbauer discusses the complex nature of Edith Somerville's political position in *Edith Œnone Somerville Archive in Drishane House*, 202–203. Julie Anne Stevens elaborates on the writers' satire of Irish-Catholic nationalist versions of the Irish past in 'Picturing the Past: Reaction to Popular Representation of the Nation in Somerville and Ross's *Irish R.M.* Stories', 2000, 175–90.

13 Gifford Lewis (ed.), *Selected Letters of Somerville and Ross*, 1989, 39 and 137–8.

14 In 1885 George Moore published a pamphlet called *Literature at Nurse or Circulating Morals*, 1976, attacking the censorship of the Mudie circulating library and the requirement of an expensive three-volume novel form (which would die out with printing developments in the 1890s). Moore's novel, *A Modern Lover*, 1883, was refused circulation by Mr Mudie because 'two ladies in the country had written to him to say that they disapproved of the book', *Literature at Nurse*, 3–4.

15 Somerville is referring to the use of the feminine stereotype in the visual arts in 'Paris Notes', *International Art Notes*, March 1900, 10. Reference to the 'eternal feminine' as idealized womanhood recalls the final lines of Goethe's *Faust* II: V: 'Human discernment/ Here is passed by; / Woman Eternal/ Draw us on high.'

16 James Thorpe, *English Illustration: The Nineties*, 1985, 73–4.

17 For a detailed analysis of representation of the Irish peasant in the nineteenth century, see Síghle Bhreathnach-Lynch, 'Framing the Irish: Victorian paintings of the Irish peasant', 1997, 245–63.

18 Rauchbauer (ed.), *The Edith Œ Somerville Archive in Drishane House*, I.71.a.

19 Edith Somerville, letter to Pinker, 19 July 1904, Pinker Correspondence, Dublin: Trinity College Library, no. 3330-1. In her letters Somerville repeats frequently to Pinker her belief that an illustration must do more than repeat a story's contents.

20 Somerville and Ross, 'The Boat's Share', 1905, 72–80.

21 Edith Somerville, 'West Carbery as Sketching Ground', 1900, 83–4.

22 'Children of the Captivity', 1906. Violet Powell claims the writing of the collection can be attributed solely to Martin (*The Irish Cousins*, London: Heinemann, 1970, 84). See also Edith Somerville's later discussion of Carleton's 'humiliatingly exaggerated buffooneries' in 'Stage Irishmen and Others', *Stray-Aways*, 1920, 242.

23 Pinker Correspondence, no. 3330-1.

24 Edith Somerville, 'The Educational Aspect of Women's Suffrage', address to Munster Women's Franchise League, 15 December 1911, in 'Essays on Irish and Suffragette affairs by E.Œ Somerville, 1910–1925', Queen's University Belfast, no. 898.

25 For a detailed survey of the history of Irish Art, see Anne Crookshank and the Knight of Glin, *Ireland's Painters 1600–1940*, 2002.

26 Founded in 1943, the Irish Exhibition of Living Art was a *salon refusé* for work deemed unacceptable for the annual exhibitions of the Royal Hibernian Academy.

Nuns, ladies and the 'Queen of the Hurons': souvenir art and the negotiaton of North American identities

Ruth B. Phillips

Charles MacKay's travel book of 1859, like those of other contemporary visitors to North America, contains a description of his trip to Quebec City, the 'picturesque' Montmorency Falls and the nearby village of Lorette. Here, he tells his readers:

> resides the last scanty remnant of the once powerful tribe of the Hurons, the former lords and possessors of Canada. Paul, the chief or king of the tribe, is both the most exalted and the most respectable member of the tribe, and carries on with success, by means of the female members of his family, a trade in the usual Indian toys and knickknacks which strangers love to purchase, and in his own person cultivates a farm in a manner that proves him to be a skillful and thrifty agriculturalist. His aged mother and her sister, the 'Queen of the Hurons', received us hospitably in their neatly-furnished cottage (MacKay, 1859, 369).

It would be hard to find an anecdote that better typifies the mixture of historical commemoration (the 'once powerful tribe'), sentimentalism ('the last scanty remnant'), assimilationism (the 'thrifty agriculturalist'), and commerce ('the successful trader') that characterizes the representation of Native North Americans in what Mary Louise Pratt has called the 'contact zones' of colonial interaction (Pratt, 1992, 4).

Nineteenth-century Lorette was representative of such sites. Wendake, as it is known today, was founded in the late seventeenth century by Catholic Hurons fleeing the destruction of their homeland east of Lake Huron. The 'Indian toys and knickknacks' routinely bought there during the eighteenth and nineteenth centuries were quintessential examples of the transcultural arts that women in contact zones produce. I examine these objects as visual texts that produced ethnicity not simply by reflecting imposed stereotypes, but by actively negotiating and contesting them. Lorette souvenir arts, in this sense, can be seen as authentic 'autoethnographic' expressions, constructed,

as Pratt writes, in 'partial collaboration with and appropriation of the idioms of the conqueror' (Pratt, 7).

One category of tourist art associated with Lorette is particularly useful in such an investigation: the bark and fabric objects embroidered in dyed moosehair that were among the most popular 'Indian' souvenirs of the eighteenth and nineteenth centuries. These objects, which were displayed in cabinets of curiosities and on the mantelpieces and whatnot shelves of Victorian parlours, include domestic ornaments and personal accessories such as fans, ladies' reticules and handbags, gentlemen's cigar cases, calling card trays and boxes sized to hold everything from playing cards to needlework equipment. They are ornamented with floral motifs and pictorial vignettes of the imagined life of Woodlands Indians. Because their two-hundred-year history of production permits the examination of diachronic process, and because, most unusually, this history comprises three overlapping phases of production associated with ethnically differentiated groups of makers, these wares present, through their characteristic forms of artistic expression, a particularly rich site for the study of the transcultural process of image construction conducted by women in settler societies. I focus here on three groups of women embroiderers in moosehair: French-Canadian nuns, white settlers and native women.

French-Canadian nuns invented the art of moosehair embroidery on birchbark towards the beginning of the eighteenth century, and their production reached its height between 1759 and about 1810. Around 1800, and sporadically until the mid-century, moosehair embroidery on birchbark also enjoyed a brief vogue as a genteel pastime for Euro-Canadian women. The Aboriginal phase of production was by far the largest; it began early in the nineteenth century and peaked during the explosion of tourism in the northeast during the second half of the century.[1] The iconographic tradition displayed on these wares evolved in response to the complex play of subjectivities that this history suggests. During the first two phases of production nuns and ladies constructed images of Indianness out of a conventional array of tropes of the Noble Savage and the picturesque exotic. As will be seen, when Aboriginal women took over this iconography they selectively exploited the pre-existing tradition, stressing aspects of self-representation that had value within indigenous systems of thought and eliminating others that made no sense within these systems.

Past generations of ethnologists and art historians have not only failed to recognize the mediating role of souvenir and other transcultural arts but have actively devalued them, damning them as acculturated (and therefore 'degenerate') and as commercial (and therefore inauthentic) (Kasfir, 1992; Phillips, 1995). Furthermore, since the late nineteenth century museums and collectors have routinely assigned all objects made in these media to the

Huron, who are known today as the Wendat. This systematic inaccuracy is particularly striking because there is abundant documentation for the convent origins and initial phase of the art contained both in archivally based scholarly studies and in a spate of travel books that appeared around 1800. Priscilla Wakefield's account, published in England in 1806, is typical:

> The works of these sisters in birchbark, embroidered with elk hair, dyed of the most brilliant colours, are very ingenious! Of these materials they make pocket-books, work-bags, dressing boxes, models of Indian canoes, and a variety of warlike weapons used by the Indians. Strangers are expected to purchase some of them, which I did willingly, and shall send them by the first opportunity to Catherine and Louise. (Wakefield, 1806, 303)

In 1943 the Canadian ethnologist Marius Barbeau published his discovery, in the basement of the Ursuline convent in Quebec City, of account books, inventories and artefacts that documented the nuns' role as the originators of the art. Paradoxically, it would seem, Barbeau's intervention had the effect of de-authenticating the whole category of work in bark and moosehair in the eyes of museum anthropologists. Essentialist discourses hate a hybrid, and until the end of the twentieth century not only salvage anthropology but also idealist art histories continued to define both the Euro-Canadian and the Aboriginal productions as derivative: the nuns' because of their commercial appropriation of Indian materials and object types, and Aboriginal women's because of their adoption of Euro-North American styles and genres.[2] The failure to recognize the diachronic and dialogic aspects of Huron moosehair embroidery is, thus, itself an artefact of the inability of modernist academic discourses adequately to represent transcultural art forms.[3]

ORIGINS: THE CONVENT PHASE OF MOOSEHAIR EMBROIDERY

The history of moosehair and bark ware begins sometime around 1700. In 1714, during an epidemic outbreak of disease, the Ursuline nun Mère St Joseph offered to teach two of the nuns the Ursuline speciality of embroidery, first in silk thread and cloth. 'And then Mother St Joseph demonstrated before us', the convent's annals tell us,

> the making of some boxes in the Indian style [*boëtes sauvages*] in order to teach us how to work in bark; this inspired in several of the sisters the desire to try to make them, and they perfected the art so well that, the next year, their works were sought after as examples of proper workmanship and good taste, of the type that, since that time, we have sold every year for small sums, and that furnishes us also with things to give as presents to people to whom we are obliged. (Jamet, 1939, 393 [my translation])

Initially, the nuns made these elegant embroidered birchbark curios as gifts for important patrons in Quebec and France. The incorporation of pictorial

motifs allowed them to depict to benefactors in France the Aboriginal people whom they were attempting to convert.[4]

The production of this fancywork soon became an important source of income not only for the Ursulines but, as Barbeau documented, for other Quebec orders as well. The invention of moosehair and bark wares seems to be part of a still broader trend during the early eighteenth century towards the commodification of curiosities and the invention of new souvenir genres in New France. Nicolas Perrot, writing between 1680 and 1718, for example, reported on the commercial manufactures of the Great Lakes peoples who made 'many curious little articles which are much in demand by our French people, and which they even send to France as rarities' (Blair, 1911, vol. 1, 76). In 1708 the Sieur de Diereville recorded the specialized production of decorated moccasins by the Mi'kmaq in Nova Scotia for consumption by French curio buyers (Diereville, 1933, 167), and Ruth Whitehead has convincingly argued that the Mi'kmaq also invented their popular line of porcupine quill-decorated birchbark boxes, chairseats and other objects sometime during the first half of the eighteenth century (Whitehead, 1982). Visitors to New France were clearly eager to acquire 'Indian' curios, and the nuns, always good entrepreneurs – they were already well known as producers of such commodities as artificial flowers, fancy food confections and tailored shirts for the fur trade – were quick to capitalize on the new market.

The growth of consumer demand also corresponds with the reformulated attitudes towards the Aboriginal peoples of North America disseminated through early seventeenth-century books of history and travels. The three volumes on his Quebec travels published by Lahontan in 1703 are credited as the earliest to set out a coherent view of the North American native as a Noble Savage living a freer, easier life than that of the European, more in harmony with nature, and less ridden with conflict, superstition and irrational cruelty. This idealized view displaced earlier and more ambivalent representations circulated well into the nineteenth century in such texts as the Jesuit Relations and controlled European discourse about the Indian.[5] Through their incorporation into the writings of the French *philosophes*, the idealized models of Native life were circulated throughout Europe, gradually informing the tastes and expectations of what were largely French viewers of pictorial imagery on early souvenir wares.

During the fifty years following the British conquest of Canada in 1759, the market for 'Indian' curios was expanded by the influx into the region of military personnel, administrators and their wives, most of whom either passed through, or were stationed at, Quebec City and Halifax, the centres of the trade in moosehair and bark wares. The habits of consumption of these British and Continental newcomers were informed not only by the

established discourse of the Noble Savage, but also by the upper-class vogue at that time for curiosity collecting. They eagerly sought out Indian curiosities not only for themselves but also as gifts for friends and relations at home. One accomplished Ursuline embroiderer, Mère Esther de l'Enfant-Jesus, gave a vivid account of this trend in a letter of 1761:

Despite all the troubles that have been visited on this country, one doesn't lack for the necessities of life if one has enough money; but we have nothing except what we earn from our little works in bark. As long as they remain in fashion the earnings that we get from them will be an important source of income, for we sell them really dear to Messieurs les Anglais. Moreover, the people who buy them seem to us to feel under an obligation to do so, and they consider themselves privileged and happy in being able to acquire them. It is impossible, in effect, despite our zeal for the work, to furnish this kind of merchandise to all the people who request them. (quoted in Barbeau, 1943, 84–5 [my translation])

The enthusiasm of the British remained strong throughout the remaining decades of the century. It is important to recognize that British buyers were often motivated as much by a desire to commemorate their experience of the colourful French Catholic population that they had colonized as to acquire souvenirs of the indigenous peoples. The travel books of the period make it clear that the British constructed both the French-Canadian *and* the Aboriginal peoples of Quebec as Other, commenting with as much curiosity on the customs and exotic appearance of the *habitant* farmers as they did on the local Indians. Moosehair and bark curios thus carried a doubled valence of the romantic and the exotic. As Isaac Weld noted in his description of his visit to the Ursuline convent at Trois Rivières at the end of the eighteenth century: 'We selected a few of the [embroidered bark] articles which appeared most curious, and having received them packed up in the neatest manner in little boxes kept for the purpose, [we] promised to preserve them in memory of the fair Ursulines' (Weld, 1799, vol. 2, 17).

The convent records do not relate what images were embroidered on the early eighteenth-century bark souvenirs, and not until the period of the American Revolution are there any firmly dated examples of these objects. Stylistically, they are connected to convent-made ecclesiastical embroidery, reproducing similar species of flowers executed with the same 'nuances' or monochromatic shadings as well as compositional devices such as the medallion frames that enclose the Indian figures.[6] It is known that during the early 1700s the nuns read the works of the French travel writers and philosophical historians with close attention. For example, in 1729 the author of the annals of another Québec monastic foundation that produced moosehair embroidery, the Hôtel Dieu, expressed to a correspondent her qualified approval of Lahontan's account. In her foreword she assured her readers of her familiarity with all the historians 'who have written about

Canada ... [and] of the customs of the Savages, of the multitude of their nations, [and] of the difference of their languages'.⁷ The two-dimensional pictorial representation of those texts would have posed no problem, for the nuns' prowess at drawing is amply displayed in the accomplished late Baroque style of the figurative scenes they embroidered on church textiles. The European graphic tradition brought by the nuns to their 'savage' curiosities is evident in the flowing naturalism of the style they employed in the depiction of humans and animals, clearly seen on an unfinished heart-shaped bark panel that entered the famous *Kunstkammer* of Herzog Anton Ulrich of Braunschweig in the late eighteenth century. The incised outline of a deer displays a naturalistic, curvilinear style which contrasts dramatically with the more stylized and economical contours of animal representations in early contact-period Aboriginal art.⁸

Two of the largest and most iconographically complex surviving examples of convent-generated moosehair and bark work are a lady's work basket from the Bedford Collection, now in the Royal Ontario Museum (Figure 8.1), and a large, lidded oval box now in Frankfurt. Each piece constitutes a kind of emblem book of Indian symbols. In a series of pictorial vignettes that read continuously around their curving surfaces, the seasonal round of Indian life is depicted much as it is described in eighteenth-century philosophical histories. Landscapes of forest, lake and snow, unified by a continuous groundline, are painstakingly represented. Indian figures, accompanied by their dogs, paddle in canoes and walk through the pine trees while birds swim in the water and alight on the tops of bark wigwams. Other figures sit on the ground smoking long-stemmed pipes beside trade kettles suspended between forked sticks. Women carry cradleboards on their backs, men pull toboggans over the snow and children hold out tomahawks. Like the attributes of saints in Christian religious art the canoes, tomahawks, kettles and pipes are presented as signs of the Indian in a state of grace as 'natural man'.

Flowers bloom everywhere in these scenes, creating an atmosphere of perpetual Spring (despite the occasional toboggan) and conveying a sense of the endlessly renewable bounty of nature. Close literary equivalents to these scenes occur not only in philosophical history but also in contemporary poetry. *Tomo-Cheeki*, Philip Freneau's work of the 1790s, is typical of such texts. In it the idealized Creek Indian hero describes the Woodlands Indian way of life:

In the morning early we rise from the bed of skins to hail the first dawn of the sun. We seize our bows and arrows – we fly hastily through the dews of the forest – we attack the deer, the stag, or the buffaloe, and return with abundance of food for the whole family. Wherever we run it is amidst the luxuriant vegetation of Nature, the delectable regale of flowers and blossoms, and beneath trees bending with plump and joyous fruits. (quoted in Pearce, 1988, 144)

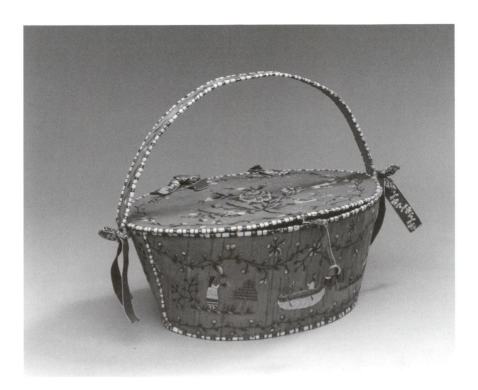

8.1 Work basket, probably Quebec convent work, 27 x 19 x 10 cm,
birchbark, moosehair, thread and ribbon, *c.* 1800

Smaller bark objects usually feature just one of these scenes. A late
eighteenth-century set of four boxes sized to hold playing cards suggests the
systematic nature of the iconographic system displayed on convent-made
items (Figure 8.2). On the embroidered top of each the symbols of one of the
four suits of cards frame a medallion that encloses an Indian figure hunting,
gathering, or engaged in one of the leisure activities identified with the life of
the Woodlands Indians. On one a woman walks through the woods with a
cradleboard on her back, while on another a woman sits under a tree
smoking a long-stemmed pipe, a basket at her feet. On the third box a man,
clad only in a breech clout, aims his bow and arrow at a bird; on the fourth
another man, dressed in the distinctive clothing of the 'domiciliated' Indians,
sits under a tree and drinks from a bottle.[9]

These figures function as emblems, their actions and accoutrements
linking them to specific verbal texts, or topoi, whose complex meanings

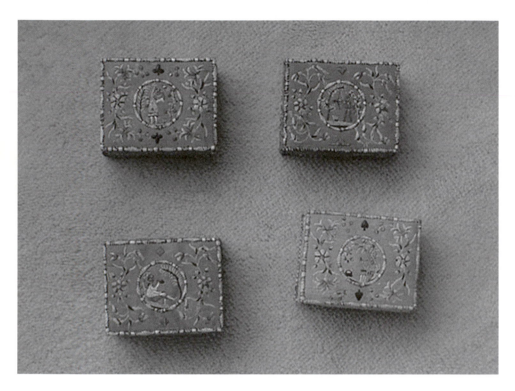

8.2 Set of playing card boxes, probably collected before 1786

eighteenth-century viewers were expected to be able to supply (Paulson, 1975, 15). As I have indicated, the texts that were engaged by the imagery of moosehair and bark wares were both the philosophical-historical disquisitions on the life of the Noble Savage and the more popular representations that occurred in poetry and novels. This literature was not, of course, homogeneous, but contained a range of interpretation and argument about the nature of Native life that changed during the course of the eighteenth century. The linking of verbal and visual texts was, therefore, inherently unstable, and individual readings of the images were conditioned by subjectivities tied to specific literary cultures, to gender, and to the degree and nature of an individual's experiences of Aboriginal people.

The contradictions between experiential realities and idealized fictions are particularly evident in the contrasting styles of dress depicted on the eighteenth-century bark ware. Clothing style was the primary visual signifier for the nuns, distinguishing not only Indians from Europeans, but also Christianized from 'pagan' Aboriginal people. The 'domiciliated' Indians

who settled near colonial towns and were, at least nominally, converts to Christianity, were shown fully clothed in garments made of European fabric in distinctive Aboriginal styles. The detail with which their shirts, leggings, wampum ornaments and peaked caps are depicted is remarkable, considering the minute scale of the figures. In contrast, the still nomadic 'savage' and pagan peoples who came to trade or to negotiate with the Europeans were represented as naked or scantily clothed. Such visible signs of cultural difference were a key component of the picturesque aesthetic of the late eighteenth century, and contributed pleasurably exotic elements to landscape scenes; like rough and irregular land formations, they added a necessary interest to painting. Vignettes of both 'domiciliated' and 'savage' Indians like those on the playing card boxes just discussed also occur regularly in the views of late eighteenth-century British topographical painters such as James Peachey and Thomas Davies.

The majority of the convent-made bark and moosehair work of the eighteenth century, however, features Indian figures wearing the picturesque dress of the domiciliated Indians, so that those few that display the sharply contrasting image of the pagan savage are all the more noteworthy. On one embroidered bark base for a woman's reticule a man wearing a breechcloth and feather headdress is shown brandishing a club and is strangely juxtaposed with a lounging female figure.[10] On another, the man is shown as a hunter, pulling his arrow back against the string of his bow while a woman sits back, a bottle to her lips. The structured contrasts that characterize the images on the set of playing card boxes described above suggests the systematic nature of the iconography of moosehair and bark ware as a whole. It also reveals that the careful balancing of representations masked the tensions and divisions introduced into the Aboriginal world by missionization, warfare, trade and colonization. From the seventeenth century onwards missionaries had made a rigorous moral distinction between unclothed pagans and clothed Indian converts, and for them the clothed figure carried positive significations. When the nuns depicted unclothed figures in their moosehair embroidery they seem both to have been acknowledging the authority that textual constructions of the Indian as Noble Savage had by then gained in the popular imagination and to have been catering to the expectations of their customers. By the late eighteenth century this imagery was already imbued with a certain nostalgia, simulating a sentimental sympathy towards Aboriginal people who were admired on a number of levels but whose inherent weakness in the face of the superiority of European civilization was understood to ensure their ultimate disappearance. Furthermore, most Europeans regarded hybrid dress styles as outlandish and did not understand the important political and economic significations that trade materials or the wearing of a British military coat or

hat had for Aboriginal people (Shannon, 1996). Such ways of seeing inform, for example, the widely circulated prints produced by author and illustrator Grasset de San Sauveur, which may have been used as direct sources by the nuns.

A GENTEEL ART: WHITE WOMEN AND THE FASHION FOR MOOSEHAIR EMBROIDERY

By the end of the eighteenth century a second group of women in Quebec and Halifax had taken up moosehair embroidery on birchbark, not as a commercial production, but as a form of fancywork that could be employed to make gifts for family members and friends. Well-born young women schooled by the nuns may initially have spread this form of needlework beyond the convents. Marius Barbeau, for example, illustrated a birchbark box in a private collection embroidered in moosehair by a Mlle Normanville in Quebec in 1798.[11] An advertisement placed in a Halifax newspaper in 1789 by a Mrs Cottnam for the school for young ladies she ran in St John, New Brunswick, can be seen as further evidence that the art became fashionable in genteel circles. Lessons, she stated, were given in 'Plain work and Marking; with variety of fine Works on Muslin, Silk and Bark, etc'.[12]

In 1791 Mrs Benedict Arnold, wife of the American general who crossed over to the British, was given an elaborate work box by a female friend as a farewell gift when she left Nova Scotia for England (Figure 8.3). The outer box, of bird's-eye maple, is a piece of professional European or Euro-Canadian cabinetry. Its interior is intricately fitted with eight boxes and a pincushion made of birchbark, fabric and silk, ornamented with motifs of cornucopias and flowers executed in a combination of silk and moosehair embroidery. In style and technique the box and its component parts are unlike the pieces associated with the convents: the construction of the pincushion and individual boxes that make up the set is different, as are the needlework materials, and the designs and stitches used for the embroidered flowers.

Inside one of the boxes is a small birchbark booklet enclosed in a straw-work slipcase. The dedication reads: 'When more pleasing scene engage / And you in Polish'd Circles shine, / Then let this wild, this Savage Page / Declare that gratitude is mine!' It is signed 'Elisaba of the Micmac Tribe'. Although Elisaba is the Mi'kmaq form of Elizabeth, the needlework techniques, the style of the handwriting and the verse form all lead to the conclusion that the writer of these lines – and the maker of the fancywork – was a genteel English or Euro-Canadian woman. Other features of late-eighteenth century British literary culture add further evidence, for a popular plot in contemporary novels involved lost or captured English ladies and gentlemen who experience the idyllic life of the Noble Savages for a period

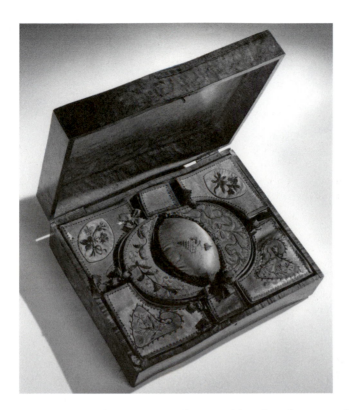

8.3 Work box, presented to Mrs Benedict Arnold on her departure from Halifax, Nova Scotia, in 1791, 44 × 35 × 15 cm, bird's-eye maple, with fittings of birchbark, fabric, silk, silk embroidery floss and moosehair

before returning to civilization. The verses – and the style – of Mrs Arnold's box directly relate to this kind of fashionable romantic literary imagery. Elisaba was the one who stayed in Canada, and playfully appropriated a 'native' Mi'kmaq identity either as a self-satirizing reference to her temporary exile from society in a 'savage' land or, perhaps, to her more permanent assumption of a North American identity. This example suggests, further, that the consumers of both convent-made and hobbyist bark wares, who were drawn from the same social milieu, may also have read the imagery on their curiosities with a hitherto unsuspected sense of irony.

One of the most splendid of all surviving examples of late eighteenth-century bark and moosehair work is a tea caddy now in Cotehele House in Cornwall (Figure 8.4). I will argue that it, too, is the product of an upper-class Englishwoman rather than a nun.[13] The wooden caddy is of European manufacture and is faced with moosehair-embroidered birchbark panels

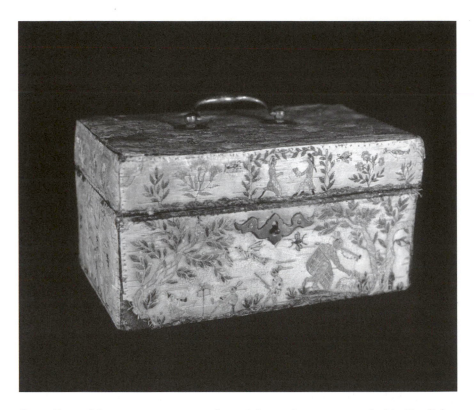

8.4 Tea caddy, 23 × 13 × 12.5 cm, late eighteenth century, probably English work following the fashion of 'Indian' curios

whose imagistic detail and quality of pictorial narrative is exceptionally elaborate. A vignette on one of the ends, of two Europeans at table drinking tea, suggests the use to which the box was put. On the larger surfaces of the box are scenes showing soldiers fencing, dressed in eighteenth-century military uniforms, and a mounted horseman hunting with Indian companions. On the top, in the most prominent position, is a scene showing Indian warriors in a forest setting. The iconography of this box is unique in many aspects, and there is no other known example of moosehair embroidery that so closely reflects the life of the British military and administrative personnel living in Canada during the late eighteenth and early nineteenth centuries.[14] Although the Indian figures in the forest warfare scene resemble images on convent-produced wares of Noble Savages cast as hunters, the figures on the Cotehele box are inserted into a fully pictorial scene of forest warfare. One other example of the tea-drinking vignette is known, as will be seen, but both the narrative structure of the scene pictured



on top and the depiction of an Indian crouched for attack on one of the long sides of the box are unique. They reflect the engagements of European soldiers with Indian allies and enemies during the wars of the late eighteenth and early nineteenth centuries in which the owner's husband, General Arnold, had played a prominent role.

Moosehair embroidery as an exotic medium for fancy needlework continued to interest Euro-American women from prominent families during the first half of the nineteenth century. Lady Mary Durham, for example, daughter of one Governor-General of Canada and later, as Lady Elgin, wife of another, took lessons in bark embroidery in Quebec city in the 1830s (Godsell, 1975, 121). Later, in 1860, when the Prince of Wales made his much-heralded first royal visit to Canada, examples of moosehair embroidery on birchbark were among the many gifts presented to him and included in the displays of Aboriginal gifts installed in the Swiss Cottage Museum at Osborne House, Isle of Wight (Phillips, 2004). Several of these can be identified as the work of a young white woman, Sarah Rachel Uniacke, a member of a prominent Nova Scotia family likely to have been involved in welcoming the Prince of Wales (Figure 8.5). Two of the objects display unique seashell motifs as well as unusual techniques of construction. Mrs Uniacke's identity is conclusively established by a bookmark that she sent to relatives in England as a sample of her work in moosehair with a note reporting that she was taking weekly lessons in the art from a Mi'kmaq woman. It displays a conch shell motif identical to one that appears on one of the Prince's gifts.[15]

The presentation to the Prince of Wales of Sarah Rachel Uniacke's work alongside the works of Mi'kmaq women, as well as their subsequent juxtaposition in the glass cases of the Swiss Cottage Museum, is, it must be concluded, a further example of the ease with which exotic artisanal techniques and materials could still be appropriated in the 1860s. This minor footnote to the history of moosehair embroidery, when considered together with the work of the nuns and of the makers of the Cotehele House tea caddy and Mrs Benedict's Arnold's sewing box, illuminates attitudes towards stylistic authenticity in the middle of the nineteenth century that were to change radically during the next few decades. The earlier examples involve prominent people and exchanges of gifts of value; they demonstrate an easy acceptance of the appropriation of 'Native' materials and imagery by white makers and consumers. In these instances imitation does seem to have been the sincerest form of flattery, as was also the case when Aboriginal women took over and made their own the production begun by the nuns. With the establishment of anthropology as a scientific discipline, and particularly with the development of doctrines of cultural evolutionism, the fluidity of cultural exchanges in the contact zone would harden into a more rigid system of classification. Authenticity would be defined – retroactively, in the case of

8.5 Pocketbook, attributed to Sarah Rachel Uniacke, a non-Native woman, with 'Ich dien' (the motto of the Prince of Wales) embroidered on the front fastener, presented to the Prince of Wales in 1860, 12 x 8 x 1 cm

moosehair and bark work – in essentialist ways, as functions of the maker's ethnic identity and of the cultural 'purity' of style, materials and techniques. The great expansion of consumer economies during the second half of the nineteenth century reinforced this trend, causing Aboriginal people to become careful of their cultural copyright as a means of protecting their markets.

THE ABORIGINAL REAPPROPRIATION: MOOSEHAIR EMBROIDERY AND SOUVENIR PRODUCTION

By about 1810 the nuns seem to have largely given up their production of Indian wares, and visitors to Quebec and Lorette attest that Native appropriation – or reappropriation – of bark and moosehair souvenir manufacture had begun. In that year John Lambert saw women from Lorette

bringing baskets of birchbark objects and moccasins into the market at Quebec (Lambert, 1810, vol. 1, 93). Jeremy Cockloft noted in 1811 that 'at Laurette are to be sold toys, made of bark, by the Indians.' (Cockloft, 1960, 31)[16] Economic necessity lay behind the Native involvement in the trade. During the half-century from 1800 to the 1850s seizures and cessions of Aboriginal land escalated, forced by the flood of Europeans settling in eastern Canada, and Aboriginal people became ever more dependent on the production of handicrafts as a source of subsistence. The Lorette Huron and other communities located at strategic places along the tourist itinerary did well, and they developed sophisticated marketing networks that distributed their products to the major tourist markets at Niagara Falls and elsewhere.

The German traveller Johann Georg Kohl, visiting Lorette in 1861, saw 'tuns and chests full of moccasins embroidered with flowers, cigar-cases, purses, &c.' being prepared for shipment to Montreal, Niagara and New York (Kohl, 1861, 180). During his subsequent visit to Niagara, Kohl saw these items displayed for sale and noted their distinctive qualities:

The taste displayed in them is peculiar, quite unlike anything to be seen in Europe, so that I believe it to be, as I have been assured it is, of real Indian invention. They seem to have a very good eye for colour, and much richness of fancy; and they imitate strawberries, cherries, and other wild fruits of their woods, very exactly, as well as daisies, wild rosebuds, and countless beautiful flowers of their prairies, which are represented in the most lively and natural colours and forms (Kohl, 155).

Kohl's account attests to the Native mastery of the mid-nineteenth-century Euro-American naturalistic aesthetic. The peculiar genius of this Native appropriation of European decorative art is that it managed, at the same time, to remain stylistically distinctive. Kohl's admiration is typical of mid-nineteenth-century audience reception; Lewis Henry Morgan made similar remarks about Iroquois beadwork during the same years (Morgan, 1967; Tooker 1994, 151–2).

The pictorial vignettes displayed on Indian-made souvenir wares continued to inscribe stereotypical and ever more outdated images of the nomadic life. They also became increasingly metonymic, the tripod and cooking pot standing for the Indian encampment in the forest, the hunter with his game or the fruit picker and her tree representing their work-free Edenic natural setting (Figure 8.6). Under the conditions of colonial domination in the nineteenth century, the employment of the common currency of stereotypes could not have been avoided. It is important to recognize, however, that Huron and Mi'kmaq artists modified the iconographic tradition that they had inherited from late eighteenth-century nuns and ladies in subtle but significant ways.[17] Towards the middle of the nineteenth century Huron and Mi'kmaq artists added new motifs to the standard iconography. The stock figure of the basket seller accurately

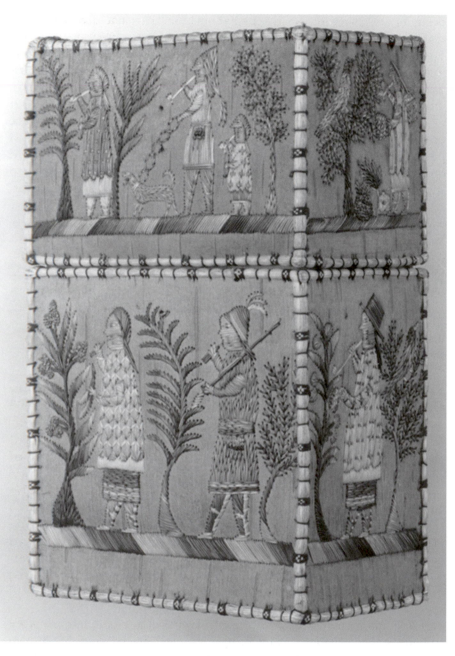

8.6 Cigar or cigarette box, Huron-Wendat, bought at Niagara Falls by Mr Döllner in 1847, 14 x 8.5 cm, moosehair embroidered

portrays the itinerant Native pedlars whose marginal economic life depended in many areas on such production. Such figures also appear in the contemporary paintings of white artists like Cornelius Krieghoff. Men and women are frequently depicted drinking from bottles, an image white viewers would have interpreted as portraying the negative stereotype of the drunken Indian. At the same time, as Richard Rhodes has argued, such images probably still retained for nineteenth-century Aboriginal viewers positive references to eat-all feasts, wellbeing and plenty, which have deep pre-contact roots, despite the terrible addictive consequences of 'binge consumption' when applied to alcohol (Rhodes, 1993).[18]

Native women also intervened in the representation of dress that occurs on moosehair-embroidered objects. The archaic images of semi-clothed warriors were not taken up by Aboriginal artists. Instead, the later production is characterized by the depiction of figures clothed in the full dress adopted for special occasions. Fine clothing, traditionally an important form of visual artistic expression among Woodlands Indians, was represented on Huron-Mi'kmaq barkwork as a positive sign of difference. This kind of image, however, also continued to resonate with the tastes of the consumers for the picturesque, evidence of the necessity incumbent on artists working for the tourist trade to portray their own ethnicity in ways that coincided with the views of the dominant society.

Through its long history the central theme of the pictures of Indians in moosehair embroidery remains the harmonious existence of human beings in a benevolent world of nature. This image, sanctioned by theoretical and romantic traditions in European thought, translates relatively easily into ideals of blessing and reciprocity amongst the different kinds of spiritual forces that animate the universe in Aboriginal belief systems. The goal of Aboriginal people in the nineteenth century, as it remains for many today, was to live in a balanced way on the land, supported by its resources. The multiple readings of images I have suggested here must, of course, remain speculative. But they offer ways of thinking about how Aboriginal artists may have been able to produce their ethnicity in terms that 'made sense' both to themselves and to a consumer group drawn from the politically and economically empowered settler society. The recognition of such polyvalence may explain the remarkably long life of the iconography of 'natural man'.

This brief discussion suggests that in the three overlapping phases of bark and moosehair production the constructed identities of 'Native', 'North American' and 'Indian' were re-examined by each successive group of makers. For British women visitors and settlers the use of indigenous North American materials served to naturalize identity, although this process seems inevitably to have carried with it the complex longings and doubled

consciousness of displacement. The iconographic tradition established by the nuns inscribed the fiction of the Indian as natural man living a free nomadic life in a bountiful Edenic landscape. The later, Aboriginal, production shifted the emphasis to the picturesque, archaic and folk qualities of the Noble Savage trope, neutralizing its potential threat to the land tenure and lifestyle of the new settler population. The transfer of this art form among three groups of women also has important implications for the negotiation of gender roles. There is a complex relationship between the democratization of the art of embroidery from an aristocratic to a bourgeois pastime, which occurred between the eighteenth and the late nineteenth centuries, and the formalization of assimilationist doctrines during the same period (Parker, 1989). These doctrines reconstructed the idealized image of Aboriginal people: from that of nomads of the wild to that of docile, agricultural peasants. The references to Chief Paul as a good farmer and to his great aunt as 'Queen of the Hurons' in the passage quoted at the beginning of this essay (1858) show that during the transitional period of the middle decades of the century both images were in play. This was the period when Lorette embroidery was at its height. A further explanation for its popularity, I would argue, is the successful exploitation of two sets of positive associations of embroidery with femininity: older references to the typical pursuit of noblewomen and newer ones to the home crafts of 'civilized' Victorian housewives. The inscription of the souvenir cannot be adequately understood without reference to such implied texts, for in popular audience reception these meanings frequently overrode or elided literal readings of the iconography.

By the end of the nineteenth century a number of economic and cultural factors had combined to wind down the production of moosehair and bark embroidery. The new definitions of authenticity that arose as a by-product of cultural evolutionism were one of the most powerful. While mid-nineteenth-century travellers had admired the picturesque hybridity of Huron dress represented by and on tourist wares, a late nineteenth-century tourist could write, disparagingly, that 'the dress worn by "warriors" and chiefs on exceptionally solemn occasions, are almost wholly artificial in their make-up … No trace is seen of the mythical and symbolic forms characteristic of the primitive art of the Huron-Iroquois' (Guerin, 1900, 564). For some years, only the Plains Indian had been able to meet the criteria of Indian ethnicity established by scientific ethnology and the embryonic primitivist movement within art history, and Woodlands Indians would increasingly replace elements of their earlier dress with the pan-Indian styles derived from Plains clothing. By insisting on equations of outer appearance, ethnic or racial difference and subjectivity, late nineteenth-century commentators effectively 'disappeared' the Indian in keeping with their own predictions. A letter

written early in the twentieth century by an Englishwoman named Agnes Grau to accompany her gift of an early nineteenth-century moosehair-embroidered box to the Governor-General of Canada illustrates the destructive combination of sentimental and ideological tropes that clung to the genre after its production had ceased. The box, now in the Canadian Museum of Civilization, bears on its lid a depiction of two Europeans drinking tea (Figure 8.7). It appears to have been produced in the same *c.* 1800 milieu – if not by the same hand – as the tea caddy at Cothele House. For Mrs Grau, however, its origins were inevitably tied to the sentimentalist notions of Noble Savages and disappearing Indians that had characterized Mackay's description, written fifty years earlier. Mrs West wrote:

This box was worked by the squaw of the last chief of the Huron tribes now extinct. It represents the French governor of Canada and his wife at tea, as seen by the Huron chief and his squaw during their visit to them and is embellished with emblematic Napoleonic bees. It was given by the Huron chief and his squaw to my ancestor Captain Eyre Powell in return for a kindness he rendered the Huron chief and his squaw and it is presented by Captain Eyre Powell's lineal descendant.[19]

Even apart from the improbable connection of a French governor of Canada with Napoleon and the premature extinction of the Huron, the passage reduces to the level of absurdity the long and complex history of exchange and negotiation among French, British and Aboriginal women artists that has been briefly examined in this essay. The utility of recovering this art history is that it allows one to see the different kinds of negotiations performed by each of these groups in the face of these seemingly monolithic tropes.

As Serge Gruzinski has argued in his discussion of parallel episodes of copying and negotiation among Mexican indigenous artists and Spanish colonists, such processes of mestizaje and melange are characteristic of colonial contact zones in the Americas. 'The mimesis required by the West', he writes, was 'prone to misappropriations that thrived under the mistaken appearance of carbon copies … In fact, right from the earliest days, the concept of copy was shown to be very elastic, ranging from exact replica to fair copy to inventive interpretation.' (Gruzinski, 2002, 61) He warns that these earlier understandings of 'copying' must be distinguished from the kinds of replication that occur in modern forms of mechanical reproduction. He stresses that the Renaissance concept left room for artistic interpretation on the part of indigenous Mexican painters who, 'had no notion of the history of European painting nor of stylistic developments', and he concludes that 'their ignorance and distance constituted both a technical handicap and a source of relative freedom' (Gruzinski, 62).

In just such a way Huron women embroidered on the French Baroque tradition of '*peinture à l'aiguille*' that Quebec nuns had previously adapted to serve the new economic needs they faced, and that genteel British ladies had

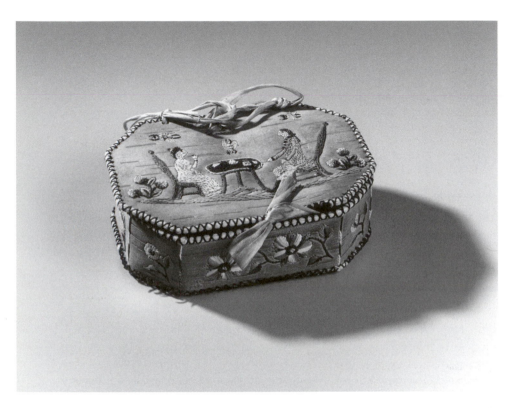

8.7 Box, Euro-Canadian work, 11.8 x 8.8 x 3.8 cm, moosehair-embroidered birchbark, late eighteenth century

taken up in their turn in order to serve the new cognitive needs and sensibilities engendered by their experience as transients and settlers in colonial Canada. For all three groups the technical and iconographic tradition of moosehair embroidery became a medium for interlinking a set of distinctive New World imaginaries: European fantasies of indigeneity, settler projects of identification, and Aboriginal images of the self as seen through the eyes of the other.

References

Barbeau, M., *Saintes Artisanes: I. Les Brodeuses*, Montreal: Cahiers d'Art Arca, no. 2, 1943.
Berkhofer, R.F., Jr., *The White Man's Indian: Images of the American Indian from Columbus to the Present*, New York: Alfred A. Knopf, 1978.

Blair, E. H. (ed.), *The Indian Tribes of the Upper Mississippi Valley and Region of the Great Lakes, as Described by Nicolas Perrot, French Royal Commissioner to Canada; Morrell Marston, American Army Officer, and Thomas Forsyth, United States Agent at Fort Armstrong*, Cleveland, Ohio: Arthur H. Clark, 1911.

Cockloft, J., *Cursory Observations Made in Quebec Province of Lower Canada in the Year 1811*, Toronto: Oxford University Press, 1960.

Dickason, O.P., *The Myth of the Savage, and the Beginnings of French Colonialism in the Americas*, Edmonton: University of Alberta Press, 1984.

Diereville, Sieur de, *Relation of the Voyage to Port Royal in Arcadia or New France*, ed. John Clarence Webster, Toronto: Champlain Society, 1933.

Godsell, P. (ed.), *The Diary of Jane Ellice*, [Toronto]: Oberon Press, 1975.

Gruzinski, S., *The Mestizo Mind: The Intellectual Dynamics of Colonization and Globalization*, trans. Deke Dusinberre, New York: Routledge, 2002.

Guerin, L., 'The Hurons of Quebec', *Report of the British Association for the Advancement of Science*, London, 1900.

Jamet, A. (ed.), *Les Annales de l'Hôtel-Dieu de Québec, 1636–1716*, Quebec City: Hôtel-Dieu de Quebec, 1939.

Kasfir, S.L., 'One Tribe, One Style? Paradigms in the Historiography of African Art', *History in Africa*, **11**, 1992, 163–93.

Kohl, J.G., *Travels in Canada, and through the States of New York and Pennsylvania*, trans. Mrs Percy Sinnett, London: George Manwaring, 1861.

Lambert, J., *Travels through Lower Canada, and the United States of North America, in the Years 1806, 1807, & 1808*, London: Richard Phillips, 2 vols, 1810.

MacKay, C., *Life and Liberty in America: or, Sketches of a Tour in the United States and Canada in 1857–58*, New York: Harper and Brothers, 1859.

Morgan, L. H., *League of the Ho-de-no-sau-nee or Iroquois*, New York: Corinth Books, 1967 (1851).

Parker, R., *The Subversive Stitch: Embroidery and the Making of the Feminine*, NewYork: Routledge, 1989.

Paulson, R., *Emblem and Expression: Meaning in English Art of the Eighteenth-Century*, London: Thames and Hudson, 1975.

Pearce, R.H., *Savagism and Civilization: A Study of the Indian and the American Mind*, Berkeley: University of California Press, rev. edn, 1988.

Phillips, R.B., *Patterns of Power: The Jasper Grant Collection and Great Lakes Indian Art of the Early Nineteenth Century*, Kleinburg, Ontario: The McMichael Canadian Collection, 1984.

——, 'Why Not Tourist Art? Significant Silences in Native American Museum Representation', in G. Prakash (ed.), *After Colonialism: Imperial Histories and Post-colonial Displacements*, Princeton, N.J.: Princeton University Press, 1995.

——, *Trading Identities: The Souvenir in Native North American Art from the Northeast, 1700–1900*, Seattle: University of Washington Press, 1998.

—— and C.B. Steiner (eds), *Unpacking Culture: Art and Commodity in Colonial and Postcolonial Worlds*, Berkeley: University of California Press, 1999.

Phillips, R.B., 'Making Sense out/of the Visual: Aboriginal Presentations and Representations in Nineteenth-Century Canada', *Art History*, **27** (4), 2004, 593–615.

Pratt, M. L., *Imperial Eyes: Travel Writing and Transculturation*, New York: Routledge, 1992.

Rhodes, R., 'Drunkards, Thieves, and Liars: Stereotypes of Indians', paper presented to the Algonkian Studies Conference, Carleton University, Ottawa, 1993.

Shannon, T., 'Dressing for Success on the Mohawk Frontier: Henrick, William Johnson and the Indian Fashion', *William and Mary Quarterly: A Magazine of Early American History and Culture*, **53**, 1996, 13–42.

Smith, D., *'Le Sauvage': The Native People in Quebec Historical Writing on the Heroic People (1534–1663) of New France*, Mercury Series, History Division Paper, no. 6, Ottawa: National Museums of Canada, 1974.

Tooker, E., *Lewis H. Morgan on Iroquois Material Culture*, Tucson: University of Arizona Press, 1994.

Turgeon, C., *Le Fil de l'art: les broderies des Ursulines de Québec*, exh. cat., Québec: Musée du Québec, 2002.

Wakefield, P., *Excursions in North America, described in Letters from a Gentleman and his Young Companion, to their Friends in England*, London: Darton and Harvey, 1806.

Weld, I., *Travels through the States of North America and the provinces of Upper and Lower Canada during the years 1795, 1796, and 1797*, London: John Stockdale, Piccadilly, 2 vols, 1799.

Whitehead, R.H., *Micmac Quillwork*, Halifax: Nova Scotia Museum, 1982.

——, 'I Have Lived Here since the World Began', in *The Spirit Sings: Artistic Traditions of Canada's First Peoples*, exh. cat., Glenbow Museum, Toronto: McLelland and Stewart, 1987.

——, 'East Coast', in *The Spirit Sings: Artistic Traditions of Canada's First Peoples, A Catalogue of the Exhibition*, exh. cat., Glenbow Museum, Toronto: McLelland and Stewart, 1987.

Notes

This essay is a revision of 'Nuns, Ladies, and the Queen of the Huron: Appropriating the Savage in Nineteenth-Century Huron Tourist Art', in Phillips and Steiner, (eds), *Unpacking Culture*, 1999, 33–50.

1 The Lorette Huron were the primary producers of moosehair embroidery during the nineteenth century. As Ruth Whitehead has shown, these wares were also produced by Mi'kmaq and Malecite women ('I have lived here', 1987, 17–29; and 'East Coast', 1987, 11–36).

2 See Phillips, *Trading Identities*, 1998, chapter 2, for a discussion of the relationship between changing anthropological and museological definitions of authenticity and the collecting of moosehair-embroidered barkwork and other souvenir arts.

3 See Parker, *The Subversive Stitch*, 1989, for a more general discussion of the gender bias behind art history's neglect of embroidery as an artistic medium.

4 During the eighteenth century Quebec nuns also made dolls and doll assemblages for canoe models as gifts for their patrons in France in order to represent the Aboriginal people with whom they were working. See Phillips, *Trading Identities*, chapter 3, for a discussion of these miniatures.

5 On eighteenth-century images of the Indian as Noble Savage, see Berkhofer, *The White Man's Indian*, 1978; Dickason, *The Myth of the Savage*, 1984; Pearce, *Savagism and Civilisation*, 1988; and Smith, *'Le Sauvage'*, 1974.

6 On the Ursuline embroidery tradition, see Turgeon, *Le Fil de l'art*, 2002.

7 J. Francoise Juchereau de St Ignace, 'Avant Propos', in Jamet (ed.), *Les Annales de l'Hôtel-Dieu*, 1939, I and n. 1.

8 See Phillips, *Trading Identities*, 110–11 and figs 4.4 and 4.5 for illustrations of these objects.

9 These boxes, which are in a private collection in South Africa, were inherited by the descendants of George and John Cartwright, explorers of Newfoundland, who left Canada for the last time in 1786 and 1770, respectively. I am grateful to Eva Major-Marothy for bringing them to my attention.

10 Rijksmuseum voor Volkenkunde, Leiden, B191-53.

11 Barbeau, *Saintes Artisanes*, n.p. The present whereabouts of the box is unknown.

12 *Nova Scotia Gazette and the Weekly Chronicle*, 20 January 1789, 4, column 2 (Newspaper File, Public Archives of Nova Scotia).

13 Cotehele House is now owned by the National Trust and was formerly the property of the Edgecumbe family. The family papers, which might have illuminated its history, were destroyed during the 1939–45 war.

14 There are numerous references to the popularity of hunting: for example, in the correspondence of Jasper Grant, a British army officer stationed in the Great Lakes between 1800 and 1809. See Phillips, *Patterns of Power*, 1984.

15 The Nova Scotia Museum acquired the bookmark (80.105.1) from the maker's granddaughter. The envelope enclosing the bookmark bears the note: 'Red Indian work done by Sarah Rachel Uniacke. She had a squaw come to instruct her every week.' I am grateful to Ruth Holmes Whitehead and Marie Elwood for sharing this information with me.

16 The manufacture of those objects had already been going on at Lorette for at least two decades, as evidenced by an inscription on a set of dressed dolls in the Canadian Museum of Civilization (III-H-429, 230, 431) stating that they were bought in Lorette in 1788.

17 See Phillips, *Trading Identities*, 103–58 for a more extensive discussion of these iconographic changes.

18 Alcohol may also have been used as an analogue for mildly hallucinogenic substances smoked to induce visions and the attainment of out-of-body experiences.

19 Canadian Museum of Civilization, III-H-400.

Placing Frances Anne Hopkins: a British-born artist in colonial Canada

Kristina Huneault

In the field of feminist thought, the concept of place is on the map. Contemporary thinking about gendered subjectivity has assumed spatial dimensions, from the centring impetus of a 'politics of location' to the deterritorialized potentialities of 'nomadic subjects'. As a motif that brings person and place together, travel has figured prominently within this spatialized sensibility, and scholars have turned their attention to the role of travel in the construction and deconstruction of gender (Kaplan, 1996; Lawrence, 1994; McEwan, 2000; Mills, 1991). Opinion on the subject is mixed. The mobility of travel has appealed to feminists as a trajectory of self-actualization and discovery. Travel embodies the possibility of liberty; nowhere has this been more intriguing than in the history of those middle-class Victorian women who distanced themselves from the social restrictiveness of nineteenth-century Britain (Frawley, 1994). Yet Western ideas of travel are linked to the masculine sphere on an Odyssean scale. Almost by definition, the adventurer has been he who travels far enough to leave women behind (Wolff, 1995). Then, too, the historical inequities of imperial power relations have cast a shadow on the liberating potential of female travel: at whose cost comes the empowerment of the white, Western woman away from home?

This essay considers the subjective placements and displacements effected by travel in the Canadian paintings of British-born artist Frances Anne Hopkins (1838–1919). As Joan Kerr's chapter in this volume documents for Australia, women painted and sketched their colonial environments. In pre-confederation Canada, an important part of British women's production stemmed from their travel in the context of governance and settlement; as wives of colonial governors, Elizabeth Simcoe, Amelia Falkland and Harriet Georgiana Dufferin all voyaged and sketched extensively in the lands under

their husbands' jurisdictions. Millicent Mary Chaplin, Katherine Jane Ellice and Amelia Frederica Dyneley did likewise on trips connected to their husbands' military or diplomatic commissions.

Hopkins is unique among these visitors from England because her travels became the cornerstone of a lengthy professional career. From three wilderness expeditions made during the 1860s in the company of her fur-trader husband and a crew of Mohawk *voyageurs*, Hopkins derived half a century of inspiration. Her scenes of canoe travel she exhibited publicly – first of all at the Royal Society of British Artists in 1867, then at the Royal Academy and in provincial exhibitions, and subsequently at commercial galleries. As late as 1914, in an exhibition at Walker's Galleries, the seventy-six-year-old artist gave pride of place to her watercolours of 'Canada in the Days of the Bark Canoe'.

No sales records have survived, but Hopkins's few existing letters convey a canny businesswoman with a strong sense of her professional interests.[1] In the context of the renewed imperialism of the early twentieth century, Hopkins occupied a niche in the market for colonial genre scenes, but the sheer longevity of her commitment to the subject of canoe travel suggests that these paintings also mattered to the artist in a more personal way. According to her husband, Hopkins 'liked neither the people, the climate, nor the customs' of Canada, and the couple blamed the country for the deaths of two of their young children.[2] In September 1866, after eight years in Canada, Hopkins moved back to London permanently; she appears to have returned only once, in 1869, for a 'pleasure trip' at the time of Edward's retirement.[3] Despite her apparent animosity to the country as a whole, however, 'pleasure' does seem to have been an appropriate adjective. The testimony of her canvases is reinforced by Edward: 'I have never seen Mrs. Hopkins so hearty in my life. Canoe travelling agrees with her.' (Clark, 1990, 39)

Considering Hopkins's art from the perspective of identity, I seek to demonstrate the ways in which her colonial travel pictures encapsulate powerful ambiguities. In her canoe, Hopkins was a woman in a world of men, a Londoner in the wilderness, a European dependent on the skill of First Nations *voyageurs*, and an upper-middle-class tourist among labourers. Her images of these formative journeys inscribe the instabilities of selfhood under the sign of the voyage.

Identity is a theme writ large in Canadian histories of the 1860s and 1870s. The nation's official formation in 1867 was but one moment in a complex interposition of interests among British, French and First Nations's residents. As the ownership and government of Canadian lands entered a new phase, colonial patterns of resource extraction (such as the fur trade) were altered by speculation in settlement. The wife of a senior officer of the Hudson's Bay

Company, Hopkins was implicated in the changing patterns of international mercantilism that underpinned Britain's imperial power. Her marriage and move to Canada in 1858 coincided with the dissolution of the East India Company. Like this better-known commercial monopoly, the Hudson's Bay Company was a political body in its own right, exercising absolute control over a geographical area twice the size of India. The sale of the company's lands to the new country of Canada in 1870 was instrumental in Edward Hopkins's retirement.

While the circumstances of her personal life were thus intimately linked to the colonial fur trade, Hopkins's ties to the British Empire far preceded her marriage. Born Frances Anne Beechey, she was part of a prestigious London family, whose name marks Canadian geography from the Arctic archipelago to the tip of Vancouver Island. Her grandfather, the portraitist Sir William Beechey, memorialized the political and military leaders of empire in the New World, while her father, the Arctic explorer Sir Frederick Beechey, used his abilities as a topographical draughtsman to re-encode colonial territory, structuring it for European consumption. For both men, art and imperial identity were linked, and Hopkins participated in this larger discourse, herself commemorating scenes of colonial spectacle in *The Red River Expedition at Kakabeka Falls* (1877, Figure 9.1) and *The Visit of the Prince of Wales to Lachine Rapids* (RA, 1902).

It is in a more intimate artistry of the self, however, that Hopkins's concerns with identity are most apparent. In a manoeuvre highly unusual among Victorian women artists depicting colonial scenes, Hopkins inserts her own body into her pictorial narratives. *Canoe Manned by Voyageurs Passing a Waterfall* (Figure 9.2) is characteristic: the artist sits, with her husband, in the centre of a canoe. Hopkins's presence in these images fascinates, and commentary on the paintings consistently binds these elaborate studio compositions back to the artist's experience. Such discussion has often been based on an uncritical assumption of interchangeability between Hopkins's art and her life (Chalmers, 1971), but it is possible to interrogate more deeply the visual terms in which the artist's presence is formulated. To read Hopkins's work for traces of identity is to engage with an act of pictorial self-fashioning that is, in essence, creative rather than documentary.

Admittedly, the impulse to conflate art and life is particularly strong with Hopkins's work. When *Canoe Manned by Voyageurs* was exhibited at the Royal Academy, *The Times* made special note of its 'truthfulness' (18 June 1870, 6). And 'truthfulness' has remained the watchword for Hopkins's commentators, inevitably impressed by her mastery of detail. The stubble on the *voyageurs'* chins, the straining of fabric against buttons – everything is depicted with scrupulous attention. So valued for their accuracy are Hopkins's depictions that when the Canadian Museum of Civilization

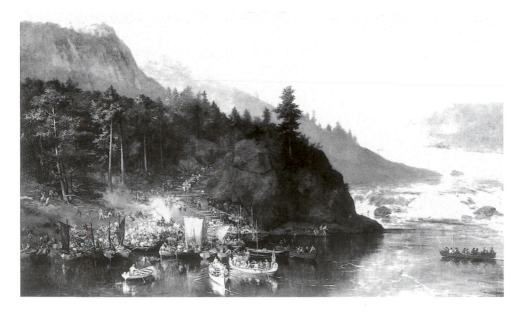

9.1 Frances Anne Hopkins, *The Red River Expedition at Kakabeka Falls*, 91.4 × 152.4 cm, oil on canvas, 1877

decided to build a replica of a fur-trade canoe it took a Hopkins painting for its model (*Ottawa Citizen*, 28 November 1997). Yet like that of all realist artists, Hopkins's reality is the product of aesthetic choices; water lilies do not grow at the foot of waterfalls, after all (Perrin, 1996). Nor was Hopkins limited to a realist vocabulary by inclination or ability; she holidayed extensively in France, and the French landscapes that make up the remainder of her oeuvre are distinctly painterly. One explanation for this stylistic discrepancy lies in the works' different commercial niches. Whereas her impressionistic handling would have conformed to collectors' expectations for French landscape painting, the realism of her Canadian scenes spoke to British curiosity about an unfamiliar colony. But the difference between realism and impressionism is also a difference in the degree of subjective engagement, the visible extent of the artist's personal presence on the surface of the canvas. Hopkins's experience of travel in familiar European landscapes signifies differently in her oeuvre to her colonial voyaging. Realist detail functioned, I shall suggest, as a technique through which to negotiate the instabilities of the artist's subject position.

These instabilities are born of the intersection of gender and empire. As Anna Jameson makes clear in the more jubilant moments of her book *Winter Studies and Summer Rambles in Canada* (1838), to move freely through the vast

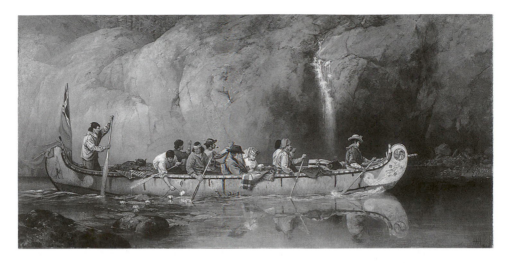

9.2 Frances Anne Hopkins, *Canoe Manned by Voyageurs Passing a Waterfall*, 73.7 x 152.4 cm, oil on canvas, 1869

spaces of this British colony was inescapably to break the gendered conventions of her age and place. To publish or exhibit accounts of these experiences was to mark an additional departure from gendered norms, and Hopkins was one of no more than a handful of women contributing travel subjects to the Royal Academy in the 1870s. She was empowered to do so by virtue of her colonizing position – as a Hudson's Bay Company wife and as daughter of the president of the Royal Geographic Society. Both institutions, however, were rigorously patriarchal: from the politics of marriage in the Hudson's Bay Company (Driscoll, 2001) to those of women's admission to the Royal Geographic Society (Foster, 1990), masculine hegemony within empire was well secured. Little surprise, then, that many Victorian women were unable to adopt the imperial voice with complete conviction (McEwan, 46). Female travellers were positioned by gender and empire in a precarious balance of marginalization and power, and their texts are often characterized by 'a lack of straightforward authority' that finds expression in an 'ambivalence of narrative voice' (McEwan, 46). It is this question of narrative authority that I would like to think through in relation to Hopkins's realist detail.

The Victorian women who wrote about imperial travel alternated between two pre-eminent narrative voices (Foster, 76). The first was a model of neutral and objective detachment that aimed descriptively to document 'abroad'. In the face of the surprise elicited by the very act of women's travel, female authors were under special pressure to authenticate their accounts. This

paradigm, however, was offset by a more participatory approach, in which women travellers immersed themselves in their environment and invested in the idea of self-expression through travel, often by presenting dramatic narratives of encounters shared with indigenous inhabitants. Hopkins's realist painting speaks with both voices. Her credentials for objective and documentary observation are unsurpassed in Canadian art, yet her inclusion of herself and her careful differentiation of fellow participants creates a strong sympathetic attachment. This dual effect of objective subjectivity is achieved through the meticulous inclusion of non-essential minutiae, convincing us of the artist's factual precision and imparting a sense of even-handed credibility. At the same time, the details pull the viewer into the story, enhancing the affective appeal of an image that seems to offer an interpretation of personal experience.

And viewers have been eager to make such biographical interpretations, sighting Hopkins even where she does not appear, as is the case with the figure in the central canoe of *Red River Expedition at Kakabeka Falls* (Figure 9.1). Despite frequent claims to the contrary (Chalmers, 21; Harper, 1977, 416; Luckyj and Farr, 1975, 20), there is no evidence that Hopkins was a member of this military mission, and an inscription on the canvas itself identifies the passenger as General Wolseley. The point here is less that Hopkins's commentators have been mistaken, than that it is an error fostered by her pictorial technique. Through the apparent objectivity of her realism the artist lays claim to an experiential authority that creates a *desire* for this passenger to be Hopkins: it is a relief to notice, at the far right of the canvas, a similar figure that may yet be her, and to learn that she may indeed have visited the expedition with Wolseley's wife (Johnson, 1971, 16).

The disjunction between Hopkins's presence and absence is most apparent in her ambiguous treatment of herself as an artist in *Canoe Manned by Voyageurs* (Figure 9.3). At first glance it appears that Hopkins has painted herself making a botanical drawing; her gaze is lowered and her right hand is clearly poised to hold a pencil. But if her posture and rapt attention speak of the artist at work, the corroborating details are missing: where a sketchbook should be visible, there is only a fold of blanket; look for it as one will, no pencil protrudes from her clasped fingers.

By stopping short of embracing full artistic self-referentiality, Hopkins moderates her engagement with her subject matter, reinstating a certain detachment of vision. Comparison makes this point vividly. *West Cliff at Nipigon, Canada West* (1866, Figure 9.4), by Daniel Wilson, depicts two women in European dress sketching from a canoe (Clark, 1990, 49). Here, then, are similar scenes, but the artists have adopted radically different vantage points. If Hopkins positions herself at the centre of *Canoe Manned By Voyageurs*, it is as the object of an externalized gaze. The position of observation that she

9.3 Frances Anne Hopkins, *Canoe Manned by Voyageurs Passing a Waterfall*
(detail), 73.7 × 152.4 cm, oil on canvas, 1869

occupies as artist is omniscient and disembodied. Wilson, by contrast,
embraces the immediacy of a much more corporeally centred perspective,
claiming his place in the canoe without the mediation of a removed viewing
point.

Without specifying either position as simplistically masculine or feminine,
it is as well to be attentive to the gendered implications of Hopkins's
perspective. Norman Feltes (1993) has called attention to Hopkins's
simultaneous production and disruption of the signifiers of femininity. He
notes a set of tensions in *Canoe Manned by Voyageurs*: a claustrophobia despite
the wilderness setting; a conflict between forward-gliding motion and a
sense of stillness at its centre, a contrast between the natural colours of the
voyageurs' clothing and the artificial dye of Hopkins's garments. Reading
these disjunctions as symptomatic of the larger anomalies of Hopkins's
position – a Victorian woman, fragile water lily, assuming the strength to
make an arduous voyage and the creative power to record it – Feltes suggests
that 'the painting not only portrays Hopkins as obviously incongruous but
emphasizes the constructedness of the incongruity.' (Feltes, 17) Hopkins, he
argues, 'savours the oddness of her presence in the painting, but savours also
for a moment the oddness that it should be odd.' (Feltes, 17) The painting
captures this instant of doubled consciousness through its gaze: the traveller

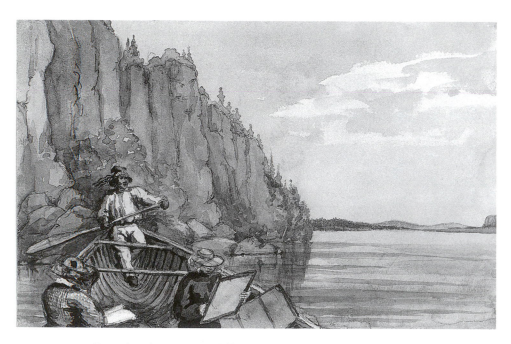

9.4 Daniel Wilson, *West Cliff at Nipigon, Canada West*, 16.2 x 25.1 cm, watercolour, 1866

Hopkins stares at a conventional sign of femininity; the artist Hopkins stares at her self looking at a symbol of herself. Indeed, Hopkins did take the water lily as a symbol of selfhood; a stylized version of it appears as a kind of artistic 'trademark' on the canoes in most of her paintings (Clark, 31). To look at one's self looking at one's self was a dual sensibility familiar to Victorian women travellers (Mills, 1991, 98), but Feltes's analysis reaches beyond a recognition of women's internalization of objectification. More significant is his sensitivity to the way that formal tensions in the artist's use of pictorial detail serve as material examples of her awareness, conscious or not, of the tensions produced by gender.

In *Canoe Manned by Voyageurs* this dynamic assumes form in Hopkins's handling of her own reflection in the glassy water, where – in contrast to the figures of her companions – the artist elides her body from the scene. In reflection, Hopkins passes directly from the tip of her chin to the blanket on her lap. As one would expect with Hopkins, there is a logical explanation. She was a small woman in a canoe 5 ft wide: from her position at the far side of the craft the angle of reflection would have blocked even more than her torso from view. Yet Hopkins has insisted upon the full inclusion of her face and hat, and a correspondingly complete elimination of her body. In the

alternative watery reality she constructs, Hopkins includes the physical register of her personality (her face) and even the cultural marker of her femininity (her hat) but she leaves no room for her sexual difference.

Whatever its realist credentials, this pictorial move has much to recommend it as a compensatory strategy, for Hopkins must have been highly conscious of this difference from her companions, not least because her trips spanned a full menstrual cycle. In the absence of her reflected body we catch a glimpse of the subtle but persistent stresses that would confront a woman travelling among men whose grinding conditions of employment fostered an aggressively masculine culture of competition, strength and bravado (Podruchny, 1999). On the surface, Hopkins's gender is written conventionally: pastel hat, petite body, constrictive clothing. Looking more closely, however, the difference of her femininity may be most tellingly inscribed in its absence.

It all comes back to the details, those minute indications that signal the place of anomaly within the work: the woman who is both object and subject of vision, present yet disembodied. Within Hopkins's imagery the realist detail serves as a mechanism whereby such anomalies at the level of cultural *meaning* may be embodied within the form itself. Through realism, Hopkins's use of detail formally instantiates a paradoxical conjuncture of detachment and engagement; it is this same paradox that defines the painting's meaning. Signifier and signified come together in the details' simultaneous inscription of the absence and presence of the artist. Meaning, in Hopkins's oeuvre, may be seen to be a detailed construction of connection to, and distance from, her scenes, a working-through of the subject position.

This paradox mirrors the position of a Victorian lady traveller, for femininity is written both into and out of narratives of travel in Western culture. Georges van den Abbeele charts this gendered ambiguity as an economy of the voyage: a back-and-forth movement between here and there, an exchange of home and away (van den Abbeele, 1992, xviii). The constituents are interdependent, for the voyage can only be conceptualized relative to its leave-taking; travel is always already contained by the home. To say the domestic is, historically, to say the feminine – particularly within Victorian painting. But if femininity has been designated as the fixed point of reference that makes 'away' possible, this binary opposition is troubled by the economy of the travel narrative. As van den Abbeele points out, containment is reinstated *into* travel through its narrativization – a process whereby the rupture of spatial and cultural dislocation may be countered through the supportive embrace of a good story (van den Abbeele, xix).

In 1864, 1866 and 1869 Hopkins lived brief and intense periods of dislocation. She then painted them for fifty years. In other words, she domesticated them, turning away into home. As feminist travel theorists

have pointed out, however, the home cannot be simply conceived as the safe and stable place of security that anchors the flux and displacement of the voyage (Morris, 1988). Hopkins knew this well, for her own home reeled under the loss of her children, and it is surely not coincidental that her first lengthy canoe trip was taken within months of a death. In such circumstances it may be absence from home that offers the stability of respite, and the opportunity to recentre oneself in the face of another's absence.

Travel, then, puts into play a complex dialectic of location and displacement, loss and gain, confinement and liberation, and these tensions mark the subjectivity of experience. How did Hopkins negotiate these circumstances? From the time of her arrival in Canada to the peak of her exhibiting career in the 1870s, Hopkins's art undergoes three simultaneous changes: a movement from the domestic to the space of the wilderness, a displacement from land to water, and a process of the gradual incorporation of her self into her images. Hopkins's earliest works, contained in the Lachine Sketchbook (1858–60, Toronto: Royal Ontario Museum) centre on her home and family. As she began to travel in the 1860s, however, her grounded domestic vision became progressively mobile and aquatic. The change is embodied in her watercolours of the timber rafts that floated down the St Lawrence and Ottawa rivers (Figure 9.5). Large enough to support dozens of men and upright trees, these craft were liminal structures that straddled the stability of land and the fluidity of water. With their campfires and multiple log cabins, they were domestic environments serving an economic function in the middle of nature. In a scene of the Houses of Parliament (1867, Toronto: Art Gallery of Ontario) the artist again refigures the domestic, this time on a national scale. At the same time a couple in a canopied rowing boat in the foreground foreshadows the scenes of canoe travel to come. Indeed, the further she got from her home, the more likely Hopkins was to include herself in her sketches.

Hopkins comes fully into her own as an artist with the representation of her displacement along watery trade routes. Still, such images are not entirely removed from the domestic. In paintings such as Voyageurs at Dawn (1871, Ottawa: Library and Archives Canada) Hopkins is attracted to the encampment, and the daily activities of the home away from home: sleeping, setting fires, cooking. In Canoe Manned by Voyageurs domesticity is apparent in the details: in the pipe that Edward Hopkins smokes, the pillow behind his back, the blanket that keeps him cosy. Most of all it is there in the teakettle which sits like a signal of domestic felicity – only ever so slightly off balance. While such kettles are reliably included in the equipment lists for Hudson's Bay Company canoes (Kent, 1997, 222), I would suggest that this detail, like Hopkins's reflection in the water, also exceeds its literal significance, signalling another tension at work in this representation of travel: that between wilderness and settlement.

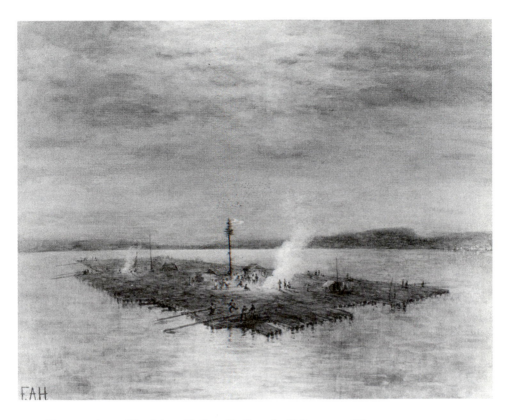

9.5 Frances Anne Hopkins, *Timber Raft on the St Lawrence River*, 39.4 × 49.5 cm, watercolour and gouache, n.d.

The 1860s marked a period of economic reorientation for the Hudson's Bay Company. After two centuries of exploitation of natural resources, the beaver had been hunted to the point of extinction. And with Canadian expansion imminent, the Hudson's Bay Company shifted its emphasis from resource extraction to speculation, selectively selling its lands to the Dominion in 1870 while developing its trading posts into the department stores needed by settlers (Williams, 1983). Corporate restructuring marginalized old 'wintering partners' like Edward Hopkins, and, as the company was profitably transformed from an intrepid trader of furs into a domestic purveyor of teakettles, he decided to retire. The final journey he took with his wife was a species of nascent Canadian tourism. But if the couple took comfort in their wilderness canoe, tourism's domestication came with them. This situation of the domestic within the wilderness is painted into *Canoe Manned by Voyageurs* – not only at the level of what the teakettle symbolizes, but in the nature of the pictorial handling itself. Through her use of realist

detail Hopkins makes *intimate* her experience of the Great Outdoors. We are drawn into the story at the level of its particularities.

It is a story of identification (this hat, that particular piece of luggage) that itself becomes a tale of identity: of passage through and claim to a land, a home, a sphere of belonging. Nowhere is this transition more apparent than in the detail of the flags. Partially furled at the stern of the canoe in the picture, a Red Ensign marks the presence of the British in North America. This prominent sign of empire is haunted by an echo, however: painted on to the birchbark immediately beneath it is a second flag. Though it is barely visible in reproduction, Hopkins is meticulous in its inclusion, not only here but in an oil sketch known as *Stern Paddler* (see Clark, 78). The small detail is part of a larger motif, Native in appearance, comprising a figure smoking a pipe and holding a flagpole. Flags were in use by First Nations during the nineteenth century, and their importance as tools of diplomacy casts the painting in another light. Suddenly, the story of presence and absence detailed in *Canoe Manned by Voyageurs* becomes refigured in terms of treaty negotiation, land appropriation and a quite altered sense of the possibilities of loss implied by European travel. No conclusive identification of this flag has been possible, but in the end this itself is significant,[4] and if Frances Anne Hopkins's paintings are to be seen from the perspective of identity, the implications of this unidentifiability cannot be ignored.

As with so many European artists, the First Nations' subjects in Hopkins's paintings are usually anonymous, ethnicity being all the designation considered necessary. Her contributions to the exhibition of the Art Association of Montreal in 1870 are typical: *Indian Canoe Guide*, *Iroquois Voyageurs* and *Indian Steersman*. At the end of her exhibiting career, however, Hopkins was to rupture this anonymity with the sale in 1914, at London's Walker's Galleries, of a watercolour: *Baptiste Assanienton, Canoe Guide*. The name, just slightly misspelled, is Mohawk: 'Asennaienton' translates as 'he/she has bestowed a name.'[5] There is an ironic beauty in the meaning; here, in the sole known instance when Hopkins identifies one of her *voyageurs*, the name itself reflects this action. Flag and name: two identifying moments in a narrative of travel that signifies at the level of economy. And like all economies, this one is a question of property, multiply conceived. In its most material sense, the intrusion of the proper name Asennaienton into this story of travel marks the return of the territorially dispossessed, staged in terms of the most personal and symbolic possession of all: one's name.

Christened Jean-Baptiste on 11 May 1802, Asennaienton was the son of Agnes Skonsaksenni and Jacques Tonitarionne, residents of Caughnawaga, a Mohawk reserve just opposite Hopkins's first home in Lachine, Quebec.[6] Like Hopkins, Asennaienton travelled in the wake of loss – all his first four children died in infancy, and his wife Kaheriennentha followed

shortly thereafter. Asennaienton hit the waterways, first appearing in the account books of the Hudson's Bay Company one year later: a thirty-year-old *voyageur* working a three-year contract far from home in the Columbia District. In 1838 he remarried and arranged for employment as a 'Summerman', a position which (by *voyageur* standards) kept him closer to home. After the death of the first child from his second marriage, however, he was back on the long trail, a bowsman on the hand-picked crew that brought Hudson's Bay Company Governor George Simpson on the Canadian leg of his journey round the world in 1841. This voyage was shared by Edward Hopkins, then a novice in the company on his first lengthy canoe trip. In 1841 Asennaienton returned to Caughnawaga where, over the next two and a half decades, he raised seven children, buried his second wife and married a third, and worked summers transporting goods and passengers along the route between Lachine and York Factory on Hudson Bay. By the time that Frances Hopkins met him in the early 1860s Asennaienton was a guide, notable for his age, position of responsibility and long acquaintance with her husband. His name is checked off on a list of *voyageurs* available to transport Mr and Mrs Hopkins on their trip from Fort William to Montreal in 1864.[7] It is just possible that she also had him in mind when she painted the grizzled bowsman in her remembered scene of *Shooting the Rapids* at Lachine. Whatever the case, the period of their acquaintance was brief; Asennaienton was buried on 8 November 1865.

Asennaienton's biography raises the question: can Hopkins's work be excavated for the residues of Native voices? The *Art Journal* apparently thought so. In a striking commentary from 1871, the 'general style' of Hopkins's work was said to be 'derived from the art of the American Aborigines' (178). Taken at face value, the statement is bewildering. Hopkins was, after all, a realist of tremendous precision, her style unquestionably that of a white European. And yet *Canoe Manned by Voyageurs* is haunted by traces of Aboriginal participation in Western culture's symbolic order. It is there, most obviously, in the painted designs on the bow and stern of the canoe. But it also asserts itself in a more surprising way: viewed with an imaginative eye, the raised hands of the two paddlers immediately behind Hopkins (on the far side of the canoe) might almost be construed to be writing on the stone wall behind them – an allusion, perhaps, to the petroglyphs that do, in fact, dot the north shore of Lake Superior.[8] A closer look reveals the position of the hand on the blue-shirted paddler to be unmistakably that of a painter and a line leading directly to (or is it from?) the hand of his hatted companion. It is fancy, to be sure, but in the context of Hopkins's erasure of her own artistic activity (the hand that holds no pencil), even the most speculative traces of writing or painting on the part of the canoe's other occupants are striking.

The Aboriginal identity of these occupants raises the unlooked for possibility of taking the *Art Journal* at its word, and looking for the role of First Nations influence in Hopkins's approach to painting. Doing so would entail a close examination of Hopkins's work – not for the stylistic influence of Aboriginal design, but rather for signs of the complex destabilization of the artist's identity that would make such a comparison possible.

In the end, to be sure, all that Hopkins's art can tell us about is her perspective, and even that is not so easy to decode. What, for example, is the chivalry of the episode with the water lilies in *Canoe Manned by Voyageurs* all about? Does it indicate Hopkins's perception of an amity of sorts with her Native guides? Or, within a fur-trade labour system 'organized around indentured servitude, paternalism, and cultural hegemony' (Podruchny, 47), is it rather the execution of a command, or a statement of deference (either real or imaginary) to a white bourgeois Englishwoman? The moment is exemplary of what fur-trade historian Carolyn Podruchny terms a ritual theatre of daily rule, wherein *voyageurs* and their masters 'engaged in a dialogue of accommodation and confrontation as a means of constructing a workable relationship.' (Podruchny, 49) Female passengers played a role within this theatre, for the Hudson's Bay Company recognized that marriage to European women reinforced the distinction between its high-ranking officials and the rest of its employees (Driscoll, 2001). As overdetermined as their position undoubtedly was by race, class and gender, it was occupied by women in different ways (Buss, 1989). Examined closely, Hopkins's painting articulates a divided perspective within this theatre of power – one which, if not obviously empathetic with the crewman's experience, also suggests something more complex than objectification. While Hopkins focuses her attention on the flower to the exclusion of the paddlers' efforts to obtain it, the artist has nevertheless linked the figures in a compositional chain which is, paradoxically, held together most strongly at the point of its greatest disjuncture: the clothing. While the colours and fit of Hopkins's clothes distinguish her clearly from the Mohawk *voyageurs*, she does share with them the accessories – earrings, feathered hats – that pull an outfit together. Small details, but seen within the context of Hopkins's oeuvre, they are suggestive of the dual movement of connection and distancing that underwrites her relation to the people with whom she shared the boundary-shifting experience of the journey.

As away became home and the foreign became familiar, Hopkins's pictorial representations of First Nations people suggest a divided recognition of the implication of otherness within selfhood. Both poles of this movement are apparent in *Minnehaha Feeding the Birds* (1874, Figure 9.6), a

work based on Longfellow's popular *Song of Hiawatha* of 1855. Here, Hopkins abandons the cultural complexity posed by Catholic Mohawk *voyageurs* in contemporary dress in favour of a clear inscription of 'Indianness'. With its saccharine idealization, the image mitigates against the possibility of real connection by immuring Native cultures in stock character identities. Hopkins shares this strategy of sympathetic distancing with Longfellow, whose epic ballad enshrines the familiar 'topos of the doomed aboriginal' through Hiawatha's voluntary departure from his homeland at the point of European immigration (Jackson, 1998, 478). In Hopkins's *Relics of the Primeval Forest* (RA 1885, Toronto: Art Gallery of Ontario), the artist echoes the poet's historical vision as much as his words, offering an unsubtle parallel between the charred stumps of old-growth forest and the Indians who fish nearby.

There is something more than stereotyping at play in *Minnehaha Feeding the Birds*, however, and I would like to explore the possibility that the painting also inscribes an earnest fantasy of proximity between artist and subject. Much has been made of Hopkins's fidelity to detail in the work: robin, bluebird and swallow are all faithfully transposed from Longfellow's poem (Clark, 41). But a larger discrepancy has gone unremarked, for Minnehaha does not feed the birds in *The Song of Hiawatha*, nor does she sit in a canoe. That particular motif is pure Hopkins. And, indeed, there is something of the artist's personal history in Longfellow's poetic tale of a bride who leaves her home and follows her husband to a faraway land. Like Hopkins, Minnehaha is represented as the ideal Victorian wife: a chaste companion on her husband's travels. In this context, Hopkins's 'trademark' water lily, placed conspicuously beneath the Indian Princess, symbolizes more than feminine purity; as in *Canoe Manned by Voyageurs*, it is a sign of the artist herself. Hopkins's painting of a young bride in a canoe in the wilderness offers more than it would seem to: not a self-portrait, but a parallel – the cipher of a fellow traveller.[9]

If, without being reductive, attention is given to the elements of self-identification in Hopkins's canvas, what are we to make of the gesture that aligns the carefully safeguarded tourist and the solitary Native woman? The need for prudence is clear, and the historical minefield of colonialism has made any investigation cautious – to ensure that Native identities are not refashioned, expurgated, destroyed in any way. If Longfellow has been roundly criticized for his Europeanizing of Native subjects, it is fair to ask whether Hopkins's apparent reversal of the scenario – wherein a European self is 'Nativized' – only feeds into a parallel appropriation. European artists have long used otherness as a veil for subjective expression, arrogating to Western culture the privilege of recasting the other as a screen for the self. It is, of course, romanticism to imagine any genuine making of common cause, but it is a romanticism not without pressing motivation in the relief that

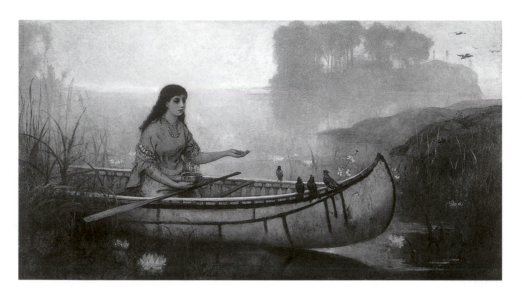

9.6 Frances Anne Hopkins, *Minnehaha Feeding the Birds*, 61 x 106.7 cm, oil on canvas, 1874

comes when a part of the self, doomed to invisibility within one's own culture, is momentarily made visible through another's; in the desire of the woman who wants not only (à la Rousseau) to be at home in the wilderness, but also (à la Virginia Woolf) to be alone in her canoe. The possibility, in short, is that through Minnehaha, Hopkins inscribes her wish to be a woman at home in her native land.

It was a desire felt acutely by many British women in the 1860s when, in response to Victorian women's experiences of political marginalization at home, a first wave of organized feminism arose. To be marginal at home is a poignant contradiction, because, above all, home is meant to be the space in which one is centred. Such simultaneity of belonging and disconnection is characteristic of women's place in a Western culture to which they have been central, but which has not been organized around their interests. To be a woman in a patriarchal society is to be constantly negotiating one's place in the face of a place that has already been given. The potential for paradox is rife.

Hopkins engaged materially with this ambiguity of identity. It is suggestive that of the five known photographic portraits of her (all taken prior to her canoes trips) three are in fancy dress (Notman Archives, McCord Museum). Through costume, Hopkins invokes very different kinds of womanhood: a shepherdess, coquettish and maidenly; Portia, clever and deceptive in lawyer's robes; an old woman, mourning her loss in black. For

her husband's ball, in 1863, Hopkins chose to be Portia, a woman in the guise of a male professional (*Montreal Gazette*, 30 May 1863, 2). The character was a popular choice at Victorian costume balls, reflecting contemporary fascination with a figure who could signify both at the level of women's emancipation and as a champion for marriage and the paternal control of women's property (Rozmovits, 1995).

Costume's potential for self-fashioning would be refigured for Hopkins through her depictions of travel, just a few years later. Like fancy dress, Hopkins's travel art is marked by an indeterminacy of identity. It appears like a fly in the ointment, a niggling suspicion that I have been unwilling to recognize: the truth is that no one *knows* that the woman in *Canoe Manned by Voyageurs* is Hopkins. Indeed, she was once thought to be Lady Monck, wife of Canada's Governor General (Chalmers, 25). Since the pioneering writings of Grace Lee Nute (1947) the figure's identity as a self-portrait is commonly agreed upon by scholars, but the face bears no clear resemblance to Hopkins's photographs. Instead, we must infer the artist's presence through the figure of her husband. *He* is identifiable from her drawing of him on the balcony in the Lachine Sketchbook – by his height, his beard, his sharp-nosed bone structure. Frances Hopkins is known by her signs – dress, posture, hat – but they are none of them *her*. In a sense, and despite her presence, Hopkins is not there in her images: what *is* there is a woman, as saccharine and stereotyped as Minnehaha herself.

The strength of feminist art history has been its insistence on 'reading for the woman', and with their self-referential narratives of travel, Hopkins's paintings hold out the promise that we might do this quite literally. But there is a need for caution in reading a woman's life into her art, for representation is never a transparent gateway to the self. There is no such thing as direct expression of a pre-existent subjectivity, and hope as one might, one can never get 'home' to the place of a femininity unmediated by language. One of the problems for women has been that the stories our culture tells have been so patently non-coincident with women's experiences. In Longfellow's poem Minnehaha is an impossible embodiment of Victorian femininity; without desire of her own, she passes placidly from father to husband. To the extent that it is possible to say anything about Hopkins's self, the artist's life experiences and their visualization over the length of her career suggest that she was a woman with desire and passion of her own – a woman, indeed, to whom desire (to travel, to paint) was fundamental. As such, Hopkins does not fit the Minnehaha story, and her painting of it cannot be a simple self-portrait. But then neither is any of her art, and there is the rub. Interpreters of Hopkins's work cannot avoid the fact that she painted herself – for surely it *is* her – into her canoes. To fail to consider these works in relation to her travels goes against their grain. But neither should it be overlooked that she

painted herself out: she erased her body, gave no clear self-portrait. She is there but she is not there. This is Hopkins's position in relation to her art. It is also the position of women within patriarchy.

If, in reading for the woman, part of feminism's task is to be attentive to the ways in which 'the woman' is not there, does not fit, and cannot be at home, then this becomes all the more imperative within the locations and dislocations of colonial travel. The task of looking for the gaps in Hopkins's art confronts the spectator with the possibility of indeterminacy that is travel's risk, as it is its promise: that the subject is always in process and always in excess of the boundaries set for it.

In unpacking the implications of this, I am brought back to Hopkins's inclusion of Asennaienton, the name that means name-giver. There is a metadiscursive richness at play here that exceeds the register of Iroquois loss and dispossession, for in Hopkins's hands the name also refers back to the artist herself: she who has bestowed a name. In a sense 'Asennaienton' translates as 'Hopkins'. This is more than a straightforward theft of identity, however, for naming speaks also of a desire to *recognize* the other, to establish the commonality of a proper name: the artist's signature on the paper, the sitter's name on the title card. And in another sense 'Asennaienton' is a name marked by a still larger estrangement – one that has nothing to do with Hopkins or North American history, but which references the alienation at the heart of all naming, a moment when the designation of one's subjectivity is conferred by another. A complex semiotic nexus is at work here, linking Hopkins' artistic identity to questions of naming, possession and dispossession, put into play by an experience of travel that is ambiguously configured in terms of belonging. For Frances Hopkins the effect of travel's displacement was profound enough that she would devote a fifty-year career to reliving the journeys, continuously working to make them her own. She began this process by painting herself into a string of Royal Academy exhibition canvases. By the end of her career she rarely included herself in the smaller watercolour scenes of *voyageur* travel that she made for sale, but it is at this point that the ambiguous name emerges. What are we to make of it?

The connection between journey and name is theorized by van den Abbeele, who suggests that travel discourse is often the site of a powerful self-referentiality, wherein the uncertainties of the voyage mirror the textual uncertainties of representation itself, thus calling authorship into question. Hopkins was an artist who used realism to play out travel's subjectively experienced tensions between presence and absence, painting herself out of the surface of her works at the same time that she painted herself into their scenes. As a realist, Hopkins's aim was to make her artistry invisible, but her professional success depended on recognition of that invisible exercise of skill. The *mise en abîme* that realism sets in motion foregrounds the presence

and absence of the artist, and echoes travel's blurring of identity and difference. As such, Hopkins's art engages with what van den Abbeele proposes as the travel narrative's central moment: its propensity to a metadiscursivity that opens 'on to the deconstruction of the writer's claims to a certain *property* (of his home, of his body, of his text, of his name)'. Both name and voyage stand in this unsettled relation to possession:

For if the property of the home is put in doubt by the voyage ... it should not be too surprising to find that what is at stake in the discourse of [travel] writers is that most fundamental of all properties, the property or properness of the proper name, a name whose properness becomes suspect the moment its signature is stamped with the sign of the voyage. (van den Abbeele, xxiv)

Frances Anne Hopkins's name is stamped with the sign of the voyage, and it has cast her identity into question. It affected, certainly, how others named her: Frances Anne was 'Mr Hopkins' to an *Art Journal* blinkered by the expectations of gender (1874, 163). What is significant about Hopkins's own act of naming is that the deconstructive thrust of its self-referentiality becomes unavoidable at a moment of *Native* presence. 'Asennaienton' is an ambiguous marker of definition and recognition, whose referents are far from clear. In drawing attention to this ambiguity, I have been moving cautiously towards a suggestion of elasticity in the subject–object interval, made possible through travel. The displacements of travel, its fluidity, its economic character of *exchange*, raise the possibility of a subject whose relations with the other do not turn that exteriority into an object to be known or subsumed – a relation in which desire does not need to be predicated on objectification, but can also be grounded in recognition, and where the processes of differentiation and identification lead to a productive problematization of a common border space. This problematic underwrites Hopkins' inscription of self into the scene of colonial travel. With its gender-neutral pronoun and its reminder of cultural definitions, recognitions and erasures, 'Asennaienton' inscribes this semiotic fluidity; there can be no uncomplicated act of naming here.

In various ways, this essay has been concerned with the place of Frances Anne Hopkins. The appeal of travel theory has been as a lens that highlights the elements of instability running through both the artist's life and her work. Hopkins seems to be situated on the edge. Voyaging between Canada and Rupert's Land on the eve of its transition from colony to nation, Hopkins was on an edge between travel and tourism, work and leisure, and a corporate movement from resource extraction to retail sales and real estate. She was British and Canadian, resident and traveller, and she occupied a position of ambivalence between the empowerment accorded to her race

and class, and the restrictions attendant on her gender. As a woman adventuring in a canoe manned by *voyageurs*, she was on the edge of activity and passivity, and this tension finds its way into work that treads the boundary of looking and being seen, of physical presence and corporeal absence. Painted over the length of a career, her oils and watercolours reside in an uncertain space between experience and memory, while her unremitting specificity of realist detail inscribes the work with the detachment of a factual objectivity that is nevertheless based upon drawing viewers into an intimate sense of subjective experience. Most importantly of all, Frances Anne Hopkins's travel scenes inscribe the ambiguous edge between self and other that accompanies any displacement of home and away. Balancing in her canoe, she was warm and dry, yet immersed in the waters of another culture.

References

Art Journal, 1871, 178.

Art Journal, 1874, 163.

Buss, H., '"The Dear Domestic Circle": Frameworks for the Literary Study of Women's Personal Narratives in Archival Collections', *Studies in Canadian Literature*, **14** (1), 1989, 1–17.

Chalmers, J., 'Frances Ann Hopkins: The Lady Who Painted Canoes', *Canadian Geographic Journal*, **83** (1), 1971, 18–27.

Clark, J.E., *Frances Anne Hopkins, 1838–1919: Canadian Scenery*, Thunder Bay, Ontario: Thunder Bay Art Gallery, 1990.

Driscoll, H.R., '"A Most Important Chain of Connection": Marriage in the Hudson's Bay Company', in T. Binnema, et al. (eds), *From Rupert's Land to Canada*, Edmonton: University of Alberta, 2001, 81–107.

Feltes, N.N., 'Voy(ag)euse: Gender and Gaze in the Canoe Paintings of Frances Anne Hopkins', *ARIEL*, **24** (4), 1993, 7–19.

Foster, S., *Across New Worlds: Nineteenth Century Women Travellers and Their Writings*, New York: Harvester Wheatsheaf, 1990.

Frawley, M.H., *A Wider Range: Travel Writing By Women In Victorian England*, Rutherford, N.J.: Fairleigh Dickinson University, 1994.

Harper, J.R., *Painting In Canada: A History*, Toronto: University of Toronto, 1977.

Jackson, V., 'Longfellow's Tradition; Or, Picture-Writing A Nation', *Modern Language Quarterly*, **59** (4), 1998, 471–96.

Jameson, A., *Winter Studies And Summer Rambles In Canada*, Toronto: McClelland & Stewart, 1838.

Johnson, A.M., 'Edward and Frances Hopkins of Montreal', *Beaver*, **302**, 1971, 4–17.

Kaplan, C., *Questions of Travel: Postmodern Discourses of Displacement*, Durham: Duke University, 1996.

Kent, T.J., *Birchbark Canoes of the Fur Trade*, Ossineke, Michigan: Silver Fox Enterprises, 1997.

Lawrence, K., *Penelope Voyages: Women and Travel in the British Literary Tradition*, Ithaca, N.Y.: Cornell University, 1994.

Luckyj, N. and D. Farr, *From Women's Eyes: Women Painters In Canada*, Kingston Ontario: Agnes Etherington Art Centre, 1975.

McEwan, C., *Gender, Geography And Empire: Victorian Women Travellers In West Africa*, Aldershot: Ashgate, 2000.

Mills, S., *Discourses of Difference: An Analysis of Women's Travel Writing and Colonialism*, London: Routledge, 1991.

Morris, M., 'At Henry Parkes Motel', *Cultural Studies*, **2** (1), 1988, 1–47.

Nute, Grace Lee, 'Voyageur's Artist', *Beaver*, **278** (1), 1947, 32–6.

Perrin, Carole, *'Éléments de romantisme dans l'oeuvre peint de Frances Anne Hopkins'*, MA Thesis, Université de Montréal, 1996.

Podruchny, C., 'Unfair Masters and Rascally Servants? Labour Relations Among Bourgeois, Clerks and Voyageurs in the Montréal Fur Trade, 1780–1821', *Labour/Le Travail*, **43**, 1997, 43–70.

Rozmovits, L., 'New Woman Meets Shakespeare: The Struggle over the Figure of Portia', *Women's History Review*, **4** (4), 1995, 441–63.

van den Abbeele, G., *Travel as Metaphor: From Montaigne to Rousseau*, Minneapolis: University of Minnesota, 1992.

Williams, G., 'The Hudson's Bay Company and the Fur Trade: 1670–1870', *Beaver*, **314** (2), 1983, 4–86.

Wolff, J., 'On the Road Again: Metaphors of Travel in Cultural Criticism', in *Resident Alien : Feminist Cultural Criticism*, New Haven: Yale University, 1995.

Notes

I am fortunate in the assistance of the Social Sciences and Humanities Research Council of Canada and the Fonds québécois de la recherché sur la société et la culture, more fortunate still in my colleagues, students, and friends. Warm thanks to Brian Foss, Janice Anderson, the Yale Victorian Visual Culture Reading Group and, most particularly, to David Capell.

1　Hopkins's correspondence indicates her familiarity with copyright law and a clear sense of the market value of her work. McCord Museum of Canadian History, McCord Family Papers, 5031.

2　Edward Hopkins to William Hardisty, 30 January 1867, Montreal Correspondence Books Outbound, HBC Archives, B.134/b/27. Thanks to Donna McDonald, whose forthcoming biography of Hopkins will be published by Dundurn Press. See also letters to James Stewart, 23 January 1865, and John Black, 6 August 1865, B.134/b/34.

3　D. Smith to H. Brack, 12 July 1869, B.134/b/29.

4　Thanks to all who offered their opinion about this flag, including Bruce Patterson, Auguste Vachon, Kevin Harrington, Shawn Patterson and Laura Peers.

5　It is my great good fortune to know Roy Wright, peripatetic linguist and friend of Martin Loft at the Kahnawake Cultural Centre. Warm thanks to them, and also to Nicole St-Onge and Carolyn Podruchny.

6　I have reconstructed Asennaienton's biography from Caughnawaga censuses and parish registers in the Archives nationales du Québec à Montréal, and records in the Hudson's Bay Company Archives, B.129/g/10-42; B.134/g/25-39; B.134/z/1 fos. 85, 104, 105.

7　Father Burtin to Edward Hopkins, 13 June 1864, B.134/c/94.

8　My own allusion is to Michael Fried, *Courbet's Realism*, Chicago: University of Chicago, 1990.

9　Hopkins's contemporary, the sculptor Edmonia Lewis, also disrupted the expectations of racial identity by using Minnehaha as a veiled symbol for herself. See J.M. Holland, 'Mary Edmonia Lewis's *Minnehaha*: Gender, Race, and the "Indian Maid"', *Bulletin of the Detroit Institute of Arts*, **69** (1–2), 1995, 25–37.

Chronicles in cloth: quilt-making and female artistry in nineteenth-century America

Janet Catherine Berlo

During the past three decades a substantial body of scholarship has revolutionized the understanding of the female artist in a global context, from European and Chinese painters, to Native American potters and beadworkers, to African and Peruvian textile artists. Art historians have shed new light on the roles of nineteenth-century female painters and sculptors in America (Nelson, in this volume; Tufts, 1984–89; Tufts, 1987; Hirshorn, 1996). During the same three decades there has been a quieter, yet no less substantial, revolution in the study of North American textile arts. The needlework sampler and the quilt, for example, have been studied from numerous angles: technique and materials, artistic 'schools', individual biography, and social history. The results of this study have not been well integrated into the mainstream history of American art, in which textile arts and the female textile artist are still peripheral, mute and sometimes invisible, perhaps because much scholarship on American textile arts has been carried out by amateurs, collectors, textile artists themselves, or scholars in fields such as folklore, textile science, or women's studies.[1] The textile arts illuminate the role of women in American culture, their participation not only in a domestic economy but a global one, and their keen interest in subject matter that transcends the so-called 'women's sphere'.

Erroneously seen as an anonymous art, needlework has not been given the same credence and weight granted to painting and sculpture. We do, however, know the works, names and biographies of many textile artists, from the schoolgirls who proudly worked their names and ages into the embroidery of their colonial samplers, to the adult quilt-makers, some of whom, equally proudly, stitched their names and dates into their works as well. To illustrate this essay, which focuses on one type of quilt, the pictorial appliqué, I have deliberately chosen works whose makers are known, in

order to put a human face on this supposedly anonymous art, and to reveal the volitions and interests of these undervalued artists.

In making their fine needlework, American women forged a parallel system of artistic accomplishment to that of mainstream art academies and salons. While some American academies did admit female members, their numbers were small. If the female painter or sculptor was the exception in this century, the female textile artist was the norm. Nonetheless, art history has not accorded such women the status of 'artist'; indeed, few claimed this role for themselves, despite the fact that hundreds of thousands of American women were accomplished at the arts of the needle, and hundreds of thousands of their works survive in museums as eloquent testimony to their artistry. Discussing the vexed categorization of European embroidery (not art/not exactly craft; work/yet more than work), Rozsika Parker has provided insights into all creative work of the sewing needle, pointing out that needlework is, in fact, art, for it is 'a cultural practice involving iconography, style, and a social function', and concluding,

That embroiderers do transform materials to produce sense – whole ranges of meanings – is invariably entirely overlooked. Instead embroidery and a stereotype of femininity have become collapsed into one another, characterised as mindless, decorative, and delicate; like the icing on the cake, good to look at, adding taste and status, but devoid of significant content. (Parker, 1989, 6)

Before examining the quilt-makers, though, it is useful to understand the education in fine needlework afforded to many American girls in the colonial and federalist periods, an education that cultivated an appreciation for the arts of the needle.

NEEDLEWORK AND FEMALE EDUCATION

In colonial New England, both male and female children were taught to read, but in most communities only boys were taught to write, while girls learned to fashion their letters through the use of the sewing needle. The many samplers sewn by girls in the seventeenth and eighteenth centuries are evidence of their learning. By the end of the eighteenth century girls from middle-class urban families were sent to private academies run by women who were generally expert at fine needlework; these girls thus learned all the skills and accomplishments in this medium deemed necessary for young women of their social standing.

Mrs Rowson's Academy in Boston provides a good example. In 1797 she placed a notice in a Boston newspaper, advertising that she would be 'instructing young Ladies in Reading, Writing, Arithmetic, Geography, and Needle-work'. Later, she added drawing to the curriculum, though drawing

and embroidery lessons cost $6.00 each per quarter, the same amount as all the other subjects combined, suggesting that only those from the most prosperous families would receive instruction in the arts (Giffen, 1970). The works of embroidery and painting done at the school were shown publicly at annual exhibitions, which were reviewed in the Boston magazines, and where silver medals were awarded for excellence. So, even before 1800 American women had venues to display their work and to see that of other women outside the domestic environment, even though they were excluded from most male artistic academies and salons until the second half of the nineteenth century.[2]

The most common needlework in the period from 1650 to 1850 was the sampler, a literal 'sampling' of stitches to show off the technical virtuosity of a young textile artist. Nearly all the thousands of known samplers produced in prosperous towns from Maine to South Carolina were made by girls aged from six to twenty. The first American samplers closely followed their English prototypes: long, narrow strips of linen in which many different stitches were worked in bands across the cloth. They usually included the name of the maker, her age, the date and some Bible verse or moral proscriptions. Some textile artists stitched ambitious pictorial scenes: landscapes, fishermen, shepherdesses, and the like.[3] A popular trend in early nineteenth-century needlework was to memorialize the beloved dead through elaborately worked mourning pictures. Other works documented family births, marriages and deaths in embroidered family records.[4] As will become clear, these themes would be expanded and enlarged in the quilts made by adult women in the nineteenth century.

'Female accomplishments', a phrase used throughout the eighteenth and early nineteenth centuries, referred to the ability to do fine needlework (along with a smattering of other social skills, like music and watercolour painting). Schoolmistresses such as Susanna Rowson, mentioned above, who provided guidance in style and subject matter and set the direction for more than a century of women's art, have been called 'the most neglected of American artists' (Ring, 1993, vol. 1, xix). They are almost never mentioned in mainstream surveys of American art, only in the specialized literature on needlework.

Embroiderers, like the quilt-makers who came after them, sometimes tackled ambitious topics in their work. While a student at the Ladies' Academy in Dorchester, Massachusetts, in 1804, fifteen-year-old Maria Crowninshield embroidered an allegorical image of female education. Following the neoclassical painting style of its day, her embroidery depicts a classical temple in which a young girl in flowing robes reads from a book held by her teacher while a goddess crowns her with a wreath (Richter, 2001, plate 27). The propriety of education for women was hotly debated in affluent

households throughout the eastern seaboard at the beginning of the nineteenth century; it is noteworthy that in this image, the book from which the pupil reads is Hannah More's *Strictures on the Modern System of Female Education* of 1799. In her popular book this moderate reformer urged that education would make women better mothers and educators of the next generation of male citizens. Her more radical contemporary, Mary Wollstonecraft, in *Thoughts on the Education of Daughters* (1787) and *A Vindication of the Rights of Woman* (1792), argued, by contrast, that women could be the intellectual equals of men if properly trained. Wollstonecraft was widely read (and often pilloried) in educated households in Federalist America. These British writers, as well as Catharine Macaulay, in her *Letters on Education* (1790), scorned 'female accomplishments' as trivial; they believed that young women's minds should be sharpened by exposure to all the same subjects studied by young men in the best schools. Mary Wollstonecraft argued that needlework constricted female minds 'by confining their thoughts to their persons' (Wollstonecraft, 1975, chapter 4). Yet it was through the art of needlework that girls learned to write, to appreciate the arts, and to express themselves on a host of topics. Indeed, Maria Crowninshield deftly turned her talents in 'female accomplishments' to a quietly subversive end; she argued through the work of her needle that female education was a lofty goal, fitting with the neoclassical aspirations of the new republic.

As the century unfolded the making of fine quilts became an even more important arena for female artistic accomplishment than the stitching of samplers or embroidered pictures. Yet there was also an increasing criticism among American reformers who, like their British predecessors, found needlework to be symbolic of all that confined women to the domestic sphere, and kept them from intellectual achievement in other realms. Pictorial needlework made as part of a girl's education declined sharply by 1850, in part because of the work of reformers like Catherine Beecher and Emma Willard, and in part because many girls began to attend public schools rather than private female academies. Needlework continued to be made at home, however. With the increase in fine imported cloth in the early decades, and then less expensive printed cloth manufactured in America after 1850, many women turned their attention to quilts, for only a lucky few had the opportunity to become professional painters and sculptors within a male-defined arena. In quilts American women artists of all classes and ethnicities expressed their creativity and aspirations.

CHRONICLES IN CLOTH: THE UNIQUE PICTORIAL APPLIQUÉ

The geometric pieced quilt – the kind which typifies the American quilt – affords a nearly limitless range of design possibilities. By combining squares,

rectangles and triangles of different sizes and proportions in different colour schemes, even familiar patterns like Log Cabin or Nine Patch can produce radically different results.[5] Yet geometric patchwork tells only part of the story of nineteenth-century women's artistic creativity. Even bolder in design and conception, perhaps, were many of the appliqué quilts made by women who often chose this format to chronicle a personal iconography.

Late eighteenth-century American quilts were often whole-cloth quilts of solid colours, in which fine hand-quilting provided the only embellishment, or they were *palampores*, bed coverings of painted and printed cottons from India (or replicas of such cloth manufactured in Europe), which were backed and hand-quilted.[6] By the end of the century, prosperous women in both England and North America began to fashion central medallions from these fine imported fabrics. Called *broderie perse*, or cut-out chintz appliqué, this technique of snipping designs from printed fabric and sewing them onto a plain fabric ground was an innovative and yet less costly way of mimicking an expensive *palampore*. Sometimes appliquéd flowers, trees and other imagery cut from fine imported chintz were mixed with elaborate pieced borders, usually of less costly cloth.

The appliqué quilt was an opportunity for the textile artist to conceive of her quilt as a canvas onto which she could stitch an ambitious pictorial composition, not bound by the geometric structure of piecework. Numerous women chose to express their creativity through the appliqué format. While many early nineteenth-century quilts are genteel renditions of the cut-out chintz appliqué style, occasionally an artist exceeds the boundaries of conventional style. In 1803 Sarah Furman Warner Williams of New York (born *c.* 1763) made an extraordinary pictorial coverlet in honour of the marriage of her young cousin Phebe Warner. In it Williams took the conventions of cut-out chintzwork in a new direction. An oversize vase of lush flowers is flanked by big trees in which huge birds roost (Figure 10.1);[7] humans and animals frolic, too, in a landscape beneath the trees. Williams's work is more akin to the fine embroidery popular in her youth than it is to other conventional quilts *c.* 1800. She has taken the miniaturized genre of embroidery and greatly enlarged it to make an emphatic artistic statement.

As the century progressed, such impulses in quilt-making became more common, and the results even more striking. While unique appliqués may have comprised a proportionally small number of American quilts made in the nineteenth century, their originality is remarkable, and quilt-makers today continue to work in this genre, greatly influenced by the work of their nineteenth-century artistic forebears.[8] The Baltimore Album quilt was a well-known variant, taking hold in Maryland and Pennsylvania in the mid-1840s. Its popularity was widespread but lasted no more than a decade

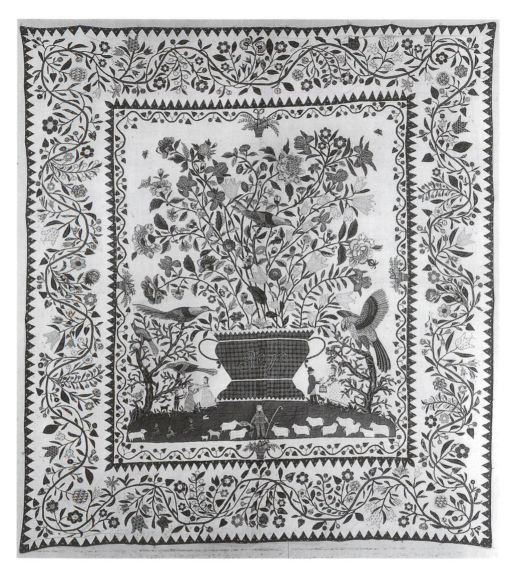

10.1 Sarah Furman Warner Williams, *Phebe Warner Coverlet*, 262.25 × 229.87 cm, linen with linen and cotton appliqué and silk embroidery, *c*. 1803

(Goldsborough, 1994), yet original appliqué work both pre- and post-dates this influential regional style.

In the 1830s Hannah Stockton Stiles of Philadelphia (1799–1879) enlivened the chintz and calico Tree of Life on her quilt by encircling it with scenes of maritime trade and riverport activity, giving rise to its title *The*

Trade and Commerce Quilt (Figure 10.2).[9] Some of the figures are barely 10 cm. tall, yet the artist has embroidered their facial features and many minute details. She has exploded the notion of a regular, repeating floral border (like that in Figure 10.1), turning it into a riverscape with thirteen large boats and several small ones. This, in turn, is surrounded by a border depicting the bustling life of her neighbourhood in the Northern Liberties area of Philadelphia, along the Delaware River. Her facility in accurately depicting paddle steamers, prosperous sloops and small dories suggests an intimate knowledge of the maritime activity near her home. The men off-loading cord-wood from a sloop and meticulously stacking it between the grocery and the tavern on the left border of the quilt may have been employees of her husband, John Stiles, Jr, who followed his father into the lumber business. At the bottom of the quilt are men and women dressed in fashionable calicoes. On the sides she appliquéd genre scenes, including a storehouse, grocery, bathhouse, tavern and a milkmaid. Unlike many works of appliqué, the *Trade and Commerce Quilt* is not a showcase for fine needlework. Originality of design and communication of her unique vision of the social and economic life of her era were more important to Hannah Stockton Stiles. Like the genre painters of her day, she grappled with the vigorous new spirit of enterprise that gripped America's cities in the 1820s and 1830s. Her pictorial appliqué of the busy river port, its inhabitants intent upon their commercial ventures, encapsulates the spirit of urban America in this era.

Numerous original pictorial compositions, some combining piecework and appliqué, have survived from the mid-century. In 1843 Elizabeth Roseberry Mitchell of Kentucky (1799–1857) devised an ingenious use of a quilt as both a family record and an object of comfort and mourning (Figure 10.3). She made a pieced quilt in the LeMoyne Star pattern but in the centre, instead of a larger accent star, she appliquéd a fenced graveyard. A larger fence on the quilt's border echoes this interior enclosure. Though she made this after the deaths of two of her sons, Mitchell clearly envisioned it as a family record – not only of herself, her husband and their eleven children, but their future families as well. In addition to some two dozen coffins that she appliquéd (most on the perimeter of her quilt), she hand-stitched the outlines for many more possible coffins along the fencing that borders the quilt. Most have strips of paper or cloth attached to them, labelled with family names. She also embroidered trees and flowering vines around the fencing of the central graveyard, making it a more hospitable place for the coffins that were eventually moved there, and perhaps symbolically emphasizing the contrast between life and death.[10] Like the quilt in Figure 10.1, this work of art seems to replicate on a grand scale the earlier nineteenth-century conventions of small-scale needlework, in this case the popular mourning picture. Mitchell's

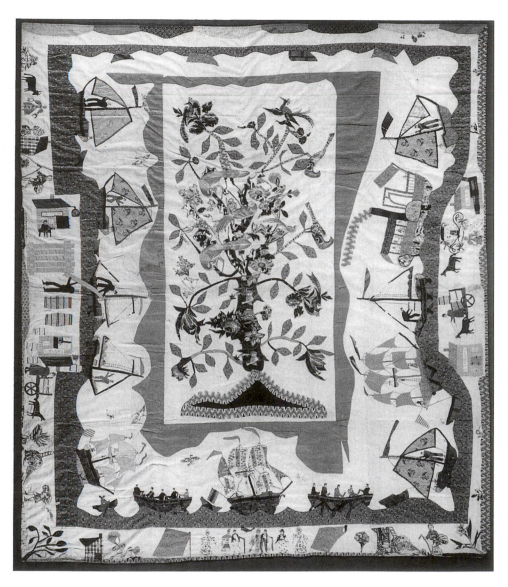

10.2 Hannah Stockton Stiles, *Trade and Commerce Counterpane*, 266.7 ×
226.06 cm, appliquéd and embroidered cottons, *c.* 1830

work not only articulated her creativity but her sorrow, too, her needle giving
eloquence to her maternal loss.

It is noteworthy, perhaps, when considering the space that an artist takes
up in practising her work and displaying it, that the quilt is a large-scale

10.3 Elizabeth Roseberry Mitchell, *Family Graveyard Quilt*, 215.9 x 205.74 cm, pieced, appliquéd and embroidered cottons, *c.* 1843

object. Yet it is an object that is easily folded up and put away. Moreover, it can be worked on piecemeal, with small portions being carried into the drawing room, or the carriage, or the 'Quilting Frolic', to be worked on in the company of others. So while the quilt has something in common with the small-scale arts of needlework also practised by women, it also has something in common with the large-scale painting.

Unique pictorial appliqué quilts provided occasions for the creative needlewoman to stitch autobiography, aspiration and imagination into her

work. They also provided the opportunity to express political sentiments and organizational affiliations at a time when no women had the vote and few had the opportunity to express their political views publicly. In the United States the nineteenth century was the great age of male fraternal organizations. Though meant to exclude women, the Odd Fellows and Freemasons, under pressure from the wives of members, began in the 1850s to form women's auxiliaries. The many appliqué quilts of the second half of the century displaying the symbols of these fraternal organizations were made by women's auxiliary members, and presumably were hung in the meeting halls, as well as being given as gifts to male members.[11] Later in the century many quilted and pieced banners proclaimed women's political sentiments regarding issues of temperance and feminism, carrying women's artistry into the public domain.[12]

Just as women pieced quilt blocks in designs with names like Whig Rose, Burgoyne Surrounded and Clay's Choice to express political beliefs or commemorate historical events, they also created pictorial documentation of Confederate or Yankee partisanship during the Civil War which split the United States apart in the early 1860s.[13] Perhaps the finest social document in needlework of the post-Civil War era is a quilt made by Lucinda Ward Honstain (1820–1904), with an embroidered notation 'Done Nov th. 18, 1867.' (Figure 10.4) In forty appliquéd blocks, she combined family biography, political commentary, genre scenes and conventional decorative motifs common to mid-century appliqué quilts. Recent research on this spectacular work of art has demonstrated the autobiographical nature of many of the scenes.[14] The central rectangular block (taking up the area of three squares) probably depicts Honstain's home in Brooklyn, New York. The prosperous-looking brick house with picket fence, American flag, mullioned windows, fruit trees and domestic animals anchors the scene. Below, an equestrian figure probably represents the artist's daughter Emma, an accomplished horsewoman. To the right is a three-masted ship from the nearby Brooklyn Navy Yard where Emma's husband's ship had embarked for its Civil War tour of duty. In the second row from the bottom, one of the blocks depicts a man driving a horse-drawn wagon. Embroidered on the side of the wagon is 'W.B. Dry Goods', a reference to Ward and Burroughs Dry Goods, a firm owned by the artist's brother.

Honstain was avidly interested in the public events of her era, for she commemorated patriotic, military and political themes, including Jefferson Davis (second row, middle). The famous Confederate president had been released from prison in 1867 – the year during which she was working on the quilt – after two years' incarceration for treason. In the third row, left, an eloquent reminder of the outcome of the Civil War is inscribed in the embroidered message 'Master I am free', uttered by a black man facing a

10.4 Lucinda Ward Honstain, *Pictorial Album Quilt*, 243.84 × 218.44 cm, pieced, appliquéd and embroidered cottons, 1867

white man on horseback. Honstain's family had owned slaves when she was a child. After the New York anti-slavery law of 1827 those freed blacks continued to live in the neighbourhood, and in several scenes Honstain provides an insight into the jobs available to freed blacks in New York City: boot black (bottom row) and ice-cream vendor (second row, left). It is hard to

discern Honstain's opinion about the freed African Americans she depicts in cloth. Like the mid-century genre paintings of blacks by white painters, her images partake of stereotype in the use of large everted lips and other exaggerations of physiognomy, perhaps revealing an ambiguous relationship to the idea of emancipation (Johns, 1991, 100–36). Yet, as well as commemorating their freedom ('Master I am free'), she depicts African Americans at work, a portrayal that few antebellum or immediately post-Civil War painters attempted. Though the assimilation of freed blacks into the trades was a major theme in nineteenth-century social and literary discourse, this was seldom depicted in genre painting (Boime, 1990, 79; Johns, 131), making this quilt an even more notable artefact of nineteenth-century American visual culture.

The style of appliqué stitchery differs from block to block in this quilt, suggesting that even if its artistic conception was Lucinda Honstain's alone, she may have had help in its execution. Both she and her daughter were listed as dressmakers in the 1870 census, as was the artist's older sister Sarah. Between her brother's dry goods firm and her husband's tailors shop, the maker of this quilt clearly had access to a wide range of materials. Though she earned her living by sewing for others, her love of needlework and her need for personal expression led Honstain to spend many hours making this superlative work, which provides a social snapshot of American society right after the Civil War.[15]

Though a small number of women made professional inroads into such fields as botany and astronomy (Slack, 1987; Mack, 1990), it was more common for women to display their scientific knowledge – and perhaps to pass it on to others – through the medium of quilts. In 1865 Ernestine Zaumzeil created a unique botanical appliqué in which the vines (more often used as bordering elements, as in Figure 10.1) take over the entire design field. The artist has depicted a half-dozen recognizable varieties, carefully delineated as to leaf shape and size.[16] Harriet Miller Carpenter (1831–1915) created a series of quilts depicting the planets and the Milky Way in the 1880s and 1890s as teaching devices for her grandchildren (Berlo and Crews, 2003, plate 20). Ellen Harding Baker is said to have used her appliquéd and embroidered Solar System Quilt (1876) as a visual aid when she gave popular science lectures in Iowa.[17] Such works, again, take a so-called 'domestic' art out of the home and into the public realm, as didactic objects that demonstrate a woman's knowledge.

Most of the quilts that have survived from the nineteenth century are fine textiles that were saved within families, seldom washed, and perhaps seldom used. So most are from middle- and upper-class makers. Few examples of African American quilts remain from the nineteenth century. But African American quilter Harriet Powers's Bible quilts, one of which is in the

Smithsonian Institution in Washington (*c.* 1886) and another (Figure 10.5) in the Museum of Fine Arts in Boston (*c.* 1895), are among the best known of all American quilts.[18] A seamstress who was born a slave, Powers (1837–1911) completed these works in her late middle age, using a range of typical fabrics of the time. Most of the stitching was done with the use of the machine. Numerous stars were separately pieced and inset within the ground cloth in an ingenious style of reverse appliqué, while the larger figures were machine-appliquéd in a free-spirited manner.

Like Hannah Stockton Stiles (Figure 10.2), Powers was more concerned with her message than with delicacy of execution. Her Boston quilt is composed of fifteen scenes, ten referring to biblical stories, including Adam and Eve, Jonah and the Whale, John baptizing Christ, and the Crucifixion.[19] Four other scenes depict mysterious weather occurrences, among them 'Black Friday' in 1780, when pollution caused by forest fires caused the sky to darken, and the meteor storms of 1833 and 1846. This extraordinary textile was most likely used didactically, like several quilts already mentioned. Powers herself called her Smithsonian quilt a 'sermon in patchwork': how better to teach the memorable stories of the Old and New Testaments, as well as to illustrate God's mysterious powers (as evidenced by shooting stars and other meteorological anomalies) than through pictorial means? The square directly in the centre of the quilt depicts the all-night Leonid meteor storm of 13 November 1833. Eight chrome yellow stars stand out vividly against the blue background, while a large white hand is appliquéd to the upper left corner. Powers said of this event, 'the people were fright [sic] and thought that the end of time had come. God's hand staid the stars.' (Perry, 1994) Stitched some sixty years after the event, Powers's work reaffirms the potency of oral history, stories of extraordinary times handed down through families and preserved in cloth as well as memory.

Unfortunately, Powers's remarkable works of American vernacular art are almost never contextualized within the history of American quilting, nor seen as part of the American appliqué tradition under consideration here. Instead, they have been used exclusively to establish putative links with West African textile traditions, links which have more to do with a mythologizing and essentializing impulse in African American studies at the end of the twentieth century, in which everything is examined through an African lens.[20] I would assert, in contrast, that Harriet Powers, like Williams, Stiles, Mitchell, Honstain and countless other women before her, is a quintessential American artist, working in a genre popular among both black and white quilters alike in the nineteenth century, and using her talent and ingenuity to express a keen interest in Bible stories and wondrous events from oral history. Though poor, she owned a sewing machine, and used it to pursue her craft. Her work may be seen as no less American in its conception, its imagery and its

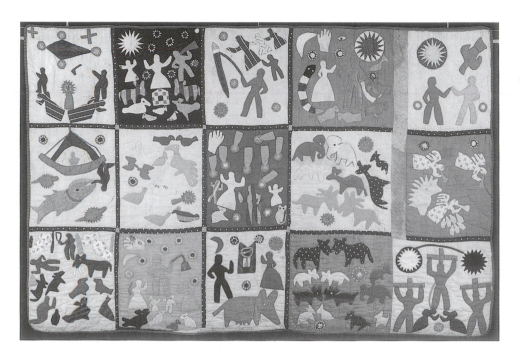

10.5 Harriet Powers, *Bible Quilt*, 172.72 x 266.7 cm, pieced and appliquéd cottons, *c.* 1895

execution than any other nineteenth-century appliqué quilt. Divorcing her important works of art from their local context does an injustice to Harriet Powers both as a self-motivated artist and as a product of her American heritage – a heritage in which she was a devout Christian who exhibited her quilts at regional fairs, and sold them to white buyers who valued their remarkable expressiveness. Her Smithsonian quilt was displayed at the 1886 Cotton Fair in Athens, Georgia, and circumstantial evidence suggests that the quilt in Figure 10.5 was displayed at the Cotton States and International Exposition in Atlanta in 1895 (Fry, 1990, 86). Such fairs were crucial for the public dissemination of ideas and art forms for quilters, as I discuss in the next section. It is most logical to assume that Powers was influenced by the society in which she lived and worked rather than by supposedly ancestral West African forms.

WOMEN AND QUILTS IN AMERICAN VISUAL CULTURE

Nineteenth-century North American society – more so than the century before or the century after it – has been characterized as one structured by

rigid gender boundaries. Most women's daily lives were built around female networks. Among their sisters, cousins and church members, women formed long-lasting friendships. As Nancy Cott elucidates,

A woman discovered among her own sex a world of true peers, in valuing whom she confirmed her own value. In one sense, the female friendships of this period expressed a new individuality on women's part, a willingness and ability to extract themselves from familial definition and to enter into peer relationships as distinct human beings. In another sense, these attachments documented women's construction of a sex-group identity. Women had learned that gender prescribed their talents, needs, outlooks, inclinations; their best chance to escape their stated inferiority in the world of men was on a raft of gender 'difference'.[21]

Women's friendships flourished not only within home and church, but within the sewing circle as well, which served as a place of artistic education. Though most women designed, cut, and pieced (or appliquéd) their quilt tops at home, they came together in a group to finish the work and do the laborious hand-quilting that held top, stuffing and backing together. In the early nineteenth century the name for the communal effort that later came to be called the Quilting Bee was 'Quilting Frolic'. The British writer Frances Trollope, who lived in Cincinnati during the 1820s, described this event:

The ladies of the Union are great workers, and, among other enterprises of ingenious industry, they frequently fabricate patchwork quilts. When the external composition of one of these is completed, it is usual to call together their neighbours and friends to witness, and assist at the *quilting*, which is the completion of this elaborate work. These assemblings are called 'quilting frolics,' and they are always solemnized with much good cheer and festivity (Trollope, 1949, 416).

The term 'Bee' was reserved for mundane tasks, such as the corn-husking bee, or the fruit-paring bee. Frolic, in contrast, suggests the excitement and high spirits present in the gathering of friends and artistic peers. The quilting frolic was the female equivalent of the art academy and the salon (institutions that, as mentioned before, until the end of the century routinely excluded women, or sharply limited their numbers). The quilt tops brought for assembly and hand-quilting would be admired, discussed and used as creative fodder for the next quilts to be made within a community of intimates. At a quilting frolic, one might see the latest fabric purchased in the big city, or the most recent clever use of pieced blocks, or a new appliqué design.[22]

While few, if any, quilts hung on museum walls in the nineteenth century, many were offered for public viewing at fund-raising anti-slavery fairs from the 1830s to the 1860s and Sanitary Commission Fairs during the Civil War. Even more widespread were the numerous county, state and world fairs, where prizes were given for quilts.[23] Women flocked to these public venues to exhibit their work and to judge that of their artistic peers, just as painters

and sculptors looked to exhibitions held at academies, salons and museums. Many more people visited quilt exhibitions at county and state fairs in the nineteenth century than visited museums – hundreds of thousands of visitors would attend a large fair like the Ohio State Fair. Quilt-making was a democratic art that crossed boundaries of class and ethnicity.

It has been a truism of three decades of scholarship that quilt-making is a reflection of women's separate domestic sphere. Patricia Mainardi was the first to position quilts as the legitimate feminist ancestry that those interested in women's arts in the 1970s were so avidly seeking:

Needlework is the one art in which women controlled the education of their daughters, the production of the art, and were also the audience and critics, and it is so important to women's culture that a study of the various textile and needlework arts should occupy the same position in Women's Studies that African art occupies in Black Studies – it is our cultural heritage. (Mainardi, 1973, 1)

Much of the language of feminist writing from the 1970s to the 1990s sought to ennoble and reclaim the artistic work of women. One aspect of this reclamation project was the notion that quilts represented a counter-discourse, a covert female language that said the unsayable in a form of silent public oratory. Mainardi wrote,

In designing their quilts, women not only made beautiful and functional objects, but expressed their own convictions on a wide variety of subjects in a language for the most part comprehensible only to other women. In a sense, this was a 'secret language' among women, for as the story goes, there was more than one man of Tory political persuasion who slept unknowingly under his wife's Whig Rose quilt.[24]

Indeed, quilts were the medium for presenting women's convictions about a number of issues. But today, the so-called secret language of quilts seems instead to be a widely shared visual discourse that crossed many media, was used by both genders and diverse races, and was a constituent part of a visual culture encompassing the iconography of fraternal organizations, Christian symbols, political iconography, Pennsylvania Dutch *fraktur* painting, weaving, embroidery, Staffordshire plates, printed textiles and folk paintings, among other things. Some of this was imagery that immigrants brought with them, while some was adapted from material goods traded in the global economic system. Some aspects of quilt iconography may have been purely idiosyncratic, autobiographical, or meant for an audience of female peers alone. But the more that is learnt about nineteenth-century America, the less do quilts seem to be cloistered solely within a female realm. A re-evaluation of women's textile arts places them squarely within American visual culture, as a medium that formed part of the visual background of men's lives, too. In this medium, female artists stitched not only autobiographical narratives, but also social, religious and political

narratives, as the examples illustrated demonstrate. A re-examination of the classic feminist trope of 'separate spheres' (male/public versus female/private) is currently ongoing within the field of American Studies; inquiries into quilt history should interrogate overly simplistic accounts of gender, too.[25]

The nineteenth-century quilt artist was not only working within a local, gendered sphere; she was participating in national and international artistic and economic realms. Patterns and materials for quilts were part of the international flow of commerce that linked so much of the world in the nineteenth century. The importation of chintz early in the century was followed by the rise of textile manufacturing in the United States. By the 1830s calico printing had expanded rapidly in New England, and a scant two decades later American women had an abundance of fine, domestically printed cloth from which to choose (Ordóñez, 2000, 146). Women who made silk Crazy quilts in the last quarter of the century were not only responding to artistic trends engendered by the Japanese exhibits at the Centennial Exposition in Philadelphia in 1876 (McMorris, 1984; Hosley, 1990), but also to global economic currents that first increased the importation of affordable silk fabrics from China and later ensured that two-thirds of the world's silk was woven domestically – in the United States – from Chinese fibres (Maines, 1986, 87).

In the twentieth century quilt-making was celebrated as an anti-modern impulse, a sphere in which thrift, feminine domesticity and 'making-do' were the chief virtues (Berlo, 2003). These values have been mistakenly projected back upon the nineteenth century. A more up-to-date analysis finds quilt-makers like Sarah Williams, in 1803, participating in a visual conversation with roots extending back into eighteenth-century American educational standards for female accomplishment and a reach embracing fine textiles from India and England. In the 1830s Hannah Stiles depicts the vigour of early nineteenth-century commerce on the Delaware River, providing a genre scene in cloth akin to those painted by George Caleb Bingham (1811–1879) or Winslow Homer (1836–1879). In the 1860s, grappling with the aftermath of the Civil War, Lucinda Honstain records in fabric the actors and events of that era, from the recently imprisoned Confederate president to the newly emancipated African American. If trends in visual and cultural studies and the so-called 'new art history' truly aim to revolutionize an understanding of the past, the aspirations and cultural productions of those women who worked in media heretofore outside the purview of mainstream art history – cloth and thread – must be taken into account.

References

Adams, M. J., 'The Harriet Powers Pictorial Quilts', *Black Art: An International Quarterly*, **3** (4), 1979, 12–28.

Adamson, J., *Calico and Chintz: Antique Quilts from the Collection of Patricia S. Smith*, Washington D.C., 1997.

Atkins, J., 'Pricking the Social Conscience', in *Shared Threads*, exh. cat., New York: Museum of American Folk Art, 1994.

Austin, M.L. (ed.), *The Twentieth Century's Best American Quilts*, Golden, Colorado: Primedia Publications, 1999.

Bassett, L. and J. Larkin, *Northern Comfort: New England's Early Quilts: 1780–1850*, Nashville: Rutledge Hill Press, 1998.

Berlo, J.C., ' "Acts of Pride, Desperation, and Necessity": Aesthetics, Social History, and American Quilts', in Berlo, J.C. and Patricia Cox Crews (eds), *Wild By Design: Innovation and Artistry in American Quilts*, Seattle: University of Washington Press, 2003.

—— and P. Cox Crews (eds), *Wild By Design: Innovation and Artistry in American Quilts*, Seattle: University of Washington Press, 2003.

Boime, A., *The Art of Exclusion: Representing Blacks in the Nineteenth Century*, Washington, DC: Smithsonian Institution Press, 1990.

Brackman, B., 'Fairs and Expositions: Their Influence on American Quilts', in Lasansky, J. (ed.), *Bits and Pieces Textile Traditions*, Lewisburg, Pa: Union County Historical Society, 1991, 90–9.

Clawson, M.A., *Constructing Brotherhood: Class, Gender and Fraternalism*, Princeton, N.J.: Princeton University Press, 1989.

Cott, N., *The Bonds of Womanhood: 'Woman's Sphere' in New England 1780–1835*, New Haven: Yale University Press, 1977.

Crews, P.C. (ed.), *A Flowering of Quilts*, Lincoln: University of Nebraska Press, 2001.

Davidson, C. and J. Hatcher, (eds), *No More Separate Spheres! A Next Wave American Studies Reader*, Chapel Hill, North Carolina: Duke University Press, 2002.

Elsey, J. and C. Torsney (eds), *Quilt Culture: Tracing the Pattern*, Columbia: University of Missouri Press, 1994.

Fisher, L. and D. Harding, *Home Sweet Home: The House in American Folk Art*, New York: Rizzoli International, 2001.

Fry, Gladys-Marie, *Stitched From the Soul: Slave Quilts from the Ante-Bellum South*, New York: Dutton Studio Books, 1990.

——, 'Harriet Powers: Portrait of a Black Quilter' in Wadsworth, Anna (ed.), *Missing Pieces: Georgia Folk Art 1770–1976*, Atlanta: Georgia Council for the Arts and Humanities, 1976.

Fox, S., *Wrapped in Glory: Figurative Quilts and Bedcovers 1700–1900*, exh. cat., Los Angeles: L.A. County Museum of Art, 1990.

Giffen, J., 'Susanna Rowson and Her Academy', *Antiques*, **98** (3), 1970.

Goldsborough, J., *Lavish Legacies: Baltimore Album and Related Quilts from the Collection of the Maryland Historical Society*, Baltimore: Maryland Historical Society, 1994.

Gordon, B., 'Playing at Being Powerless: New England Ladies Fairs 1830–1930', *Massachusetts Review*, **26** (4), 1986, 144–66.

Groseclose, B., *Nineteenth-Century American Art*, Oxford: Oxford University Press, 2000.

Hedges, E. et al., *Hearts and Hands: Women, Quilts and American Society*, Nashville: Rutledge Hill Press, 1987.

Hirshorn, A.S., 'Anna Claypool, Margaretta, and Sarah Miriam Peale: Modes of Accomplishment and Fortune', in Miller, Lillian (ed.), *The Peale Family: Creation of a Legacy, 1770–1870*, New York: Abbeville Press, 1996.

Hosley, W., *The Japan Idea: Art and Life in Victorian America*, Hartford, CT: The Wadsworth Museum, 1990.

Houck, C. and C. Nelson, *Treasury of American Quilts*, New York: Greenwich House, 1987.

Huber, C., *The Pennsylvania Academy and Its Women*, Philadelphia: Pennsylvania Academy of the Fine Arts, 1974.

Johns, E., *American Genre Painting: the Politics of Everyday Life*, New Haven: Yale University Press, 1991.

Jurgena, M.S., and P.C. Crews, 'The Reconciliation Quilt: Lucinda Ward Honstain's Pictorial Diary of a American Era', *Folk Art*, **28** (3), 2003.

Lipsett, L.O., *Elizabeth Roseberry Mitchell's Graveyard Quilt*, Dayton, Ohio: Halstead and Meadows, 1995.

Macaulay, C., *Letters on Education*, London: William Pickering, 1996 (1790).

Mack, P., 'Straying From their Orbits: Women in Astronomy in America' in Farnes, P. and G. Kass Simon (eds), *Women of Science*, Bloomington: Indiana University Press, 1990.

Mainardi, P., 'Quilts: The Great American Art', *Feminist Art Journal*, **2**(1), 1973.

Maines, R., 'Paradigms of Scarcity and Abundance: The Quilt as an Artifact of the Industrial Revolution', in Lasansky, Jeannette (ed.), *In the Heart of Pennsylvania*, Lewisburg, PA: Union County Historical Society, 1986.

McMorris, P., *Crazy Quilts*, New York: E.P. Dutton, Inc. 1984.

Moonen, A., *Quilts: en Nederlandse traditie/ the Dutch tradition*, Arnhem, Nederlands: Nederlands Openluchtmuseum, 1992.

Moore, H., *Strictures on the Modern System of Female Education*, London: T. Cadell and W. Davies, 1799.

Oliver, C.Y., *Fifty-Five Famous Quilts from the Shelburne Museum*, New York: Dover Press, 1990.

Ordoñez, M., 'Technology Reflected: Printed Textiles in Rhode Island Quilts', in Welters, Linda and Margaret Ordoñez (eds), *Down By the Old Mill Stream: Quilts in Rhode Island*, Kent, Ohio: Kent State University Press, 2000.

Parker, R.,*The Subversive Stitch: Embroidery and the Making of the Feminine*, New York: Routledge, 1989.

Peck, A., *American Quilts and Coverlets in the Metropolitan Museum*, New York: Metropolitan Museum of Art, 1990.

Perry, R., *Harriet Powers's Bible Quilts*, New York: Rizzoli International, 1994.

Pohl, F., *Framing America: A Social History of American Art*, New York: Thames and Hudson, 2002.

Przybysz, J., 'Quilts, Old Kitchens, and the Social Geography of Gender at Nineteenth Century Sanitary Fairs', in Martinez, K. and Kenneth Ames (eds), *The Material Culture of Gender/ The Gender of Material Culture*, Winterthur, Delaware: the Winterthur Museum, 1997, 411–41.

Ramsey, B. and M. Waldvogel, *Southern Quilts: Surviving Relics of the Civil War*, Nashville: Routledge Hills Press, 1998.

Richter, P., *Painted With Thread: The Art of American Embroidery*, exh. cat., Salem, Mass.: Peabody Essex Museum, 2001.

Ring, B., *Girlhood Embroidery*, 2 vols, New York: Alfred A. Knopf, 1993.

Shaw, R., *Quilts: A Living Tradition*, New York: Hugh Lauter Levin Associates.

Slack, N., 'Nineteenth-Century American Women Botanists: Wives, Widows, and Work' in Abir-Am, Pnina and Dorinda Outram (eds), *Uneasy Career and Intimate Lives: Women in Science 1789–1979*, New Brunswick, NJ: Rutgers University Press, 1987.

Smith-Rosenberg, C., *Disorderly Conduct: Visions of Gender in Victorian America*, Oxford, England: Oxford University Press, 1985.

Trollope, F., *Domestic Manners of the Americans*, New York: Alfred A. Knopf, 1949 (1832).

Tufts, E., *American Women Artists, Past and Present: A Selected Bibliographic Guide*, 2 vols, New York: Garland Publications, 1984–89.

——, *American Women Artists, 1830–1930*, Washington, DC: National Museum of Women in the Arts, 1987.

Vlach, J.M., *The Afro-American Tradition in Decorative Arts*, Cleveland Ohio: Cleveland Museum of Art, 1978.

Ward, G. et al., *American Folk: Folk Art from the Collection of the Museum of Fine Art*, exh. cat., Boston: Museum of Fine Art, 2001.

What's American About American Quilts, Washington, DC: National Museum of American History, Smithsonian Institution, 1995.

Wollstonecraft, M., *A Vindication of the Rights of Woman*, New York: W.W. Norton, 1975 (1792).

——, *Thoughts on the Education of Daughters*, Oxford: Woodstock Books, 1994 (1787).

Notes

1 In contrast, *The Subversive Stitch: Embroidery and the Making of the Feminine*, 1989, which focuses principally on European work, was written by Rozsika Parker, a distinguished historian of European art. For introductory bibliographies on quilt history, see Elsley and Torsney, (eds), *Quilt Culture*, 1994, and Berlo and Crews (eds) *Wild by Design*, 2003. The most recent textbook survey of American art (Pohl, *Framing America*, 2002), a product of the 'new art history', which presumably is intent on dismantling old hierarchies of gender and media, devotes two of its 560 pages to colonial needlework and a scant one page (which consists of erroneous, outdated information) and two of its 665 illustrations, to American quilts. A recent survey of nineteenth-century American art (Groseclose, *Nineteenth-Century American Art*, 2000) is not untypical in its focus on female painters and sculptors and its neglect of needlework and quilts.

2 There were exceptions: Sarah and Anna Peale, members of a distinguished artistic family, were elected in 1824 to membership in the Pennsylvania Academy of Fine Arts, the oldest and among the most prestigious of such institutions in the United States. See Huber, *The Pennsylvania Academy and its Women*, 1974, who discusses not only the Pennsylvania Academy but professional opportunities for American women artists in the nineteenth century in general. On the Peales, see Hirshorn, 'Anna Claypool, Margaretta, and Sarah Miriam Peale', 1996.

3 See, for example, Hannah Otis's *View of Boston Common* (1750), in which the artist has rendered in needlework a naturalistic landscape and an accurately rendered Georgian colonial house. Illustrated in Ward, et al., *American Folk*, 2001, 76. A wide variety of works are illustrated in Ring, *Girlhood Embroidery*, 1993.

4 For mourning pictures, see Richter, *Painted with Thread*, 2001, plates 22, 23, 25. For embroidered family records, see Fisher and Harding, *Home Sweet Home*, 2001, 27 and 34.

5 See the variety of works illustrated in Shaw, *Quilts*, 1995.

6 For whole cloth quilts, see Bassett and Larkin, *Northern Comfort*, 1998, plates 4, 7, 9. For palampores, see Adamson, *Calico and Chintz*, 1997, plates 1 and 2. These types were also favoured in Europe. See Moonen, *Quilts*, 1992, plates 1–14, 18.

7 A dozen years later, she created an even more inventive appliquéd landscape in a quilt she made for a niece. Within a scalloped medallion she created a village scene with some five dozen people and animals, surrounded by a profusion of flowery vines. See Peck, *American Quilts and Coverlets in the Metropolitan Museum*, 1990, 18.

8 Many fine twentieth-century examples are published in Austin (ed.), *The Twentieth Century's Best American Quilts*, 1999.

9 The best colour illustrations of this quilt are in Fox, *Wrapped in Glory*, 1990, 48–53. All genealogical data on Hannah Stockton Stiles was compiled for me in June 2002 by Melissa Woodson Jurgena, using Philadelphia census record and city directories.

10 At Elizabeth Mitchell's death in 1857, her daughter became custodian of the quilt. In the central graveyard, she sewed down her mother's coffin, to join those of her little brothers. She also had the unhappy task of adding her own husband's and baby's coffins to the quilt. Though the quilt passed down through the Mitchell family for ninety years, after 1870 it no longer served as an active family death register, but simply as a reminder of the woman who had conceived such an unusual use for a quilt. See Lipsett, *Elizabeth Roseberry Mitchell's Graveyard Quilt*, 1995.

11 See Clawson, *Constructing Brotherhood*, 1989, especially chapter 6; also Charlotte Gardner's Odd Fellows Quilt Top, in Berlo and Crews (eds), *Wild by Design*, plate 13.

12 See, for example, Mary Willard's Crazy Quilt made for her daughter Frances, the first president of the Women's Christian Temperance Union, illustrated in Crews (ed.), *A Flowering of Quilts*, 2001, plate 51; Atkins, 'Pricking the Social Conscience', 1994.

13 See, for example, Susan Robb's Confederate Quilt in Ramsey and Waldvogel, *Southern Quilts*, 1998, 20; and the Abraham Lincoln Presentation counterpane in Oliver, *Fifty-Five Famous Quilts from the Shelburne Musuem*, 1990, 18.

14 See Jurgena and Crews, 'The Reconciliation Quilt', 2003.

15 Other autobiographical pictorials are known from this era. Comparable to Honstain's, in its ambitious pictorial programme and its combination of autobiographical and genre scenes, is the Burdick-Childs bedcover (1876) in the Shelburne Museum. In thirty-six blocks, its makers commemorate America's centennial, family anecdotes, genre and architectural scenes. See Fox, *Wrapped in Glory*, 104–107.

16 See Houck and Nelson, *Treasury of American Quilts*, 1987, plate 35. For other quilts with botanical motifs, see Crews (ed.) *A Flowering of Quilts*.

17 Illustrated in (no author) *What's American About American Quilts*, 1995, Appendix, 2.

18 They have been widely illustrated; see, for example, Fry, 'Harriet Powers … Black Quilter', 1976; Vlach, *The Afro-American Tradition*, 1978; Adams, 'The Harriet Powers Pictorial Quilts', 1979, and Perry, *Harriet Powers's Bible Quilts*, 1994, who provides full-page illustrations of details from both quilts.

19 Though Powers was illiterate, her descriptions were recorded in 1898 by an anonymous writer. Significant excerpts are published by Perry, *Harriet Powers's Bible Quilts*, 1994.

20 Folklorist Gladys-Marie Fry was the first to make this transatlantic link (1976), emphasizing the supposed relation of quilts by Powers to appliqué flags made by Fon men in Dahomey and Akan men in Ghana. Vlach follows suit (*The Afro-American Tradition*, 48–54). Perry (1994) asserts that there are no American prototypes for Powers's works, and finds parallels in West Africa. I discuss these arguments more fully in Berlo, 'Acts of Pride', 2003, 19-21.

21 Cott, *The Bonds of Womanhood*, 1977, 190; also Smith-Rosenberg, *Disorderly Conduct*, 1985.

22 For an early nineteenth-century genre painting of such an event, see John Krimmel, *Quilting Frolic*, 1813, illustrated in Johns, *American Genre Painting*, 1991, fig. 26.

23 See Hedges et al., *Hearts and Hands*, 1987, 72–81; Gordon, 'Playing at Being Powerless', 1986; Brackman, 'Fairs and Expositions', 1991; Przybysz, 'Quilts, Old Kitchens, and the Social Geography of Gender…', 1997. Paintings were sometimes exhibited at such fairs, too. See Hirshorn 'Anna Claypool, Margaretta, and Sarah Miriam Peale', 244–6.

24 Mainardi, 1973, 19. I address the issue of quilt historiography, and the changing interpretation of quilts from 1900–2000 in Berlo, 'Acts of Pride', 2003.

25 For a critique of such gender boundaries in literary studies, see Davidson and Hatcher (eds), *No More Separate Spheres*, 2002.

Edmonia Lewis's *Death of Cleopatra*: white marble, black skin and the regulation of race in American neoclassical sculpture

Charmaine Nelson

Mary Edmonia Lewis is a cultural rarity within the colonial and patriarchal annals of Western art. A mixed-race female sculptor of black and Native ancestry, Lewis created a space for herself within the indisputably masculinized artistic sphere of international neoclassicism centred in Rome in the mid-nineteenth century and she developed a significant professional career marked by critical acclaim and international patronage. Most often recognized as a member of the 'white Marmorean flock', Lewis's simultaneous experience of multiple marginalizations marked her difference as dramatically and irredeemably removed from the normative Western ideal of the artist–genius as white and male.

For artists, Rome as a base of cultural production and patronage was an obvious choice. For sculptors it was even more so.[1] Rome's popularity was confirmed by Nathaniel Hawthorne's rather cynical observation that, '…though the artists care little about one another's works, yet they keep each other warm by the presence of so many of them.' (Hawthorne, 1871, 92) The mythic nature of Rome as a haven for white female artists was initiated in the nineteenth century by Madame de Stael's novel *Corinne, or Italy* (1807) and confirmed in Elizabeth Barrett Browning's *Aurora Leigh* (1857). Writing to Wayman Crow in August 1852 with an awareness of her impending departure for Rome, Harriet Hosmer captured its romantic viability for artists,

You have already enjoyed what is before me, your heart and mind have been filled with beauty and a sense of infinity by the glories of nature and art, but I feel that I am on the eve of a new life, that the earth will look larger, the sky brighter, and the world in general more grand … I take it there is inspiration in the very atmosphere of Italy, and that there, one intuitively becomes artistic in thought. (Hosmer, 1912, 18–19)

While these fictional texts offered the possibility of an imaginary identification of a white woman artist beyond the phallic signification of male artists, for the possibility of alternative significations of the female/feminine body, no such imaginary possibility of the black/Native female artist predated Lewis. Nancy Proctor has described the Roman experience for American women sculptors as

... less a 'flight' from a sexist United States to an Italian feminist commune, than as a sacrifice of security, support and acceptance that these emerging women sculptors enjoyed within their circle of friends at home, for the harsh realities of competitive professional ambience in Rome. (Proctor, 1998, 81)

Proctor's pioneering work has brought many important aspects of this colony's work to light. Nonetheless, her account neglects the overwhelming evidence of the possibilities Rome provided, albeit to a limited extent, for alternative significations of the white female body, which ruptured and displaced normative ideals of bourgeois femininity, femaleness and heterosexuality. The energetic pursuit of professional recognition, unchaperoned social mobility, rigorous physical activity, the independent maintenance of living environment, financial self-sufficiency and independence, and an overwhelming rejection of heterosexual marriage: the life these women led was simply not possible to the same degree in mid-nineteenth-century America.

For white female sculptors, Rome offered a reprieve from the more rigid practice of bourgeois ideals of sex and gender within American culture, which placed hindrances upon female physical activity, social mobility and vision in ways which effectively prohibited the professional pursuit of the cultural knowledge necessary to produce the most exalted and canonized forms of art. It was in recognition of the relative social freedom of the Roman colony that Harriet Hosmer wrote, 'I wouldn't live anywhere else but in Rome, if you would give me the Gates of Paradise and all of the Apostles thrown in. I can learn more and do more here, in one year, than I could in America in ten.' (Hosmer, 27)

Crucial distinctions must be made between the white female sculptor's access to culture, and cultural production, and that of Lewis. These distinctions hinge not solely upon race but on the racial implications of class status, and mainly on the colonial notion that non-white subjects were always already of a lower class or had no essential right to aspire to anything above such a status. The broader cultural context for neoclassical patronage and production in Rome was its iconic status as the terminal and, arguably, most significant point on the Grand Tour. While, for the most part, white bourgeois tourists used their travel to reconcile, perform and entrench class privilege, the narratives of black travellers, often fugitive slaves or servants,

initiated what Malini Johar Schueller terms a 'disaffiliation with American citizenship', and an aspiration towards racial equality made possible by the potential for imagining new and different meanings for their blackness (Schueller, 1999 [1858], xxvi and xxiv). While whites were often tourists, blacks, outside slavery, were more often travellers. While travel, for many bourgeois whites, was a means to reinforce or elevate social and cultural status, for blacks, enslaved or free, it often symbolized a search for racial equality and demarcated dramatic shifts in identification.

Whereas many nineteenth-century black American travellers to Europe experienced what the fugitive slave William Wells Brown described in *The Travels of William Wells Brown* (1855) as a liberation from the oppressive American identifications of blackness, Lewis's experience, which shifted rapidly from traveller to resident, may not have afforded a sustained sense of such liberation.[2] As for Lewis, while Rome could also have represented an opportunity to transcend the social, material and psychic limitations of her racial/colour identity in America, the exceedingly small and exclusive white bourgeois and aristocratic expatriate community in Rome may have served to intensify Lewis's racial identifications and visibility because of the lack of alternative communities and the compounding nature of class, race and culture/language barriers. Additionally, many members of the Roman colony were affluent white Americans who imagined blackness through the colonial logic of their own slave-holding and racially segregated country.

UNTANGLING THE FLOCK

The so-called 'flock' was made up of several independent professional American women sculptors,[3] some loosely associated with the internationally renowned American actress Charlotte Cushman (1816–1876) who provided, by example, a model of the possibility of a successful, independent professional woman.[4] The condescending label of the 'white, marmorean flock' was affixed to the group by the novelist Henry James, who described the women's relationships as a 'strange sisterhood' (James, 1903, 257). James's labels indexed the (im)possibility of the female sculptor in the nineteenth century, his use of quotation marks around the term 'lady sculptors' indicating their sex/gender difference as the source of his discomfort and his objection to their presence in the colony and public visibility as professional women artists (James, 257). Yet, sexuality was certainly implicated here too as several of the women were involved in 'open' lesbian relationships.[5] The threat of professional, successful female artists was twofold: first, they problematized the traditional patriarchal expectation of an unquestioned female desire for marriage, domesticity and motherhood;

and second, they offered the possibility of professional and intimate relationships that required neither male authority nor sexuality.

As Griselda Pollock and Rozsika Parker argued in their pioneering feminist text *Old Mistresses* in 1981, 'structurally, the discourse of phallocentric art history relied upon the category of a negated femininity in order to secure the supremacy of masculinity within the sphere of creativity' (Pollock, 1999, 5). Contrary to the group identity which James's naming implied, I wish to problematize the easy assumption of facile camaraderie and unconditional friendships amongst these women sculptors and their female patrons and supporters. Significantly, this uncomplicated idea of an artistic sisterhood is something which has continued to be perpetuated by twentieth-century white feminist art historians and I am guided by Pollock's call for a 'demystifying analysis' (Pollock, 13), grounded in her desire to question what she has termed '...the mythologies of the woman artists Western feminism has been fabricating' (Pollock, 8). It has largely been white feminism's refusal to discuss the intersectionality of race/colour with sex/gender and its implications for class, sexuality etc. that has led to the deployment of a universalized category of Woman and a discursive practice which, in turn, has perpetuated the silence around coloniality. What is necessary here is a demystifying consideration of the impact of the nineteenth-century complex of race, gender, sex, sexuality and class differences which mediated the relationships of these women, their membership in the colony and their success as sculptors.

The impossibility of the white female sculptor for Harriet Hosmer, Emma Stebbins, Anne Whitney and others was multiplied for Lewis by the impossibility of the black/Native (female) sculptor. Fighting against the art-historical desire to unify these women artists, Nancy Proctor has insisted that the 'flock' had no common class, race or nationality. However, although I agree with Proctor's desire to refute an easy mystification of these women artists under the suspicious label of the 'flock', I would argue that she unintentionally reinforces the nineteenth-century (in)visibility of Lewis's black/Native body when she fails to note Lewis's obvious racial difference from the other women sculptors and thus her sharp displacement from the normative category of the white artist (Proctor, 1998, 6). For these women sculptors and more so for Lewis, there is an actual symbolic failure in the inability of languages and discourses of nineteenth-century Western culture to represent the productive body of a female artist and the inability of other subjects in the space to 'see' them as such. Lewis was recognized as one of the 'flock' but, unlike her white female contemporaries, the visibility of her black/Native body within the Roman colony made more complex her experiences as a female sculptor, because her racial identity challenged the 'regime of race' as it problematized the normative ideal of the white artist (Pollock, 1994, 354–5).

MAKING CLEOPATRA SUBJECT

Edmonia Lewis's *Death of Cleopatra* of 1875 (Figure 11.1) is arguably her most acclaimed and infamous sculpture. It is often juxtaposed with William Wetmore Story's earlier *Cleopatra* of 1862 (Figure 11.2).[6] Although it does not appear that Story and Lewis were friends, they were surely aware of each other as they moved in some of the same social circles within the small Roman colony. Story's knowledge of Lewis was confirmed in his acknowledgement of Miss Cushman and her 'little satellites'.[7] Thus, both neoclassical Cleopatras were produced by American artists who were contemporaries, known to each other and active within the same expatriate colony in Rome. Although both sculptures were produced within the Roman art colony, their intended audience was transcontinental. While Story's sculpture was exhibited in London at the International Exhibition of 1862 and Lewis's at the Chicago Exposition of 1878, both works appeared at the Philadelphia Centennial Exposition of 1876 along with other representations of Cleopatra by Margaret Foley, James Henry Haseltine, V.C. Prinsep and Enrico Braga (Gerdts, 1973, 49). Access to the works was also gained through the privileged cultural practice of the Grand Tour which offered the artist's studio as a site of cultural exchange for wealthy or prominent tourists. Both Story's and Lewis's knowledge of and involvement with abolitionism is confirmed through their geographical links to the American abolitionist centre of Boston and their acquaintances and friendships with prominent abolitionists.

Although Edmonia Lewis's *Death of Cleopatra* has been read as an uncomplicated response to William Story's earlier *Cleopatra*, Lewis's thematic and compositional choices and her representation of race shifted significantly from the standards mapped by her predecessors and contemporaries. While Cleopatra's suicidal demise is the broad theme of both works, Story chose to capture the moment of Cleopatra's suicidal brooding while Lewis depicted a more advanced moment in the implied sequence of events. These two distinct thematic choices were informed in part by the thirteen-year gap between the pieces and the dramatic political and social shifts which led up to, and transpired after, the Emancipation Proclamation of 1 January 1863, the American Civil War (1861–65) and Reconstruction (1865–77). Story's sculpture was produced and exhibited during the Civil War while Lewis's is associated with the failure of Reconstruction.

The deep racial crisis, which had at its centre the question of the unstable transitional position and status of the black body in American society, provided the context for Cleopatra's representation as a black woman. Prior to, and during, the nineteenth century Cleopatra was most frequently represented as a white woman. Any sense of exoticism, foreignness or racial

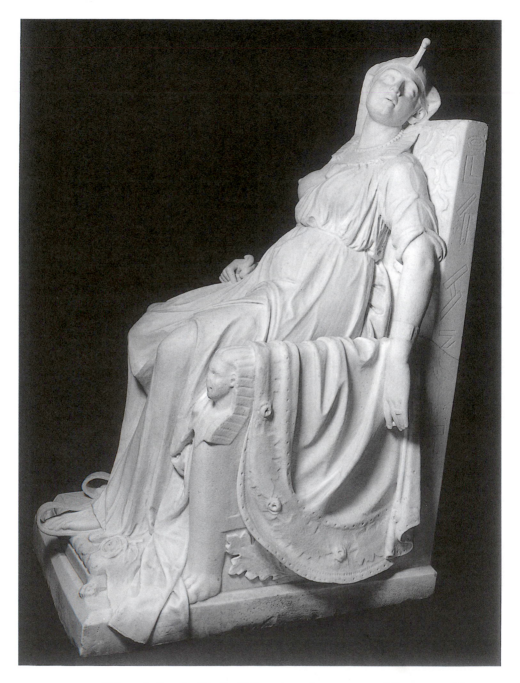

11.1 Edmonia Lewis, *Death of Cleopatra*, 160 × 79.4 × 116.84 cm, marble, 1875

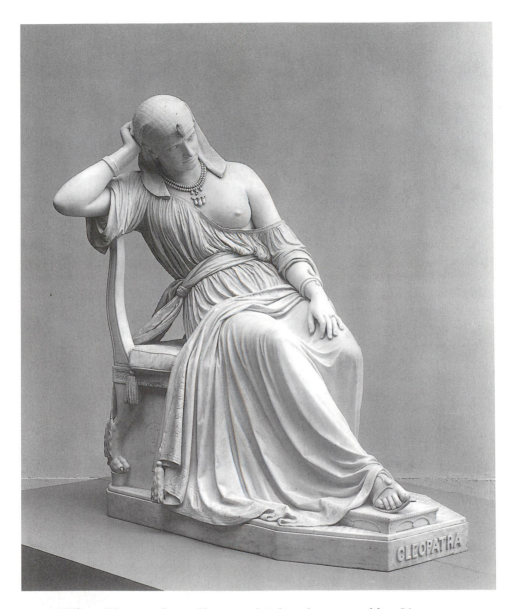

11.2 William Wetmore Story, *Cleopatra*, height 138.4 cm, marble, 1869

difference stemming from her reign as an African queen was customarily represented through the signification of the space occupied by her body.[8] The nineteenth century was a moment of representational rupture for representations of Cleopatra; there were many images produced and these related to a shift in racial signification directly linked to her recuperation within abolitionist discourse.[9] As Kirk Savage has aptly noted, 'The shift from slavery to freedom precipitated by the Civil War was the cataclysmic event and the central dilemma of the century, one that continues to shape American society even today.' (Savage, 1997, 3) Significantly, the black/Native artist Edmonia Lewis had 'escaped' this very racial crisis by going to Rome.[10]

It is important to proceed with an awareness of the vast differences in the identities and subjectivities of each artist and the ways their symbolic positions would have mediated social opportunity and affected their thematic and representational choices, material practices, access to and interaction with patrons and sitters, mobility and freedom within nineteenth-century America and Rome. While William Story was an upper middle-class, highly educated, heterosexual white man from an affluent and influential family, Edmonia Lewis was a black/Native and possibly lesbian woman,[11] with a limited education and uncertain financial resources and no recourse to familial bonds to provide access either to the highly segregated realm of art education or to stable sources of patronage.[12] Although it is clear that Lewis was one of the youngest amongst her fellow female sculptors, her dates are often vaguely given as 1843/45–post-1911.[13] As a person of African ancestry with first-hand experience of racial violence, Lewis's engagement with abolitionist themes holds a particularly significant and personal resonance.

A part of the search for the deployment of meanings will be bound up in an exploration and understanding of the symbolic value of white marble as a paramount term of cultural currency within nineteenth-century neoclassical sculpture. Inevitably, we must come to grips with the aesthetic paradox of white marble being called upon to represent black bodies at a moment when other sculptors were actively engaging with alternative approaches and media which could deliberately and effectively represent the colour of black skin. Two such examples are the applied polychromy of Jean-Léon Gérôme's *The Ball Player* (1902) and the material polychromy of Charles Cordier's *Grand Salon, Château de Ferrières avec Atlantes et Caryatids* (1861–2). Without access to the representation of black skin, neoclassical sculptors relied upon combinations of corporeal and externalized signs to signify blackness. But, inevitably, such racialized aesthetic practices circumscribed the visualization of blackness and revealed the impossibility of the black body as a subject of so-called high art.

THE PRIMACY OF WHITE MARBLE AND THE REGULATION OF RACE

Before I proceed with a discussion of Lewis's *Death of Cleopatra* and its cultural and social context, I wish to address the aesthetic and material specificity of neoclassical sculptural practices and its investment in the colonial racialization of bodies. The preferred whiteness of the medium of marble was not of arbitrary significance but functioned to mediate the representation of the racialized body in ways that preserved a moral imperative essential to the ideals of nineteenth-century neoclassicism. White marble was the medium of neoclassical sculpture, not by default but by design. As the seemingly endless nineteenth-century literature of the Grand Tour attests, marble's symbolic value incorporated material and commercial attributes, and yet superseded mere economic value.[14] Perhaps the author most responsible for the mystification of marble is Nathaniel Hawthorne, whose *French and Italian Note-Books* spiritualized marble as gleaming with 'so pure and celestial a light', further describing the difference between plaster and marble as that between 'flesh' and 'spirit' (Hawthorne, 1871, vol. 1, 157). In his *Marble Faun* (1860), the fictionalized novel based upon these notes, Hawthorne would lend further religiosity, embellishing marble with words like immortality, fidelity, sacred, consecration and priesthood (Hawthorne, 1983 [1860], 965–6).

Hawthorne's distinctions and definitions point up the regulatory function of marble, which he saw as embodying the power to transform the potentially transgressive sexual and biological body into morally pure art. The abstracted whiteness of marble, like white flesh but not quite, performed an aesthetic regulation of the body. In psychoanalytic terms, marble was a critical part of the fetishization of the body through representation. But as Parveen Adams has urged, fetishization is not merely a regulation of the body, it is the regulation of difference (Adams, 1996, 32). This is especially the case for white marble. Since nineteenth-century neoclassicists were certainly aware that the marble prototypes of their ancient predecessors had once been suffused with coloured pigment (Drost, 1996, 62), their rigid deployment of marble, which was almost exclusively faithful to the original whiteness of the medium, locates a conscious ideological choice. Other aesthetic choices were disavowed or rejected. Critical reactions often registered not only reverence for whiteness, but the abjection of colour and the naturalization of white as the always already (non-)racial state. Works like the French sculptor Charles-Henri-Joseph Cordier's *Negro of the Sudan* or *Sudanese in Algerian Dress* (1856–57) were seen by critics like James Jackson Jarves as 'artistic freaks', which, appealing to feeling rather than intellect, constituted the 'violation of (art's) primary truth' (Jarves, 1885, 66 and 155–6). Jarves's criticism demonstrated yet another facet of marble's allure: not only was it deemed to

be materially transformative but psychically so, in its sensorial effect upon the body of the viewer/sculptor. That this latter had much to do with sex was confirmed in Hawthorne's paraphrasing of the sculptor Hiram Powers, who purportedly decried the colouring of marble on the basis of its immodesty and provocation of shame (Hawthorne, 1871, vol. 1, 371).

The whiteness of neoclassical marble might be considered the privileged signifier of race just as the phallus was the privileged signifier of sex (Nelson, 2002, 87–101). In either case what is secured through the process of fetishization is the differencing of bodies, the ideal subject and the abject, racial or sexual 'other'. Polychromy was potentially transgressive because it did not regulate or disavow complexion as the key and highly visible criteria of racial identification. Thus, the threat of polychromy was that abstracted skin may become too much like 'real' flesh and with the possibility of white flesh comes the possibility of the skin/colour of the 'other' bodies of black subjects. Again, blackness as a colour was associated with the sensuality, immorality and pathology of the body as opposed to the assumed purity and sacredness of the intellect, symbolized by whiteness. This was not only some socially removed aesthetic ideal but one with great social implications for the cross-racial contact of bodies and the white fear of proximity – physical and sexual – to the 'other' body of the black.[15]

SUICIDE, DEATH AND NEOCLASSICISM'S FEMALE SUBJECTS

What has been described above is the aesthetic and material vocabulary into which Mary Edmonia Lewis inserted herself – first at Oberlin and Boston and, by the winter of 1865–66, in the established expatriate cultural colony in Rome. By the time Lewis began work on her Cleopatra, an indelible shift in the possibility of Cleopatra's racial identification had already taken place. Cleopatra had become readily identifiable as a black female subject. In her choice of subject, Lewis would have been keenly aware that her sculpture would inevitably be scrutinized for its deployment of race and specifically compared to Story's earlier celebrated work (which was overwhelmingly received as a black queen),[16] as well as to Harriet Hosmer's Zenobia (1859).[17] In addition, Lewis would likely have been aware of Anne Whitney's struggle to imbue the body of her Africa (c. 1863–64) with race to an 'acceptable' level of blackness, an aesthetic and material process which would have had far greater personal implications for Lewis than for her white contemporaries (Payne, 1971, 247).[18] I mentioned earlier three areas in which Lewis had diverged from her contemporaries: theme, composition and race. Before charting the evolution of Lewis's racing of Cleopatra, I will turn briefly to the first two categories.

Thematically, the choice of a suicidal Cleopatra was not new. Traditionally,

visual representations of Cleopatra's suicide have offered bodies precariously preserved in a state of aesthetic completeness which, as viewers, leads us only to anticipate and yet not witness the inevitability of organic decay and the fullness of death. Death as a thematic possibility enabled the visualization of female sexual excess, made it legible and palatable to a viewing body invested in the preservation of idealized white female bourgeois sexuality. But, more specifically, the self-destructiveness of female suicide has also historically indexed a female self-determination, a declaration of self-possession that thwarted male authority, be it paternal as in Boccaccio's 'The Tale of Tancredi, Ghismunda, and Guiscardo' in *The Decameron* or sexual, as with Lucretia's suicide after her rape by Tarquin.[19] The distinctiveness of Lewis's portrayal of Cleopatra was that rather than contemplating suicide, the queen had already committed the act.

While many sentimental neoclassical sculptures, like Edward Augustus Brackett's *Shipwrecked Mother and Child* of 1851 (Figure 11.3), represented dead female subjects, these bodies most often evoked sleep or repose rather than death and many compositionally displayed the body in reclining poses which suggested not just sleep but the peacefulness of an afterlife. The presentation and representation of dead bodies in this manner did not disrupt their interpretation as beautiful because they refused the signs of death and disavowed the decaying body of the corpse. In contrast, Lewis's Cleopatra, with head thrust up and backwards and the carelessly draped left arm extending down over the side of the throne, suggested pain and abandon, both incongruous, with a gentle or temporally removed death, and yet evocative of the physical loss of control and torment associated with death by venom or poison. Hers was a violent death. Compared with what Elisabeth Bronfen has termed 'secured dead bodies' (Bronfen, 1992, p.11), Lewis's newly dead queen was not comforting. Rather, the body's instability was disquieting and threatening. This was not a body already prepared for burial, but a body in its death throes. The immediacy of Cleopatra's death constructed a narrative of witness – she died as viewers gazed. This indecorous and destabilized body refused the nineteenth-century tradition of the fetishization of death that regulated the difference of the dead body through the aestheticization of the corpse.

Lewis's dramatic shift in the moment of representation corresponded with the abolitionist fictional and radical proposal of the slave's self-annihilation as a certain and immediate means to abolish slavery – an abolition that could only be effected through self-inflicted genocide. This connection will be made more tangible when I discuss below the manner in which abolitionists deployed Egypt as the ancestral legacy of the black diaspora in ways which would support a reading of this *Cleopatra* as a symbol of a black body politic. If Lewis's sculpture is to be read as the possibility of a 'liberated' Cleopatra –

11.3 Edward Augustus Brackett, *Shipwrecked Mother and Child*, 87 × 188.6 cm, marble, 1851

a black female subject liberated from the oppression of a white master/enslaver – it was liberation at an extreme price. According to this logic, as Sánchez-Eppler has noted, '[t]he obliteration of the body thus stands as the pain-filled consequence of recognizing the extent to which the body designates identity' (Sánchez-Eppler, 1988, 51).

HOW BLACK CAN SHE BE?

Racing black female subjects

Evidence of Lewis's conscious experimentation in racing her own black subjects exists in a contemporary description of her *Morning of Liberty/Forever Free* (1867) and her *Freedwoman* (c. 1865–67), now lost, which compared the two female figures and concluded that the more recent figure was 'less original and characteristic than in the *Freedwoman*' (cited in Buick, 1995, 10). Characteristic of what? I would offer that in the colonial context of the neoclassical aesthetic, and with the intense racial scrutiny of Lewis as a black/Native artist, the reference was to the characteristic nature of the race or blackness of the two female subjects. The implication, then, is that Lewis's

first black female, in *Freedwoman*, was somehow 'more black' than her second attempt. Kirsten Buick has also noted that Lewis's representation of Longfellow's Minnehaha exhibited a similar racial shift – evident in a profile examination of the Native female subject in *Minnehaha* (1868) and *Old Arrow Maker* or *Old Indian Arrow Maker and his Daughter* of 1872 (Figure 11.4; Buick, 4–19; Holland, 1995, 26–35). Like Lewis's free black women, this Native female's physiognomy became less obviously 'Native' between her first and her later representation as the modelling of the nose was adapted to a more European model. It is significant that Lewis's experimentation with racing her subjects demonstrated a progression away from deliberately and unequivocally black subjects towards a more inter-racial, white Negro visualization of the black body.

Reclaiming a black Cleopatra through abolitionist discourse

In addition to the reasons cited above, for Lewis the possibility of *Cleopatra*'s blackness derived from her direct interaction with, and knowledge of, prominent black and white abolitionists, whose beliefs, personal writings and public declarations supported the idea of a black Cleopatra as a means of re-locating with pride ancient black civilizations as the source of contemporary black peoples. The prominent Boston abolitionist and advocate of female equality Lydia Maria Child described a young black female in a personal letter, as being, '…queenly enough for a model of Cleopatra' (Child, 1982, 414).[20] What is more, Child's racial description of a 'dark brown girl' with 'nostrils expanded proudly' and a 'well-shaped mouth' designated a so-called full-blooded Negro type as handsome (Child, 414). Like Child, Harriet Beecher Stowe, author of the internationally acclaimed abolitionist novel *Uncle Tom's Cabin* (1852), had also specifically deployed the term Egyptian in describing the famous black female abolitionist orator Sojourner Truth (Stowe, 1863, 473–81). Besides affiliations with such influential abolitionists as Frederick Douglass, the Rev. Leonard A. Grimes, Rev. J.D. Fulton, R.C. Waterson, William Lloyd Garrison, William Craft, William Wells Brown (Buick, 7)[21] and the extraordinary Remond family, Lewis had early sought help from the Rev. Henry Highland Garnet, who used both biblical and ancient scholarly references to support his claim of the blackness of Egyptians (Garnet, 1969, 7).[22] Confidence in Lewis's knowledge of the nineteenth-century symbolic conflation of Egyptian-ness with blackness also derives from her own oeuvre. Created the same year as her *Death of Cleopatra*, Lewis's *Hagar* (Figure 11.5) explicitly located an Egyptian female slave within a biblical narrative which prophesied the sexual marginalization of black female slaves within transatlantic slavery.[23] What

11.4 Edmonia Lewis, *Old Arrow Maker*, 54.61 × 34.59 × 34 cm, marble, 1872

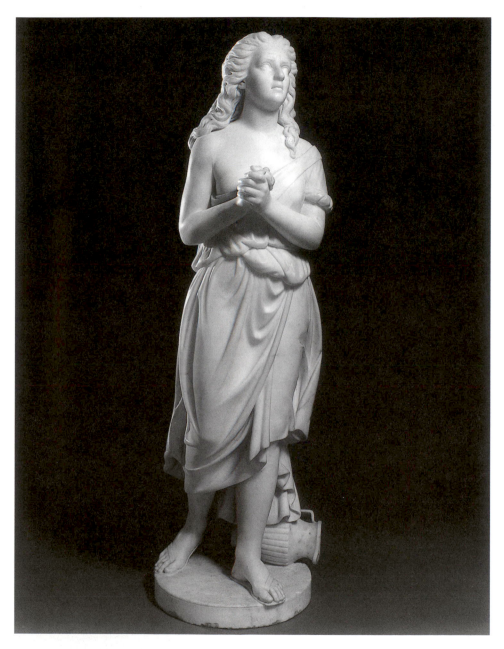

11.5 Edmonia Lewis, *Hagar*, 133.65 × 38.74 × 43.5 cm marble, 1875

these abolitionists performed was a (re)constitution of Egypt as black Africa, a step which allowed for the deployment of Cleopatra as a black queen capable of symbolizing the body politic of a diasporic people living under the yoke of slavery.[24]

LEWIS'S CHOICE: 'TO BE BLACK OR NOT TO BE BLACK?'

As a sculptor whose race was widely read as black, white audiences and Lewis's contemporary white sculptors would have expected her to deploy black subjects, to engage with the abolitionist visual discourse and specifically to race her Cleopatra black. Despite this expectation, one of the most thorough contemporaneous descriptions of Lewis's *Death of Cleopatra* refutes this assumption. In a book suggestively titled *Great American Sculptures* (1878), William J. Clark had strong praise for Lewis's work on the basis of its 'authentic' deployment of race:

This was not a beautiful work, but it was a very original and very striking one, and it deserves particular comment, as its ideal was so radically different from those adopted by Story and Gould in their statues of the Egyptian Queen. Story gave his Cleopatra Nubian features, and achieved an artistic if not a historical success by so doing. The Cleopatra of Gould suggests a Greek lineage. Miss Lewis, on the other hand, has followed the coins, medals, and other authentic records in giving her Cleopatra an aquiline nose and a prominent chin of the Roman type, for the Egyptian Queen appears to have had such features rather than such as would positively suggest her Grecian descent. This Cleopatra, therefore, more than nearly resembled the real heroine of history than either of the others (Clark, 1878, 141).

Lewis's racing of Cleopatra is not so exceptional when viewed within the context of her other representations of black female subjects. Like many of her contemporaries, Lewis seemed to struggle with the Eurocentric aesthetic limits of neoclassicism that equated the racialized white ideal of the classical with the Beautiful. In such a context, the representation of a racially precise black body became problematic, limiting the symbolic, subjective and narrative possibilities of a sculpture. As I have already discussed, contemporary descriptions of Lewis's earliest ideal works demonstrate a conscious shift away from deliberately black and Native, so-called full-blooded female subjects towards neoclassicism's prevalent inter-racial body type. Lewis's white Negro women coincide with the dominant sculptural tendency to restrict the amount of blackness in the female subject. Her deployment of race falls within the acceptable limits set by the nineteenth-century neoclassical community of which she was a part. However, for Lewis, who had a much more personal stake in abolition than any of her white contemporaries and who had, at the time of her *Cleopatra*, a personal stake in Reconstruction, to avoid a black female Cleopatra at a moment when

such a representation would have been welcomed and praised, marks a difficult and deliberate ideological choice – likely informed by her personal experiences with racism and her day-to-day life as a professional artist in a dominantly white colony and art world.

Lewis's choice to race her Cleopatra 'white' is part of what Nancy Proctor has called the, '...ingenious negotiation by Lewis of the double-edged "Pygmalion effect"' (Proctor, 126), a term that describes the patriarchal desire to petrify the active female producing body through incessant visual scrutiny, surveillance and objectification. In refusing the visible racial signs of blackness for her *Cleopatra*, Lewis thwarted the 'Pygmalion effect' and distanced herself from any attempts by her white audience to read her into the work. Quite simply, Lewis did not race her sculpture black because she did not have to and to do so would constitute a threat to her artistic subjectivity. The associations between Cleopatra and a black Africa within abolitionist discourse were so profound and had been so thoroughly popularized by the 1870s that, as William Clark's analysis attested, any deployment of the ancient Egyptian queen had to contend with the issue of her race and potential blackness. In choosing to compose what Clark described as a Roman physiognomy, Lewis cloaked herself in the protective veil of cultural authenticity which released her from the potentially crippling expectation of a black queen and refused an autobiographical reading, even though she still engaged with contemporary racial discourses.

The identification of neoclassical subjects was informed by conscious and unconscious racial desires which indexed the problems of racial identity and subjectivity and the societal regulation of cross-racial contact in nineteenth-century Western societies. Although bound by the prescriptions of their visual discourse, neoclassical sculptors, many of the abolitionists, deliberately represented black female subjects within particular narratives or thematic contexts in order to challenge the dominant regime of race and the white supremacist ideologies they supported. However, they were consistently confronted by pressure to conform to Eurocentric notions of an ideal body. Lewis's *Death of Cleopatra*, positioned in opposition to the post-emancipation persistence and escalation of racial violence and discord, demonstrates her continuing use of abolitionist visual culture as a counter-hegemonic source of alternative representations of blackness. The explicit, conscious and continual political engagement of abolitionists with visual culture should alert us to the necessity of reading race in and through these art objects, not only because it is a pressing concern of our own time, but because it was an urgent requirement of their own.

References

Adams, P., *The Emptiness of the Image: Psychoanalysis and Sexual Differences*, London: Routledge, 1996.

Bronfen, E., *Over her Dead Body: Death, Femininity and the Aesthetic*, Manchester: Manchester University Press, 1992.

Buick, K., ' The Ideal Works of Edmonia Lewis', *American Art*, **9**, Summer, 1995, 4–19.

Child, L.M., *Lydia Maria Child Selected Letters, 1817–1880*, eds M. Meltzer and P. G. Holland, Amherst: The University of Massachusetts Press, 1982.

Clark, W.J. Jr., *Great American Sculptures*, Philadelphia: Gebbie and Barrie, Publishers, 1878.

Drost, W., 'Colour, Sculpture, Mimesis', in Andreas Blühm, (ed.), *The Colour of Sculpture: 1840–1910*, Amsterdam: Van Gogh Museum, 1996.

Garnet, H.H., *The Past and the Present Condition, and the Destiny, of the Colored Race: A Discourse Delivered at the Fifteenth Anniversary of the Female Benevolent Society of Troy, N.Y. Feb. 14, 1848*, Miami: Mnemosyne Publishing Inc., 1969.

Gerdts, W., *American Neo-Classic Sculpture: The Marble Resurrection*, New York: The Viking Press, 1973.

Hawthorne, N., *Passages from the French and Italian Note-Books of Nathaniel Hawthorne*, London: Strahan and Co., Publishers, vol. 1, 1871.

Hawthorne, N., 'The Marble Faun', *Novels*, New York: Literary Classics of the United States Inc., 1983, 965–6.

Holland, J. M., 'Mary Edmonia Lewis's "Minnehaha": Gender, Race, and the Indian Maid', *Bulletin of the Detroit Institute of Arts*, **69** (1–2), 1995, 26–35.

Hosmer, H., *Letters and Memories*, ed. Cornelia Carr, New York: Moffat, Yard and Co., 1912.

James, H., *William Wetmore Story and His Friends*, 2 vols, London: Thames and Hudson and Boston: Houghton Mifflin, 1903.

Jarves, J. J., *Art-Hints, Architecture, Sculpture and Painting*, London: Sampson Low, Son, and Co., 1855.

Kasson, J., *Marble Queens and Captives: Women in Ninteeenth-Century American Sculpture*, New Haven: Yale University Press, 1990.

Nelson, C., 'White Marble, Black Bodies and the Fear of the Invisible Negro: Signifying Blackness in Mid-Nineteenth-Century Neoclassical Sculpture', *Canadian Art Review*, **27** (1–2), 2002, 87–101.

Payne, E.R., 'Anne Whitney: Art and Social Justice', *Massachusetts Review*, **12**, 1971, 245–60.

Pollock, G., '"With My Own Eyes": Fetishism, The Labouring Body and the Colour of Sex', *Art History*, **17** (3), 1994, 342–82.

Pollock, G., *Differencing the Canon: Feminist Desire and the Writing of Art's Histories*, London: Routledge, 1999.

Proctor, N.E., 'American Women Sculptors in Rome in the Mid-Nineteenth-Century: Feminist and Psychoanalytic Readings of a Displaced Canon', PhD Diss., University of Leeds, 1998.

Sánchez-Eppler, K., 'Bodily Bonds: The Intersecting Rhetorics of Feminism and Abolition', *Representations*, **24**, Fall, 1988, 28–59.

Savage, K., *Standing Soldiers, Kneeling Slaves: Race, War, and Monument in Nineteenth-Century America*, Princeton: Princeton University Press, 1997.

Schueller, M.J. (ed.), *A Colored Man Round the World, by a Quadroon*, David F. Dorr, Ann
 Arbor: The University of Michigan Press, 1999 (1858).
Stowe, H.B., 'Sojourner Truth, the Libyan Sibyl', *Atlantic Monthly*, **11**, 1863, 473–81.

Notes

1 For the neoclassicist, Rome provided a concentrated access to the examples of the Greek and
 Roman antique from which their own sculptural forms were inspired.

2 William Wells Brown, 'The American Fugitive in Europe: Sketches of Places and People Abroad',
 The Travels of William Wells Brown, New York: Markus Wiener, 1991, 98; cited in Schueller (ed.),
 Colored Man, xxiv–xxv. Significantly, although Lewis was of mixed race, she was most often
 racially identified with her black heritage, in part because of her affiliations with abolitionism and
 her recuperation by abolitionists as an example of the accomplishments of free blacks. Although
 Lewis visited America several times after the establishment of her Roman studio (mainly to
 exhibit or dedicate her sculpture), it appears that she never again assumed a residence in her
 native country.

3 The members of the 'flock' were considered to be: Sarah Clampitt Fisher Ames (1817–1901),
 Margaret Foley (1827–1877), Florence Freeman (1836–1876), Harriet 'Hattie' Goodhue Hosmer
 (1830–1908), Lavinia 'Vinnie' Ream Hoxie (1847–1914), Louisa Lander (1826–1923), Mary Edmonia
 Lewis (1843–45–post-1911), Blanche Nevin (1838–1925), Emma Stebbins (1815–1882), Anne
 Whitney (1821–1915), although Nancy Proctor also names Elisabeth Ney. See Henry James,
 William Wetmore Story and His Friends, vol. 2; Proctor, *American Women Sculptors*, 1998, 6.

4 Cushman had adopted the role of mentor to many of the younger women, chaperoning them on
 the long voyage to Rome; encouraging them to pursue their art professionally often in the face of
 familial discouragement and patriarchal social barriers; assisting them in obtaining studio space
 and instruction; securing patronage; and even boarding them in her large apartments at 38 Via
 Gregoriana. See Hosmer, *Letters and Memories*, 1912, 144, 224, 306.

5 Charlotte Cushman and the sculptor Emma Stebbins were partners, while Harriet Hosmer's
 letters reveal more than one intimate relationship with women.

6 Although Story first completed this sculpture in 1861–62, the work reproduced in this chapter is
 dated by its housing institution as 1869. Story participated in the normal neoclassical practice of
 producing and selling several sculptures over a period of time based upon one original concept.

7 Quoted from letter written by Story to Charles Eliot Norton from Rome in 1863 or 1864. Although
 Story appears to have been hostile initially to some of the female sculptors, he and his wife
 Emelyn were later to become good friends with the sculptor Harriet Hosmer. See Hosmer, *Letters
 and Memories*, 275–6, 334–6.

8 In other words, race was externalized and implied through the proximity of 'other' non-white
 bodies to a white Cleopatra. Examples of this tradition include: Alexandre Cabanel's *Cleopatra
 Testing Poisons on Condemned Prisoners* (1887), Hans Makart's *Death of Cleopatra* (1875) and
 Giovanni Battista Tiepolo's *Anthony and Cleopatra* and *The Banquet of Cleopatra* (1743–44).

9 The social and political potential of Cleopatra as a symbol of abolitionist sentiment must be
 understood in terms of the overwhelming narrative intention of neoclassical sculpture which, as
 Joy Kasson has observed, had a vested interest in 'art for morality's sake'. Joy S. Kasson, *Marble
 Queens and Captives*, 1990, 32. The moral and religious purpose of nineteenth-century art was
 widely accepted and is reflected in Nathaniel Hawthorne's concept of sculpture as 'sermons in
 stones'. See Nathaniel Hawthorne, *The Marble Faun*, 151.

10 Edmonia Lewis sailed for Europe on 19 August 1865 and arrived in Rome early in 1866. As any
 black person living in nineteenth-century Western society, she could not fully escape racism but
 simply moved from one particularly charged and overt context to what could be described as a
 more covert but not necessarily less hostile environment.

11 I say possibly because, unlike her female compatriots Harriet Hosmer and Emma Stebbins for
 whom clear archival documentation has confirmed their same-sex or lesbian partnerships,
 research to date has not provided similarly clear proof of Lewis's sexuality. Also, although recent

feminist art-historical literature presumes the homosexuality of many of the female sculptors present in the Roman colony at mid-century, we must factor into consideration the public heterosexuality of Vinnie Ream Hoxie and Louisa Lander.

12 Although Joy S. Kasson has demonstrated that many of the American sculptors of this period were of working class origins, coming to sculpture through their work as crafts people, her inclusion of Edmonia Lewis as one of the few 'privileged' artists considers neither the symbolic power of race and its conflations with class identifications nor the specificities of marginalization of black and Native women in the nineteenth-century. See: Kasson, *Marble Queens and Captives*, 6–7 and Romare Bearden and Harry Henderson, *A History of African American Artists from 1792 to the Present*, New York: Pantheon Books, 1993, 55–6.

13 Lewis, a Catholic, may have been mistakenly buried in the Protestant Cemetery at Rome; their cemetery registries indicate a Mary Lewis-Mitchell of North American origin dying on 11 April 1931 at the age of eighty-nine.There are several key factors coinciding to make this a viable lead for the final confirmation of Lewis's dates. First, because of Lewis's race and colour, those who claimed her body and prepared it for burial (especially if unrelated to her) may have assumed a Protestant affiliation. Second, the age of Lewis-Mitchell at the time of death coincides with the accepted range of Edmonia Lewis's birth date (1843–45). Third, the use of the specific identifier North American as opposed to simply American may indicate a knowledge of Lewis's Native ancestry. In addition, records indicate that the body of Lewis-Mitchell was exhumed and transported to America, although a date and destination was not recorded.

14 Nineteenth-century neoclassical sculptural production and the practices of viewing were widely documented within guidebooks, tourist literature, travel diaries, novels, personal letters and articles in popular journals. See, for example: Rembrandt Peale, *Notes on Italy Written During a Tour in the Years 1829 and 1830*, Philadelphia: Carey and Lea, 1831; Nathaniel Hawthorne, *Passages from the French and Italian Note-Books, 1871*; S. Russell Forbes, *Rambles in Rome: An Archaeological and Historical Guide to the Museums, Galleries, Villas, Churches, and Antiquities of Rome and the Campagna*, 9th edn, London: Thomas Nelson and Sons, 1903.

15 The period of neoclassicism under discussion was a time of overwhelming legally and socially sanctioned racial segregation in the West, driven by the fear of the black body as a biologically contaminated threat to the white.

16 Story's *Cleopatra* was frequently animalized and sexualized, her body identified through a corporeal excess which was equated with her blackness through terms like race and nation. See Henry Adams, *The Letters of Henry Adams: 1858–1868*, eds J.C. Levenson, Ernest Samuels, Charles Vandersee and Viola Hopkins Winner, Cambridge: The Belknap Press of Harvard University Press, 1982, vol. I, 147; James Jackson Jarves, *The Art-Idea*, ed. Benjamin Rowland Jr., Cambridge: The Belknap Press of Harvard University Press, 1960 (1864), 224.

17 The similarities between Zenobia and Cleopatra invited comparison as both were powerful, ancient 'foreign' queens who challenged Roman authority and were eventually overthrown by Roman rulers. Kasson, *Marble Queens and Captives*, 152.

18 Whereas Whitney's whiteness would have guarded against the audience's desire to read her into the subject of a black woman, Lewis's obvious and much quoted inter-racial identification would have presented an opportunity for her audience to read the deployment of black female subjects as autobiography.

19 See Jill M. Ricketts, 'Boccaccio, Botticelli, and the Tale of Nastagio: The Subversion of Visuality by Painting', *Visualizing Boccaccio: Studies on Illustrations of The Decameron, from Giotto to Pasolini*, Cambridge: Cambridge University Press, 1997, and Ian Donaldson, *The Rapes of Lucretia: A Myth and its Transformations*, Oxford: Clarendon Press, 1982.

20 Letter from Lydia Maria Child to William P. Cutler, 10 July 1862. In their introduction to *Selected Letters*, Meltzer and Holland suggest that the young black woman was likely Charlotte Forten (1837–1914) of Salem, Massachusetts, whose grandfather James Forten had become a principal backer of the anti-slavery newspaper the *Liberator* after creating a successful sail-making business in Philadelphia.

21 These abolitionists were participants in the dedication of Lewis's *Forever Free/ The Morning of Liberty*, which was presented to Rev. Leonard A. Grimes during a ceremony at the Tremont Temple, Boston, in October 1869.

22 Lewis presented her *John Brown* sculpture to the Rev. Garnet in a ceremony at Shiloh Presbyterian Church in New York. 'Miss Edmonia Lewis', *Woman's Journal*, 4 January 1879, 1.

23 Lewis had previously completed another sculpture of *Hagar* (*c.* 1868) which was exhibited in Chicago but is now lost. It is unclear if Lewis's second *Hagar* (1875) was different from the first. See Buick, 'Ideal Works', 1995, 11 and Lynda Roscoe Hartigan, ' Edmonia Lewis', *Sharing Traditions: Five Black Artists in Nineteenth-Century America*, Washington, D.C.: Smithsonian Institution Press, 1985, 93.

24 The abolitionist reclamation of a black Egypt countered much eighteenth- and nineteenth-century human science racial discourse which positioned Egyptians as an in-between race – sometimes a 'higher' form of blackness, at other times a 'lower' form of whiteness, or neither. See Robert Knox, *The Races of Men: A Philosophical Enquiry into the Influence of Race Over the Destinies of Nations*, 2nd edn, London: Henry Renshaw, 1862, 178–9, 181.

Modernity and tradition: strategies of representation in Mexico

Stacie G. Widdifield

Why is so little known about nineteenth-century women artists in Mexico in comparison to those of the twentieth century? The first comprehensive study, entitled *Pintoras Mexicanas del Siglo XIX* (*Nineteenth-Century Mexican Women Painters*) was published in 1985 in conjunction with a major exhibition at the Museo de San Carlos in Mexico City. In her catalogue essay, Mexican art historian Leonor Cortina proposed two primary reasons for the paucity of studies on the subject up to that point (Cortina, 1985). First, she argued that the study of nineteenth-century art and history was in general greatly affected, indeed 'impoverished' by a tendency to analyse them through a revolutionary, twentieth-century lens (Cortina, 27). Second, Cortina cited the fact that nineteenth-century women artists, unlike most of their male counterparts, were not professionals (Cortina, 67). Their work did not circulate in the economy of validation offered by the patronage and market system available to male artists.

Nineteenth-century Mexican women artists have thus seemingly inhabited two rather fixed spaces. The first is the symbolic and discursive space of the twentieth-century art-historical narrative, more specifically in the trajectory of Mexican art history. The second is a private, non-commercial and, by implication, domestic sphere. Inasmuch as the systematic study of nineteenth-century Mexican women and their art is relatively recent, it is important to consider how these two spaces may intersect, and how the narrative has inflected an ability to investigate and to picture their historical practices. The 1985 exhibition catalogue provides a starting point for the examination of both the discursive and historical spaces that are the focus of this essay.

Cortina's first assertion points to a persistent location of the nineteenth century in a teleological sequence, which has as its predestined, evolutionary

outcome the Mexican revolution of 1910–21. Nineteenth-century Mexico, which officially gained independence from Spain in 1821, has been understood as national, but pre-revolutionary. Cultural manifestations of the period are at best precursors and thus only approach the 'true' modern and national art that for many is still epitomized by the post-1921 mural production of artists such as Diego Rivera (1886–1957), José Clemente Orozco (1883–1949) and David Alfaro Siqueiros (1896–1974). Such art, produced by highly trained male artists, has been valued for its public accessibility, its monumental scale, and its claim to the expression of an ideally shared revolutionary-nationalist discourse. Nineteenth-century women, by contrast, typically produced small-scale easel paintings, a category of art excoriated in print by this revolutionary artistic trinity in the 1920s for its bourgeois individualist properties. Cortina's observation that nineteenth-century Mexican women artists did not enter such paintings in the commerce of art and thus that they were not serious, wage-earning artists, effectively confirms the entrenched view of women as mere dabblers in their craft. That most of their works are even today in private, and largely family, collections rather than in publicly accessible museums, much less on public walls, further damages their reputations.

Cortina's assertions implicate nineteenth-century women painters and their production in several apparent oppositions, namely, public versus private, national versus personal, as well as mural versus easel painting. The first term in each of the three pairs is commonly understood to characterize twentieth-century, male, revolutionary art; the second of each is understood to characterize nineteenth-century art in general, and women's art in particular. Nineteenth-century women artists and their work are burdened also by an apparent opposition to twentieth-century women artists, who are construed as feminist and modernist, the most well known of which are Frida Kahlo (1907–1954), María Izquierdo (1902–1955) and Nahui Ollin (born Carmen Mondragón, 1893–1978). The modernist-feminist construction of the likes of Kahlo, Izquierdo and Ollin makes a virtue of three broad factors that are, by contrast, shortcomings for their nineteenth-century colleagues. These are: (non-academic) artistic training, access to the public sphere, and the display of the body. This essay focuses on training and access to the public sphere, both of which imbricate issues of space. The display of the body, that is, either the representation of one's own or another's nude body, was not practised at all by nineteenth-century Mexican women artists, and this distinctly differentiates the two groups. Training and access to public spaces, however, distinguish them from each other less than might be imagined.

ARTISTIC TRAINING

The comparatively limited formal artistic training of twentieth-century artists is generally considered as liberating in contrast to the strictures of the extensive, institutional training of the previous century. These modern artists, it is thought, triumphantly relied on innate, natural and intuitive talent, and they incorporated, to a greater or lesser degree, the conventions and subjects of so-called traditional Mexican imagery in their modern works. Kahlo, for example, took formal compositional cues from the *ex-votos*, images with text commissioned by the recipients of divine interventions to be placed as offerings of thanks in churches and commonly painted on tin. Ollin turned to the non-academic commemorative mortuary portrait of regional artists, and Izquierdo incorporated an array of contemporary, popular imagery into many of her works, including ceramics, glass and cut paper. Their essentially non-academic training and the value they ascribed to traditional and popular imagery have come to characterize their works as original; and originality is construed as a foundational aspect of modern art.

By contrast, women artists of the nineteenth century were trained in an academic pedagogy, either by attending the very limited number of classes open to them at the Academy of Fine Arts in Mexico City, such as those in copying, drawing from plaster casts, *chiaroscuro* studies, or by taking lessons from academic artists in their own homes (Cortina, 65). They were, however, prohibited from attending life-drawing classes in which nude models were present. Women's art training was more lesson than it was curriculum, and it paralleled the expected acquisition of other skills, such as needlework, music and foreign languages.

For much of the century the intertwined gender and class limitations imposed on these artists, who were predominantly from the middle and upper-middle classes of the so-called *mujeres decentes* (well-bred, well-born and respectable women), prevented them from straying far from home, church, or, in general, any public sphere in which they were unaccompanied. The protection of the domestic sphere as the site of women's governance made common cause for both liberals and conservatives, who comprised the two major political parties during most of the century. And, as Cortina's work demonstrates, many nineteenth-century women artists ceased studying art after they got married and/or had families. Not surprisingly, much of their work consisted of copies of the work of their teachers or of other academic artists, as well as representations of subjects easily available to them in their own homes. Thus, in addition to copies, women often painted portraits, self-portraits, still lifes and scenes of the domestic interior, none of which were exalted by an academic pedagogy that valued as its crowning achievement the original, narrative-based history painting.

The *Portrait of Juliana San Román* by her sister Josefa San Román (active mid-nineteenth century), who was among the few mid-century women artists who continued to paint regularly after having married, well exemplifies women's practices (Figure 12.1). Beautifully dressed in the silks and lace typical of her elite status and poised between two partially visible paintings (one on an easel ready to be worked), Juliana touches her gold bracelet, one glove still on and its pair on the table next to her paint box. This is an impressive allegory of the relationship between women and painting in the nineteenth century – the practice of painting is, like glove, fan and bracelet, about the acceptable accoutrements of decoration, rather than work. Josefa is dressed in clothes suitable for an appearance outside of the home, not for the messy pursuit of oil painting. The black mantilla she wears signals that she has just returned from Mass and thus refers to the Catholic-conservative ideological structure of San Román's upbringing – as well as that of most of her fellow artists (Velázquez Guadarrama, 2001). That this painting is actually a copy of the original done by San Román's painting teacher Spaniard Pelegrin Clavé, who was a devout Catholic as well as director of painting at the Academy, all the more reaffirms typical painting practices of the women of this period.

A mid-century *Self-portrait with Family* by Guadalupe Carpio (active mid-nineteenth century) also typifies women's practice and the spaces in which they worked (Figure 12.2). Carpio, the daughter of a well-known poet, depicts herself with her family and a servant, who watch while she paints in a studio space shown as confined and windowless. Carpio seems to present herself as an artist actively engaged in painting a portrait of a man. This is clearly different from the San Román/Clavé portrait in which Julia is not actually shown painting. Yet, two elements in the painting thwart this impression of active engagement. In the first place, Carpio momentarily turns away from painting to acknowledge the viewer, thus interrupting her work. Second, painting is subtly presented as secondary to the primary task of hearth and home because servant and children are literally at her back. Moreover, the male portrait she paints is that of her husband, who is present only in the painted image. Certainly, during the day he would be elsewhere, in the public sphere of men. The presence of his portrait thus also offers an egress to the outside, if only symbolically.

The father/husband role in the domestic hierarchy is intensified by the location of his portrait above the figures of the artist, her family and servant. His gaze also acknowledges the viewer's just as his wife's does, but of course because he is present only symbolically, his work cannot be interrupted. Reaffirmation of his position is also given by the position of his daughter's hand. In the bottom right-hand section of the painting, she points her index finger as well as her eyes upwards towards her father's portrait. This

12.1 Josefa San Román, *Portrait of Juliana San Román*, 103 × 81 cm, oil on canvas, 1851, copy after Pelegrin Clavé

invisible line of vision urges the viewer's gaze towards the father in a rather iconic fashion. This device creates a somewhat ambiguous effect, for, on the one hand, it integrates the absent father into the family unit, and, on the other hand, distracts from the ostensible subject of the painting, namely the artist herself at work. It might be said that the girl's gesture points to the spatial as well as practical limits seemingly set for women artists such as her mother.

As Velázquez Guaddarama's recent study shows, the scenes of the domestic interior and of still life actually linked women artists to artists not directly trained at the Academy of Fine Arts in Mexico City and their work (Velázquez Guaddarama, 2001). In spite of the fact that these women were essentially the recipients of academically based training, they often shared more with their non-academic colleagues, whose works were normally identified in the Academy catalogues as distinct from the products of the Academy itself. Specifically, these were foreign artists living in Mexico City as well as independent national artists who had not been trained at the Academy of Fine Arts in Mexico City and who were often identified as regional painters. Additionally, domestic interiors and still lifes by European artists were collected by Mexico City patrons and displayed in the Academy exhibitions.[1] As a group, they shared an interest in the meticulous rendering of everyday objects and scenes. They were not overly concerned with the artifice of such academic practices as single focal-point perspective, the rendering of the idealized human figure, or the application of colour as subordinate to line. The artists resident in Mexico, but not trained at the Academy in Mexico City, often concentrated specifically on the representation of regional locales, clothing, practices and objects of the popular classes, known in the nineteenth century as *costumbrista* painting. Local colour, multiple perspectives allowing fuller views of objects, and an intense focus on the exactitude of detail, of object-ness, often characterized this class of painting. Women artists shared some of these same concerns.

Eulalia Lucio (1853–1900), for example, painted a number of still lifes in domestic interiors and has earned a reputation as a particularly adept realist who paid extraordinary attention to the details of the material culture she depicted. Her *Objects for Embroidery* of 1884, for example, demonstrates her skill, but also seems, at first glance, to offer little beyond the conventionalities of women's imagery of the period (Figure 12.3). With objects used for embroidery as the focus, it highlights the needlework at which women were expected to excel. In fact, the practice of embroidery is emphasized by the open sewing box with its gleaming, golden scissors, thimbles and bobbins. Of provocative interest is the carefully rendered mirror in the interior of the lid of the box which, within the Western allegorical tradition of the mirror, has been associated with vanity. The mirror here reflects no figures, rather only a partial view of the adjacent basket of threads as well as the *manta*, or coarse

12.2 Guadelupe Carpio, *Self-Portrait with Family*, 157 x 82.5 cm, oil on canvas, n.d.

12.3 Eulalio Lucio, *Objects for Embroidery*, 31 × 41 cm, oil on canvas, 1884

cotton cloth, that hangs over the table's edge. This doubles their presence in the painting – similar to the way that polished silver and copper could reflect back the surfaces of opulent goods collected and displayed by the well-heeled middle class in seventeenth-century Dutch still-life painting (Bryson,

1990). Lucio's mirror not only reflects back the proper practices of a bourgeois woman, but also the array of objects owned by such a woman. Moreover, like San Román's and Carpio's paintings, it depicts the rhetorical device of the woman stopped in the midst of her work. In Lucio's painting we see that the *manta* which, presumably, she has so carefully been stitching, is not finished. Thus, her creative act is also arrested.

At the same time, the *manta* provides a link between Lucio's painting and that of Agustín Arrieta, a regional artist from the state of Puebla. Arrieta was quite well known for the *costumbrista* paintings he exhibited at the Academy exhibitions in Mexico City from the 1850s until the 1870s. These included still lifes, as well as interiors and street scenes. The *manta* appears in several of his paintings, including kitchen scenes in which the surfaces of a diversity of objects and clothing are carefully rendered. On the one hand, the *manta* hanging over the edge of the table serves to emphasize the three-dimensionality of the painting. On the other, it is a subtle marker of regional handiwork. The coarse cotton cloth is local, not imported. The handiwork itself is foregrounded in Eulalia Lucio's canvas and the step-fret designs are very likely derived from pre-Hispanic architectural designs which were well known and well published by mid-century. These combine to emphasize a subtle national character which was already recognized in the works of artists like Arrieta.[2]

Lucio had direct access to at least five of Arrieta's works because they were among her father's extensive art collection. Rafael Lucio was a renowned physician and patron of the arts and had among his works a number of still lifes as well as *costumbrista* paintings. His connection to the Academy as a physician was quite direct. He showed works from his collections in a number of Academy exhibitions.[3] He also delivered an extensive address to the Academy of San Carlos on behalf of the Medical School, thanking sculptor Juan Soriano and the Academy for its gift of a life-size statue of St Luke for the lobby of the Medical School.[4] He was so well thought of by the Academy that one of its members eulogized Lucio upon his death. He provided a kind of site of intersection between art and medicine that surely must have influenced his daughter's own artistic practice and particularly her realist concerns for clear, detailed depictions of the individual objects in a still life. A broadly parallel case would be the realism and precision of painting that characterizes the work of Frida Kahlo, who is credited with refracting in her art her own brief medical education as well as the photographic practices of her father. Lucio's still life might also be regarded as a site of intersection between the academic and the non-academic (*costumbrista* painting) as well as between the spheres of art and medicine.

Using Eulalia Lucio's work as an example, it becomes clear that, somewhat like that of their twentieth-century counterparts, the work of

nineteenth-century women artists opened on to a much broader sphere of art than the did the work of male artists trained in the Academy. It was not until 1867 that the Academy in Mexico City gave its formal approval to the genre of *costumbrista* as part of the curriculum. Even then it was not ranked at the peak of the academic hierarchy. Nevertheless, women's practice of *costumbrista* and still-life painting intersected with a space outside the Academy and thereby suggests rich implications for revising the ways in which their art is analysed. Instead of seeing this genre as part of a vertical hierarchy of academic categories, and one fit for women because by necessity they had access to it, still life might be regarded more fruitfully within a map of artistic production in the nineteenth century. This would allow for both the work of women artists, artists trained outside of Mexico City as well as outside of the Academy to be far more mutually informative than previously thought. The barriers to a complete academic training, requiring the command of history painting and the nude figure, in a sense turned women artists to produce works which, if not by style or a consciously politicized choice, are also not as distant from the work of their twentieth-century sisters as might be imagined.

ACCESS TO THE PUBLIC SPHERE

Ironically, if nineteenth-century Mexican women artists did not sell their works, they did have access to relatively regularly held public exhibitions and, as a consequence, their works were relatively regularly subject to contemporary art criticism (Rodríguez Prampolini, 1964). Beginning in 1849, the Academy of Fine Arts in Mexico City held public exhibitions that included hundreds of images by faculty, students and artists from outside the Academy, as well as works of art from private collections (Romero de Terreros, 1963). Women artists started to show their works that year and continued to do so throughout the twenty-three exhibitions held until the end of the century. Moreover, women artists also showed their works in the Mexican pavilions at international expositions. Mexico began participating in these enormous, complex enterprises in 1876 at the US Centennial Exposition in Philadelphia and it was here that Mexican women's art made its first appearance.

Academy exhibitions in particular brought women's works before a significantly large public and consequently promoted a relatively regular, public commentary. This was certainly one of the benefits of the nineteenth-century Academy. To be sure, twentieth-century women artists showed their works both nationally and internationally, and in small group and one-person shows. They also garnered publicity and exposure in very different ways from nineteenth-century women artists: for example, through mid-

twentieth-century mass media such as film and fashion magazines, and international tourism, too, played a significant role. Through these means the women themselves, not just their art, gained notoriety. The modern mechanisms of entrance into the public sphere were obviously not relevant for the nineteenth century. Nevertheless, art criticism was crucial to a public sphere for artists of the nineteenth century trying to gain access and of profound importance when the nineteenth-century woman artist herself may not have had any means of direct entry into it.

Expectedly, the criticism did much to reinforce women's art as the product of the well-bred woman whose proper domain was indeed at home and whose art was, by training and focus, merely a runner-up to art made by their male peers. Their works could be described as charming or delicious, the same terms that might be applied to the women themselves. Or, a copy of a male artist's painting could provoke a critic to address more directly the skills of the original artist rather than her skills as a copyist. Eulalia Lucio's copy of French artist Edouard Pingret's *Cocina* (*Kitchen Scene*, mid-nineteenth century, Mexico City: Museo Nacional de Historia) is a case in point. In short, the criticism damned the painting twice. First it was merely a woman's copy and second it was based on what the critic regarded as the stiff and 'untruthful' character of the original work by Pingret (Rodríguez Prampolini, vol. 2, 425). Other comments suggest the 'unfulfilled' character of women's art. What one artist submitted as a finished painting to the Academy exhibition, a critic saw only as a study. What another artist submitted as a copy of an entire print, a critic saw only as her copy of the dress, implicitly merely women's fashion, worn by one of the figures in the original print (Rodríguez Prampolini, vol. 3, 22). Moreover, in a number of instances critics reminded readers of women artists' status as 'the fair sex' and occasionally lamented the fact that marriage and family cut short their artistic potential. Such commentary re-inscribes the woman artist's place as properly in the home, where the fair and beautiful sex could be protected and where her status as artistic also-ran was not at issue.

Nineteenth-century Mexican women artists, however, also provide examples of subtly transgressive practices that moved them and/or their art further into the complex sphere of modernizing Mexico. At the end of the nineteenth century, for a web of reasons, public space itself became much more definable. During the 1876–1910 administration of President Porfirio Diaz, the so-called *porfiriato*, the city in general and Mexico City in particular became the locus of vast government expenditure on public buildings for an expanding bureaucracy; investors poured money into the construction of spaces of spectacle, both public and private, as well as into the increased modernization of production in the form of factories. At the same time, with a general influx of people to the city, and with increased industrialization and

factory labour, workers began to organize themselves into mutual aid societies. There was also a significant increase in the number of single women working outside the home, not only as domestics but also as factory workers (Parcero, 1992).

Generally, social groups increasingly found ways to define themselves against each other. City dwellers defined themselves against rural society and new definitions of masculinity emerged as men confronted, among other pressures, women's expanded presence in the public sphere. This is also demonstrated by the dramatic increase in different groups exhibiting their works at the Academy shows. By the end of the century, the public would see work, for example, from students taking night classes; from participants in government-run schools of arts and trades; from trade schools outside Mexico City; from the Mexican-French Club; and from the government-run National Preparatory School, which trained Mexico's elite in mining and engineering. Leopolda Gasso y Vidal's newspaper article entitled 'La mujer artista' (1885), Eulalia Lucio's *Still Life with Objects of the Hunt* of 1888 (Figure 12.4), and Julia Escalante's exhibition of two paintings in the same year at the Hotel del Jardín, a private and non-Academy-related space, emerge within this historical context.

On 6 December and 13 December 1885 *El Album de la Mujer*, one of a growing number of regularly issued periodicals and publications designed for an increasingly literate female population, published a piece entitled 'La mujer artista' (Rodríguez Prampolini, vol. 3, 191–7). Written by Leopolda Gasso y Vidal, about whose biography virtually nothing is known, the essay firmly but cautiously addressed the plight of women artists who were also mothers and tenders of the home and hearth. It is a remarkable piece for its careful navigation of the liberating, professional and intellectual potential of a career of making art (especially painting) and the virtues of maintaining order and morality in the domestic sphere. In her argument for equal access to training and production (including access to the nude and to more formal art classes) the writer maintained that such an education and practice would only benefit the integrity of the home; she asserted that there could be 'harmony between the good mother and the enlightened woman' (Gasso y Vidal, cited in Rodríguez Prampolini, 1964, vol. 3, 194). The language she chose insistently located her in the complexities of a modernizing Mexico in which the production of good citizens, the acquisition of knowledge and culture (the affirmation of the 'civilized') and progress was set against the increasingly present voices of class and gender, of workers and of women. Through a strategic use of terms such as 'emancipation', 'reform', 'struggle', 'advances', 'the divine law of progress', and 'the modern spirit of charity', she negotiated a nexus of traditions, practices and history of both women and art on the one hand with the social, moral and (implicitly) political needs of

12.4 Eulalio Lucio, *Objects of the Hunt*, 84.5 × 105 cm, oil on canvas, 1888

the modern state on the other. Her essay effectively made the membrane between public and private far more permeable than the mid-century San Román could ever have imagined.

Leopolda Gasso y Vidal also considers the concept of progress and specifically mechanical and technological advances. This stages another point of boundary transgression between the gendered and classed public and private spheres. In the first instance she concedes that in earlier epochs 'doubly more calamitous' than the present, women had to attend to the work of the home, but with 'mechanical advances' it is certain 'that she has more time than her forebears to embellish her moral being and assure the sustenance of her family' (Gasso y Vidal, cited in Rodríguez Prampolini, vol. 3, 193). This notion of mechanical advance is particularly poignant in a period in which the mechanization of labour could cut two ways. While few Mexican artists represented industry in the nineteenth century, there are examples by both men and women that indicate an increasing concern with urban industrialization. Within the context of high art, as opposed to commercial lithographic compendia, José María Velasco, who served as the

Academy's director of landscape painting in the late nineteenth century, for example, painted one of the few views of industry in his image of the cotton factory of La Hormiga in 1863. The degree to which the factory is secondary in importance to the character of the landscape itself is suggested by the title of the painting: *El cabrío de San Angel, vista tomada desde la orilla del rio. Fábrica de la Hormiga (Goatherd of San Angel, view taken from the edge of the river. La Hormiga Factory*, Mexico City: Museo Nacional de Arte). Velasco's painting stages a process, naturalizing the factory with its smoking chimney as it is nestled in the detailed landscape of the ravine it overlooks. As Velázquez Guadarrama has also suggested, this painting subtly opposes the traditional, and thus hand-done, work of the goatherd, who is shown carefully integrated into the landscape, with the automated work of the factory employee, who cannot be seen through the slit-like windows in his or her interior mechanized workspace (Veláquez Guadarrama, 1999, 230). Dolores Soto (1869–1964), a student of Velasco, was one of the very few women of the period to paint industry. In her turn-of-the-century *Paper Factory: Peña Pobre, Tlalpan* (n.d., private collection), this same process of blending the industrial into the landscape is evident.[5]

The material culture of modernity is depicted in the heretofore cloistered world of the *mujer decente* in Daniel Dávila's turn of the century painting *Soñando (Dreaming)*, (n.d., private collection).[6] The artist represents his wife at a sewing machine which, as Velázquez Guadarrama asserts, 'has entered and integrated the private sphere, without a problem' (Velázquez Guadarrama, 1999, 206). It is a painting striking for its contrasts. This elegantly dressed woman is posed, 'dreaming', while leaning on her new machine. Dávila's wife and her labour-saving device are seated on top of an animal (seemingly a tiger) skin rug, complete with head and gaping mouth, while around her is a gilt-framed rococo folding screen as well as other rich adornments which suggest that sewing is itself still precisely adornment rather than work. This is a critical point. Sewing, in all its forms, played a crucial role as a form of women's labour and representation. Ironically, it was Leopolda Gasso y Vidal who reminded her readers several times that women's practices and their relationship to men or husbands were historically a form of adornment.

Like Clavé's original portrait of Juliana San Román as a painter, Dávila recreates his wife–seamstress as engaged in a pastime, that might be started and stopped at her leisure. The question of sewing as labour, and of the efficacy of machines in the factory system, was very clearly a significant issue for other women of the late nineteenth century whose surroundings were not so comfortable and opulent, and for whom dreaming at work would have been a severely punishable offence. The intervention of modernity into the spaces of seamstresses was certainly not so well integrated as in Señora Dávila's. Conditions had become so drastic for seamstresses working in

factories that they endeavoured to form a mutual aid society (Parcero, 95–6). There is also an argument to be made here about the relationship between the handmade and the machine-made. Dávila's painting of his dreaming wife at the sewing machine could be compared with Lucio's still-life painting *Objects of Embroidery* with the handmade and suggestively national character of her *manta* (see Figure 12.3). The unfinished *manta* may be seen as standing in as a rhetorical device for time, implying not only an awareness of the spheres of traditional and modern technologies, but also registering turn-of-the-century nostalgia for the handmade as from an earlier, pre-modern period.

When paired with her 1888 still life, *Objects of the Hunt* (Figure 12.4), Eulalia Lucio's *Objects of Embroidery* suggests a keen awareness of the gendered spheres of late nineteenth-century Mexico. To be sure, as Macías-González has suggested, the wealth of objects in both the paintings function as species of *Wunderkabinet* (cabinet of curiosities) that serve to proclaim, literally and objectively, the identity of their bourgeois owner. The painting creates an inventory of hunting accoutrements: shotgun, sombrero, hunting horn, canteen, bandolier of shotgun shells, hammer and specimen bag (as is possible with her objects of embroidery). Equally emphasized, however, is the gendered character of these objects. In the earlier painting embroidery tools objectify the domestic, delicate and decorative geography of the bourgeois sphere of women. Four years later hunting objects exemplify the rural, public, male sphere, which, according to Macías-González, became an increasingly important site for male socializing, and for defining new modes of masculinity at the end of the nineteenth century.

Cortina commented that this hunting gear implicitly contrasted with the 'the tranquil interior of the house' – with the visual rhetoric of female domestic space (Cortina, 157). Lucio's emphatic interest in these objects as specifically part of hunting is also suggested by the subtle difference between the study she did for the painting and the finished version.[7] The study presents all the objects slightly closer to the viewer. In the finished version, the viewer is implicitly farther away, as suggested by the presence of a larger area of the back wall. In the finished version, these male objects are set off even further against female elements, namely, the decorative patterning of the elaborate wallpaper, as well as the rich material of the tied-back curtain and the elaborately embroidered border of the tablecloth on which all the objects sit. Lucio's insistence on displaying the gendered spheres of her class and time is also suggested by the reflected, doubled presence of specific objects in *Objects of Embroidery*. Not all the objects are reflected in the lid of the sewing box, only the spools of thread and *manta*; neither vase, flowers nor wallpaper appear. In the end, both of her still lifes insistently highlight the objects that define gender, not all the objects that could also, or particularly, identify class.

Lucio exhibited some of her still lifes in international expositions, namely in Paris in 1889 and in Chicago in 1893. Cortina states that her *Objects of the Hunt* was among the works shown in Paris (Cortina, 157). The 1888 date of the painting argues for this as well as a second detail. When the painting was exhibited in the 1985 exhibition, it still bore the label in the centre foreground identifying it as a scene of 'objects of the hunt'. The label was written in French. Presumably this was written with the 1889 French audience in mind. But it also suggests a connection to the *afrancesamiento* (the French-ifying) of late nineteenth-century Mexican high culture and fashion in general. French clothes, French music, literature, food and language characterized elite, urban consumer culture from about 1880 until 1910. The significance of the French language for women by this time could not be merely reduced to evidence of a bourgeois woman's education, as it may have been in the middle of the century. And Lucio was hardly the only artist aware of the connotations of things French.

Julia Escalante (1854–1900) chose, for example, to base her painting of *Graziella* (1879, private collection) on the novel of the same name by the French writer and politician, Alphonse de Lamartine, published in 1849.[8] She showed the work initially at the Academy exhibition of 1879. But in 1888 she chose to re-exhibit it at another venue outside the Academy, in the parlour of the Hotel del Jardín , also in Mexico City, where it was paired with another painting, *The Milkcarrier*, originally exhibited in the Academy in 1881 (Figure 12.5). Escalante's decision – to re-exhibit works already shown at the Academy in this non-academic space – was significant, as was the critical attention they received. Several reviews underscored Hotel del Jardín's non-academic location. Modernist writer Manuel Gutiérrez Nájera figuratively and literally described the space as allowing 'more fresh air' (Gutiérrez Nájéra, 1888, cited in Rodríguez Prampolini, vol. 3, 226). A Francophile, as were many culturati of the end of the century, he framed the exhibition by claiming that through the 'open window' it provided, one could see the horizon of Paris. He referred to its participants as having escaped the Academy, and described the exhibition as revealing the new, the novel (Gutiérrez Nájéra, 227). He and an another (anonymous) critic also took pains to characterize the exhibition space. Gutiérrez Nájéra also described the frames of the paintings as luxurious and glittering, proposing that the frames did as much as shout: 'I am very rich.'[9] This seems to draw a set of critical parameters within which the works of art will also be assessed: that of display, spectacle and adornment as a prerogative of the elite, and as a means of distinguishing the high-born from the low.

In Lamartine's novel, Graziella is a young girl from an impoverished, but noble, Neapolitan fishing family. Particularly provocative are the comments of Gutiérrez Nájéra who says Graziella is 'too much señorita (respectable

12.5 Julia Escalante, (1854–1900), *The Milkcarrier*, 169 x 75 cm, exhibited 1881 and 1888, oil on canvas

little Miss) and little if at all sorrentina (from Sorrento), she is a Graziella of a very good family.' (Gutiérrez Nájéra, 226) He continues: 'This elegant girl, out of some romantic whim has dressed herself up as Graziella.' This is contrary to the girl's action in Lamartine's novel, in which Graziella is poor and can only imagine what it is like to dress in fine clothes. In one scene she tries on the finely made clothes of a rich young French girl that her friend is employed to mend. Thus, the nineteenth-century Mexican critic narrates a reversal of fortune for Graziella when he describes her as a rich girl whimsically dressing up as a poor one.

The milk carrier's fortune is also reversed. Gutiérrez Nájéra points out that Escalante has 'arranged' the young boy in a Mexican landscape, signified by the presence of a nopal cactus. In spite of this specimen of national flora, the boy is, nevertheless, not one of 'our milk carriers' (Gutiérrez Nájéra, 229). He continues: 'It is perhaps Graziella's fiancé, dressed also fantastically, very clean, very correct, very Jockey Club, very put together and only accidentally peasant' (Gutiérrez Nájéra, 229). This comment encapsulates the values of hygiene, appropriate class comportment, and spectacular dressing. The reference to the Jockey Club is especially suggestive because it was a popular and recently opened site in Mexico City for high-society socializing (Beezley, 1987). It is well known that members of Mexico's elite dressed up in certain regional costumes for a night at the Jockey Club, but it was also common to dress up for paintings and photographs. Exemplary of this is the work of Luz Osorio, Escalante's contemporary, who painted *La Papanteca* (n.d., Collection Luis Obregón Zetina), a depiction of a pouty young woman clearly dressed up and seated with props in front of a tropical landscape. Gutiérrez Nájéra's ability to read Escalante's paintings as acts of dressing up certainly signals the embeddedness of this practice in late nineteenth-century Mexico.

Both of Escalante's paintings could have been cast as charming female works and as two among many images of children as charity cases that were becoming increasingly popular with artists and critics at the end of the century. Certainly, it is no coincidence that such paintings emerged in a period in which it was increasingly necessary to distinguish one's class/social identity. But the exhibition in the Hotel del Jardín served as a node of an emerging modernist discourse in late nineteenth-century Mexico which was anti-academic, French and spectacular. Escalante re-exhibited *Graziella* and *The Milkcarrier* together in this new, non-academic site of modern, urban life. As one description of the show attests, the paintings and other art shown there would be considered as among other beautiful, luxury objects displayed in a space that had also been dressed up for the occasion.[10] The space of their exhibition itself allowed Gutiérrez Nájéra to reinterpret them within modern, elite practices.

Leopolda Gasso y Vidal's forceful declamation about the conditions of

women and women artists, Eulalia Lucio's still lifes, as well as Julia Escalante's re-exhibition of her two paintings in the Hotel del Jardín, amply testify to the vital concerns of nineteenth-century Mexican women artists. Their strategies of representation – text, image and site – suggest that they had a much keener awareness of their particular place in the practice of art and in their own society than twentieth-century criticism has revealed. This does not mean that they understood their activities to be outrightly political, much less critical of the very class structure that allowed them to paint in the first place. Yet, these examples should help to adjust the way that they and their works are positioned in the narrative of Mexican art history. Their production should not be read as ancillary to, or beneath, the work of their male counterparts. Nor, moreover, should it be processed as some inchoate form of a fully realized twentieth-century women's art. It is interesting to note that nineteenth-century critics often compared Mexican women artists to the French realist painter Rosa Bonheur. The critics understood her to be a celebrated artist, producing acceptable paintings for her time and place. And yet, if she did not distress the public as did her other more controversial Realist colleagues, Rosa Bonheur did wear pants.

References

Beezley, W. H., *Judas and the Jockey Club and Other Episodes of Porfirian Mexico*, Lincoln: University of Nebraska Press, 1987.

Bryson, N., *Looking at the Overlooked*, Cambridge: Cambridge University Press, 1990.

Cortina, L., et al., *Pintoras Mexicanas del Siglo XIX*, exh. cat., Mexico: Museo de San Carlos, INBA, 1985.

Gallí Boadella, M., *Historia del Bellow sexo. La Introducción del romanticismo en México*, Mexico: Universidad Nacional Autónoma de México, Instituto de Investigaciones Estéticas, 2002.

Gasso y Vidal, L., 'La mujer artista', in *El album de la mujuer*, 6 December 1885 and 13 December 1885, reprinted in I. Rodríguez Prampolini, 1964, vol. 3, 191–7.

Gutiérrez Nájéra, M., 'La Exposición de pinturas en el Hotel Jardín', *El Partido Liberal*, 15 and 22 July 1888, in Rodríguez Prampolini, 1964, vol. 3, 226–232.

Lamartine, Alphonse de, *Graziella*, trs. James B. Runnion, Chicago: A.C. McClurg and Co., 1890.

Macías-González, V., 'Apuntes sobre la construcción de la masculinidad a través de la iconografía artística porfiriana', in *La amplitud de la modernidad y del modernismo'*, vol. 2 of *Hacia otra historia del arte en México*, coords E. Acevedo and S. G. Widdifield, Mexico: CURARE and Conaculta, 2005, 329–50.

Parcero, María de la Luz, *Condiciones de la mujer en México durante el siglo XIX.*, Mexico: Instituto Nacional de Antropología e Historia, 1992.

Rodríguez Prampolini, I., *La crítica de arte en México en el siglo XIX*, 3 vols, Mexico: UNAM, Institute de Investigaciones Estéticas, 1964.

Romero de Terreros, M., *Catálogos de las exposiciones de la Antigua Academia de San*

Carlos, Mexico: Universidad Nacional Autónoma de México, Instituto de Investigaciones Estéticas, 1963.

Velázquez Guadarrama, A.,' Pervivencias Novohispana y tránsito a la modernidad', in *Pintura y la Vida Cotidiana, 1650–1950*, Mexico: Fomento Cultural Banamex and Conaculta, 1999, 155–243.

——, 'La representación de la domesticidad burguesa: El caso de las hermanas San Román', in: *De la ordenación colonial a la exigencia nacional, 1780–1860*, coord. E. Acevedo, vol. 1 of *Hacia otra historia del arte en México*, coords E. Acevedo and S. G. Widdifield, Mexico: CURARE and Conaculta, 2001, 122–145.

——, 'La pintura constumbrista y la pretendida construcción de la imagen nacional', in *La amplitud de la modernidad y del modernismo*, vol. 2 of *Hacia otra historia del arte en México*, coords E. Acevedo, Mexico: CURARE and Conaculta, 2005, 137–58.

Notes

1 Romero de Terreros, *catálogos de las exposiciones de la Antigua Academia de San Carlos*, 1963, reproduces all the nineteenth-century exhibition catalogues, with the exception of the first year, which has not yet been located.

2 Velázquez Guadarrama (2005) makes a very compelling argument for women and regional artists, such as Arrieta, as contributors to a vocabulary of the national in their still lifes and *costumbrista* paintings.

3 Dr Lucio had fifty-one works from his collections exhibited in the 1871 and 1873 Academy shows. His collections were primarily foreign and Mexican still lifes, landscapes and *costumbrista* paintings with lesser numbers of figural studies, originals and copies of religious paintings and portraits. The collections he exhibited are listed in Romero de Terreros, 1963, 424–30 and 461–4.

4 See Rafael Lucio, 'Discurso del Señor Lucio', in I. Rodríguez Prampolini, *La critica de arte en México en al siglo XIX*, 1964, vol. 2, 10–12.

5 The painting is reproduced in Cortina, *Pintoras Mexicanas del Siglo XIV*, 1985, 205.

6 Dávila's painting is undated, but he exhibited works in the Academy shows of the last two decades of the nineteenth century; it is likely that this painting dates from the 1880s/1900s.

7 Cortina includes both studies in her work; they are set next to each other so that these subtle differences are easily recognizable, 157.

8 Gallí Boadella, 2002, discusses Lamartine's work as also exemplary of Catholic conservative values and particularly affirmative of nineteenth-century Mexican family values. Escalante's painting of *Graziella* is reproduced in Cortina, 1985, 75. The French connection of this and *The Milkcarrier* also need to be explored in relation to the popularity in Mexico of the works of French academic artist William Bougerreau, who also specialized in paintings of well-fed peasants.

9 'Una exposición de pintura', *El Eco Universal*, 1 July 1888, in Rodríguez Prampolini, *La critica de arte en Mexico*, vol. 3, 222–5.

10 'Una exposición de pintura', 1888 and in Rodríguez Prampolini, *La critica de arte en Mexico*, vol. 3, 222.

Index